▼

HURRELL'S HOLLYWOOD PORTRAITS

▲

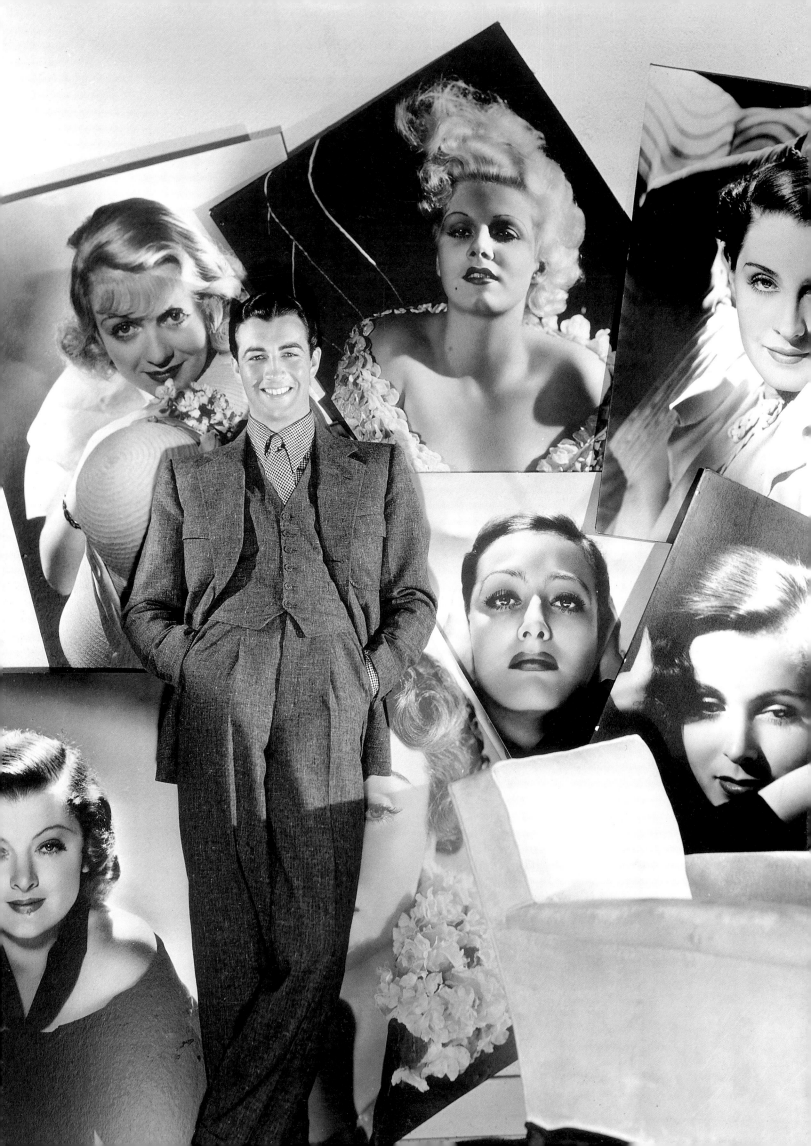

▼

HURRELL'S HOLLYWOOD PORTRAITS

THE CHAPMAN COLLECTION

▲

MARK A. VIEIRA

HARRY N. ABRAMS, INC., PUBLISHERS

To Bob Main, Jim Breen, and Paul Norwood.
And in memory of Michael Reed, who loved images by Hurrell.
—Bill Chapman

To my mother and father.
—Mark A. Vieira

EDITOR: James Leggio
DESIGNER: Raymond P. Hooper

Library of Congress Cataloging-in-Publication Data
Vieira, Mark.
Hurrell's Hollywood portraits : the Chapman collection / Mark
A. Vieira.
p. cm.
Includes bibliographical references and index.
ISBN 0–8109–3434–5 (clothbound)
1. Glamour photography. 2. Motion picture actors and
actresses—United States—Portraits. 3. Hurrell, George,
1904–1992. 4. Chapman, Bill—Photograph collections.
I. Hurrell, George, 1904–1992. II. Title.
TR678.V54 1997
77′.2′092—dc20 96–27184

Printed and bound in Japan

Harry N. Abrams, Inc.
100 Fifth Avenue
New York, N.Y. 10011
www.abramsbooks.com

CREDITS

*Wes Bond: plate 166; Alfred Chico: plate 113; David Chierichetti:
plate 19; Allan R. Ellenberger: plate 4; Kobal Collection: plates 2,
21, 25, 152, 165, 187, 191, 192, 204; Francis J. Montgomery: plates
116, 220; Photofest: plates 134, 161, 162, 230; Allan Rich: plates
171, 254; Darrell Rooney: plate 170; Turner Entertainment Co.:
plate 179; Roy Windham: plates 29, 46, 121, 234.*

FRONTISPIECE: *In 1935, George Hurrell used a selection of his
own portraits to surround Robert Taylor. Clockwise from top: Jean
Harlow, Norma Shearer, Frances Dee, Joan Crawford, Madge
Evans, Myrna Loy, and Constance Bennett. Taylor eventually
co-starred with all but Dee, Evans, and Bennett.*

CONTENTS

PREFACE

Hollywood's "Golden Era" was the supremely prosperous period between 1925 and 1950. Until it was undermined by changing tastes and the advent of television, Hollywood aped our culture, fed our culture, and to a great extent *was* our culture. Even now, few of us can resist the images we see so vividly inscribed on the silver rectangle in a darkened theatre. But what brings us there? And what recalls what we saw in that dreamlike state? Still photographs.

"Publicity stills" were once the calling cards of the stars, Hollywood's way of alerting the world to its latest creation. Hundreds of thousands of stills were printed to publicize each film that was released. The films came and went, were retired to vaults or melted for their silver content. The movie stills were stacked here and there and left in dark corners to gather dust. As the world moved on to its next sensation, they were forgotten.

In the 1960s, however, something happened. A cult of movie-still collectors emerged, and the stills made their way into private collections. Long before the Golden Era was rediscovered, still collectors were safeguarding its photographic legacy. By the 1970s, most movie studios had dumped their stills, and the pictorial history of Hollywood was in other hands.

Suddenly it was time to "rediscover" the American cinema. The greatness of Hollywood's past was proclaimed by critics, scholars, and the public. Directors, writers, and cinematographers were honored, and eventually the still photographers got their due. The media needed photographs to illustrate this greatness, and collectors such as Andy Warhol at *Interview* and Dore Freeman at MGM-UA gave the public a magic window to look through. It was from collectors that I first heard about George Hurrell, and to them that I owe the opportunity to chronicle his work.

This book was possible because of the foresight, taste, and perseverance of a singular collector, Bill Chapman. For more than twenty years, he has assiduously collected photographs made by Hurrell.

George Edward Hurrell was a studio portrait photographer from 1930 to 1943. He was also the principal auteur of the "Hollywood glamour portrait." Before him, publicity portraits were soft and undistinguished, deriving their style from the commercial portrait salon. Hurrell was responsible for creating a bold new idiom, one in which movie stars were idealized, glamorized, and, ultimately, turned into icons. Within five years, his style had become the standard, and was influencing advertising and commercial portraiture as well. Forty years later, books such as John Kobal's *The Art of the Great Hollywood Portrait Photographers* told us that old movie stills were not merely publicity material; they were fine art. George Hurrell was singled out as the master of this art.

After countless interviews, books, and exhibitions, the name Hurrell has become synonymous with the Hollywood glamour portrait and is now almost a generic term. Unfortunately, many books that celebrate Hurrell are inaccurate in describing his work, careless in their chronologies, and slavering in their praise. By the time of his death in 1992, he was tired of being called a "legend." His fans were happy to see him rescued from obscurity but sad to see him misrepresented. I met George Hurrell in 1975, when the culture was beginning to rediscover him, and assisted him with his first book. I talked with him many times about his work, and the more I learned, the more I felt that the definitive book had yet to be written.

This is the first book on Hurrell to present a survey of his Hollywood work using primarily vintage prints. The Chapman Collection is one of the world's largest private archives of original Hurrell photographs. Many of these were hand-printed by the artist himself. Once I saw this body of largely unpublished images, I knew that the full scope of Hurrell's achievements could finally be shown.

This is also the first book to treat Hurrell's work in strict chronology, outlining five distinct periods of creative activity between 1925 and 1943. Each of

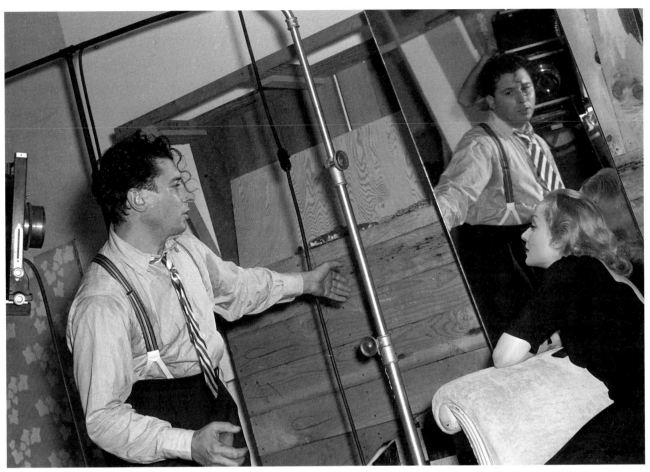

1. "If I have a special talent," George Hurrell said in 1983, "it's because I work hard at it and try my damnedest. Maybe it's mostly sweat." Here he is in 1937, with Carole Lombard, sweating.

these periods was marked by the innovation of specific techniques or by a change in working space. Each period is described in its own chapter, where its techniques are explained and its circumstances are detailed. The book uses fresh interviews, previously unseen archival material, and discoveries made in my own journey through the world of stills collecting. The Hurrell "rediscovery" of the 1970s gave the artist a second career, one that lasted fifteen years. Although that later portrait work still had integrity, it was mostly derivative of earlier periods and was created in a very different climate. As a result, it is best shown elsewhere.

Finally, this is the first Hurrell book to be written by a working photographer. I have devoted my professional life to emulating this artist and am now the only photographer in America making portraits in the classic Hollywood mode, using a large-format camera, incandescent lighting, and full negative retouching. I work exactly as Hurrell did sixty years ago. I also work as an archival printer, making modern prints from 1930s nitrate negatives, many of which were shot by Hurrell. It is from this professional background that I try to explain Hurrell's technical mastery and put his work in the context of both fine art and popular culture.

On the occasion of this book's publication, Bill Chapman wishes formally to acknowledge the many individuals who helped build the Chapman Collection: Ed Baker, Peter Bateman, Roy Bishop, Ronald V. Borst, Ralph Bowman, Jim Breen, Clare Cameron, David Chierichetti, Mack W. Dennard, Steve Edrington, David Elkouby, Peter Fetterman, Mary Griffin, Virginia and Donald Griffith, Doug Hart, Halbert Kaniger, Marty Kearns, Eileen Koslik, Paul Lisy, Peter Machaverna, Tim Malachovsky, Al Morley, Paul Norwood, Mary O'Brien, Dan Patterson, Eric Rachlis, Ken Richards, Joan Rose, Arthur Ruiz, Danny Schwartz, Stanley Simon, Erik Stogo, Lou Valentino, Marc Wanamaker, Malcolm Willits, Mark Willoughby, and Pam Wulk.

I wish to thank the following individuals, agencies, and companies for supplying additional photographs: Roy Windham of Baby Jane of Hollywood; Ed Baker; Wes Bond; Alfred Chico; Allan R. Ellenberger; Francis J. Montgomery; Lorraine Mead of Condé Nast Publications; Dave Kent and Martin

Dives of the Kobal Collection; Simon Crocker of the Kobal Foundation; Howard Mandelbaum, Photofest; Allan Rich; and Kathy Lendech of the Turner Entertainment Company.

I also wish to thank the following archives, institutions, and companies for facilitating my research: the library at California State University, Hayward; the Los Angeles Public Library; the Oakland Public Library; the Sacramento Public Library; the Sacramento State University Public Library; and the Lincoln Center Library for the Performing Arts, New York. Special thanks are due Derek Mutch, Ken Bullock, and Roy Johnson of Limelight Bookstore, San Francisco; David Wooders and Todd Gustavson, Technology Archivists at George Eastman House, Rochester, New York, and their assistant, David Gibson; Laurie Winfrey at Carousel Research and Janice Madhu at Eastman House Photo Archives; Eileen Ellis at *Interview* magazine; Janice Carpentier, Merle Thomason, and Roger Squillente at the Fairchild Collection of *Women's Wear Daily;* Al Burciaga and Alex Moradi of I.C.O. Investments; Simon Crocker of the Kobal Foundation and Julian Seddon Films; Birgitta Kuypers of the Special Collections Library, University of California, Los Angeles; Leith Adams, Jeff Briggs, and Bill Whittington of the Warner Brothers Archives; Ned Comstock of the Cinema and Television Library, University of Southern California; Dennis Wilson of the Legal Archives at Sony Entertainment; George Christy of the *Hollywood Reporter;* Lori Kleban, Assistant, and Arnold Shupack, President, Studio Operations Group, Sony Pictures Entertainment; Marc Wanamaker of the Bison Archives; and Richard P. May, Vice President, Film Preservation and Distribution Services, Turner Entertainment.

The following interview subjects are also to be thanked for sharing time, reminiscences, and insights: Bill Chapman, David Chierichetti, George Christy, J. Grier Clarke, Simon Crocker, David Fahey, G. Ray Hawkins, George Hurrell, Jr., David Leddick, Howard Mandelbaum, Marysa Maslansky, Paul Morrissey, Anita Page, Lawrence Quirk, Allan Rich, Joan Rose, Mike St. Hilaire, and David Stenn.

I would like to mention as well those interviewees who are no longer living but whose influence was never absent from this project: Ted Allan, Myron Braum, Clarence Bull, Lee Garmes, Edd Hearn, John Kobal, Laszlo Willinger, Chester W. Schaeffer, Jaime Vega, and, of course, George Hurrell himself.

Many individuals smoothed the path of research, notably: Ed Baker; Rodrigo Vega; Rob McKay; Bob Cosenza; Axel Madsen; Gavin Lambert; Brian Bundy; Carlos Rodriguez; Leonard Stanley; Bobby

Gonzales; John L. McDaniels; Bobby Litts; Peter Mintun; Bryndon Hassman; Terrence O'Flaherty; P. R. Tooke; Deborah Thalberg; Carole York of Cinema Memories, Key West; Laurie Funnell of Castro Valley Super Print; Larry Kleno of VIP Productions; Roderick Clohan of Western Photographic Imaging, Hayward, California; Mike Hawks of Larry Edmunds Bookstore; Michael Vollbracht; Jim Jeneji of MGM-UA; Joseph Caro of Bakers Caro Kano; Randall Malone, who arranged the interview with Anita Page; Allan R. Ellenberger, Ramon Novarro expert; Chuck Dembo of Gilbert Dembo and Associates Leasing; and Paul Morrissey. Special thanks go to Helen Hickish, Maria Montgomery, and Francis J. Montgomery of the Montgomery Management Co., for bringing 8706 Sunset back to life; to David A. Gibson, for his lengthy response to my queries about film stocks; to Marc Wanamaker, for a tour of old Metro; to Darrell Rooney, for hours of Jean Harlow research; to Dick May, for early encouragement and advice; and to Ned Comstock, for his patience and resourcefulness.

I must also thank the people who kept my feet on the ground while I was writing about the stars: Joe Delgadillo and Bob Ricardo of Outbound Travel in San Leandro, California; Carol Ryan Airbrushing; Frann Gordon of AVIS in Burbank, California; Andy Montealegre, Eagle Rock's answer to the Ritz; Ben Carbonetto, artists' patron and source of endless encouragement; and my brothers, sister, and parents, who supplied dollops of whiteout.

Thanks are also owed to consultants Frank Tingley and J. Davis Mannino; to Alfred Chico, for transcribing eighteen interviews; to David Chierichetti, for meticulous fact-checking; to Matias Bombal, for skilled detective work; to Garrett Mahoney, for access to his magazine collection; to Rob McKay, for advice; and to Sandy Tanaka, for helping establish the definitive Hurrell chronology.

I owe a special debt to the following individuals: Jeff Britting, whose research uncovered treasures; Gary Morris, whose patience helped me become a better writer; Albert Agate, whose sponsorship and guidance pushed me in the right direction; and Howard Mandelbaum, whose patronage and friendship helped me get there.

I also thank Cathy McCornack and Frank Weimann of the Literary Group International for finding me the best publishing house. I thank James Leggio for being the best editor.

Finally, I thank my parents for letting me stay up late and watch *Grand Hotel* in 1957.

M. A. V.

▼

LAGUNA
AND LOS ANGELES
1925–29

▲

"Oh, could I but say to the moment—hold still—thou art so beautiful!"

—*Goethe,* Faust

▼

672 SOUTH LA FAYETTE PARK PLACE

George Hurrell's first Hollywood portrait was not made in Hollywood, but in the Westlake district of Los Angeles, next to bustling Wilshire Boulevard, in a Spanish Revival–style office complex called the Granada Buildings. The address listing in the Buyers Guide of the September 1929 telephone directory reads: "GEORGE E. HURRELL, 672 S La Fayette Pk pl. DRexel-7663." His name was printed in bold type, an audacious gesture for an unknown twenty-five-year-old from Laguna Beach.

Young Hurrell could afford the gesture, and the studio, because a growing number of Pasadena social-ites preferred him to his better-established competitors. He offered qualities that were not to be found elsewhere, professionally or personally. Visitors to his studio encountered a robust, dynamic, and personable photographer, one whose work had already achieved a stylistic uniqueness. Few of his clients knew where he came from, but Los Angeles was already a mecca for self-invented personalities, so his reticence was not unusual. Eventually he declined to discuss his early life at all, but its effect on his career is undeniable.

George Edward Hurrell was born in Covington, Kentucky, on June 1, 1904. His mother was born in Baden-Baden, Germany, of Catholic parents. His father, Edward Eugene Hurrell, was a shoemaker, a U.S. citizen born to a mother from Dublin and a father from London. Raised in Cincinnati, George displayed an early interest in drawing. At sixteen, he left home and moved to Chicago on a scholarship, to study painting and graphics at the Art Institute of Chicago. In a burst of impatience, he left the Art Institute and enrolled in the Academy of Fine Arts, working odd jobs in the daytime and taking classes at night. After a year and a half, he dropped out of school altogether, establishing a pattern of behavior that would last the rest of his life.

Hurrell was still determined to become a painter, but this was the Chicago of 1922, and the willful eighteen-year-old had to eat. A job as a hand-colorist in a commercial photography studio led him to his first photographic work. After three weeks of making catalogue photos of hats, shoes, and iceboxes, he was bored enough to quit.

He was intrigued by photography, though, and for a year he went from studio to studio, learning a bit more each time, and then quitting after a few weeks, unable to mask his boredom or master his restlessness. A turning point came in January 1924, when he was hired by the most prestigious portrait photographer in Chicago, Eugene Hutchinson. Hurrell started as a colorist, but soon advanced to negative retouching, airbrushing, and darkroom work. Though he would later deny being influenced by Hutchinson's salon style, it was in this environment that Hurrell learned the art and science of photography. He wasn't impressed.

Photography turned eighty-five in 1924, but por-

Bibliographical notes giving sources for quotations can be found in the Notes to the Text, keyed by page number. An asterisk in the text signals an additional or explanatory note.

traiture had long before settled into a formulaic rut. Despite individual talents, the work of every studio looked pretty much the same as that of every other studio. This sameness was due not only to limitations of technology but also to the profit motive. Operating a successful studio was an expensive proposition, even with a thousand percent markup. Consider the technology.

The typical portrait salon utilized an Eastman Century Studio camera. It cost $150 (about $2700 in 1997 dollars) and used 8 × 10 inch sheet film that cost about 30¢ per exposure (about $5.40 today).* The camera was 5 feet high, looked more like a printing press, and needed a depth of 20 feet to shoot a head-and-shoulders portrait. This was obtained with a Kodak Portrait Lens, an equally costly necessity manufactured with a chromatic aberration that caused haloes to form around highlighted areas of the image. This "soft focus" effect gave the photograph an airy, dreamy quality, but it only occurred if the lens iris was used at its widest aperture. At this time, the fastest lenses —i.e., the most sensitive to light—were usually around F/4. (F-stops are the logarithmic increments used to determine how much light is traveling through the lens to the film plane.)

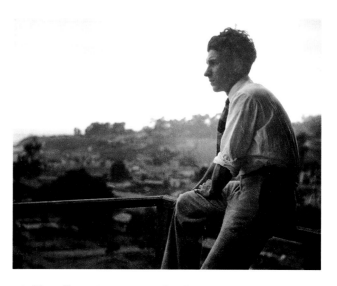

2. *Hurrell was twenty-one when he made this self-portrait on the bluffs of Laguna Beach in the summer of 1925.*

There were several advantages to soft focus. First, there was the romantic quality it imparted to subjects, reminiscent of the *sfumato* effect in Italian Renaissance painting. Second, it was economical; the softer the picture, the fewer facial flaws registered, requiring less retouching to be subcontracted at an expensive hourly rate. Third, it was easier on the subject; a lens used wide open requires less light and less exposure time. There was no need to hold still under hot lights for as long as two minutes.*

In addition to the convention of soft focus, portrait clients expected to be posed against backgrounds of medium tone and lively texture. The typical lighting scheme came from a slavish study of nineteenth-century painting. The photographer's main light source, or key light, was a large floodlight aimed from above. The shadows it cast were softened by a second light set at eye level, called the fill light. The fill light was a floodlight further softened by the addition of stretched silk scrims. A third light, called the back-light or hairlight, was aimed at the subject from behind, in order to separate him or her from the background. A fourth light could be used to illuminate the background, if the subject was posed at a sufficient distance from it.

A lighting scheme analogous to this had served painters for centuries. It satisfied the laws of both physics and anatomy, so it was now adopted by photographers. Combined with conventional poses, soft-focus lenses, and a genteel salon environment, it also satisfied the portrait-buying public. But it didn't satisfy George Hurrell, who was growing restless again. He was bored with Hutchinson's business-like atmosphere, still consumed by the desire to paint, and sick of Chicago winters.

In May 1925, Hurrell drove west with a landscape painter named Edgar Alwyn Payne,* and celebrated his twenty-first birthday in Laguna Beach, a thriving California art colony (plate 2). Hurrell's respite from photography was short-lived. He soon learned that photographs—even photographs of other artists' paintings—were more profitable than his paintings of seascapes.

He bought used professional equipment and spent the next two years photographing local artists, their paintings, and the Los Angeles socialites who came to buy them. Ironically, his photographic portraits were reproduced more widely than the painters' works, and he developed a following in Los Angeles. In 1927, he moved there. Studio Number Nine in the Granada Buildings (plate 3) became his home as well as his workplace; a shelf in the minuscule bathroom held his developing trays. The studio was a quaint, cheerful place, but its chief attraction was young George Hurrell.

At twenty-four, he was tanned, muscular, and endlessly energetic. He was five foot nine, but his ever-unruly black hair made him look taller. His unconventional good looks were accented by dark brown eyes, long eyelashes, and expressive eyebrows. His intensity was allied with a bombastic self-confidence. He was not given to shyness about his enthusiasms or his dislikes.

Although becoming established as a photographer, Hurrell occasionally returned to his easel, but the protracted process now maddened him. "That slow pace got to me. You'd have to get into that routine of doing things so much slower and I found that I didn't have the patience for that any more." This innate impatience made photography the more appealing discipline, and he studied the photographic talent displayed on the pages of *Vogue* and *Vanity Fair*.

At fifty-two, Edward Steichen was the most respected photographer in America. A mutual friend, Leon Gordon (the playwright of *White Cargo* fame), brought Steichen to visit Hurrell in June 1928. Steichen was in Los Angeles to photograph first Greta Garbo and then an advertising job. America's most acclaimed photographer had his challenges, too. He was granted a mere six minutes to pull Garbo from the set of *The Mysterious Lady* and capture images that nonetheless have become the most famous ever taken of her. Then, after shooting a job for an advertising agency, he had nowhere to develop the film.

Hurrell was, he recalled, "astounded when the great Steichen came in with four 4 × 5 negatives he wanted processed right away. When I tried to explain my cheap facilities, he smiled and said, 'That doesn't matter; some of my best photos have been made under a rug.'" Steichen stood in the two-by-four darkroom with Hurrell while he tray-processed the film, then talked shop with him while it dried. Hurrell was amazed when Steichen disclosed that the proofs to be made from this film would cost the ad agency $1500. Hurrell was then billing $50 for the same amount of work.

Before Steichen left, he offered some advice: "Never let your subject know when you are baffled. Shoot the film anyway; make the change on your next shot—but be the master of the situation at all costs." This advice would stay with Hurrell all his life. It would also help him make the most of his next opportunity.

The opportunity came by way of Florence "Poncho" Barnes, a young socialite from San Marino, Cal-

3. The exterior of Hurrell's Granada Buildings studio (1996 photo by the author).

ifornia. "She was from the Lowe family and had one of the most expensive airplanes in the world," Hurrell recalled. "She held the women's speed record for a couple of years." Her plane was named *Mystery Ship*, perhaps an allusion to her life-style, which encompassed a circle of bohemian friends and marriage to an Episcopalian minister, C. Rankin Barnes. Poncho had been one of Hurrell's first clients in Laguna Beach (along with the writer M. F. K. Fisher), and when she was not partying at his studio with what *Esquire* magazine later called the "hysterical crowd from Laguna," she was advancing his career.

In January 1929, she announced that she had a new friend for him to photograph, and at a Steichen-like fee. The friend had found Hurrell's photos of her quite impressive, and why not? He'd transformed the stocky, mannish "aviatrix" into a svelte, alluring bird-woman.

Poncho's new friend was the Mexican star of Hollywood movies, Ramon Novarro. He had just come back from Tahiti, where he had been making his last silent film, *The Pagan*. His next picture would be a talkie, *Devil May Care*. Like most silent stars with an accent, he was dreading the transition to sound. At stake was not only his popularity, but also his salary of $4000 a week. He was about to negotiate a new contract—for $10,000 a week—but if his talkie debut was a flop, he could lose everything.

He formulated plans for a new career, one that would utilize both his singing voice and the acting style he had cultivated in films such as *Ben-Hur, The Road to Romance,* and *A Certain Young Man*. Grand opera was the obvious choice. Since his new contract allowed him six months off per year, he hoped to go to Europe (where his accent would pose less of a problem) and use a flurry of publicity to launch himself as an opera star. The early stages of his plan would have to be managed without the help — or knowledge — of his proprietary employer. Metro-Goldwyn-Mayer was making many more times what it was paying him and could not afford to have him run off to Europe.

Novarro had been training for some time, and now he scheduled a concert tour. He had costumes

made and began to look for a photographer. The lack-luster quality of the salon portraits he saw made him wonder if there was any photographic talent outside the walls of M-G-M. Poncho's portraits showed him otherwise. In them, he saw the first step toward his opera debut. He asked Poncho to introduce him to George E. Hurrell. She proceeded to schedule a sitting, discreetly and secretively.

▼

THE FIRST HOLLYWOOD PORTRAIT

While Ramon Novarro was selecting costumes for his secret portrait session, George Hurrell was sitting in his studio, alone and slightly deflated. The initial thrill of getting such a commission had given way to pangs of self-doubt. This world-famous actor had surely been photographed thousands of times, in richly appointed salons. What did this humble studio have to offer him?

Hurrell reassured himself that his work was more than the sum of its parts, and the pangs subsided. The parts were odd, though. There was a beat-up 8 × 10 view camera, not a Century Studio model. There was a used Wollensak lens, the soft-focus model called a Verito. For illumination, there were two battered arc lights, the type used more often to simulate sunlight on movie sets. Of course, they were an improvement on his Laguna lights—household bulbs with saucepans for reflectors. For film he was using Eastman Commercial Ortho. He'd gotten a deal on a huge batch of this outmoded stock from a wholesaler who wanted to unload it when panchromatic had become available a year earlier.

Any portrait photographer of the day would have shaken his head in disbelief at this ragtag gear, and even more so at the unorthodox ways in which Hurrell was using it. The demands of his eye, for example, made him use the Verito lens not wide open, but stopped down to F/22 or F/32. According to photography expert Franz Fiedler, stopping down this type of lens "destroys the artistic quality, leaving only a very primitive objective with all kinds of errors." The "errors" were just what Hurrell liked. At F/22, the edges of objects had an odd, tangy look to them. This f-stop required more light, so he sometimes pulled the protective screens off the arc lights. Then he shot with the old orthochromatic film, which couldn't see the red part of spectrum and saw too much blue. The cumulative effect was that his subjects looked burnished and exotic.

His studio was only twelve hundred square feet,

so there wasn't much room for props or backgrounds, although Hurrell had managed to purchase and hand-paint a three-paneled screen. For alternate backgrounds, he used the white plaster wall or the wrought-iron staircase (see plate 13). The only other ingredient at his disposal was his personality.

Something of a mystery to family and friends, Hurrell had always typified the Gemini twins, bouncing between boisterous optimism and bitter angst. Depending on what day one saw him— or what time of day—he was as sunny as his arc lights or as caustic as his chemicals, as temperamental as any of the stars he would soon glamorize, and as volatile. His moodiness could be a problem, but when he was projecting good will, his unconventional appeal carried him a long way, charming male and female, old and young alike. When Poncho Barnes brought Ramon Novarro to meet him, he was "this hearty young man with too much energy, ready for anything."

Poncho introduced the movie star to Hurrell as "Pete" (her nickname for him) and then she dashed off to an afternoon of flying at Mines Field. The pleasant young man carried a few costumes up the stairs to the makeshift dressing room. As usual, the first thing Hurrell did was wind up the hand-cranked Victrola and play a record from his ever-expanding jazz collection. Novarro came downstairs in a black-and-silver Mexican *charro* costume that contrasted nicely with the off-white stucco and amber stained glass of the Granada Buildings. "Everyone takes me for a Spaniard," Novarro said, "but I was born in Durango, Mexico. My real name is Jose Ramon Gil Samaniego." When he smiled, the mustache pressed onto his upper lip started to come off. Hurrell told him not to worry about it; retouching would make it look real.

Novarro sat down and stared at the camera with a blank expression. Hurrell fired up the arc lights and stepped in front of them to analyze Novarro's face. "Pete had photographically perfect features. And he *could* face my camera with a blank expression. He was at his very best in left profile, or three-quarter front view, so I stayed at that angle." When Hurrell changed the Victrola to a classical piece, Novarro's face became more expressive. "I'm old-fashioned in an age of jazz, gin, and jitters," Novarro was known to say.

Hurrell began to warm up, too, and as he played with light and shadow, he experienced for the first time the thrill of working with a responsive model. "I was really inspired," Hurrell said later. He was so inspired that when Poncho returned to fetch Novarro, she had to wait for the session to wind down.

Novarro returned to the studio two days later to see the proofs, a nerve-wracking moment for both subject and photographer. But the proofs, even with-

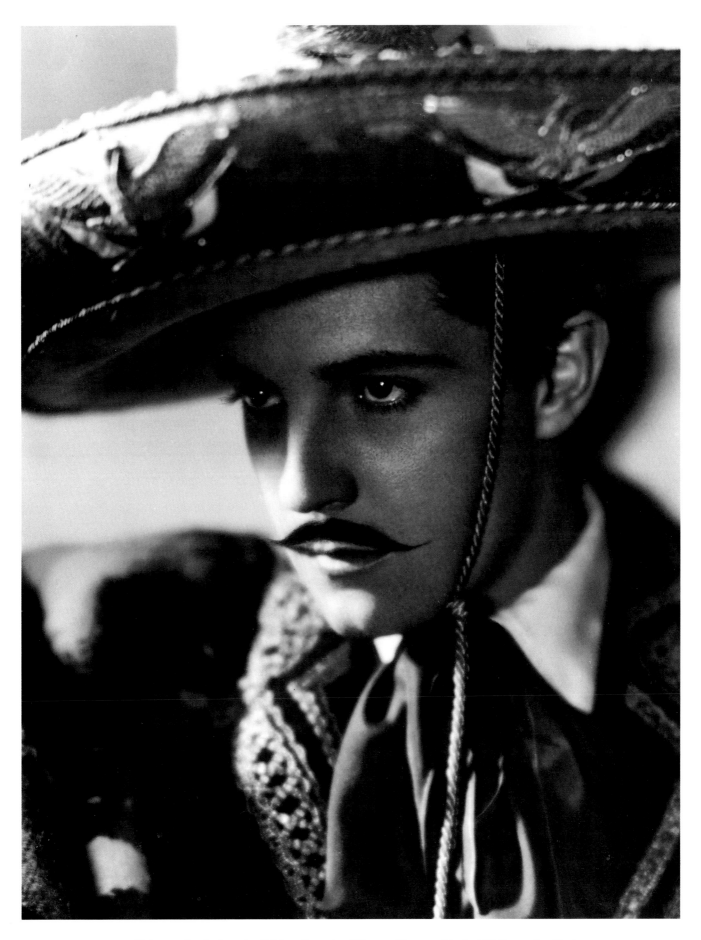

4. *This was the first portrait Hurrell made of Ramon Novarro, his first Hollywood subject.*

out retouching, were impressive. "You have caught my moods exactly . . . you have revealed what I am inside." Novarro marked the proofs for retouching, an unusual skill for an actor at that time, then scheduled a second sitting. Hurrell shot him as more opera characters, and then Novarro left for his first tour. He returned in June, and there were further portraits at his home on Twenty-second Street and then on the grounds of Poncho Barnes's estate. The collaboration was a happy one. By the end of the summer, Novarro had a unique portfolio and Hurrell had a healthy bank account.

Novarro was so taken with the photos that he had to show them to someone. But to whom? He chose a respected film director with no ties to M-G-M. F. W.

photographic studies, but they are not you. . . . Your value at present at the box office is *you.* If you are going to act a Mexican drunk or something like that, and nobody knows it's you, then it's not worth anything.'"

"And it was a shock, but it was true," recalled Novarro thirty years later; true, except that Novarro hadn't planned to play these roles on screen, but on stage. Murnau was advising Novarro to put the photographs away until such time as M-G-M would let him attempt more diverse roles. The advice made sense, but the photographs were not about to be put away. They were too strong, too compelling, too alive. Against his better judgment, Novarro took the photographs to M-G-M's publicity department. The reaction he got was more than favorable. Within a

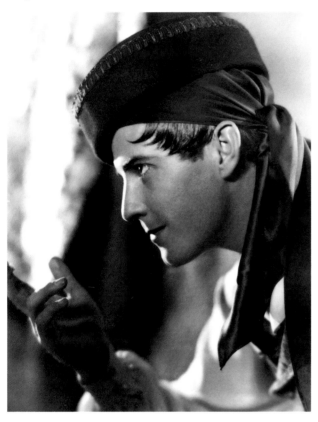

*5. The caption affixed to this print reads:
"'THE REASON WHY' . . . Ramon Novarro sings a lilting Spanish lyric from a famous song cycle, explaining why the Spanish swain loves his sweetheart."*

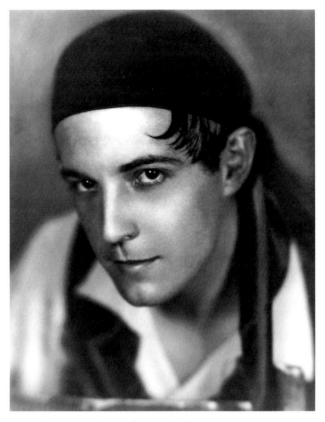

6. The original caption reads: "A SONG OF SPAIN . . . Ramon Novarro, as he sings a Spanish song cycle in his own little theatre, at one of the unique concerts the Metro-Goldwyn-Mayer star is so fond of giving his friends."

Murnau had won acclaim for *The Last Laugh* and *Sunrise,* but when he'd wanted to cast Novarro in *The Four Devils,* M-G-M wouldn't release him and Fox Film Corporation wouldn't offer more money. But the negotiations had led to a friendship. Novarro took his portfolio of fifty Hurrell prints to Murnau and asked him which to use. Murnau "chose about five of the fifty. I said, 'Oh, Fred . . . I'm spending about a thousand dollars on this!'"

Murnau explained, "'Ramon, these are very fine

month, the studio had "planted" a set of the pictures in the rotogravure section of the *Los Angeles Times.* The impressive layout was entitled "Novarro with Impressions" and ran on October 20, 1929. It was duly credited: "Photos by Hurrell."

M-G-M, meanwhile, revamped the script of *Devil May Care* and gave Novarro a showcase for his new-found avocation: four light-opera songs. Hurrell's work was already having an effect on the film industry. The industry would soon be having an effect on him.

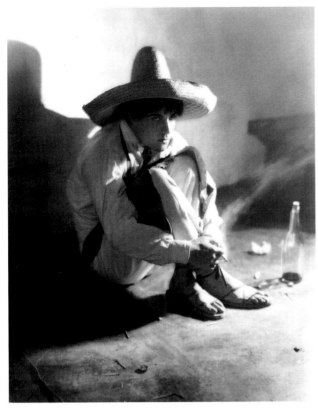

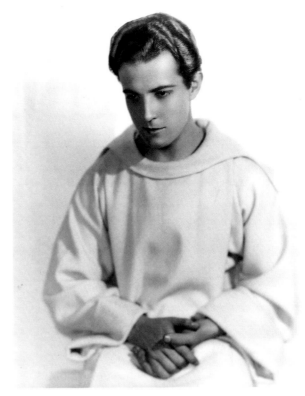

7. This caption reads: "'DAWNING' . . . A song of Mexico which is among Ramon Novarro's favorites . . ." This is one of the photos that director F. W. Murnau thought unsuitable for publication.

8. The caption reads: "'CHILDREN'S VOICES' . . . Ramon Novarro sings a song from an old German song cycle—the legend of the monk who loved a nun and could not keep her from his thoughts. Once walking among children emerging from the convent, he asked a little girl who was the most beautiful of women and was answered, 'Ermengarde'—an echo of the thought in his own heart."

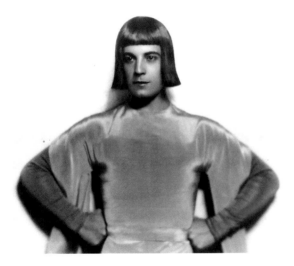

9. This photo is captioned: "PELLEAS AND MELISANDE . . . This is one of the favorite roles of Ramon Novarro, now en route to Europe for his debut in Grand Opera in Berlin."

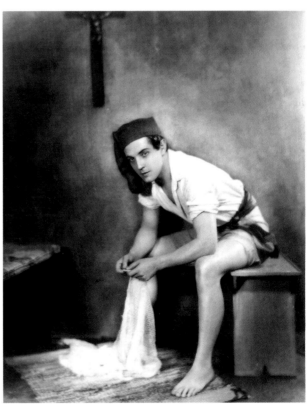

10. Novarro posed as the fisher lad in Il Pescator. Note the retouching around Novarro's head and back, as well as the enhanced highlights on his face and legs. This effect was already a Hurrell trademark.

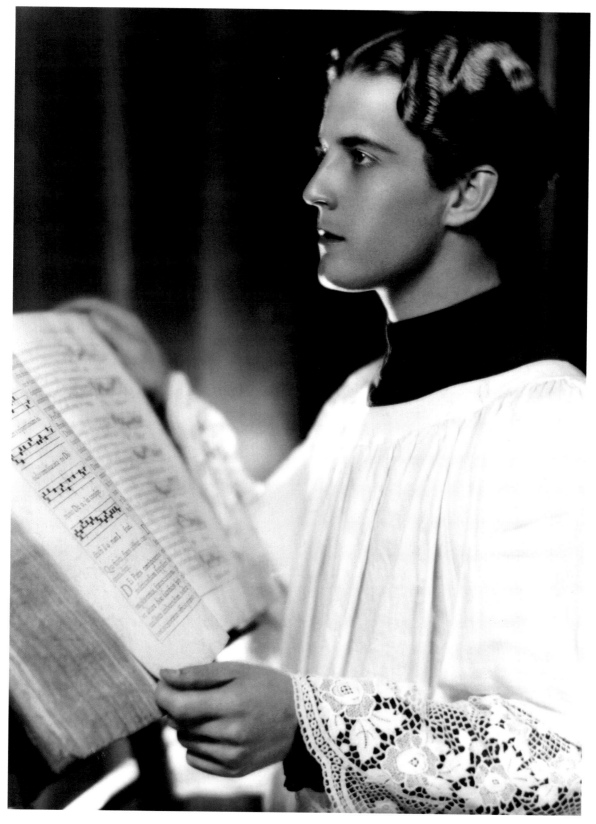

ABOVE: *11. This caption says, "'AVE MARIA' . . .
The first song Ramon Novarro ever uttered from the stage was the 'Ave Maria' by Mario La Fragola."*

OPPOSITE PAGE: *12. Hurrell and Novarro titled this portrait "The New Orpheus." These photos
did not succeed in launching Novarro's grand-opera career, but they brought Hurrell to the attention of
M-G-M star Norma Shearer. In May 1981, Christie's East sold a 6 × 9 print of "The New Orpheus" to the
Gilman Paper Company for $9000—an auction record for a portrait by a living photographer.*

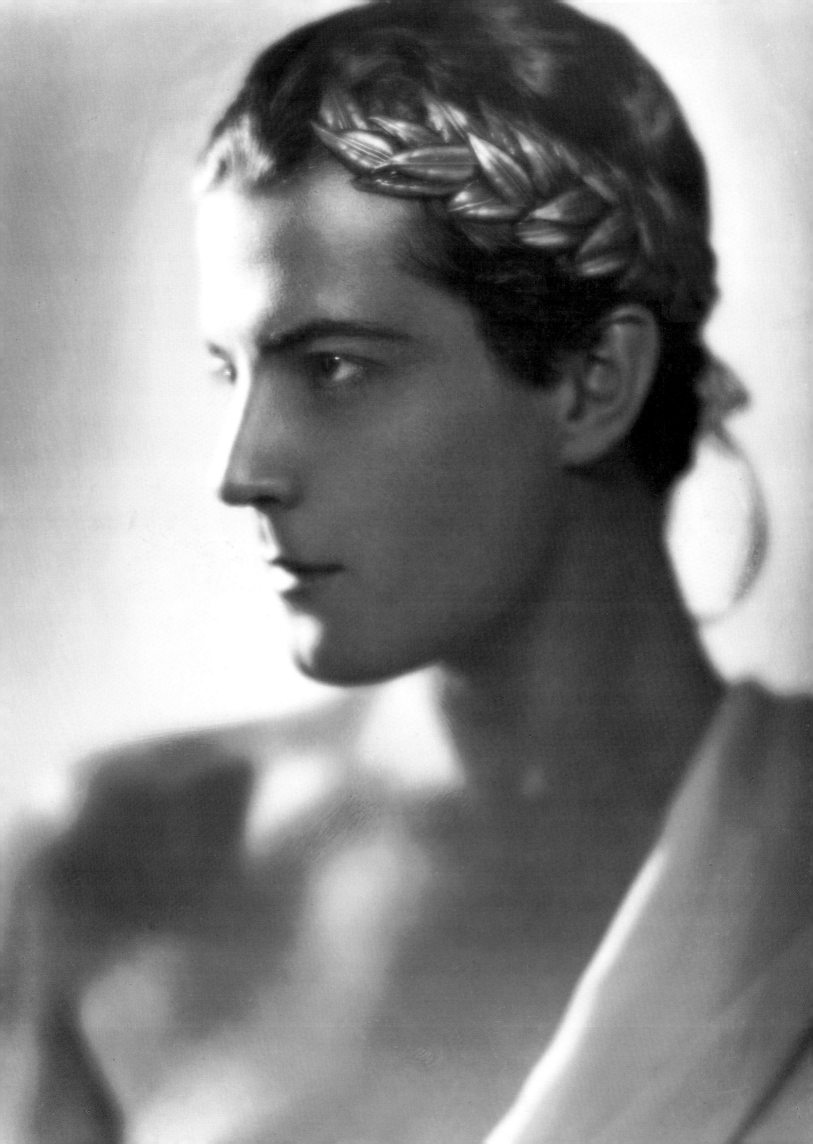

STAIRWAY TO THE STARS

Ramon Novarro had a special friend at Metro-Goldwyn-Mayer, an actress with whom he'd co-starred two years earlier, in Ernst Lubitsch's *The Student Prince in Old Heidelberg*. She'd played the barmaid Kathi to his Prince Karl Heinrich. Their friendship had begun when she stopped director Lubitsch from belittling him. Her name was Norma Shearer. The five-foot-three Shearer stood up to the cigar-chomping Lubitsch and won.

In her nine-year film career, she'd stood up to a lot of people, and now it was paying off. Shearer had been one of the top five box-office draws every year since 1925, was now earning five thousand dollars a week, and was happily married to Irving Grant Thalberg, Vice President in Charge of Production at M-G-M. In 1929, his films turned a profit of twelve million dollars, making the studio the most prosperous in Hollywood. Thalberg was known as the "Boy Wonder," his wife as the "gracious Norma Shearer."

13. *This is a detail of the wrought-iron balustrade in George Hurrell's studio (photo by the author).*

Why, then, was Shearer so preoccupied when Novarro visited her on the set of her latest film, *Their Own Desire*? Something was bothering her, and as she looked at his portraits by Hurrell, her brow knit in concentration. "Why, Ramon! You've never been photographed like this before!" What she was really saying was that no one at M-G-M had been photographed like this—least of all herself.

The studio's head portrait photographer was a twenty-five-year-old woman who went by the name of Ruth Harriet Louise. Her style was at best derivative, and at worst, unflattering. She had an inexplicable habit of shooting her subjects against a blank, flatly lit wall, and then retouching the tiny face in the middle of the negative, printing it, shooting a copy negative of the head and torso, and then printing the copy negative as the finished print. The result was grainy, fuzzy, contrasty, and marred by obvious retouching strokes. She was also given to temperament, but Greta Garbo and Louis B. Mayer, President of M-G-M, liked her, so she held her position.

Shearer had suffered the most at Louise's hands, so she tried outside photographers such as Edward Thayer Monroe, with mildly effective results. 1929 had already been an auspicious year, beginning with her talkie debut in *The Trial of Mary Dugan*, followed by a light-comedy success in *The Last of Mrs. Cheyney*, and crowned by a guest role in *The Hollywood Revue of 1929*. Her fans loved to see her play intelligent, honorable women caught in compromising circumstances. Her new film, though, required nothing more than the impersonation of an ingenue. She had turned twenty-seven on August 10 and felt that she needed to expand her repertory. Years later she said, "I always chose sophisticated parts because you can't really be interesting as a young girl, [or] . . . outstanding as an ingenue." She set her sights on *The Divorcee*, the story of a self-liberating young career woman. According to Shearer: "I knew that M-G-M owned the story, and that M-G-M was considering borrowing someone from another lot to play it. I was there on the lot, under contract, and I felt in my heart I could do it. But . . . Irving laughed at me when I told him I thought I could do *Divorcee*—it was so utterly different from the type of thing with which I'd always been associated." Thalberg later recalled that even Shearer's maid, Ursula, had said, "Oh, Miss Shearer, you don't want to play a part like that. She's almost a bad woman!" "But I was determined to prove to him that it wasn't ridiculous," said Shearer.

In mid-October, a few weeks after Novarro's visit to the set of *Their Own Desire*, a cream-colored Rolls-Royce pulled up to the side entrance of the Granada Buildings. From it emerged Norma Shearer, followed by Ursula, who was carrying an armload of outfits. Not far behind were a hairdresser, a child model and his mother, and a cranky publicist who couldn't fathom the purpose of this expedition; movie stars simply didn't go to unknown photographers. Putting aside her own misgivings, Shearer made a grand entrance into Studio Number Nine and sat Hurrell down, the better to outline her program: he must

create entirely new images of her, ranging from Radiant Mother to Coruscating Vamp. She impressed Hurrell as "a tough little gal, fighting in her own way to get the part."

Having heard her out, Hurrell told her how he could implement her concept. "The idea was to get her looking real wicked and siren-like . . . because she was not really *that* type, you know; she didn't have any of it. In fact, it was my idea to get her hair bushy—she never wore it that way."

As Hurrell watched Shearer and her hairdresser climb the stairs to the dressing room (plate 13), it occurred to him that "a great deal depended on that sitting, but if Norma was nervous, there was nothing to indicate it." She came down with her hair slightly fuller, and he shot poses of her with the little boy, and then sent him and his mother off. Once again, Shearer climbed those stairs, and the hairdresser dutifully followed, sent with Hurrell's injunction to make the hair wilder, cascading over one eye.

A half hour passed. Hurrell played record after record. He was just putting on Ted Lewis's 1926 recording of "When My Baby Smiles at Me," winding the Victrola, when he looked up the stairway. Shearer was standing on the balcony, hair gelled to unruly perfection, clad in a gold-brocaded dressing gown.

14. This uncredited 1927 portrait of Irving Thalberg and Norma Shearer was made during their honeymoon in Europe.

She paused for a moment and then descended the stairs. She walked over to the screen, and as a leg popped out from the wraparound garment, she said, "I'm afraid my legs are not my best feature, Mr. Hurrell." As he was assuring her that the angle and pose would disguise any imperfection, she skillfully found both. He began to sing with the record.

And when my baby smiles at me
There's such a wonderful light in her eyes—

She stiffened and questioned Hurrell's choice of music. (She was accustomed to having three musicians on the set to play mood music for her.) Wasn't this a rather silly song? "She didn't like it. I explained *I* needed it." This was good psychology, since this regal young woman was slightly ill at ease in his

bohemian outpost, miles away from protective Metro, about to pose for the sort of photo that only hungry starlets did. Before she could object further, Hurrell danced right into the tripod, knocking over the camera. The lens didn't break, but the ground-glass viewing back did. Fortunately, he had another. He danced off, returned with a fresh one, and mentally thanked Edward Steichen for his counsel: "Always be the master of the situation." He sang to his slightly shaken camera.

The kind of light that means just love,
The kind of love that brings sweet harmony—

The gramophone started to wind down, and instead of winding it again, Hurrell mimicked the bleary voice. Shearer stared, then shook her head, then grinned. "She laughed, and I could see that she was starting to enjoy herself." He was now master of the situation.

A technical adjustment was suddenly necessary. In order to get her legs and face simultaneously in focus, Hurrell needed to close the Verito down to F/32. He impulsively pulled the protective screens from the buzzing arc lights. Shearer squinted momentarily, but faced the camera uncomplaining. Hurrell got his F/32, and Shearer had to hold still for only two seconds, a trifle compared to what she'd endured as a New York model in 1918. Hurrell changed records, asked the musical question "Is Everybody Happy?" and started shooting.

By the time he finished, they'd worked together for four hours, consumed sixty sheets of Commercial Ortho, and forged a historic partnership.

The Rolls-Royce was barely onto Wilshire Boulevard when Hurrell locked himself in his darkroom and attacked the first sheets of film. Sixty plates struck him as "the height of lavishness"—and a full evening's work. As the negatives dried, his singing echoed in the studio. The stairway was now empty, the studio too quiet, and he felt the need to celebrate. He went out and got drunk.

"I didn't feel so good the next day, but sent red proofs [impermanent contact prints] out to M-G-M,

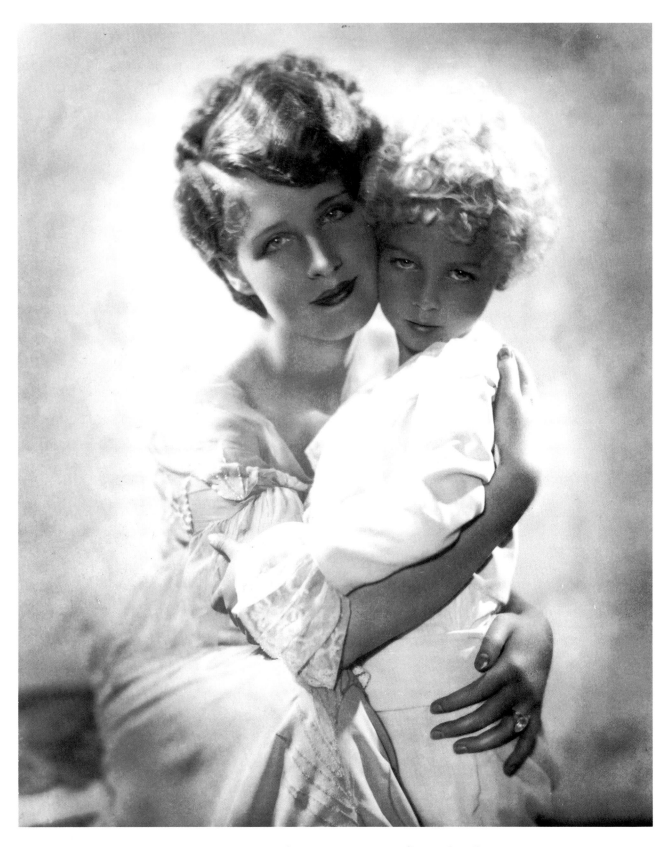

*15. Norma Shearer's portrait sitting with George Hurrell
began with formal, stylized poses.*

then sat by the telephone." As it turned out, Shearer wasn't feeling so well either. The unscreened arc lights had given her a case of "klieg eyes," a sort of retinal sunburn. Irving Thalberg watched her blink-

ing and squinting, behaving "like an excited child as she waited for the proofs." When she got them, she impulsively took them onto Nick Schenck's yacht and looked at them in daylight—and the sun faded them

16. *The sitting proceeded to its main purpose: to make Shearer look "wicked and siren-like," but she felt ill at ease.*

17. *A Ted Lewis record amused her.*

instantly. Hurrell had to recover himself and rush out sixty more proofs, but on standard photo paper. Then he had to wait.

While he waited, Shearer had the formidable task of presenting the proofs to her husband—and boss—Thalberg. The thirty-year-old genius looked at them, and his usually impassive visage assumed the look of one of his star-struck customers. He gasped. Regaining his composure, he said, "Why, I believe you *can* play that role!" Norma got the part of Jerry in *The Divorcee*, and later admitted, "It was a tremendous gamble, but a lucky one." For George, it was luckier still.

When M-G-M portraitist Ruth Harriet Louise decided to leave her job, Thalberg called Pete Smith, head of publicity, and told him that Shearer wanted Hurrell at the studio. The order moved down the chain of command and Hurrell got a call from Howard Strickling, the talented man who oversaw the portrait department. Strickling offered Hurrell a job; five days a week, at $150 a week.

Hurrell remembered, "I played hard to get, because that's the way I was in those days." Meanwhile, the stock market crashed. Strickling called again, obviously unprepared for Hurrell's indifference. "I said, 'Well, I've got a studio. What do I want with another studio?'" Hurrell stalled for two weeks, during which time the stock market did not improve. Strickling didn't offer any more money, so Hurrell

18. *Hurrell's antics relaxed her.*

decided to accept. Before he could start at M-G-M, though, he had a few things to do. He had to complete his society portrait orders, buy a car, find an apartment, and retouch the twenty-five poses ordered by Norma Shearer.

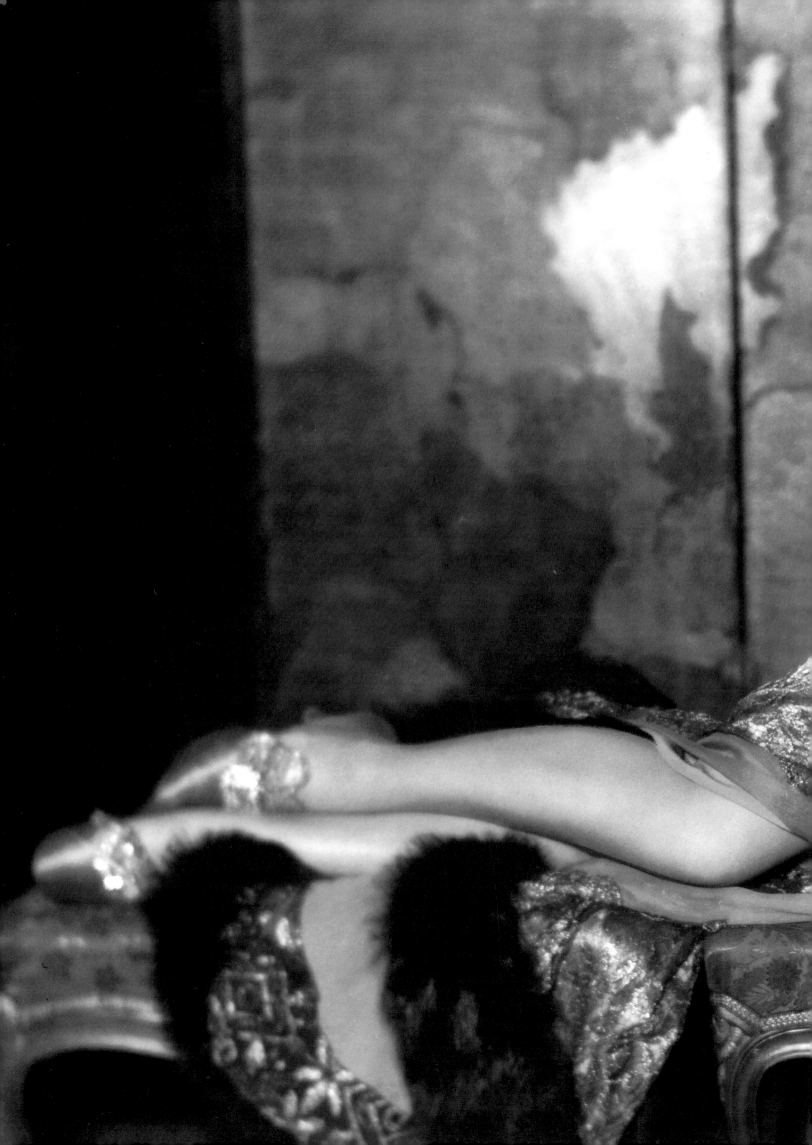

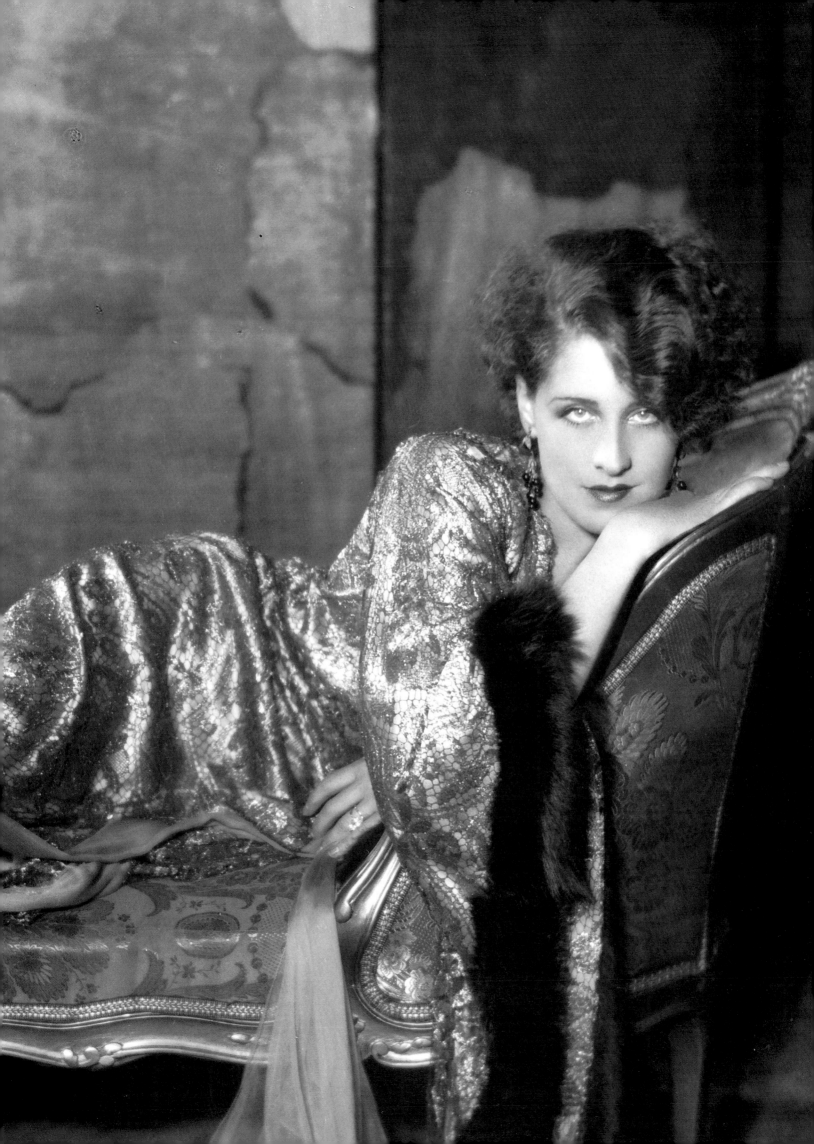

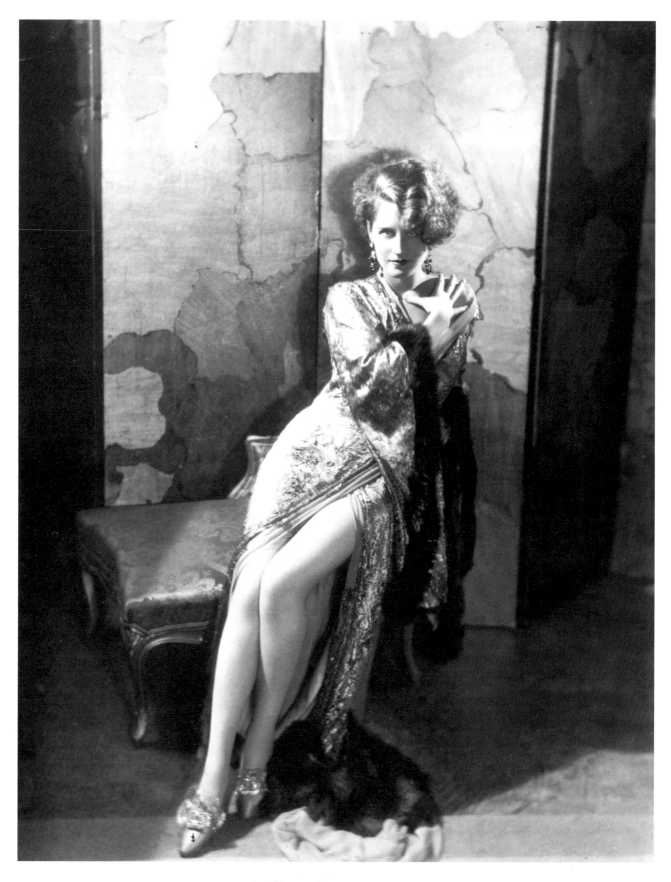

OVERLEAF: *19. And Norma Shearer became a coruscating vamp.*

ABOVE: *20. Hurrell posed Shearer to make her legs look more shapely.*

OPPOSITE PAGE: *21. Imagine the impression this portrait made on Irving Thalberg.*

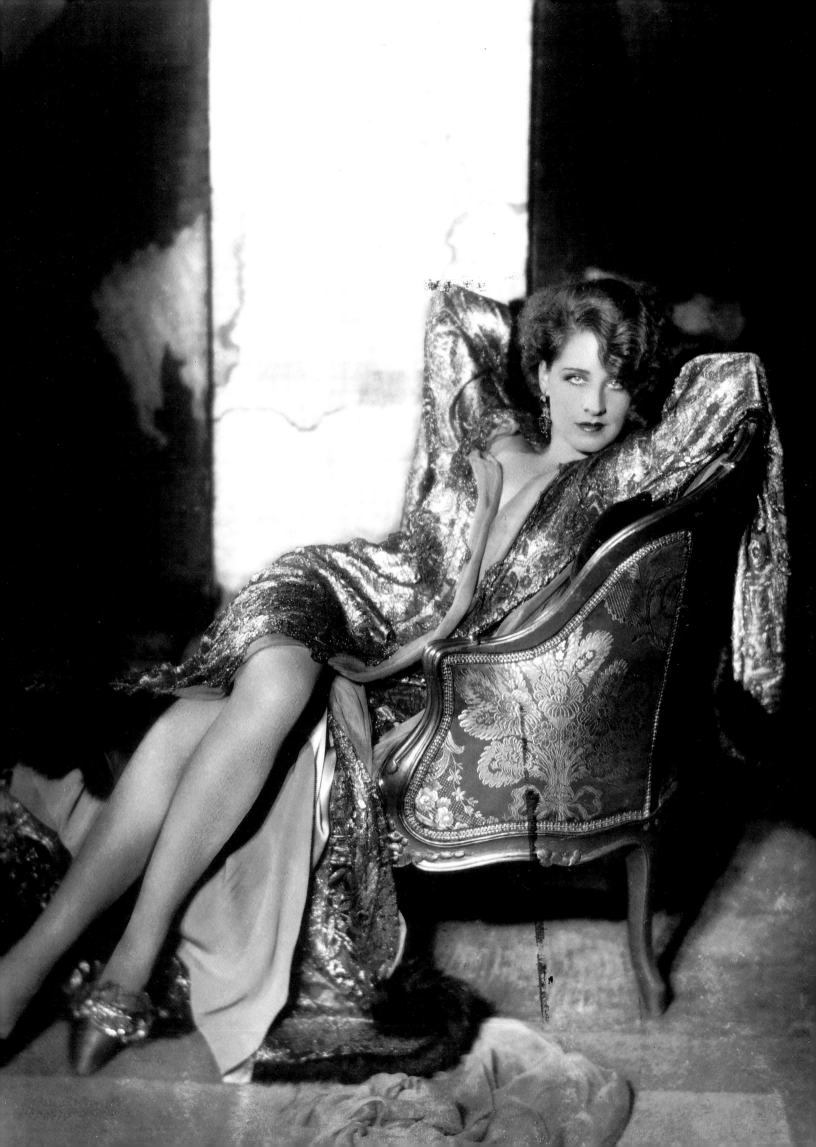

2

▼

METRO-
GOLDWYN-MAYER
1930 – 31

▲

"If only those who dream about Hollywood knew how difficult it all is."

—*Greta Garbo*

▼

IN THE LION'S DEN

On Thursday, January 2, 1930, George Hurrell emerged from his new apartment at 1261 North Flores Street in West Hollywood, climbed into his new LaSalle roadster, and drove to 10202 West Washington Boulevard. He was now an employee of the Publicity Department at Metro-Goldwyn-Mayer Studios. After seeing Leo the Lion at the beginning of movies for six years, he would now be seeing him at the top of paychecks.

The leonine symbolism was appropriate. To its employees, M-G-M was part circus, part factory. To the world outside its fifty-three acres, it was the largest of five major Hollywood studios and the most prestigious. And here was young George Hurrell, now its head portrait photographer, responsible for shooting its players for posters, newspapers, and, most important, fan magazines. In 1930, there were several dozen of them, led by *Photoplay, Motion Picture,* and *Screenland.* Each had a richly printed rotogravure section featuring the latest studio "portrait art," fully credited. That section would be the destination of Hurrell's work.

He was working for Pete Smith's Publicity Department, but his actual workplace was the Stills Studio. It was three flights up, accessible only by an outside staircase; it had been built on the roof of an editing building left from the time of the original tenant, director Thomas Ince. The Stills Studio comprised two galleries, a film loading room, a retouching area, a printing area, and a rooftop patio. The film processing area and quantity printing machines, which turned out a combination of 25,000 negatives and 14,000 prints a week, were located in another building. A third building housed the offices of Stills Department head Clarence Sinclair Bull, who also made portraits.

Hurrell was assigned to the smaller gallery of the Stills Studio, and Bull kept the larger one, although Hurrell noted that neither room was much larger than his Lafayette Park Place atelier. Besides inheriting Ruth Harriet Louise's gallery, Hurrell got her assistant, twenty-two-year-old Al St. Hilaire. St. Hilaire had been with M-G-M since the 1924 merger that created it. His job was to load film holders with 8×10 film, move lights, help with props and sets, and occasionally process film.

Supervisor Howard Strickling told Hurrell what he was expected to shoot. M-G-M released fifty-two films a year. At that moment, eight of them were completing principal photography. Studio practice was to shoot "in-character" portraits of the star on the day after completion of the film itself, when hair, makeup, and wardrobe could still be matched to what had already been shot. Hurrell would be shooting portraits to publicize Buster Keaton in *Free and Easy,* Joan Crawford in *Montana Moon,* and Marion Davies in *The Floradora Girl.* He would also be shooting starlets, juveniles, and character players, who were available during filming or between films. M-G-M's policy was to groom players for stardom gradually and systematically, using portraits to discover and then enhance their natural attributes. These willing subjects came from all segments of society, so Hurrell would no longer have to endure the stiffness of Pasadena socialites. From now on his subjects would

be eager, enthusiastic, and talented—and they would all be hungry for stardom.

Arriving in Hollywood that year, British society photographer Cecil Beaton commented on this:

Apollos and Venuses are everywhere. It is as if the whole race of gods had come to California. Walking along the sidewalks . . . I see classic oval faces that might have sat to Praxiteles. The girls are all bleached and painted with sunburn enamel. They are the would-be stars who come to Hollywood from every part of America, lured by hopes of becoming a Mary or Doug, a Joan Crawford, Gloria Swanson . . . or Gary Cooper.

America was movie-mad, and Hollywood was the maddest. Hurrell's income no longer depended on an eccentric art colony, but on a starstruck movie colony. Was he in awe of these cinematic avatars? "I didn't care about movie stars. I didn't give a damn who they were." Was he apprehensive about his new job? "I didn't care whether they liked what I did or not. I thought, Hell, this is only temporary. I'm just doing this to make a couple of bucks and [then] I'm going back to my easel and paint."

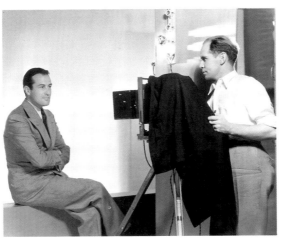

22. *C. S. Bull photographing actor Lester Vail.*

His indifference manifested itself in an unwillingness to work within company guidelines, many of which had been established by Clarence Bull. First, there was the issue of work hours. The studio functioned on deadlines, whether for shipping of film cans or portraits. No one at the studio, except for the exalted Greta Garbo, dared to leave work at five P.M. Hurrell insisted that his workday end at five, a departure from his La Fayette Park Place marathons. Howard Strickling, mindful of the executive order that had brought Hurrell there in the first place, acceded.

Then there was the issue of film processing. Hurrell recalled, "I went in there with an attitude that nobody developed my stuff but me. So they set it up. They didn't care one way or another." Strickling may not have cared, but Bull did, especially when some of Hurrell's negatives turned out too contrasty to be printed by the machines that made single-weight 8 × 10 glossies in quantities of a thousand or more.

There was also the issue of negative retouching. Bull had assembled a roomful of retouch artists, but Hurrell bristled at the idea of sharing his retouching secrets. Yet there was no longer time for him to retouch his own negatives, since each portrait negative required at least three hours to retouch and etch. He was needed in the gallery. He persisted in his demands, saying that his unique retouching effects were a large part of his technique. A compromise was reached: he was assigned his own retoucher, a willing pupil named Andrew Korf. In truth, Hurrell's retouching effects were innovative, but his retouching strokes were not as smooth as Korf's.

Film was another issue, the commodity known as "raw stock." Hurrell still had boxes and boxes of the Commercial Ortho he'd gotten so cheaply. He couldn't just throw it away; better that M-G-M buy it from him for use in his gallery. Again Bull resisted. Why use outdated, color-blind ortho when Eastman had just introduced Super Portrait film and a new edge-notching system to help film loaders and processors in the dark? Bull was outvoted, and M-G-M bought Hurrell's film.

When he finally started working in the gallery, Hurrell's demands stopped. He had at his disposal a luxurious new Eastman Century Studio camera. The ease with which he rolled it around the polished studio floor made him forget his rickety tripod and view camera, but not his Verito lens. He popped it out of the old camera and into the new. Then, he proceeded to use it in concert with the splendid assortment of lighting instruments that lined the walls of the gallery. There were 1000-watt spotlights, which he used to throw pools of yellow light. There were "Type 23" floodlights, nicknamed "double broads" by manufacturer Mole-Richardson because their rectangular shells contained two huge globes (see plate 39). When covered with silk scrims, they threw a soft, milky light. With these basic tools, Hurrell was thrust into a new decade of photographic technology and artistic experimentation.

His first subjects were not stars, but starlets such as Anita Page, who was always available to help him with his lighting experiments. Hurrell recalled, "We used to shoot pictures of her all over the place. Up in the trees; out in the fields; splashing in streams; cuddling in silks. Whenever we weren't busy, we'd call Nita in. 'Let's see. What haven't we done?'"

Anita Page remembers, "With George, it was always production. It wasn't like that with the other photographers, but with him, it was almost as though

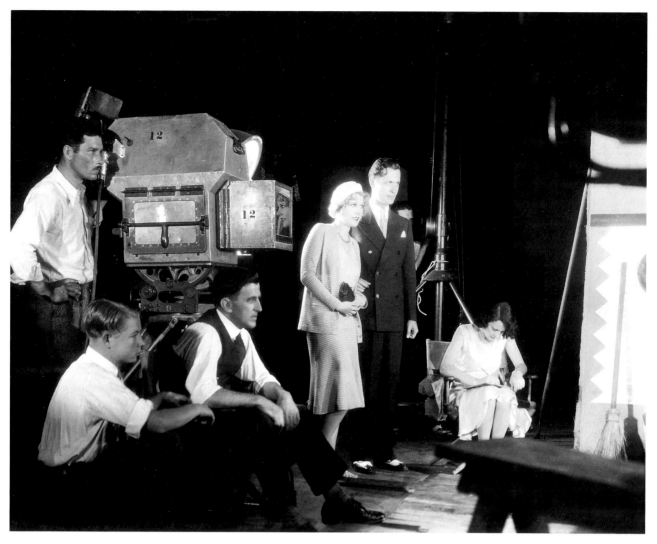

23. *By the end of his first month at M-G-M, George Hurrell was so well liked that he was invited to the set of* Free and Easy *to shoot production stills. "I invited him there," recalls Anita Page, seen here with director Edward Sedgwick and co-star Robert Montgomery.*

you were getting ready to make a picture."

Hurrell later said, "I was always fighting myself to keep from being stereotyped. In other words, I would try to interpret each sitting as a new approach." This was how he spent the first few months of 1930, happily exposing thousands of sheets of Commercial Ortho and loudly playing a new Victrola. His first M-G-M portrait to appear in print was a winsome study of Anita Page. It ran in the April 1930 issue of *Photoplay.*

Clarence Bull, meanwhile, kept to himself. He'd been working at this site since 1918, when it was Triangle Studios, then through its years as Goldwyn Pictures. Now, six years after the merger that made M-G-M, he was the consummate company man, fiercely loyal to Louis B. Mayer. He was hurt, therefore, by the company's decision to overlook his seniority and bring in the willful young Hurrell. Hurrell later commented, "He thought that when Ruth Harriet Louise left that at last he was going to have his

chance. And he hated my guts all the time thereafter."

Bull stayed in his office and Hurrell had to learn about actors on his own. "I found that capturing glamour wasn't easy," he said. "Even veterans before cameras dreaded portrait sittings. They treated them as necessary evils. Stars showed a surprising inferiority complex about their appearance and the effect of their posing." His first star assignment was no exception. Joan Crawford, star of *Our Dancing Daughters, Our Modern Maidens,* and now *Montana Moon,* was used to the dulcet tones of Clarence Bull. As she said years later, "Clarence Bull was a very quiet, serious man. He might joke with you before you started the sitting, but once you were in there, he was the most dedicated man imaginable."

Crawford's first meeting with Hurrell was a memorable clash of wills. He was assigned to photograph her at her favorite offscreen activity, knitting. She found him overbearing and he found her poses arch and artificial. Years later, he recalled:

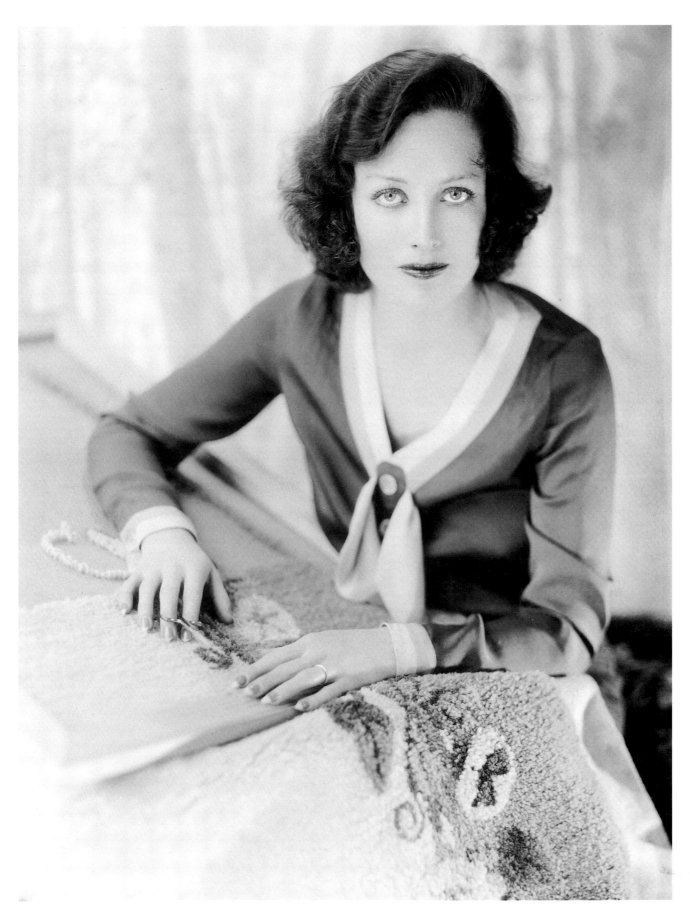

24. *This was the intense young woman who resisted George Hurrell's direction;*
Joan Crawford in her first Hurrell portrait.

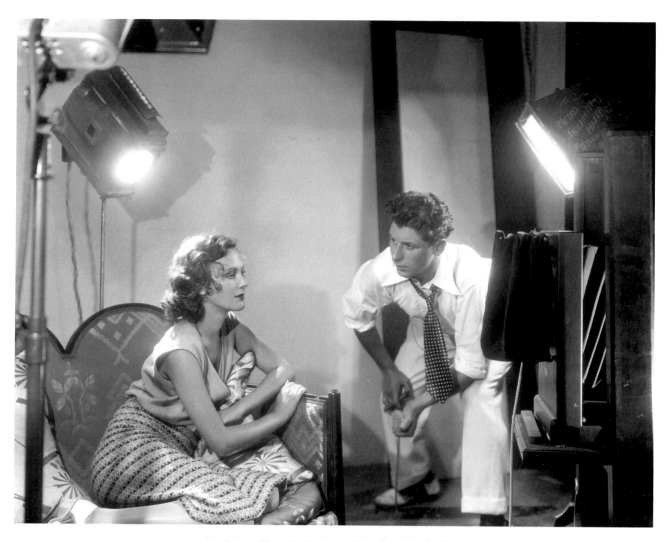

25. George Hurrell photographing Dorothy Jordan.

I kept telling her how to pose. She finally got so upset about it that she went into the dressing room and said, "I'm not going to pose any more."

So the publicity gal came out and said, "You can't talk to her like that. She knows how to pose and she doesn't want you telling her how to pose."

I said, "What the hell am I doing here then? She doesn't want me to tell her how to pose? Pack it up, Al. Let's get out of here." So he had the camera packed and we were going out the door and she came running after us.

Crawford later admitted, "I was the 'posy' type. That was something I overcame by developing a sense of humor about myself." The sitting was completed, but without many laughs.

Two days later, Hurrell was having lunch in the commissary with Al St. Hilaire when a freckle-faced young woman rushed up, knelt before him, and kissed his hand. Once he recognized her, he was astonished to hear Joan Crawford say, "Please forgive me, Mr. Hurrell. I've just seen the proofs. They are so very, very lovely." Thus was born a historic collaboration.

Hurrell photographed Crawford four more times in the spring of 1930. The resulting images were so impressive that they made the leap to an elegant East Coast publication, *Theatre Magazine.* Hurrell's work was attracting attention, not only for its publicity value, but also for itself.

▼

IMMOVABLE OBJECTS

On April 24, 1930, shooting finished on *The Unholy Three,* the talking picture debut of M-G-M's leading star, Lon Chaney. The "Man of a Thousand Faces" had overcome his aversion to the microphone and starred in a remake of his 1925 hit, playing a sinister ventriloquist. Using five vocal characterizations for a month had tired him and strained his voice, but when he arrived at the gallery on April 25, he was nonetheless an imposing presence. Hurrell could see why Chaney was so popular; even without the fantastic makeup he usually employed, he had a powerful magnetism.

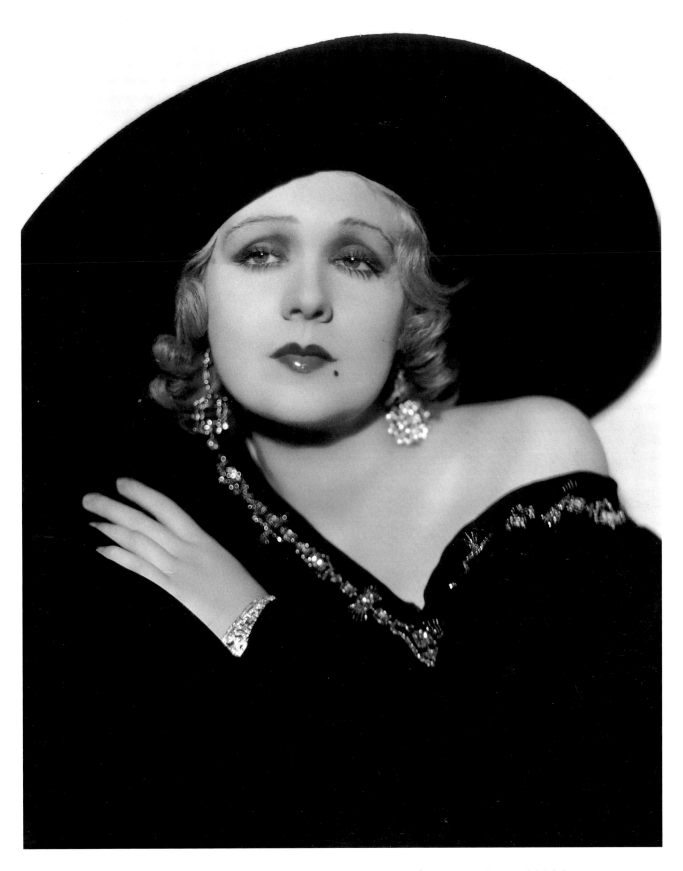

26. Hurrell departed from convention by shooting Anita Page's sexy black dress with high-key lighting and white background. (In a "high-key" photo, the background is brighter than the subject's face. In a "low-key" photo, the subject's face is the brightest area in the picture.)

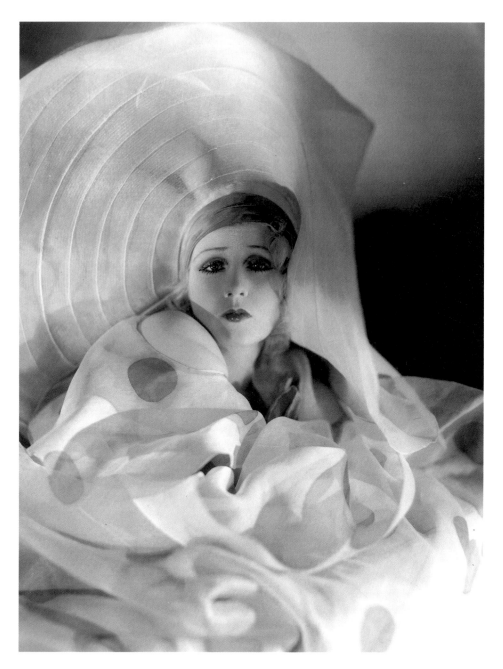

27. Anita Page by George Hurrell, 1930. Miss Page remembers being asked by the director Harry Beaumont, "Are you starting to believe your own publicity?" "Of course," she answered. "Aren't you?"

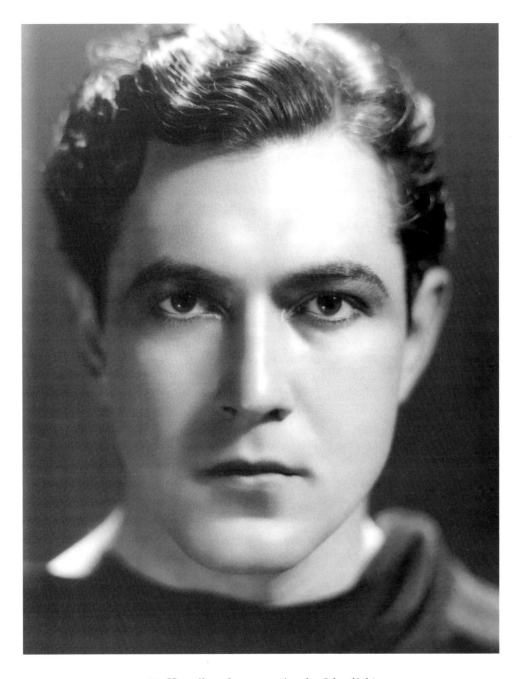

*28. Hurrell used a conventional soft key light
for this portrait of Johnny Mack Brown, but he individualized it with dramatic
backlighting, bounced fill lighting, and a dead-on stare.*

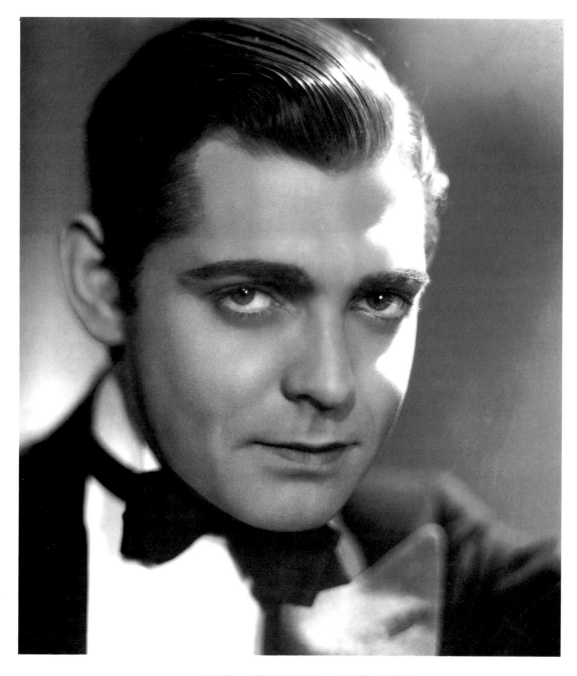

ABOVE: *29. Hurrell's first sitting with Clark Gable
took place shortly after December 4, 1930, when Gable signed with M-G-M.*

OPPOSITE PAGE, ABOVE: *30. William Haines was a star whose
portraits suggest what his movies could not.*

OPPOSITE PAGE, BELOW: *31. Male M-G-M stars were required to project a showy
virility, as exemplified by this portrait of Ramon Novarro. The sensuality of Hurrell's
work, though, gave Novarro a certain sexual ambiguity.*

ABOVE: *32. Hurrell used a soft, diffused light to present Marie Dressler to her adoring public.*

BELOW: *33. In 1979, Robert Montgomery told* Yankee *magazine, "When I signed with M-G-M, they gave me a big pitch about how I was going to play opposite Norma Shearer and Joan Crawford. I didn't have any idea whom they were talking about. I had actually seen only two films when I went to Hollywood in '29."*

OPPOSITE PAGE: *34. Lois Moran, photographed in April 1931, for* West of Broadway.

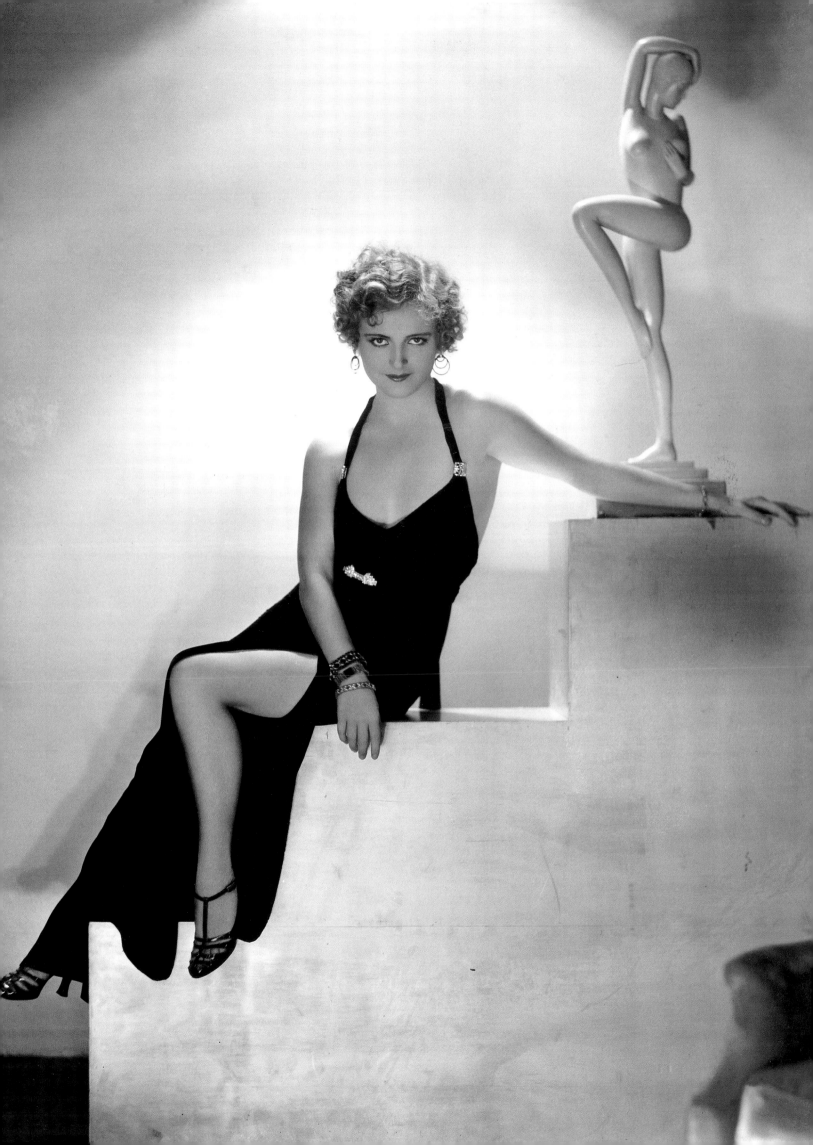

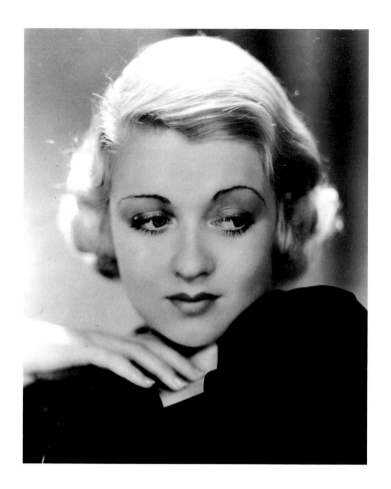

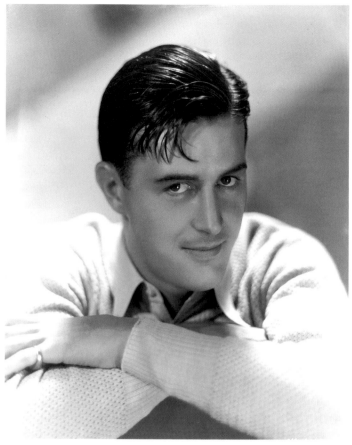

THIS PAGE

ABOVE, LEFT: *35. Constance Bennett, December 1930, for* The Easiest Way.

ABOVE, RIGHT: *36. Ray Milland, March 1931, for* Just a Gigolo.

RIGHT: *37. Hurrell's first apartment in West Hollywood (at that time unincorporated Los Angeles County), 1261 North Flores Street (photo by the author).*

OPPOSITE PAGE

ABOVE, LEFT: *38. M-G-M borrowed Kay Francis from Paramount for William deMille's* Passion Flower.

ABOVE, RIGHT: *39. Hurrell enjoyed the ambience of his new workplace. He posed Cliff ("Ukelele Ike") Edwards on a sound stage, under a 5000-watt spotlight and in front of a 2000-watt "double broad."*

BELOW: *40, 41. Hurrell scored points with this portrait of Joan Crawford when it appeared in* Theatre Magazine.

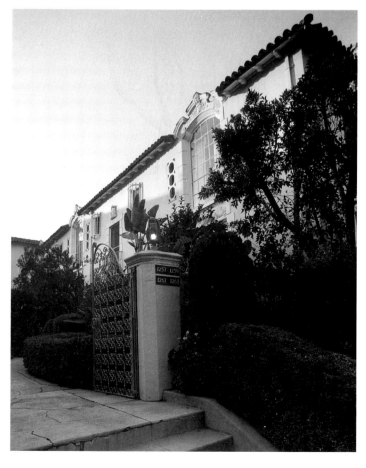

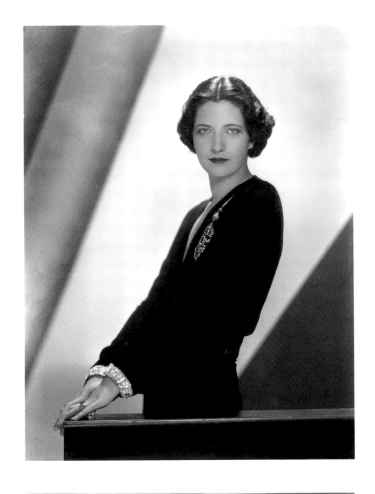

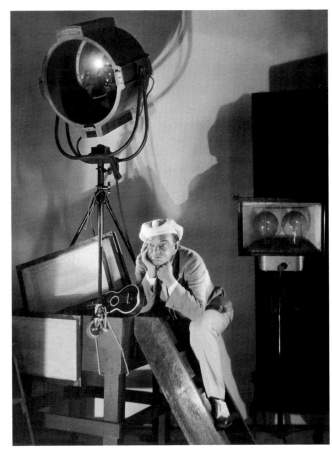

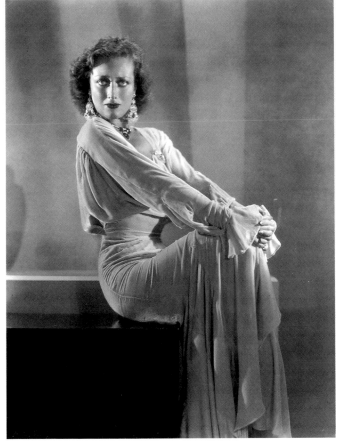

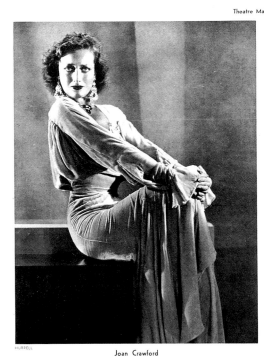

HURRELL

Joan Crawford

First Nights at the Cinema

Miss Crawford, one of the most enticing of the younger stars, will soon be seen in Metro-Goldwyn-Mayer's "Our Blushing Bride." Whereupon she will begin work upon a vocalization of Vincent Youmans' musical comedy which Broadway saw last season, "Great Day!"

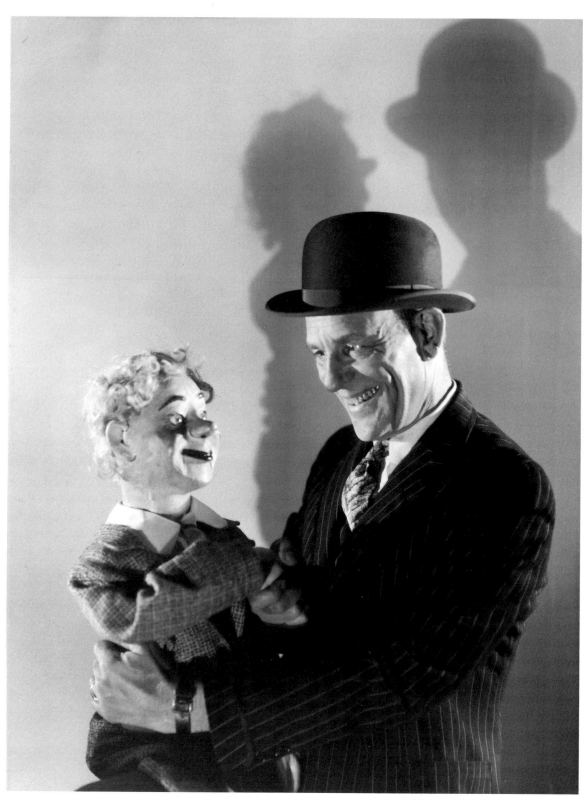

*42. An April 25, 1930, portrait of Lon Chaney made
for Jack Conway's* The Unholy Three.

Chaney, who looked much older than his forty-seven years, had already heard about Hurrell's ability to enhance his subjects. He said: "Don't worry about the wrinkles. They're my trademark."

Chaney sat down in front of the camera, and when he assumed a pose with a ventriloquist's dummy on his knee, Hurrell felt as if he were an awkward witness to an odd relation. He moved lights around and unobtrusively captured the progress of Chaney's communication with the dummy. And instead of using light to flatter this subject, he lit to expose something weird and disturbing. More than any subject Hurrell had yet photographed, Lon Chaney was posing in character, this time as a con man menacing a wooden homunculus.

Hurrell found the experience unsettling, but when the lamps were turned off and afternoon light came through the door, Chaney was once again the smiling, reserved gentleman who'd arrived an hour earlier. There was still more unexposed film, and Hurrell wanted to capture this other person, too — the "real" Lon Chaney.

"Not today. I don't feel comfortable being photographed as myself."

Hurrell later recalled that when Chaney went out the door, there was something odd about the way he said good-bye, something that made the sound of it stay in his head. He tried to forget about it, and he did, until four months later. On August 26, 1930, Lon Chaney died of throat cancer.

April 1930 was memorable for another brush with greatness. Howard Strickling, in yet another disappointment for Clarence Bull, scheduled Hurrell to photograph Greta Garbo. Under contract to M-G-M for less than five years, the twenty-four-year-old Swedish actress had already crossed the line between movie star and cultural icon.

Hurrell knew that Garbo was wary of strangers. She had been photographed in nearly all of her ten M-G-M silents by the same gifted cinematographer, William H. Daniels. She also exercised this prerogative in the portrait gallery, singling out Ruth Harriet Louise. Only the previous August, when she'd learned of Louise's impending departure, had she consented to sitting for Clarence Bull.

Hurrell had heard stories about that event. She'd scheduled a nine A.M. sitting, arrived at the studio as if for a day of filming, gathered her maid, hairdresser, and chauffeur, and then had them drive with her wardrobe to the Stills Studio while she walked the two blocks from her dressing room. She'd greeted Clarence Bull with a formal "Good morning, Mr. Bull."

"Good morning, Miss Garbo. Well, shall we do great things today?"

"No. I do not feel like doing this."

When the lights had started to warm her, though, she'd responded as if to the touch of a hand, rising to the occasion, assuming creative poses, subtly altering her position just in time for Bull to squeeze the shutter-release bulb, working straight through lunch, striking three hundred poses without a complaint, fortified by nothing more than a glass of orange juice.

Bull's assistant, Virgil Apger, had dropped a light next to her. "Do I make you feel nervous maybe?" she'd quipped. Noticing the somber music on the radio, she'd asked: "Oh, oh—is that the way we feel today, Mr. Bull?" Walking to the radio to change the station, he'd noticed that she'd been using the front element of the Eastman Kodak Portrait Lens as an impromptu mirror in which to perfect her poses. Then, suddenly, after only six hours, her face had lit up and she'd said, "Well, that's that!" She'd gathered her wardrobe (to be handed to the servants waiting outside) and said good-bye to Bull. "I'll try to do better next time, Mr. Bull."

"So will I," he'd responded, patting her hand.

Hurrell also found out that Garbo had insisted on seeing every single proof, and had realized that three were missing— out of three hundred. Equally surprising was her approval of every proof and an order for one custom 10 × 13 print of each.

At 8:50 A.M. on the day of the sitting, Hurrell heard a clomp-clomp on the outside staircase and Greta Garbo appeared at the door, loaded down with the heavy gowns Gilbert Adrian had designed for *Romance*. Hurrell recalled in 1975: "I took a look at those costumes and I thought I'd try something like one of those old daguerreotypes. There was a skylight there, so I first tried putting natural light on her, to get that feeling of an old portrait."

This was something different for Garbo, who'd grown used to the precise incandescent lighting of Daniels and Bull. "She could 'feel' light," said Bull. If she'd been slightly nervous with Bull in August, she had at least seen him around the studio before; Hurrell was an unknown quantity, and this skylight business was a little off-putting. It shouldn't have been. Hurrell said:

There wasn't any problem with photographing her . . . her features were so photogenic. You could light her face in any manner possible; any angle; up, down. Her bone structure—and her proportions, her forehead, her nose—was just right; the distance between here and here was just right. And her eyes were set in such a way that you couldn't go wrong.

But something *was* going wrong, in spite of the "interesting" poses she was assuming; she was giving

ABOVE: *43. George Hurrell's portraits of Lon Chaney were intended to record only the character Chaney was portraying in the film, ventriloquist Professor Echo.*

BELOW: *44. Chaney was uncomfortable without his props or bizarre makeup.*

OPPOSITE PAGE: *45. Hurrell captured what Chaney wanted to hide—an awareness of his own mortality.*

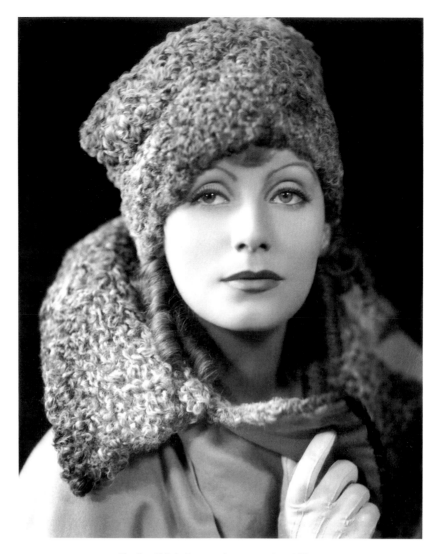

*46. Garbo didn't know what to make of Hurrell
and fell into rather formal poses.*

poses and nothing else. Years later, Hurrell would refer to her as a "stone statue," but this morning he was diagnosing her condition as mere "stiffness." The room had been cleared of superfluous persons, so he couldn't blame her reserve on anyone else.

"I hummed and jumped up and down and the result was a slight smile, which I caught. Thereafter, she was pensive; she did not appear to respond very much to my popular recordings."

He took a break while Al St. Hilaire loaded film holders and Garbo changed from black velvet to gray velvet. "I had to work with the bulky costumes as best I could."

But the costumes weren't the problem. "She was going to do what she was going to do, and that was that. There was never any give and take . . . she was pretty much self-styled." Out of desperation, Hurrell resorted to outlandish antics; he crawled on the floor and hung from a ladder. Still, he wasn't getting enough usable shots.

On each sitting, they expected to have twenty-five okayed . . . you had to shoot fifty plates to get that. I'd shoot about a hundred. . . . In those early days, they sent those publicity shots all over the world, and each editor would want an exclusive picture. So they would send out twenty-five shots and then two weeks later they'd have to send out another twenty-five shots and they would have to be different.

Hurrell cut loose with antics in the studio because "you didn't just tell a person to laugh, you made them laugh." Still, Garbo didn't laugh. She didn't do anything. "She didn't respond to me. . . . It may have been because we didn't meet on common ground in some way; because I was wild and yelling, hollering, and she wasn't particularly amused by it. It didn't do anything to her."

He had one last trick up his sleeve. The camera was focused, St. Hilaire had readied the film by pulling the slide out of the film holder, and Hurrell

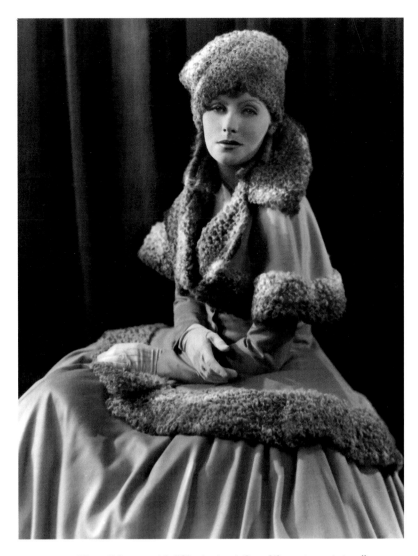

47. Hurrell later said, "She just sat there like a stone statue."

was walking backwards, holding a black rubber bulb in his hand. It was connected to the shutter release by a fifteen-foot hose. Peering at his impassive subject, he kept walking backwards, pretending to be concentrating on her. "Finally, I almost fell over some cables—and she laughed out loud. . . . In the split second while I regained balance, I instinctively squeezed the bulb." Garbo had let down her guard, revealing a wry humor.

"Once I found out she was a happy person by nature, I wondered, Why hide it by this grim look? She liked to look grim and dramatic, as if the world were coming to an end."

The sitting had come to an end. Garbo swept up her heavy gowns and departed. On her way downstairs, she passed one of Bull's assistants. "There's a crazy man in there," she confided to him.

Cecil Beaton breezed into town a few months later and managed to wangle portrait sittings with every star in town, from Gary Cooper to Norma Shearer. But he pined for that one elusive subject. He told his diary: "I at last got through to Strickling and, after having my hopes raised so high yesterday in answer to my 'What about getting Garbo?' there was the deadly 'Not a chance.' Hell. Damn. Blast the bitch. . . . She's got nothing else to do."

The man who did get Garbo had kinder words. Clarence Bull said, "The afternoon Garbo told me I was to be the only lensman to make her portraits, even I began to think I was a fair photographer."

George Hurrell had the last word: "Garbo was probably the sexiest gal among the whole darned bunch of them, but she didn't project it, because that wasn't her job." However, it was her job to cooperate with the studio's portrait photographer, and she wouldn't. The *Romance* portraits looked like character studies of an unavailable character. The studio methodically dispersed them, but Garbo and Hurrell would never work together again.

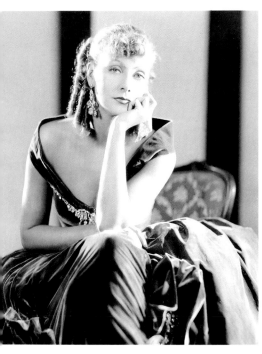
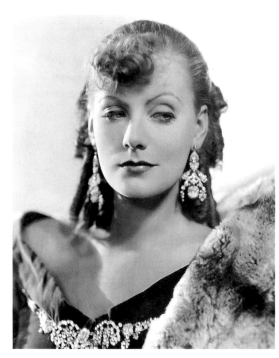
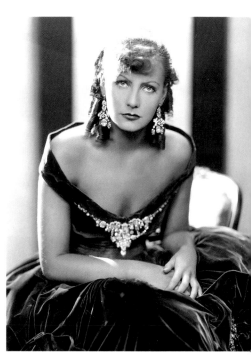
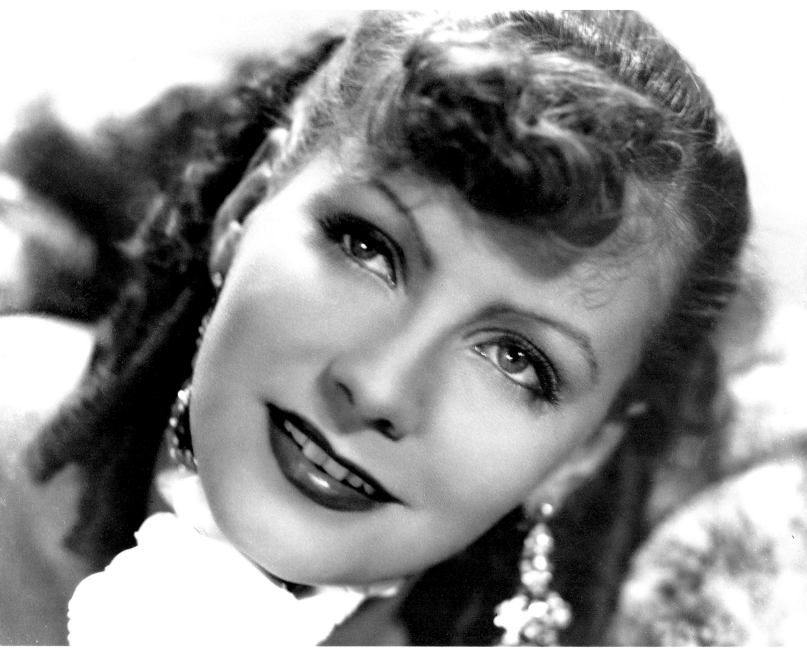

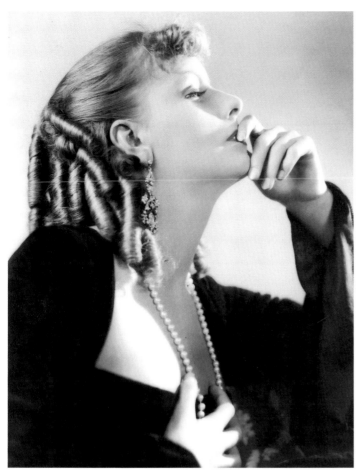

OPPOSITE PAGE

ABOVE LEFT: *48. "You couldn't get her to do anthing but lean."*

ABOVE, CENTER: *49. Hurrell's antics caused Garbo to withdraw.*

ABOVE, RIGHT: *50. Hurrell told author John Kobal, "It didn't help that I was the wild, hollering kind, leaping all over the place, talking, slamming on records."*

BELOW: *51. This was as much smile as Garbo would give. "Actually, in person she was quite happy and frivolous, but she wouldn't turn that on for the camera."*

THIS PAGE

LEFT: *52. "That grim personality thing was established in her own mind, and righteously. It gave her a quality that nobody else was able to achieve, and was quite intriguing."*

BELOW, LEFT AND RIGHT: *53, 54. Garbo's portrayal of the opera singer Rita Cavallini in* Romance *was far more accessible than her still-photo persona.*

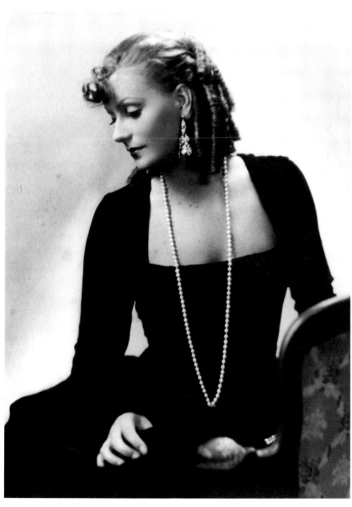

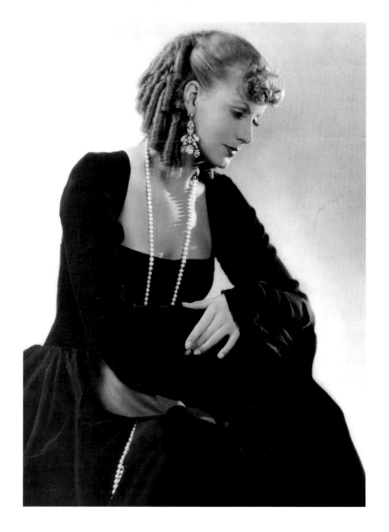

47

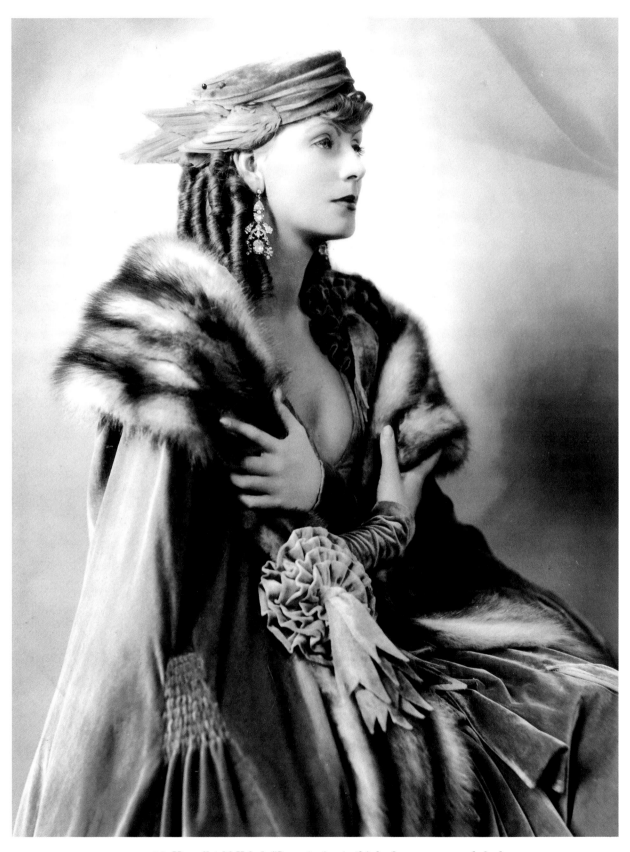

ABOVE: 55. *Hurrell told Kobal, "I was trying to think of a new approach for her.*
I had a skylight in the roof and I thought, well, why not use that? I tried going a little dark . . .
doing the kind of things with natural lighting that Vermeer did with paint."

OPPOSITE PAGE: 56. *"They didn't turn out as dramatic as my usual work . . .*
but I think it served its purpose of promoting her and the film."

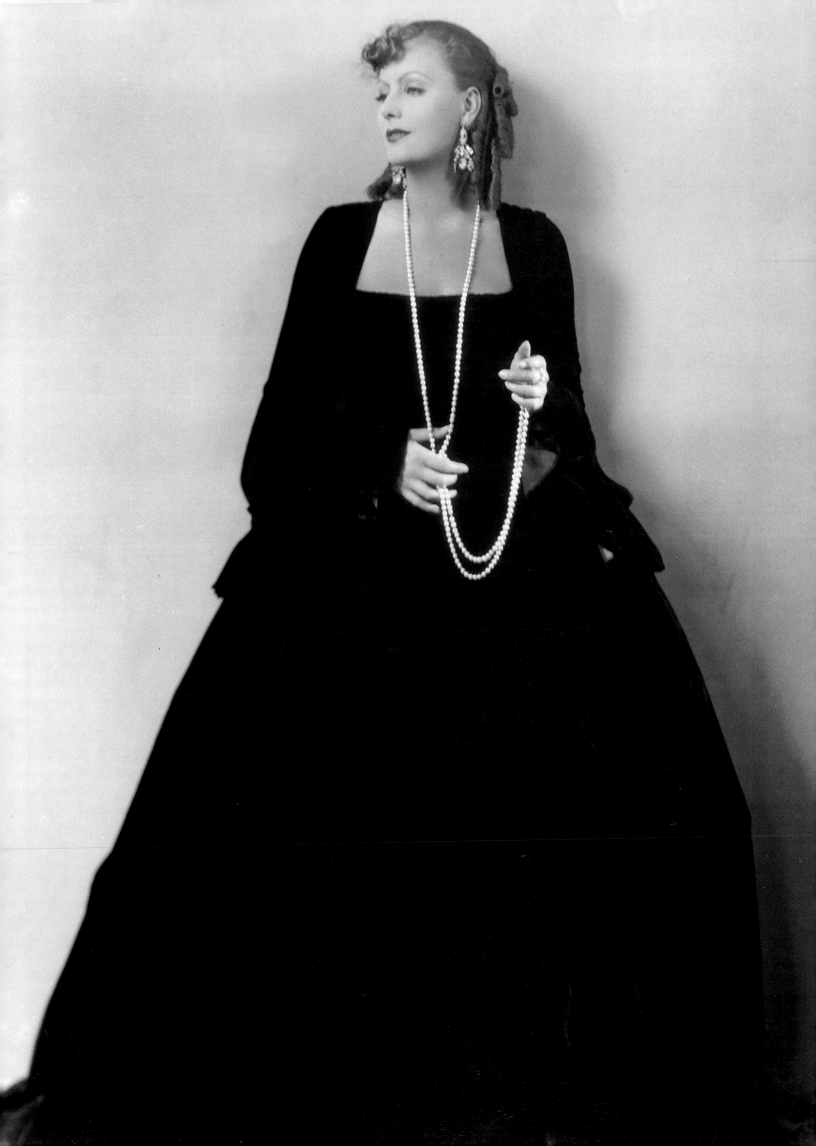

3

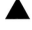

THE HURRELL LOOK
1931–32

"Hollywood is like life; you face it with the sum total of your equipment."

—*Joan Crawford*

A STYLE CRYSTALLIZED

Nineteen thirty-one was approaching, and George Hurrell was running out of ortho-chromatic film. He could have ordered more, but the range of film stock now available in the newer panchromatic was too tempting. (It included Par Speed Portrait, Portrait Pan, and Super Speed Portrait.) *Panchromatic* means "all colors," and indeed this film saw the entire spectrum. The ortho film that Hurrell had used for portraits of Joan Crawford (plate 57) and Norma Shearer (plate 58) had made their eyes too pale and their lips too dark. Hurrell took a chance on Par Speed Portrait. He found its tonal rendering an improvement over the ortho; it gave skin tones a creamy rather than burnished look, as in the Norma Shearer portrait for *Strangers May Kiss* (plate 59).

Pan film, introduced in 1928, was easier for both photographer and subject because it was faster than ortho film. This increased sensitivity to light allowed Hurrell to shoot at exposures as short as one second. He couldn't shoot much faster than that, though, because his beloved Verito lens had to be closed (or "stopped") down further to get those sharper edges he liked. Instead of using a faster lens, he poured on more light. In order to do that, he adopted a radically new lighting scheme. With its innovation, he began his third period of artistic development.

A few months earlier, Hurrell had become dissatisfied with the lights in his gallery. Although they were well-designed, functional, and aesthetically promising, they all had one problem: they were stuck on top of conventional lightstands and were only as mobile as the stands themselves.

A lightweight spotlight had been introduced by Mole-Richardson, and Hurrell had taken to it like Rembrandt to a sable brush. With it, he'd thrown sharp shadows onto a white wall. He'd projected elliptical nimbuses. He'd painted slashes of rectangular light. And when he'd thrown this light across faces, his use of it had been as playful or poetic as the moods of his subjects.

He'd put that light everywhere but at the end of his arm, and that was his frustration. He wanted the light to fly over the heads of his subjects, as it would if he held it in his hand, but the damned light was stuck on top of the damned lightstand.

He went to his boss and said, "I want a small light that can be suspended from a boom. Is there such a thing?" Howard Strickling said no, that it would have to be built, and that it would undoubtedly cost too much.

Hurrell had no patience with bureaucracy. He needed this light. Those conventional lightstands were slowing him down. "When I'm trying to get expression out of my subjects, I can't be worried about the damned lamps. I could adjust this 'boom light' in a twinkling. Now do I get it or not?"

He got it (plate 61). His artist's intuition proved right. The boomlight gave him an extension for his arm. The light could swing and swoop and soar above his subjects, mimicking moonlight or sunlight. Contrary to conventional lighting practice, he set the boomlight first, molding a compositional pattern of light on head and shoulders. Then he set the "key" light to mold facial features. His key light was usually dimmer than the boomlight, another unconventional touch. Then he skipped the "fill" light altogether, preferring to use light bounced from clothing or a table to fill in the shadows. The "bounce"-light scheme was a startling innovation, and it attracted attention.

Hurrell's photographs now looked as if he were thinking of light as a solid substance, something akin to gold spray paint. His restless eye had led him to new inventiveness, and his artistry was now abstracting from light itself (see plates 62, 63).

There was light outdoors, too, and he had learned to subordinate it to his will as readily as he did the incandescents. But there were other surprises. The higher levels of light outdoors forced him to stop down his Verito lens all the way; he found the new clarity intriguing. Impulsively he raided his savings and bought a very expensive lens, a 16-inch Goerz Celor.

This new lens was of the type known as a "commercial lens"; that is, one manufactured to be sharp at any f-stop. Hurrell started playing with it and saw that he was going to need new retouching techniques, if not a new retoucher. The Goerz Celor made even youthful skin look bumpy, especially with a 1000-watt spotlight raking across it. The softness of the Verito allowed for relatively coarse retouching, and a darkroom technique called diffusion further disguised it. A glass or cloth diffusion filter was put between the enlarger lens and the photographic paper, and when the negative was projected, the diffusion blended the dark areas into the light. Retouching strokes were smoothed out, but unfortunately, so were detail and contrast (see plates 64, 65).

There was no point in shooting with a sharp lens if the picture then had to be softened to hide coarse retouching. The solution to this problem was achieved in two ways, one human, one mechanical. A new retouching artist was found, a

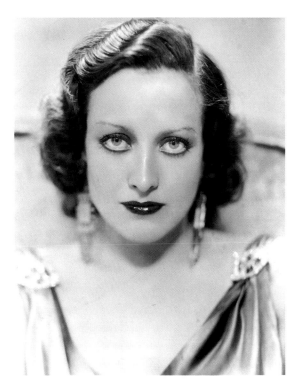

57. A 1930 portrait of Joan Crawford made with orthochromatic film by George Hurrell.

58. A 1930 portrait of Norma Shearer made with ortho film by Hurrell.

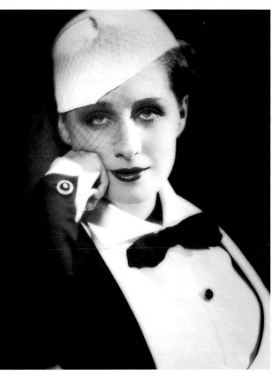

man named James Sharp. With him came a retouching machine, a device that vibrated the negative, ensuring evenness of strokes. Compare the heavily diffused printing in plate 65 to the undiffused printing in plate 66, which is both sharp *and* smooth. The original 8 × 10 nitrate negative of plate 66 can be seen in plate 67; reflected light shows the amount of pencil lead that was applied to it.

James Sharp customarily made "before and after" prints for his portfolio. Plate 68 is one of Hurrell's unretouched proofs of Joan Crawford, revealing freckles, frown lines, and sunburn damage. Plate 69 is the print made after eight hours of lead retouching on the emulsion side of the negative. Unlike Clarence Bull, Hurrell instructed his subjects to pose for him without the heavy makeup base they wore for the motion-picture camera. He later said, "I always tried to get them to leave the makeup off. In those days, it wasn't easy. Because the makeup was so caked . . . and by the time you had retouched some wrinkles out, why, it was completely flat." Referring to the specular highlights created by a spotlight, he explained that "skin has a sheen to it and as soon as you put that heavy makeup on, it goes *flat*."

Joan Crawford remembered it well: "George Hurrell used to give me just one key light, and for him, I never wore makeup. Just a scrubbed face. Hurrell loved photographing me without makeup — except for my eyes and lips, of course."

Hurrell said, "I was trying to get character into my work. That's why I went sharp, because there was no reason for that thing to be fuzzy. And that imme-

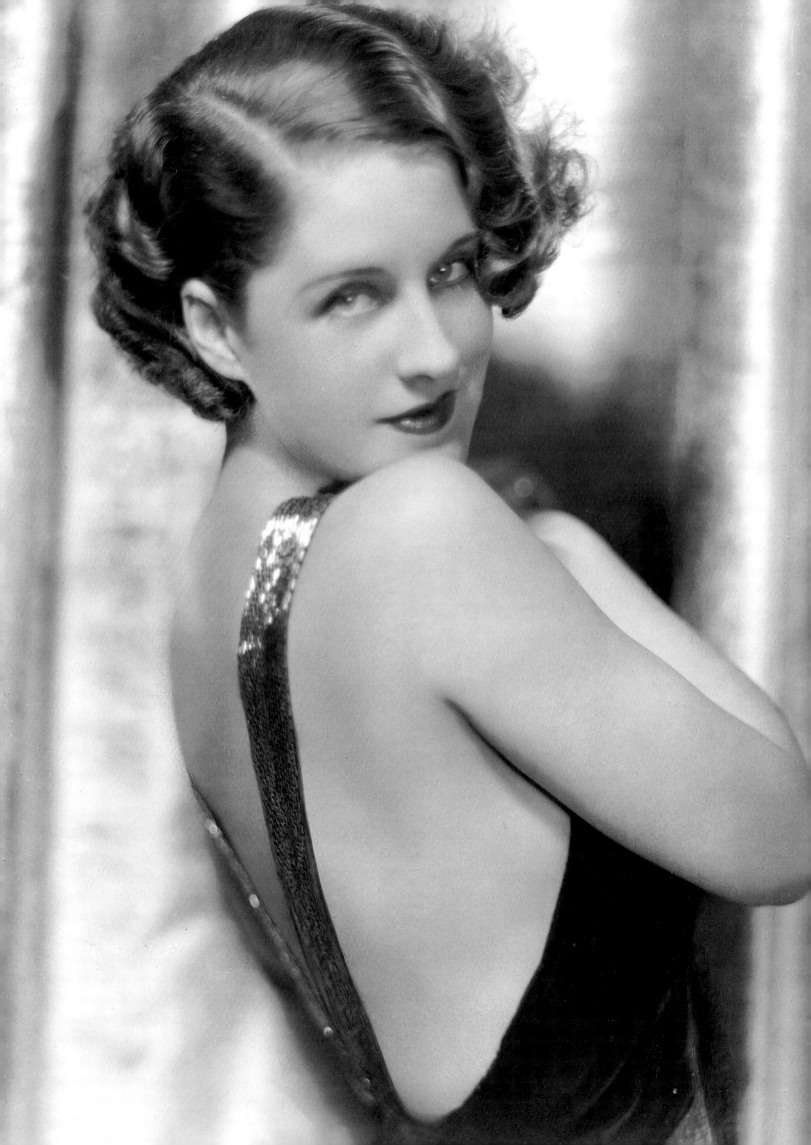

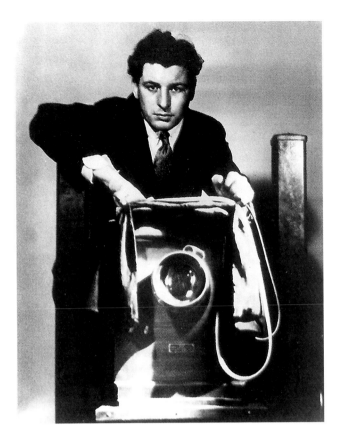

61. *Hurrell aims the Bardwell-McAllister boomlight.*

OPPOSITE PAGE: *59.*
Hurrell used panchromatic film to make this
early 1931 portrait of Norma Shearer
for George Fitzmaurice's Strangers May Kiss.

ABOVE: *60. A Hurrell self-portrait from 1930,*
showing M-G-M's Eastman Century Studio portrait
camera and his Verito lens.

make less important areas go dark and recede (see plate 71).

After a year and a half at M-G-M, Hurrell was maturing. Inside the gallery, he conducted sittings with confidence and aplomb, using his charisma to evoke honest poses and warm expressions. "I tried to create a theatricality, a mood for each shot," he said later. "Half the time I didn't know what I was doing, but it always worked. I'd get reactions." Sometimes the reactions would linger, and he began to attract a contingent of female admirers. The only romance to which he ever admitted was with Conchita Montenegro, a Mexican starlet who may have introduced him to the beauty of her homeland. He began to spend his weekends there, painting landscapes and fishing. Back at the studio, his energy and a newly kindled sensuality took him in another direction. He began a series of portraits executed in the style of the Norma Shearer sitting at La Fayette Park Place, instituting a regimen of suggestive poses. Some starlets, like Madge Evans, burst out laughing. Others, like Lili Damita, willingly cooperated, only to have the publicity department kill the proofs. Hurrell was warned not to shoot anything approaching nudity.

"That was just the rule of operation," he said. "You understood that. Because, first of all . . . they couldn't publish it. . . . You had to get them looking sexy without taking their clothes off."

But how? Thinking back to the Shearer sitting, he recalled that the real breakthrough had been her

diately gave the pictures more character, I think."

"I'd scrub my skin until it shone," Crawford recalled. She was always eager to help invent a new face. Her career was a series of "new" Joan Crawfords, created out of fear that her fans would tire of her and relegate her to the scrap heap that now held former stars such as Aileen Pringle and Marie Prevost. Hurrell was her ally in the war against obsolescence, and she welcomed any addition to his arsenal. The sharp photos he shot for *This Modern Age* (see plate 78) were startling in their newness and gained precious space in *Photoplay.*

While supervising Andrew Korf and James Sharp, Hurrell continued to refine the retouching techniques he'd used so successfully on the Novarro portraits two years earlier. He applied powdered graphite to the emulsion of the negative, then rubbed it in patterns with a rolled-up paper called a blending stump.* This embellished facial highlights (see plate 70). In the darkroom, he used the printing technique known as "burning" to increase tonal range and to

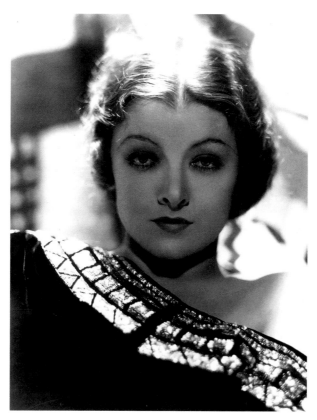

*62. Hurrell's first portrait of Myrna Loy
after she signed with Irving Thalberg.*

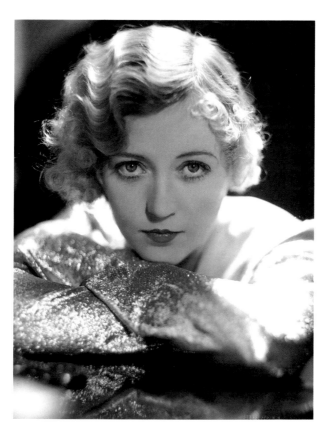

63. Marion Davies at the time of Robert Z. Leonard's
Five and Ten; *this spring 1931 portrait shows Hurrell's
use of his new invention, the boomlight. It gilds Davies's
hair and bounces light up into her eyes.*

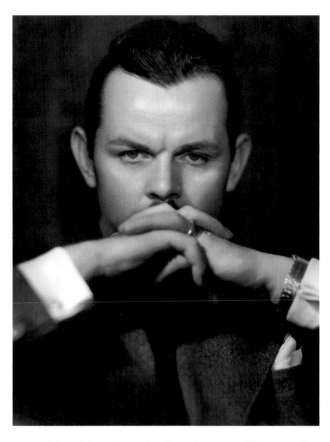

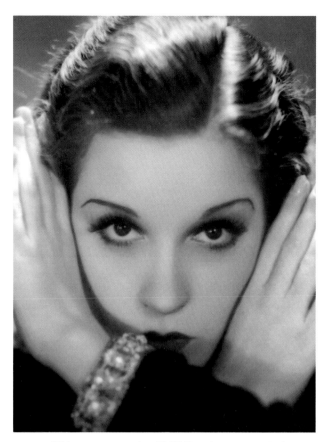

64. *Metropolitan Opera baritone Lawrence Tibbett made several films at M-G-M. This Hurrell portrait was made in connection with* The Rogue Song, *now (except for one reel) a lost film. Note the heavily diffused printing.*

65. *This 1930 portrait of Lili Damita was made for* Soyons Gais, *M-G-M's French-language version of* Let Us Be Gay. *Until foreign-language dubbing was perfected, important films were made with alternate casts in several languages.*

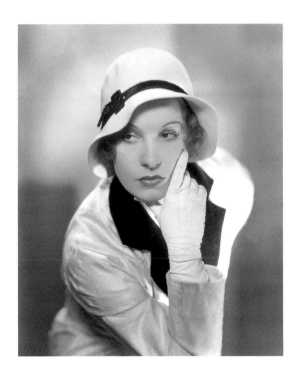

66. *Lili Damita a year later, when Hurrell had adopted the use of a Goerz Celor lens and improved retouching techniques. Heavily diffused printing was no longer needed.*

67. *This is a 1996 photo of the original nitrate negative of plate 66. Note the reflections of the lead retouching on Lili Damita's face. They are a pattern of the imperfections that had to be smoothed out with intricate pencil strokes.*

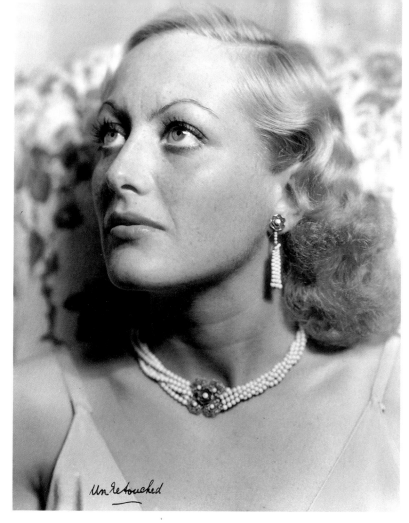

Un Retouched

68. *An unretouched Hurrell portrait of Joan Crawford made for Harry Beaumont's* Laughing Sinners.

69. *This is the same portrait, after James Sharp spent six hours retouching it.*

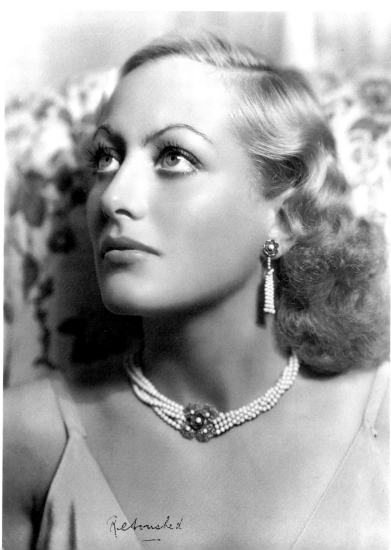

Retouched

relaxed yet alert expression. What had gotten her there? First, the music. Second, the slippery, silky kimono. Third, his coaching. The expressions he'd evoked from the formal star had been more truly sensual than those coaxed from nude models photographed in Griffith Park by Edwin Bower Hesser.

That was it. The limits imposed on him by the film studio didn't apply to the expression on a woman's face, only to the degree of cleavage or inner thigh that could be shown. An undraped shoulder, when combined with a direct stare, could be more compelling than all of Hesser's soft-focus sylphs. Armed with new film, new light, new lens, and a new retoucher, George invented a new formula, something urgent and yet uncensorable—something that made fantasy tangible. He tested this formula on any number of available subjects. "The starlets knew the gallery sessions were important to them," he said. "Some of them had very decided ideas about it."

Brainy Madge Evans, for example, would go just so far, and then rebel against what she considered the absurdity of it. But Hurrell would already have gotten some stunning shots.

Then there was Joan Crawford. Her new film was called *Possessed.* She brought a lot of Adrian gowns from it to a small set where Hurrell was to work with her. "I used to hate doing that fashion layout stuff. You couldn't do much with it. Just have her turn a little this way or that way."

When the obligatory full-length shots were done, Crawford was wearing a simple black dress. With this dress, a curtained wall, and a single spotlight, Hurrell created one of his most eloquent images (plate 74). For years it was printed, reprinted, and printed again, this icon staring with the eyes of a basilisk, eclipsing both Shearer and Garbo. With *Possessed* and this ubiquitous visage, Joan Crawford became M-G-M's supreme star, basking in the light of one perfectly positioned lamp. She would never forget who had positioned that lamp.

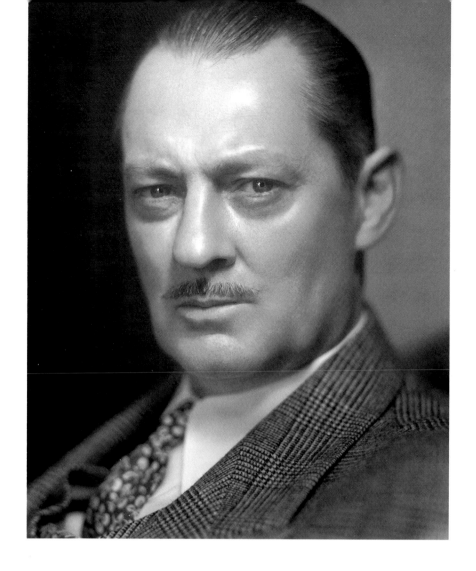

70. *After directing talkies
for two years, Lionel Barrymore
returned to acting in Clarence
Brown's* A Free Soul. *This spring
1931 portrait shows Hurrell's use of
pencil retouching to emphasize
specular highlights in skin texture.*

71. *Walter Huston's 1931
Hurrell portrait shows another way
the artist enhanced highlights: a
blending stump and powdered
graphite.*

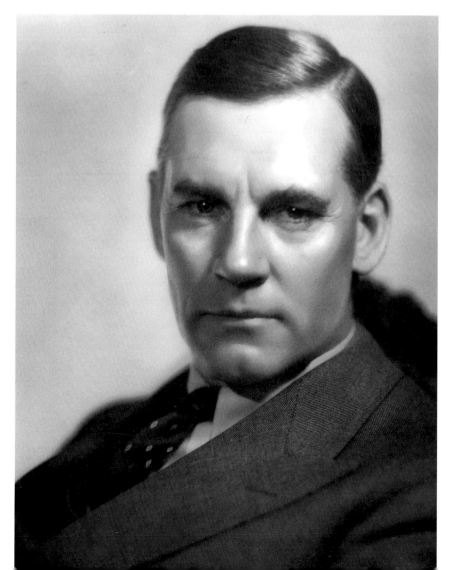

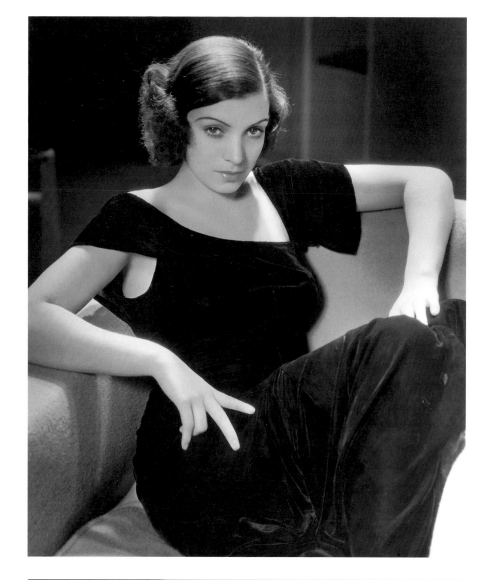

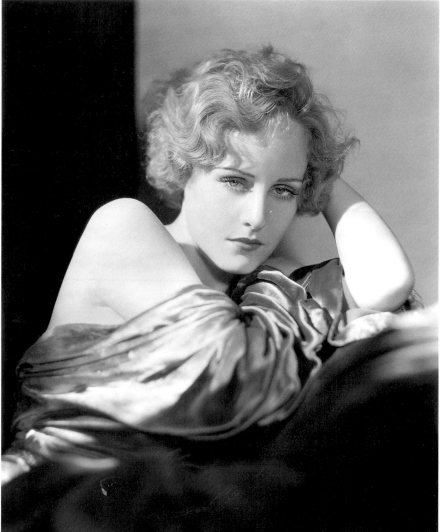

ABOVE: *72. George Hurrell shot Conchita Montenegro for W. S. Van Dyke's* Never the Twain Shall Meet *in April 1931.*

BELOW: *73. Hurrell told John Kobal, "We always used to try to make Madge Evans sexy, but she would fight it all the time—she would just laugh her way out of it."*

OPPOSITE PAGE: *74. Joan Crawford . . .* Possessed.

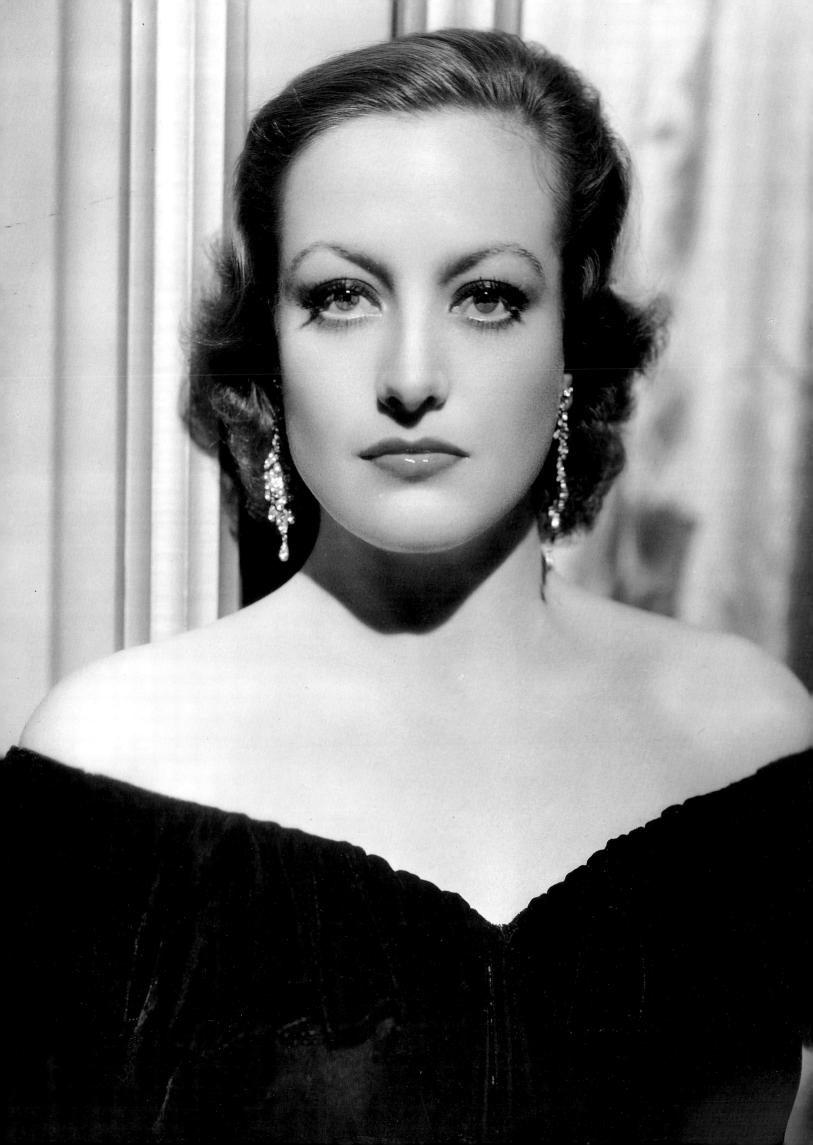

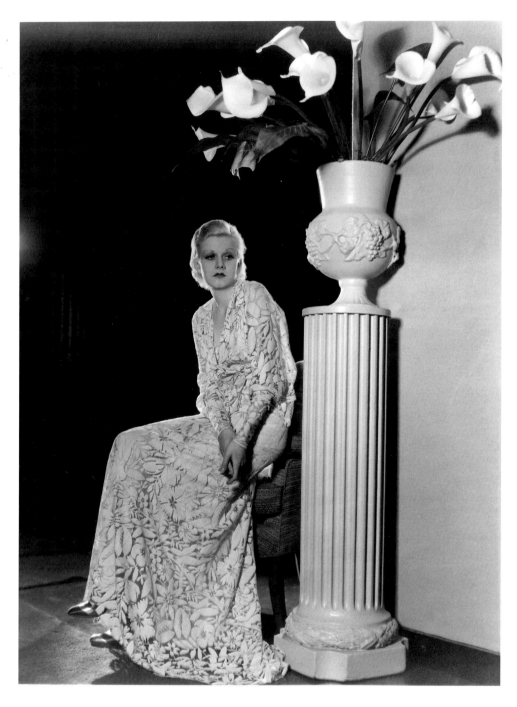

75. George Hurrell photographed Jean Harlow in April 1932, not long after M-G-M had bought her contract from Howard Hughes for $30,000.

STAR POWER

▼

In January 1932, George Hurrell celebrated his second anniversary at M-G-M. His life as an employee there was a glossy contrast to the uncertain, sometimes grim existence known to many Americans. The Great Depression was entering another year, and even Hollywood was feeling its wintry wind. Three of the "Big Five"—Fox, Warners, and RKO-Radio—were losing millions; the unemployed couldn't afford a 25¢ ticket. Only Paramount and M-G-M continued to show profits, albeit diminished.

M-G-M was solvent for one reason: it had more stars than any other studio. As long as those stars liked Hurrell, his job was secure. But stardom was an insecure profession, and it fostered odd loyalties. Hurrell never found out why Joan Crawford had taken herself to Clarence Bull's gallery from August 1930 to April 1931. But when *This Modern Age* went into production, she returned. The film was a Crawford vehicle, but not even Hurrell's portraits could overcome the word of mouth that kept fans away. "It was hopelessly artificial, especially for a Depression year," wrote Crawford. She feared not only bad films but good competition. M-G-M had let her go blonde to cash in on the popularity of the original "platinum blonde," Jean Harlow (plate 75). Now the studio bought Harlow's contract from Howard Hughes.

The search for new stars reached as far as Broadway. Irving Thalberg persuaded Lynn Fontanne and Alfred Lunt, the stage's most distinguished couple, to remake their 1924 success, *The Guardsman*. When Hurrell photographed them in April 1931, they were less than impressed. In fact, they told Howard Strickling that they expected the proofs to be the worst they'd ever seen. A week later, those proofs occasioned a very large order of personal prints. "Best photos they've ever had taken!" Strickling congratulated Hurrell—once it was safe to do so; publicity was an insecure profession, too.

Star-grooming paid off handsomely in the case of Johnny Weissmuller, a renowned Olympic swimmer. The non-actor created a sensation when cast as *Tarzan, the Ape Man.* This was the first time Hurrell saw a subject use baby oil to enhance specular highlights on skin (see plate 82). When the effect was coupled with retouching, it instantly became a Hurrell favorite, one that he would use again and again.

In 1931, Clark Gable could be seen in ten consecutive M-G-M releases. By January 1932 he was a star. His ascendance was due in part to Howard Strickling, who was now head of publicity. He had Hurrell photograph Gable in riding clothes and sportswear. His 1931 portrait (plate 81) was made, appropriately enough, for *Sporting Blood.* "He was almost shy in those early days," said Hurrell. "He did not know how long his career would last."

Conventional Hollywood wisdom had heretofore dictated one star per movie. Irving Thalberg challenged this notion with an "all-star production" of Vicki Baum's *Grand Hotel.* Instead of one star, it had five. In the ingenuity of its conception, the economy of its production, and the quality of its showmanship, *Grand Hotel* exemplified the Hollywood studio system at its most effective. The all-star ensemble that earned it a profit of $947,000 was not only in front of the camera, but behind it. Hurrell found himself in the company of director Edmund Goulding, scenarist Hans Kraly, art director Cedric Gibbons, and cinematographer William Daniels. Only two men who worked on *Grand Hotel* went uncredited. The first was Thalberg. His name never appeared in any credits. "If you can put it there," he said, "you don't need it."

The other uncredited artist was a freelance stills man named Fred Archer. Greta Garbo had not forgotten the "crazy man" Hurrell. She specified that someone—anyone—else take her on-the-set portraits. Fred Archer took the famous profile-to-profile portraits of Garbo and Barrymore.

Hurrell photographed the rest of the high-priced cast, including Joan Crawford, Wallace Beery, and the brothers Barrymore (plates 83–87). His portraits of Crawford with John Barrymore preserved the chemistry created on the set by Edmund Goulding. Of the Great Profile, Hurrell later said, "His 'presence' was similar to Chaney's, so strong that all he had to do was lean against a doorway."

Hurrell's *Grand Hotel* portraits, even though they lack Garbo, capture the magic of that wonderful film and the pride of its performers. When it premiered, on April 12, 1932, it put Metro-Goldwyn-Mayer at the top of the heap, a dizzying vantage point for a restless young artist.

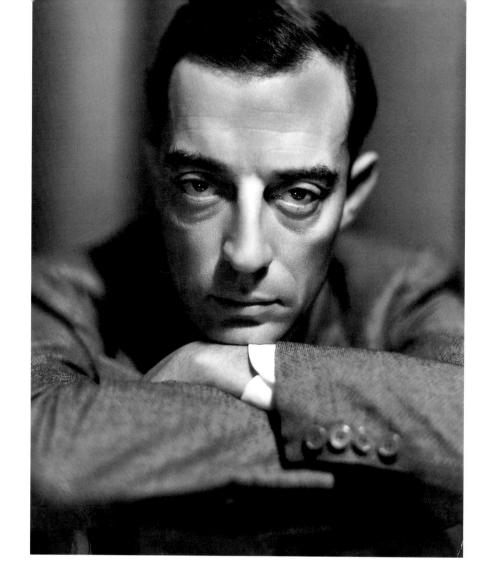

ABOVE: *76. Buster Keaton's portraits began to reveal the sadness he felt about his waning career.*

BELOW: *77. John Gilbert's portraits also revealed a growing despondency.*

OPPOSITE PAGE: *78. Hurrell made stunning images of Joan Crawford's new look, but the scenes in which she wore it were cut from Nick Grinde's* This Modern Age.

79. Hurrell's portraits of
Alfred Lunt and Lynn Fontanne were
made for The Guardsman, a 1931 Sidney
Franklin production.

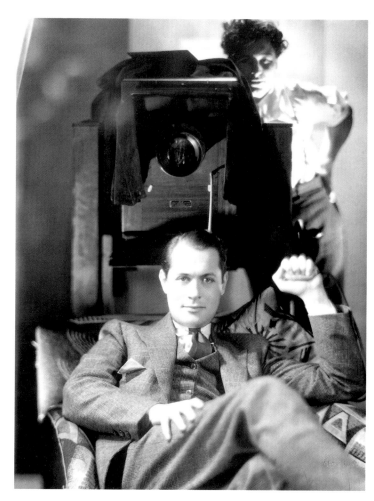

80. Hurrell used a mirror so that
Robert Montgomery could shoot a
portrait of both of them in 1931.

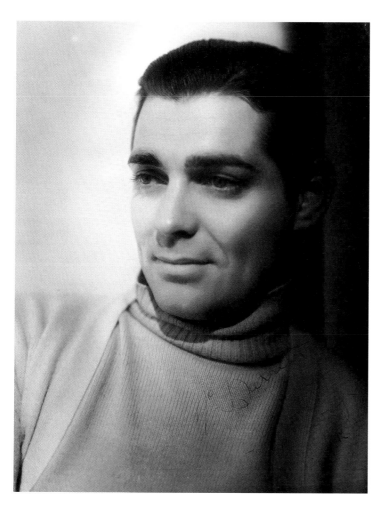

81. By the time of this May 1931 portrait,
M-G-M had reworked Clark Gable's
image. He was sleek, self-assured, and athletic.

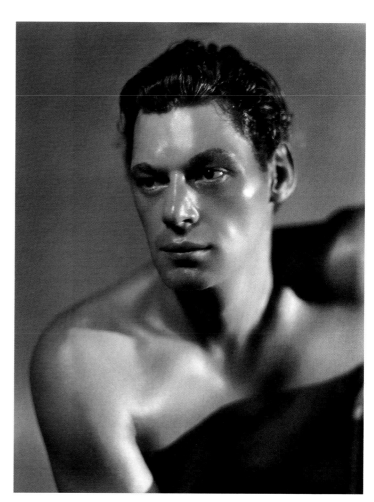

82. This Hurrell portrait of
Johnny Weissmuller was made in
November 1931.

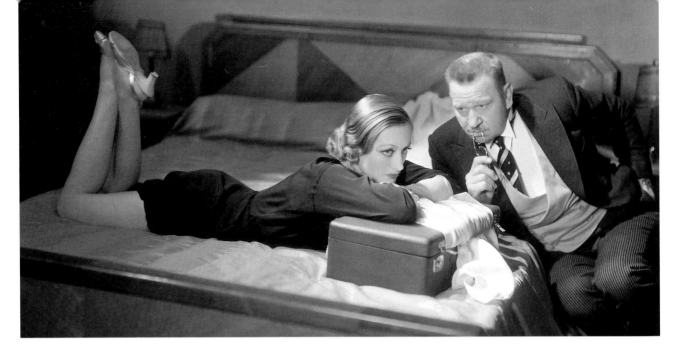
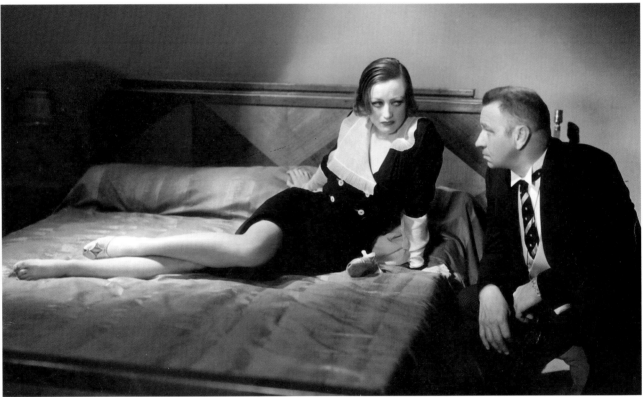
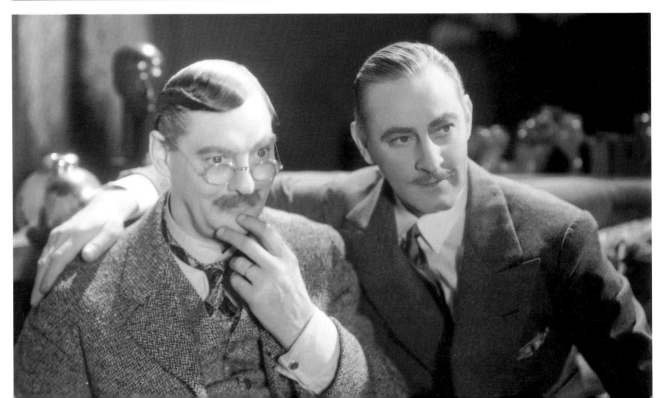

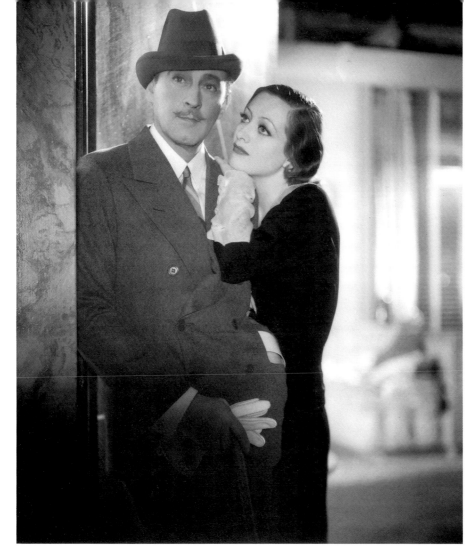

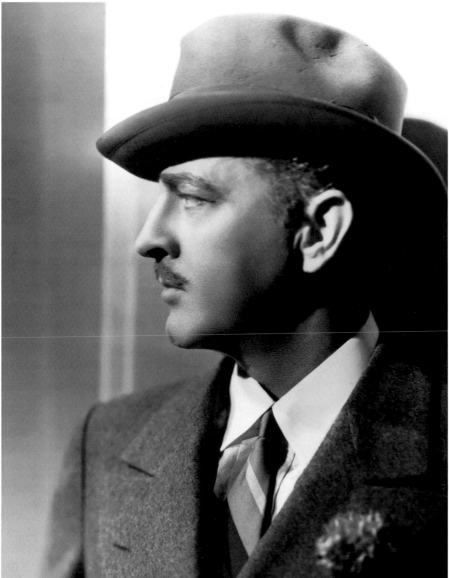

OPPOSITE PAGE

TOP: *83. Hurrell enjoyed shooting on the sets that Cedric Gibbons had designed for* Grand Hotel. *Here are Joan Crawford and Wallace Beery.*

CENTER: *84. Hurrell couldn't disguise Joan Crawford's dislike of Wallace Beery, who during rehearsals had told her to go home and learn how to act.*

BOTTOM: *85. Hurrell captured the affection between Lionel and John Barrymore in* Grand Hotel, *January 1932.*

THIS PAGE

ABOVE: *86. Joan Crawford and John Barrymore,* Grand Hotel.

BELOW: *87. At fifty, the brilliant and dissolute John Barrymore was still a majestic figure.*

▼
"LEAVE METRO?"

In the spring of 1932, Hurrell learned that it wasn't lonely at the top, just airless. He began to feel that his rooftop gallery was hot and claustrophobic, and that his schedule of sittings was not so much an artistic opportunity as a contractual obligation. From the age of sixteen, he'd been accustomed to coming and going as he pleased. Now, at twenty-seven, he was either coming from work or going to work. No matter that the work was intriguing, exciting, and fulfilling. It was still work, and he didn't feel free.

He tried to calm himself by spending his grand salary on weekend trips to Mexico. He found the trips less and less enjoyable because he would always have to return to the same publicity grind. He enjoyed working with actors, but when they had problems, even artistic crises like his own, he was unable to muster sympathy. All he could see was his own vexing immobility.

He also tried moving; perhaps a larger residence would ease his incipient claustrophobia. He rented a house at 1346 North Harper Avenue, half a block from the Sunset Strip. The house resembled a little Mexican hacienda, and for a time it quieted him.

At the gallery, the air was still stuffy, and by midsummer Hurrell found it almost intolerable, venting his frustration on anyone who represented M-G-M management.

Howard Strickling began to caution him about his high-handed behavior. For example, there was the way he spoke to people in the gallery. Hurrell later admitted it was true: "If I couldn't work alone, if somebody was sitting around, like even the Publicity, if they didn't keep their mouths shut, they had to leave—or else *I* left."

Strickling had also begun to encroach on aesthetic areas. Magazine editors told him that they would like the majority of portraits to have white backgrounds—or so he said. Clarence Bull complied with his request; Hurrell said, "To hell with the editors." Strickling would shake his head over Hurrell's latest batch of low-key pictures. Hurrell recalled: "Black backgrounds were taboo. I shot black backgrounds. If they didn't like the black backgrounds, they could throw them in the trash can. They had to wait till I was in the mood for a white background. That's the way it worked, because I was just an arrogant, egotistical bastard."

Trying to strike a compromise, Strickling diplomatically asked Hurrell if he could just leave some lightness in one of the corners of each portrait, or at

least in some of the portraits. Hurrell couldn't.

His fondness for low key, as in the *Letty Lynton* portrait (plate 103) led him to experiment with various photographic papers. He insisted on being allowed to make the first custom prints of the freshly retouched negatives from each sitting. These 10 × 13 enlargements would then be sent as exclusives to the fan magazine editors. Hand-printing these images in the little darkroom was more than the satisfying culmination of his work on a sitting; it was an aesthetic transport. Working alone in the quiet of the darkroom, he didn't have to deal with egos or politics. He was free to create.

Even though the darkroom was situated in Hurrell's gallery, it was actually under the jurisdiction of Clarence Sinclair Bull, who supervised all Stills Studio and Stills Laboratory functions. For years, M-G-M had been purchasing film and photo paper from Eastman Kodak. This was reflected in the order blanks imprinted on in-house negative sleeves. The film supplied to Hurrell by Clarence Bull was Eastman Super Sensitive Pan. The paper was E.K. AZO Double-Weight Gloss (although it was never dried glossy, but rather to a semigloss luster), or E.K. AZO Double-Weight Matte. If prints were being made for stars or producers, the paper was "buff"—E.K. AZO "E"; its deeply grained surface made unauthorized reproduction impossible, by obscuring the image. Hurrell liked all these papers, until M-G-M got a ferrotype dryer.

It dried the AZO as it was meant to dry, totally glossy, and his black backgrounds suddenly had the glistening opacity of obsidian. He excitedly removed the borders of the prints and came up with something really exceptional, a new look, an artistic breakthrough. He decided that from now on, this would be his signature paper. AZO was *it*.

There was only one problem. Company man Clarence Bull had just signed a deal with the Dupont Corporation. Throwing the huge M-G-M stills account to Dupont would earn him kudos from Mayer and new respect in the photographic world. Hurrell had tried these papers that Bull was espousing, in particular Dupont Varigam; he hadn't been impressed. He would stick with AZO—dried to a high gloss. But Bull's deal with Dupont specified exclusive use of Dupont products by M-G-M, and for once, Hurrell was no exception. A fight was brewing.*

To add to his vexation, Hurrell now received word that Mr. Mayer wanted him to work later than five o'clock on a certain day, because a visiting dignitary wanted a "Photo by Hurrell." How did he respond to this executive "request"?

"I told him to go to hell."

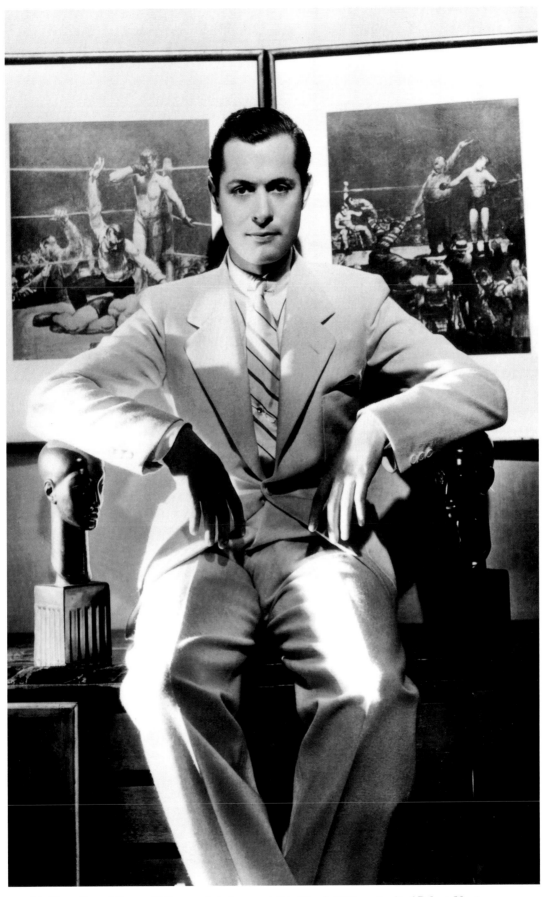

88. *Hurrell used George Bellows prints to accent this March 1932 portrait of Robert Montgomery for* Letty Lynton. *Montgomery was the most intelligent, versatile—and unimaginatively cast—actor at M-G-M. The monolithic studio could be a frustrating place to work.*

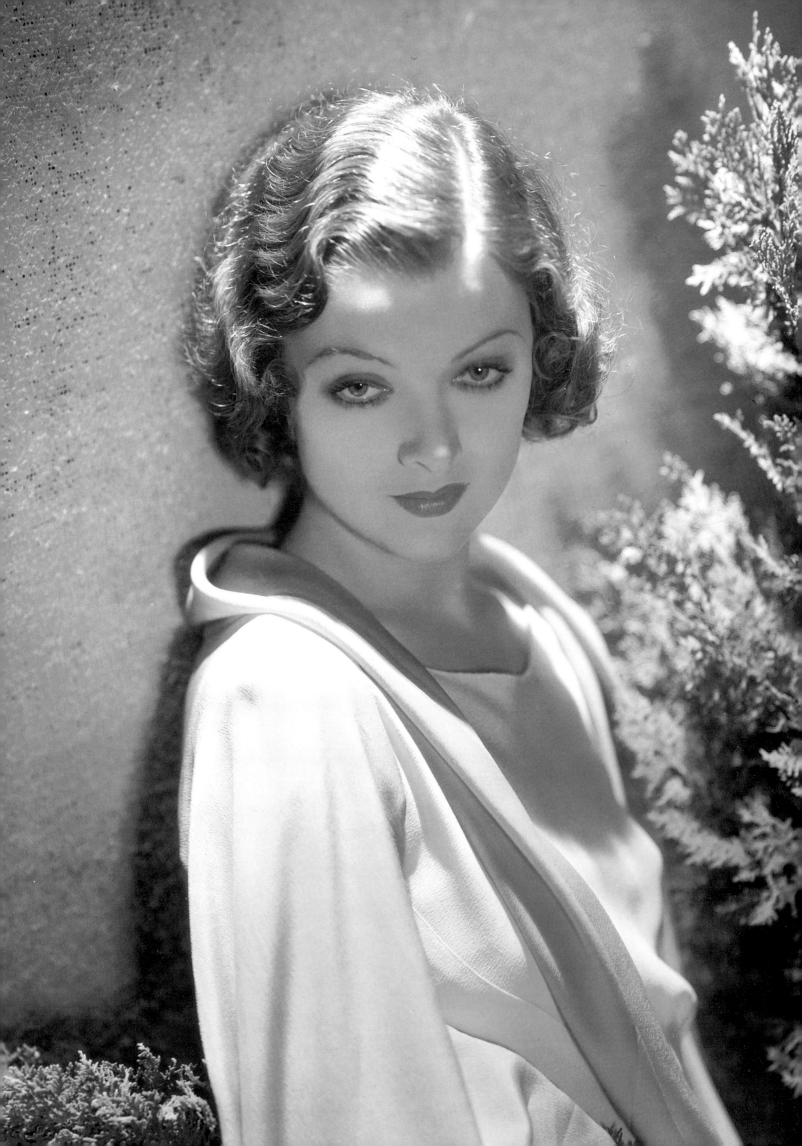

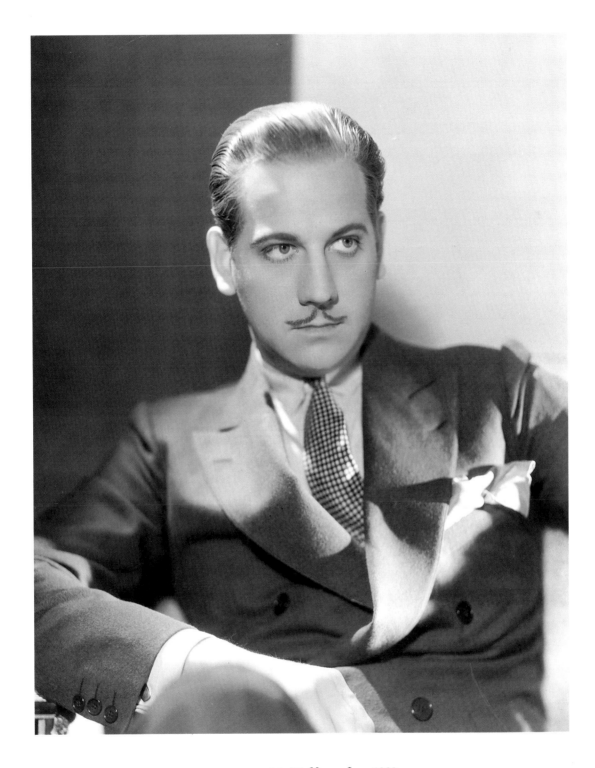

OPPOSITE PAGE: 89. *Myrna Loy, 1932.*

ABOVE: 90. *Melvyn Douglas, 1932.*

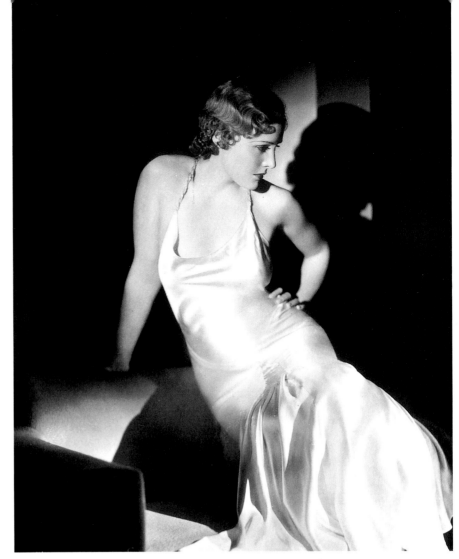

91. *Madge Evans, 1932.*

92. *Karen Morley, 1932.*

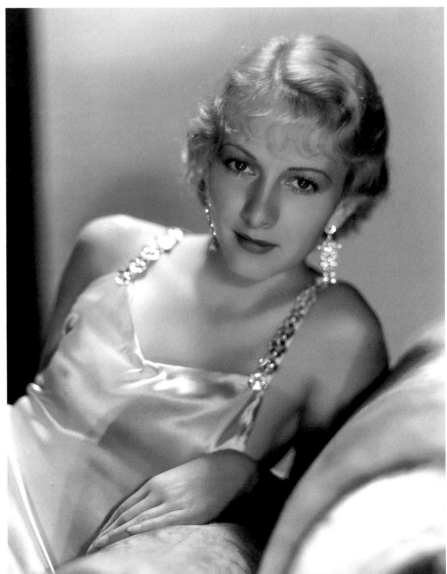

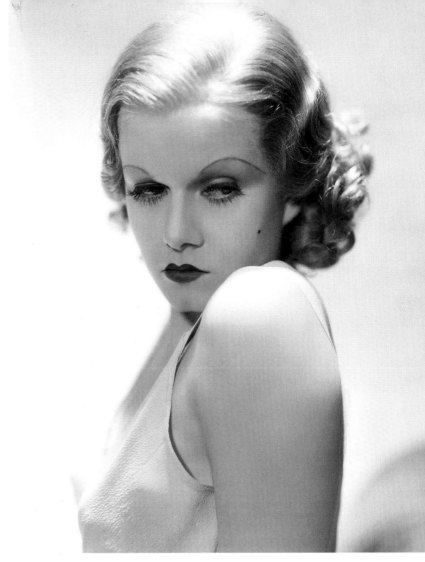

93. Hurrell's first portraits of Jean Harlow transformed the Platinum Blonde into the saucy, ruthless Red-Headed Woman.

94. "She was extremely photogenic, but I always positioned my key light at a low angle, because her eyes were deep set and you had to get the light under them or her eyes would just get too dark." Red-Headed Woman, April 1932.

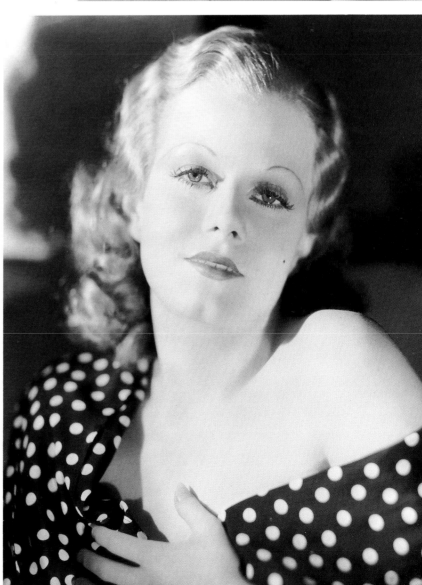

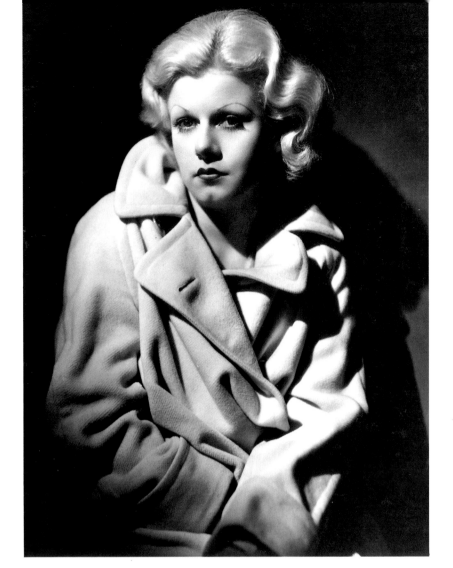

95. *Harlow by Hurrell,*
summer 1932.

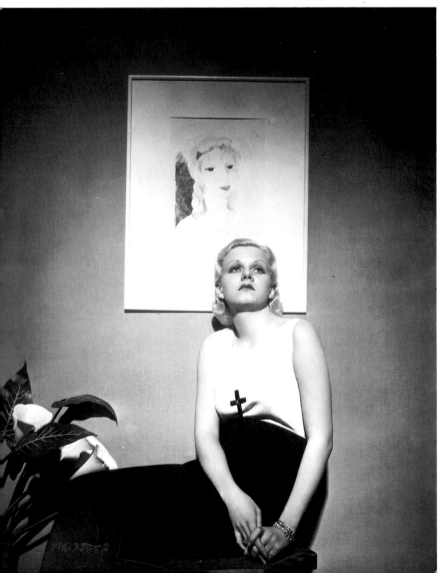

96. Red-Headed Woman *established*
Harlow as a sex symbol, but her
subsequent marriage necessitated a
change of image. Hurrell used
calla lilies and Marie Laurencin
prints to romanticize her.

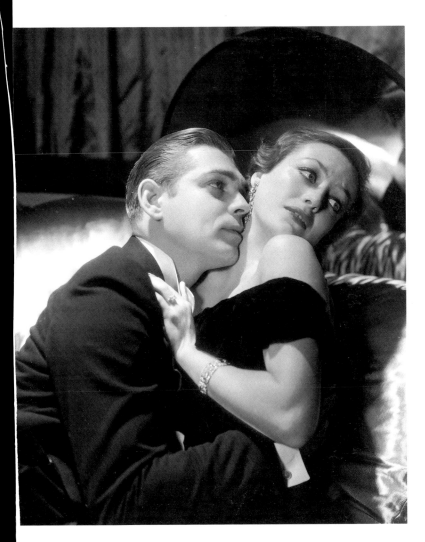

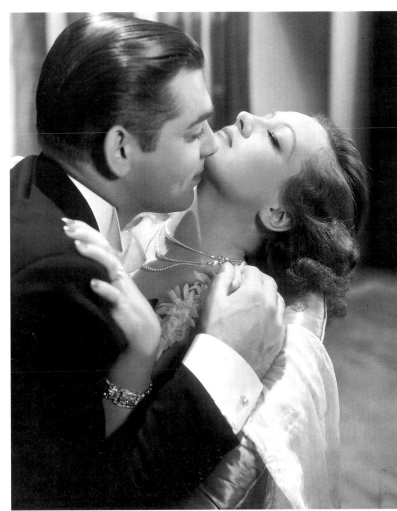

100. Joan Crawford and Clark Gable, Possessed.

101. Joan Crawford wrote: "When still photographer George Hurrell took pictures of us, he'd simply have the lights set up. Sometimes we were oblivious of the fact that he'd finished shooting." Possessed, *October 1931.*

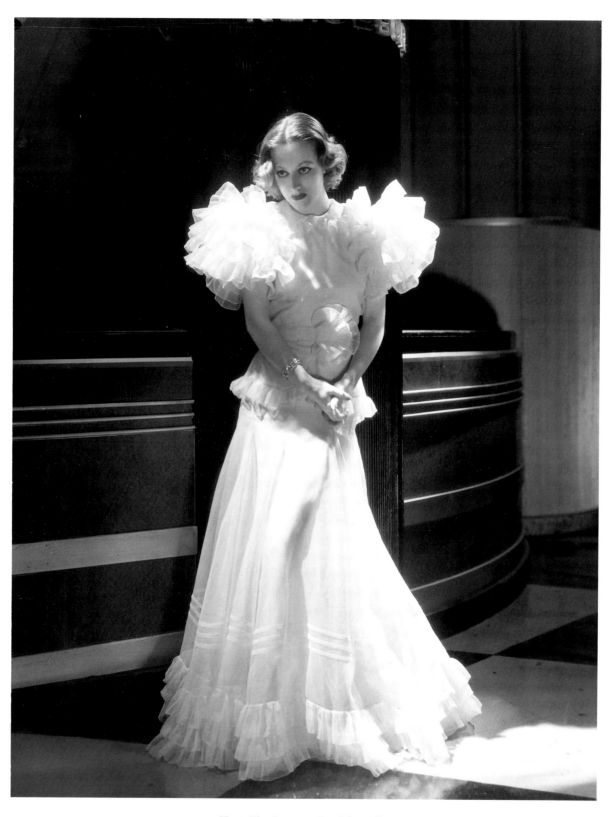

ABOVE: *102. Hurrell's photographs of Joan Crawford for*
Letty Lynton *in March 1932 helped Macy's sell 15,000
copies of this dress. Note how the shoulders of the
dress bounce light into Crawford's face, amplifying a
Hurrell trademark.*

OPPOSITE PAGE: *103. Hurrell made Crawford a sinuous
ivory icon in the* Letty Lynton *portraits.*

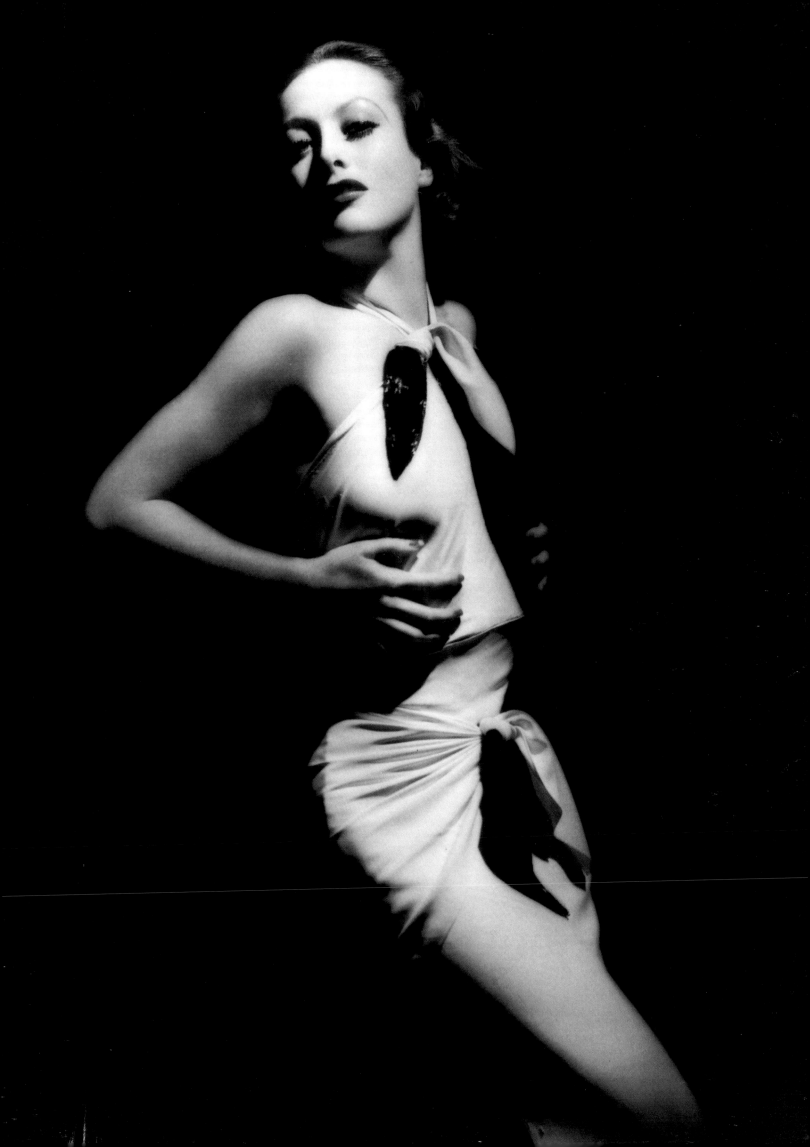

It is impossible to know if this injudicious response made its way back to Mayer, one of America's most powerful men, but before a skirmish could erupt on this front, Hurrell moved to another.

Now realizing the value of his services, he began to shoot an occasional portrait outside the studio walls. Perhaps he just wanted to create art outside the gallery, to use fresh settings, or simply to have a leg up on the corporate world. Years later, he recalled that "on a weekend I felt that I was free to go down and shoot what I wanted. So I did. It was my Sunday operation, let's say."

The Sunday operation was facilitated by a wily publicist named Maggie Ettinger. She knew that players outside M-G-M, especially freelancers, would be eager to have a portrait made by Hurrell. Capitalizing on Hurrell's discontent, she lined up a number of sittings in early August. First there was freelancer Lilyan Tashman, wife of Fox star Edmund Lowe. Hurrell photographed her at their Malibu beach house.

Then he photographed Joan Bennett, who had been on location for a backwoods role, *Wild Girl,* and who now needed glamour portraits. But she was not a freelancer; she was a Fox Film Player. Hurrell was treading on dangerous ground. "And while I had no contract with [M-G-M], they considered me under contract and I was not allowed to shoot anyone outside the studio." He was working without a contract, but "industry practice," then as now, required an implicit loyalty. Hurrell either didn't know about industry practice or didn't care. "I saw no reason why I shouldn't do it," he maintained, years later.

And he saw no reason why he shouldn't use M-G-M film, paper, or processing facilities. He surely must have known that someone would see the unfamiliar face of Joan Bennett floating in a tank of fixer or falling out of a drum dryer. Eventually someone did, and whoever it was knew that Joan Bennett was not a Metro star.*

It didn't take Howard Strickling long to find out about this treachery. Unfortunately for Hurrell, Irving Thalberg was away from the studio. Strickling consulted with Mayer, then grabbed an assistant and went looking for Hurrell.

My God, you'd think I had robbed the bank or something. They came to me and they walked [me] around the lot, talking to me and telling me what a dirty rat I was and how horrible and how could I even think of doing such a thing and how could I go and shoot a movie star from any other studio.

All they were doing was arousing my anger which finally got to a point where I told them "You know what you can do with this job!"

I just got upset and told them to shove it.

In front of a lotful of double-breasted executives, costumed extras, and dungareed grips, Hurrell turned on his heel and stomped off to the old editing building. He ran all the way up the outside staircase, and disappeared into the Stills Studio.

A few minutes later, he emerged, carrying his Verito lens, his hat, and his coat. He was followed down the stairs by Andrew Korf and Al St. Hilaire. The three men silently walked past Stage Twenty, Stage Seventeen, the commissary, the administration building, the guard post, and then out the studio gates and onto Washington Boulevard. Within minutes, Clarence Bull got a call from Strickling. "George has quit!" exclaimed the agitated Strickling.

There is no record of Bull's reaction, but there is ample evidence that Joan Bennett liked her portraits.

OPPOSITE PAGE: *104. This soulful portrait of Crawford was made in August 1932, when she had returned from the unpleasant experience of filming* Rain.

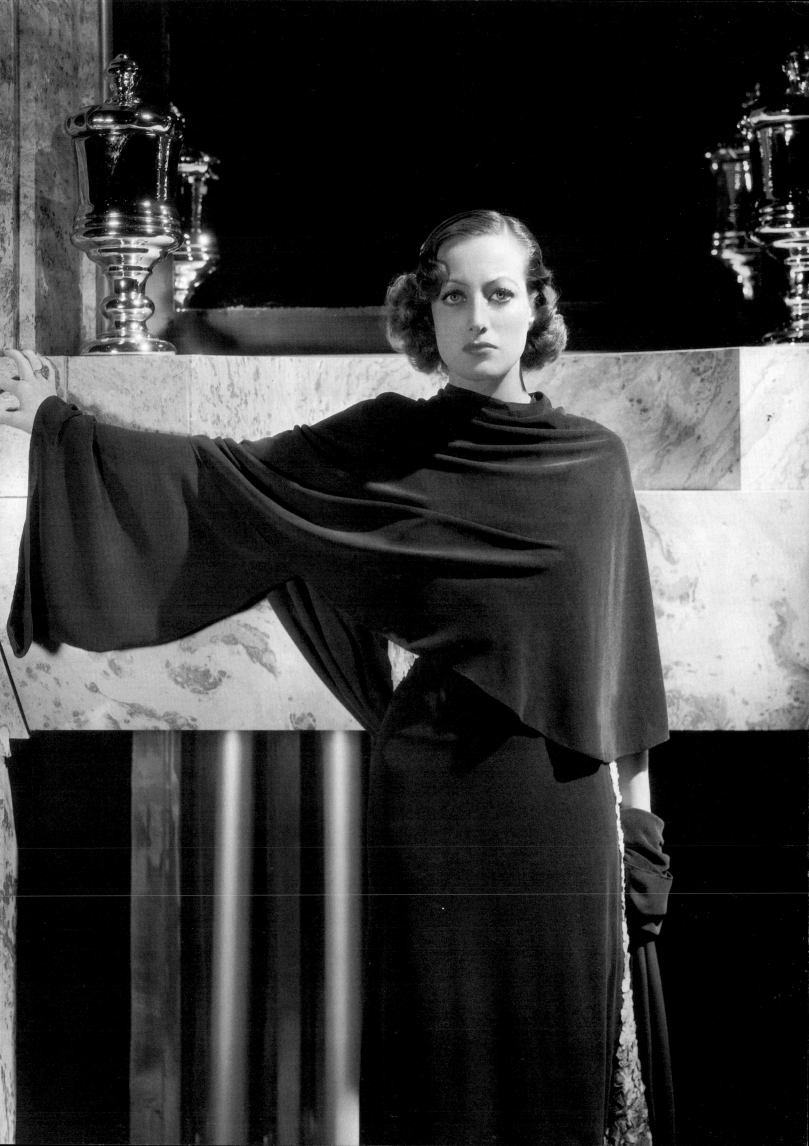

105. *Virgil Apger made this portrait of Karen Morley and Clarence Bull in the M-G-M gallery, 1932.*

106. *An uncredited photo of the print processing area in the M-G-M still photo lab.*

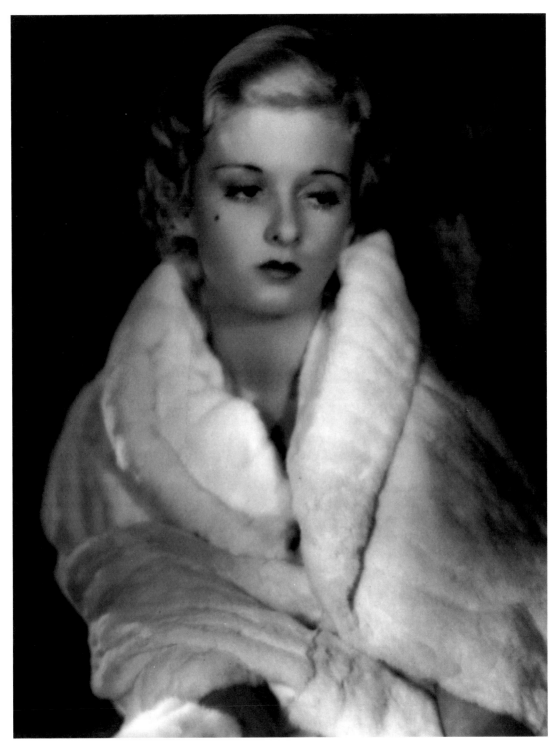

107. The shot heard 'round the town: Joan Bennett's portrait by Hurrell, August 1932.

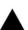

HOLLYWOOD
INDEPENDENT
1932-38

▲

"Nothing ever succeeds which exuberant spirits have not helped to produce."

—*Friedrich Nietzsche,* Twilight of the Idols

▼

8706 SUNSET BOULEVARD

When George Hurrell quit M-G-M on that August afternoon, he quit the biggest photo job at the biggest company in America's sixth-biggest industry. He quit in the middle of the Depression, when Americans couldn't afford basics, let alone portraits. He quit rudely and pungently, in a town that had a better memory for grievance than for achievement. He quit without having another job to go to. Now what would he do?

He holed up on Harper Avenue, doing what he enjoyed most, drawing and painting. His home was quiet for a week, and then the telephone rang. It was Howard Strickling. He was calling to ask if Hurrell would be interested in returning to M-G-M. He wasn't interested. He was too engrossed in a charcoal sketch. Strickling persisted, explaining that he'd arranged for an exclusive in *Modern Screen* magazine, a fashion layout of Norma Shearer. Hurrell was less than thrilled at the fashion aspect. He declined.

Strickling then offered to arrange with the studio for Hurrell to work as an outside contractor, without hidden restrictions. Hurrell grew more interested, but feigned indifference. Strickling tried a different tack. He reminded Hurrell that he'd left the studio on bad terms, and while there was no such thing as a blacklist, he might have difficulty finding work in a company town.*

This was a threat with teeth. Photographers were an easy target for studio vendettas because contractees could be prevented from using those photographers. Having tailored his style of photography to movie publicity, Hurrell would naturally want to stay in Hollywood. At least Strickling thought he would.

By this point in his life, Hurrell already had a history of impatience and restlessness. He might very well pull up stakes and go to New York. Furthermore, his work had become so influential that every photographer in Hollywood was now imitating his use of hard lens, boomlight, and single spotlight. When the imitators eventually ran out of steam, there would still be a demand for the original. Then, too, there were two hundred people for whom Hurrell had done important portraits. His subjects loved him, both for the sterling quality of his work and for his warm exuberance. They wouldn't forget him. But if M-G-M did get tough, he had one last thing to fall back on: for the last eighteen months, he had earned $350 a week and hadn't had time to spend it.

Strickling asked him how much he would charge to shoot the fashion layout. Hurrell quickly figured what he would need for this command performance. Two hundred dollars for twenty poses sounded good.

"That's highway robbery," said Strickling.

"If that's going to break the studio," he responded, "then I suggest you get someone else."

Strickling hung up. Hurrell went back to his sketch, remembering how unimpressed M-G-M was even by such outside photographers as Cecil Beaton, who'd been back in March to shoot Johnny Weissmuller.* "I'm not much of a technician," Beaton had told Clarence Bull, who'd then laughed about him with the brash Hurrell. Hurrell was laughing now. He knew that Strickling would tell Norma Shearer that

he was charging too much. Sure enough, Strickling "tried to talk her out of it, but she didn't care what the hell it was. She just wanted *me*."

Less than a week later, Hurrell entered the studio and reported to a sound stage where Shearer and Strickling were consulting with some carpenters. She had casually mentioned using a *Strange Interlude* set for the fashion shots, not knowing that the set had just been taken apart. When Shearer arrived and saw the set being reconstructed, she felt a little guilty. "Oh, don't do that," she said with a wave of her hand. "I won't use it after all." She and Hurrell found another set, where he hung his favorite Marie Laurencin print on the wall, and they spent the rest of the day shooting. The layout ran as an exclusive in the March 1933 issue of *Modern Screen* (plate 108). Hurrell later remarked that Shearer was "the Queen, and what she wanted, she usually got. No expense was spared."

Thanks to this regal patron, Hurrell had gotten a reprieve and could go back to his charcoal. And he had money to put in the bank—if it didn't collapse first. Recent bank failures had caused a number of stars to lose fortunes. But Hurrell didn't sketch for long. The Fox Film Corporation enlisted his aid in its fight to survive. Perhaps his images could enliven Fox publicity. In late August, he used Hal Phyfe's gallery (and backdrop) to shoot starlet Irene Ware and star Warner Baxter, but it wasn't a place where he'd want to work, and Fox wasn't inviting him. He needed a place of his own.

The place he found was just a few blocks from his home. The white colonial-style commercial space was being offered by Montgomery Properties, Limited, and was situated on the newly popular Sunset Strip. Hurrell looked at the deepest of its six storefronts, 8706 Sunset Boulevard. It was only twelve feet wide, but it had a huge picture window and a luxurious depth of sixty feet. Its back wall caught his eye. It was white "sprayed stucco." The skylight sent a shaft of light skimming across it, and the result was a dramatic shape floating on a cottage-cheese field. He was hardly listening when Francis S. Montgomery told him that the space was $50 a month. Hurrell signed the lease and on September 1, 1932, he moved in.*

Outfitting the studio to compete with M-G-M's gallery was another matter. It soon exhausted his savings. He turned to Maggie Ettinger for help, and her husband, the painter Ross Shattuck, lent him $800. He then bought a new camera, lens, tripod, and lights. He commissioned the construction of a new boom-light, hired a receptionist, rehired Al St. Hilaire, and subcontracted retouching to Andrew Korf. This time, his *Buyers Guide* listing was not in bold type; it read:

"Hurrell/Photographer/8706 Sunset blvd. OXford 7701." The boldness was in his pricing. A $250 portrait package would yield one print each of only twelve poses. This was portrait art for the carriage trade. How would he get it?

He invited Norma Shearer to his new studio for a complimentary portrait sitting. After she chose her favorite pose from the proofs, he would enlarge it and hang it in the shop window. When Shearer and her entourage arrived, there were still a few rough edges to the studio. The smell of paint hung in the air. Tall wooden flats were stacked against the rear wall. A telephone wire still ran along its baseboard. Norma Shearer walked over to the cottage-cheese wall, stood next to the flats, and had a ball.

She liked the pictures, but suggested to Hurrell that he use a pose he'd taken in June for *Smilin' Through*. This was her favorite portrait (plate 112), the one she'd hung over her son's bed. She arranged for Hurrell to get the negative from Clarence Bull and Hurrell paid a lab to enlarge it to 48 × 60. He then framed it and installed it in the window.

A few nights later, he went to dinner with Poncho Barnes at the Brown Derby. Word of Norma Shearer's visit to his studio had evidently spread through the film community. He was warmly greeted by every star and publicist in the restaurant. If Shearer hadn't set herself against M-G-M's threatening boycott, he might not even have been seated that night. But she had, and now, with her stamp of approval, he was in.

Fox called again, and he shot Lupe Velez, Sally Eilers, and Boots Mallory. Maggie Ettinger introduced him to another booster, Helen Ferguson. She had become a publicist in 1930 after struggling for years as an underpublicized freelance actress. She now represented players who weren't under contract to any of the Big Five. It was her clientele that helped Hurrell finish 1932 in the black.

Nineteen thirty-three brought a new calendar and a New Deal, but Hurrell's business was falling off. So was M-G-M's. Louis B. Mayer called all his employees to an emergency meeting and tearfully asked them to take another salary cut. Wallace Beery made an obscene noise and walked out, but the rest of the employees agreed to take the cut. If things had gotten that bad, could Hurrell hope for more assignments from Strickling?

As Hurrell walked into his studio one day, his receptionist handed him two phone messages from Joan Crawford. Perhaps she was tired of Clarence Bull's gentility. Perhaps she needed that Hurrell

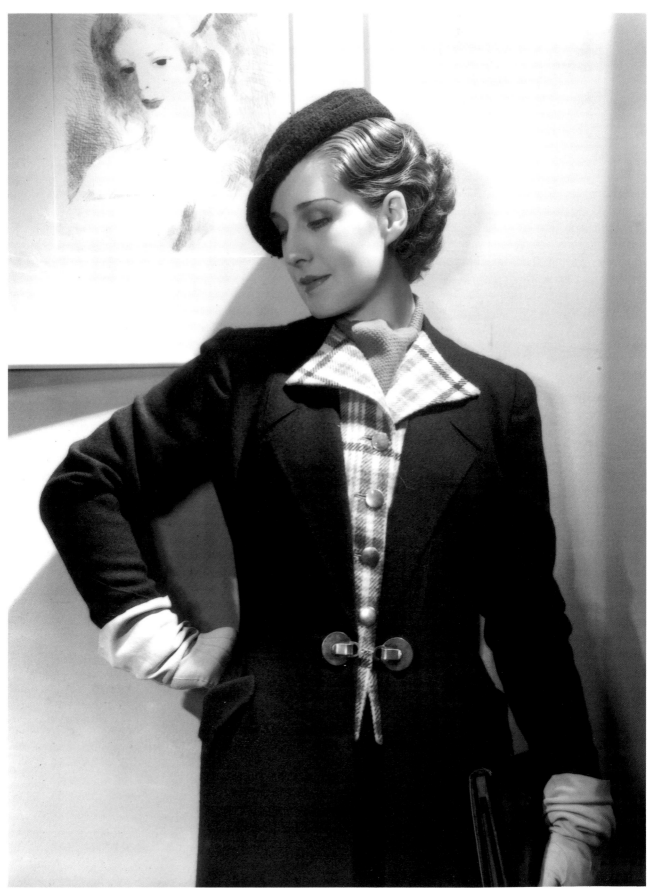

108. *The command performance for* Modern Screen *yielded this portrait of Norma Shearer. Virginia T. Lane described the outfit: "a navy blue woolen ensemble, the three-quarter coat of which has a built-in vest of red, black, and yellow plaid. With this go a hand-knit blue woolen beret and gauntlets made of antelope skin."*

"sheen." Perhaps she was tired of seeing Shearer's face in Hurrell's window. "I admire and like Joan," Shearer said later that year. "I think both of us have been hurt and embarrassed by the persistent rumors of our rivalry and hatred" (see plate 113). Crawford had been the second star Hurrell had photographed at M-G-M in 1930. She would now be the second M-G-M star to visit 8706 Sunset. In both instances, she followed Shearer.

Crawford had started 1933 in her own personal depression, after an unprecedented two flops in a row, *Rain* and *Today We Live*. She needed Hurrell's ebullience to cheer her, and she needed his photos to remind her fans that she was still perfecting her image—for them. The image was a sparkling new one. Helen Ferguson helped Hurrell use it for publicity and the phone began to ring again.

One of the first to call was Crawford's newly divorced husband, Douglas Fairbanks, Jr. He paid a visit to Hurrell (plate 125) and then brought the world-famous Doug Sr. (plate 126). "Erudite, urbane, and amusing, [Doug Jr.] would give me the exact mood I wanted. I got the impression that he was awed by his dad's reputation."

"America's Sweetheart," Mary Pickford, also saw Crawford's picture in Hurrell's window. "I wish I looked like that," she said wistfully. A session was

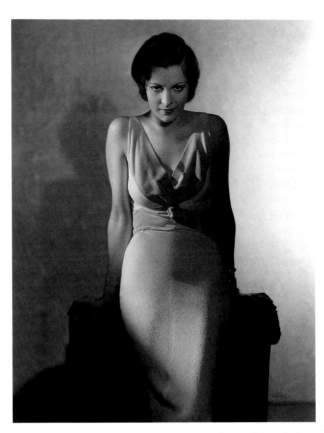

109. A portrait of Irene Ware made by George Hurrell for William Cameron Menzies's Chandu the Magician.

arranged and Hurrell brought his gear to the palatial Pickfair mansion. The portraits (plate 123) were her attempt to escape the Pollyanna image that had dogged her for years.

At M-G-M, Jean Harlow now needed Hurrell's help. The all-star policy continued, but without Thalberg, who was in Europe recuperating from a heart attack. David O. Selznick produced *Dinner at Eight*, and its surfeit of stars strained even M-G-M's resources. In February, Howard Strickling hired New York photographer Harvey White to help out. White was talented (see plates 127–129), but trouble-prone. Hurrell remembered following up on *Dinner at Eight:* "Harvey came to M-G-M after I left. . . . He was damn good. He did his best work on Harlow, but he had a problem. He was an alcoholic. He'd get stewed and sit on the steps of Howard Strickling's office, singing and shouting. Finally, L. B. Mayer passed by and saw this, and that was the end of Harvey White. They wouldn't even credit him."

When Hurrell went to M-G-M in June to photograph more Harlow *Dinner at Eight* poses, the platinum star was wearing a Palm Springs suntan. The effect was startling, and he made the most of it, using baby oil and one spotlight.

Hurrell had shot barely half a dozen sittings since January. Now back in the good graces of Strickling,

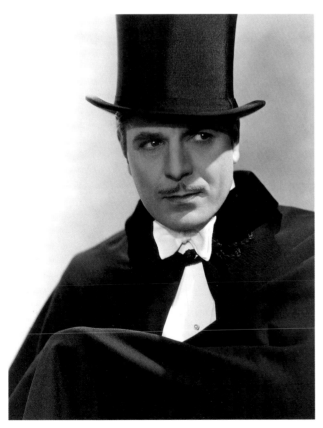

110. A Hurrell portrait of Warner Baxter for the Fox Film production Dangerously Yours.

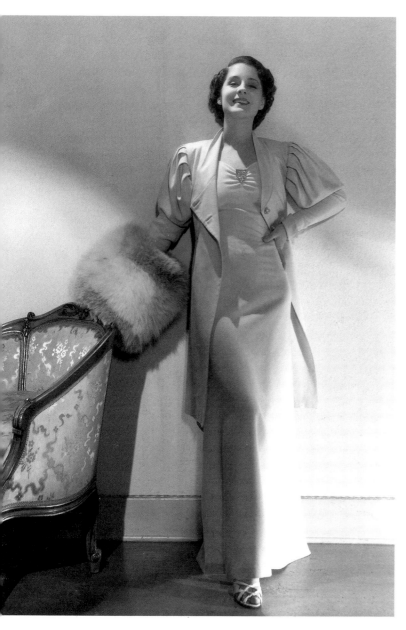

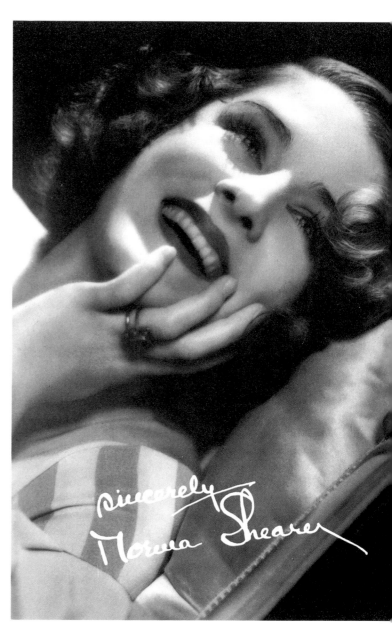

111. *The Queen comes to call;*
note the telephone wire running along
the baseboard.

112. *Shearer's favorite Hurrell*
portrait; it hung over her son's bed.
(In later years, a Laszlo Willinger
portrait of her as Marie Antoinette
became her favorite, primarily because
of her strong feeling for that film.)

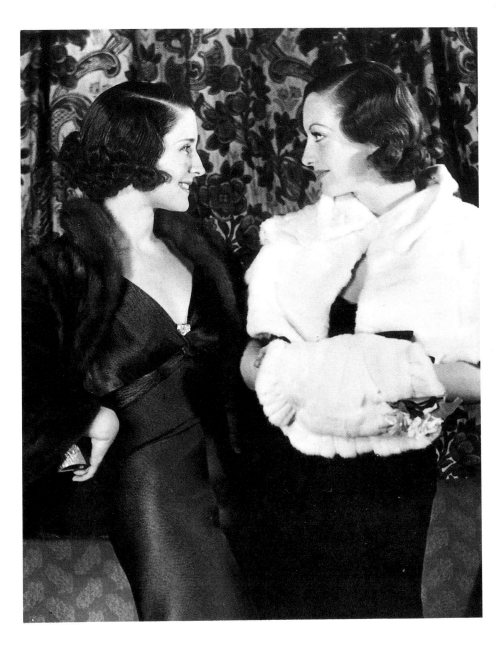

113. Norma Shearer and Joan Crawford consented to posing together at the opening of the Mayfair Club on November 5, 1932. When the uncredited photo was published, the caption described the actresses as "rivals." They were Hurrell's most photographed clients.

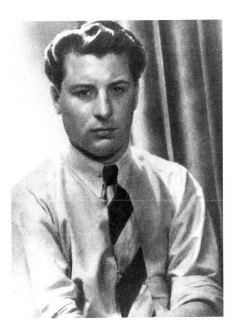

114. Hurrell's 1933 self-portrait.

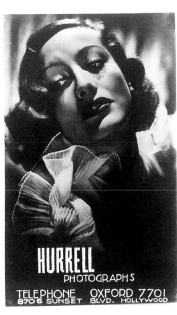

115. Hurrell's 1933 logo.

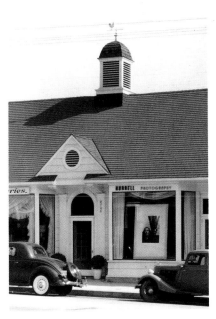

116. The facade of Hurrell's studio.

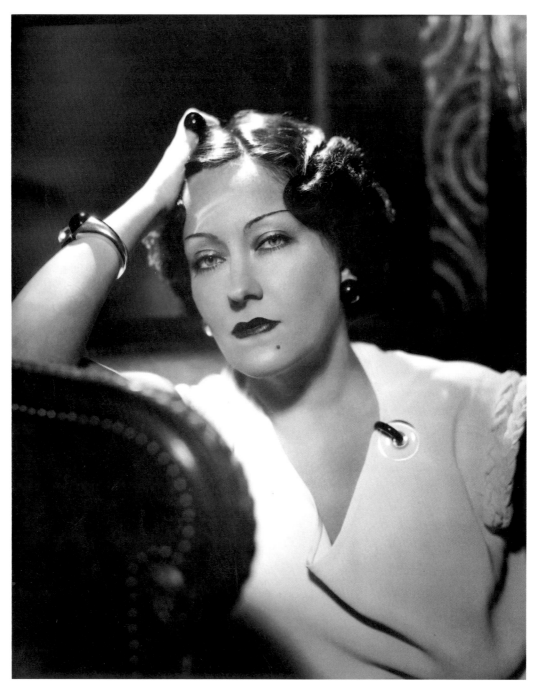

117. A Hurrell portrait of Gloria Swanson.

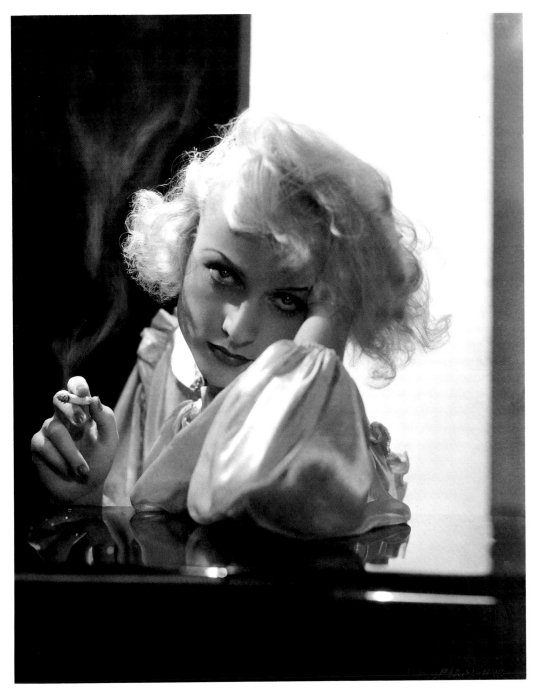

118. Carole Lombard, 1933.

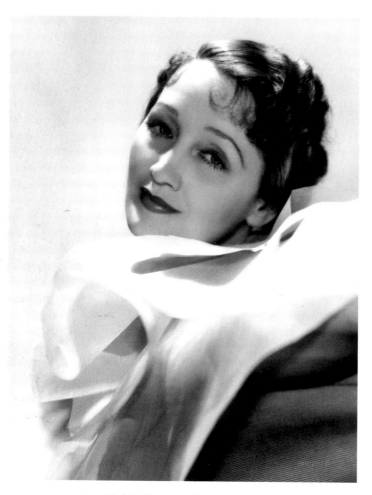

119. *Hedda Hopper, whom Hurrell photographed in 1933 to publicize her appearance in a Los Angeles stage production of* Dinner at Eight.

120. *Glenda Farrell and her son, 1933.*

OPPOSITE PAGE: *121. Paramount's Mae West visited Hurrell's studio in early 1933.*

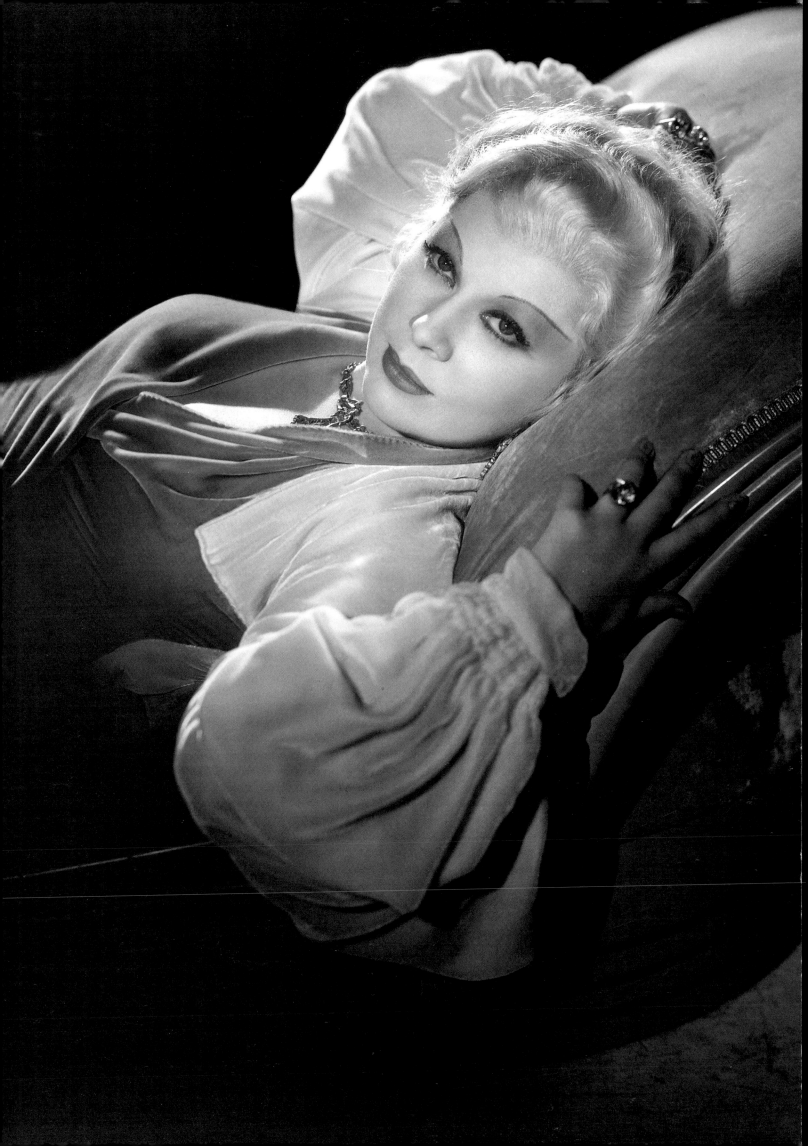

ABOVE: *122. Joan Crawford photographed by Clarence Bull, April 12, 1933; the 10 × 13 print she is holding is a February 12 portrait by Bull. The rest of the prints are by Hurrell.*

LEFT: *123. Mary Pickford, photographed at home by Hurrell in 1933.*

OPPOSITE PAGE: *124. Hurrell used Joan Crawford's image to publicize his new studio.*

125. Douglas Fairbanks, Jr., 1933.

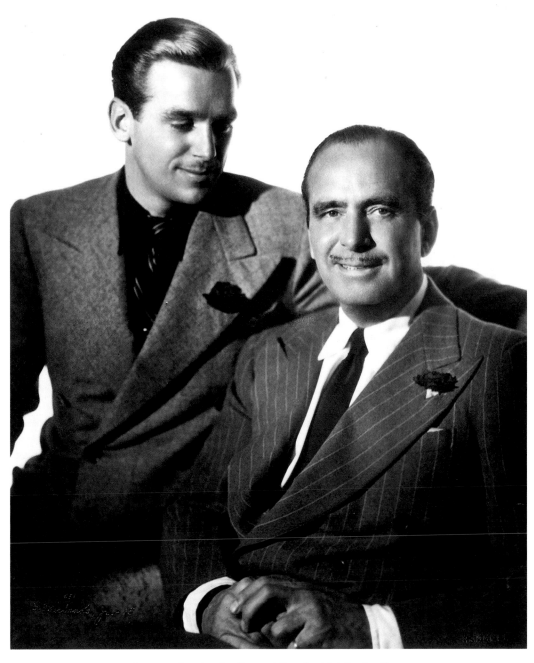

126. Douglas Fairbanks, Jr., and Douglas Fairbanks, Sr., 1934.

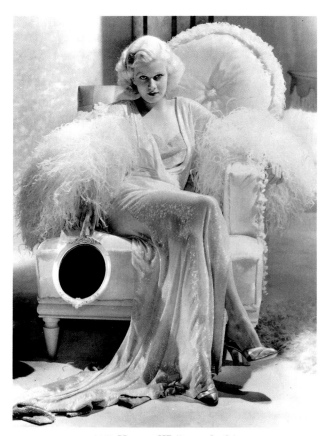

127. Harvey White made this
famous Dinner at Eight *portrait of Jean Harlow, often
misattributed to C. S. Bull.*

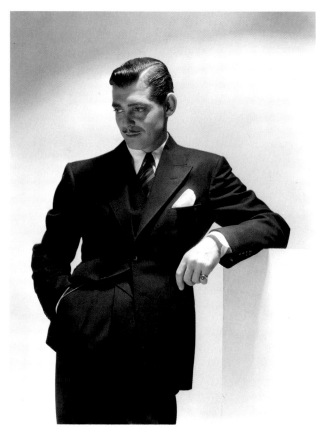

128. A Harvey White photo of Clark Gable, often
misattributed to Hurrell because White is obviously using
some sort of boomlight. Said Hurrell: "Most of them
had a rigged light on top of the backdrop,
but mine was movable."

his client load increased dramatically, and by December, he had shot fifteen more Metro stars. He didn't have to rely on Strickling for work, though, because he had a new client.

Samuel Goldwyn was regarded as the prince of independent producers, releasing his finely crafted films through United Artists. The success of Garbo and Dietrich prompted him to import an actress whom he could make a star—with Hurrell's help. She was the Soviet actress Anna Sten. Hurrell found her easy to work with and remarkably photogenic. "When I looked through the lens, I found that her face could be entirely changed by lighting. Lights from different directions painted different pictures on her features. Her face was like a canvas."

After Crawford and Shearer, Anna Sten was Hurrell's biggest account of 1933.

I took hundreds of exposures of her—in costume, out of costume, and in street clothes. Each time, Sam would say, "We make Ann a star." Sam was a funny guy. He used to set all her pictures out on the floor—he had a great big office, and he'd spread them all out. Sixty or seventy big prints of Anna. And then he'd walk around, trying to think of how to make her a star. He spent millions, but nobody ever went to see her.

But everybody saw Hurrell's photos of her, and while not impressed with Sten, they were certainly impressed with his lavish images. The publicity heads at the major studios watched the window display at 8706 Sunset with growing interest.

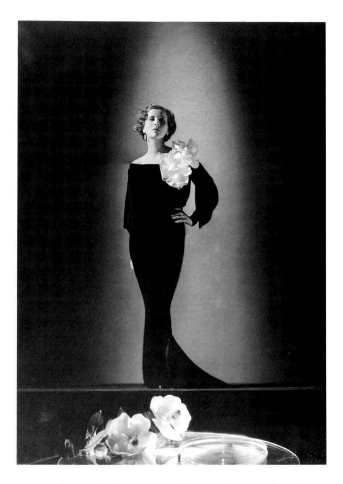

129. A Harvey White photo of Diana Wynyard; Hurrell's
successor at M-G-M was gifted but erratic.

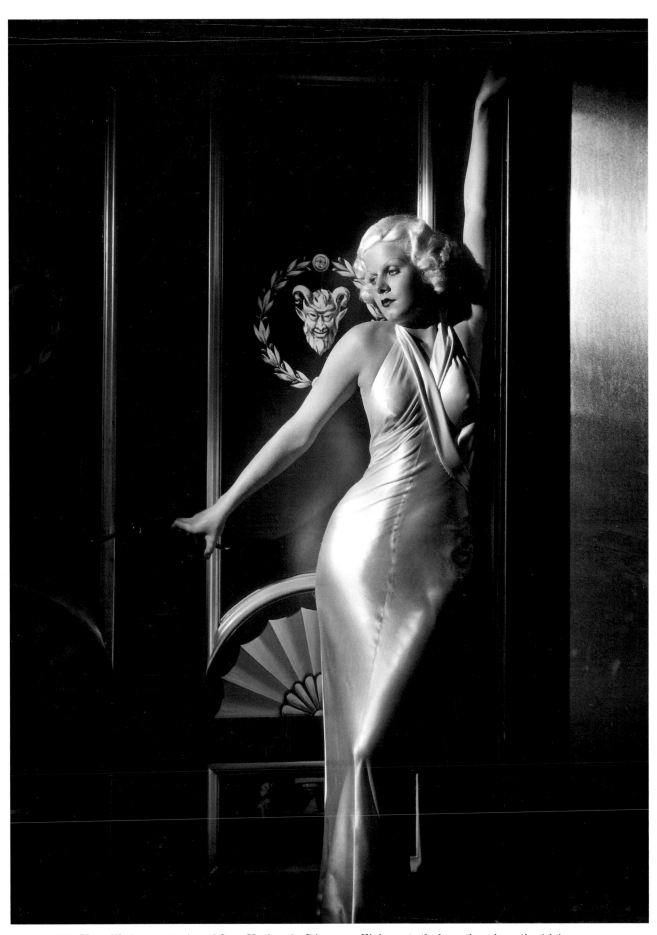

130. Hurrell's interpretation of Jean Harlow for Dinner at Eight; *note the loose threads on the Adrian gown.*
Hurrell said, "He was a real great artist, that Adrian . . . a creative genius."

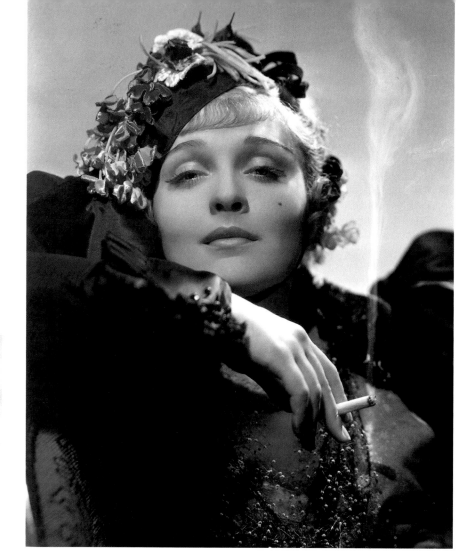

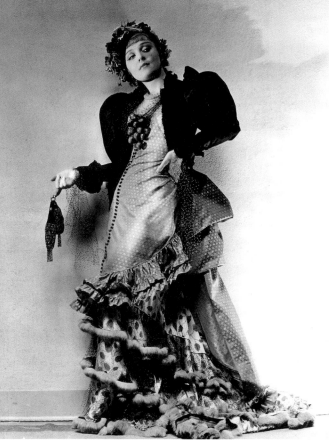

ABOVE: *131. Hurrell combined skylight and spotlight for this portrait of Anna Sten for Dorothy Arzner's* Nana.

ABOVE, RIGHT: *132. Hurrell's retouching enhanced the smoke in this Anna Sten portrait.*

BELOW, RIGHT: *133. Samuel Goldwyn would spread Sten's portraits over the floor of his office, poring over them for hours.*

OPPOSITE PAGE: *134. "If I'm your light of love—who cares?" sang Anna Sten in* Nana, *a lyric from "That's Love" by Rodgers and Hart. The song was as carefully tailored to Sten as this Hurrell portrait.*

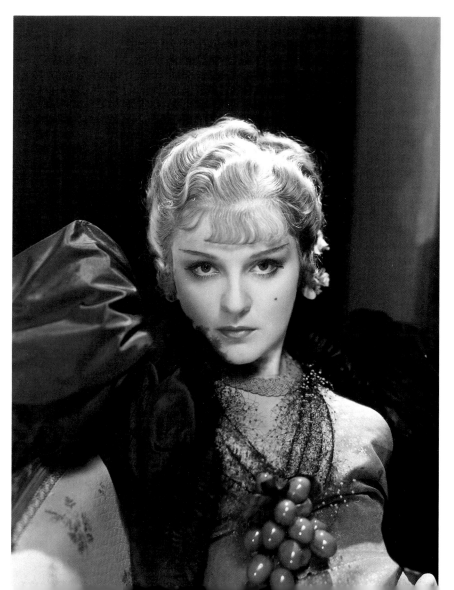

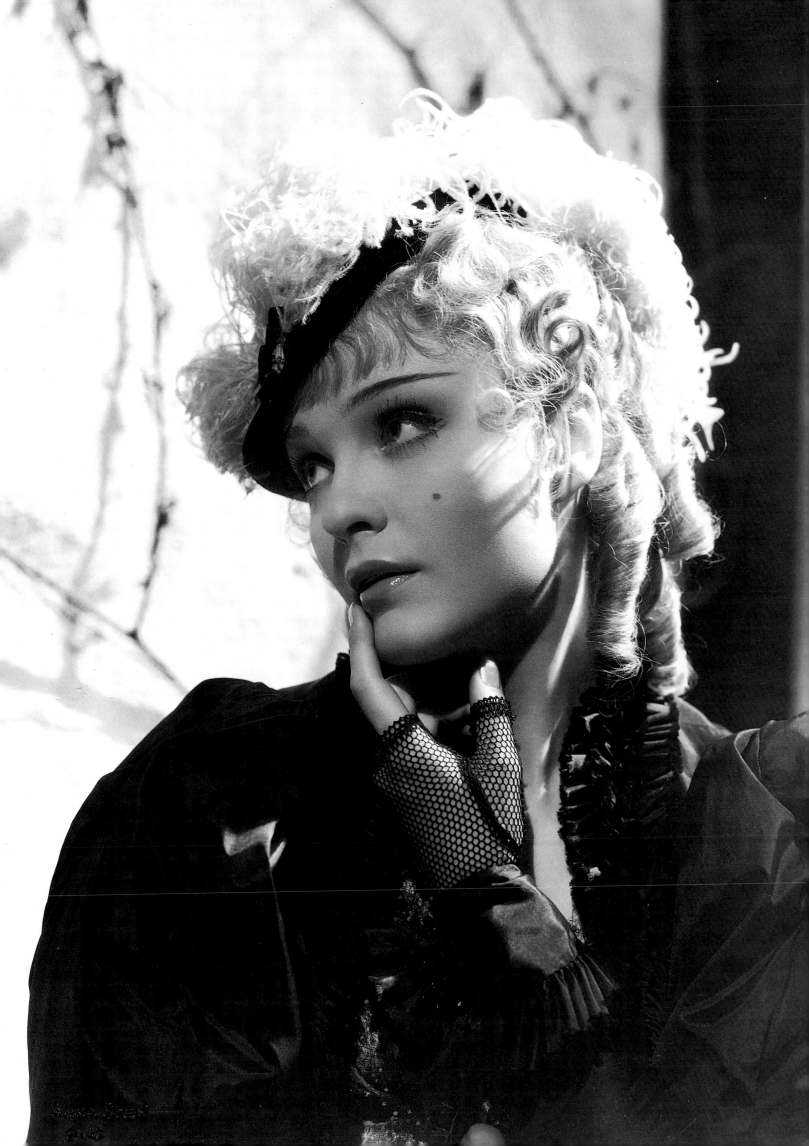

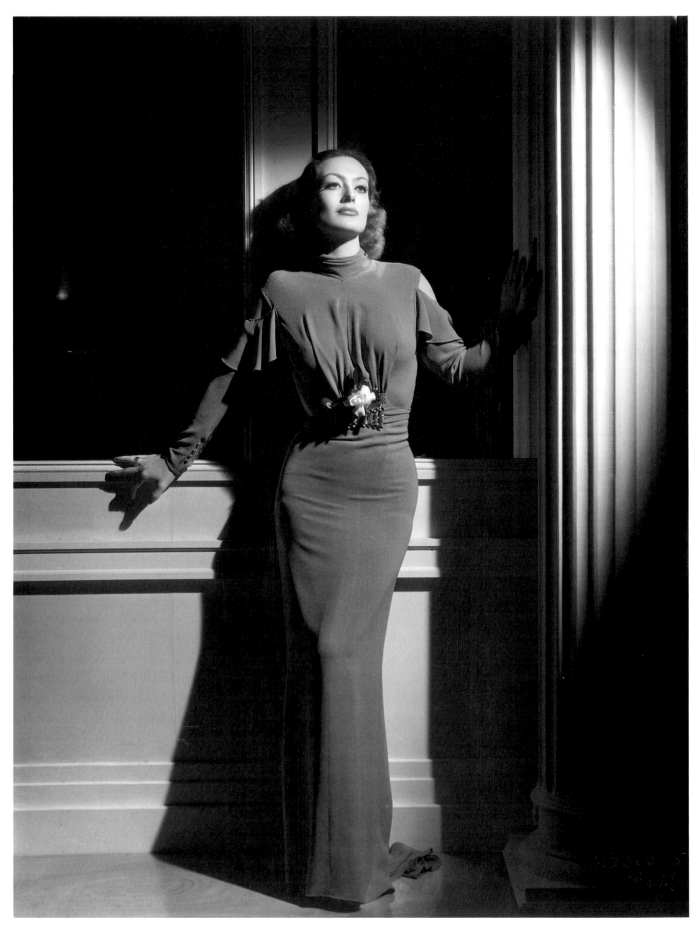

135. Joan Crawford captured in the midst of her gardenia period, January 1934.

MAJOR CHORDS

There's a saying in Hollywood: "It's not *what* you know, it's *who* you know." In the spring of 1933, Hurrell knew some very important people. Most important was Mary Pickford, who held the title coveted by both Crawford and Shearer: "Queen of Hollywood." Pickford introduced Hurrell to her studio, United Artists, and to her last director, Frank Borzage. When Hurrell attended a party at Borzage's house, he met a beautiful brunette who'd once been chosen "Miss Seattle" by Rudolph Valentino. Her name was Katherine Cuddy. By the end of the summer, she and Hurrell had eloped to Santa Barbara.

Before the newlyweds could enjoy a real honeymoon, Hurrell was swamped with work: at the Goldwyn Studios for Anna Sten, at 426 North Bristol Avenue for Joan Crawford, and at 8706 Sunset for Norma Shearer. The studios were enjoying a resurgence in ticket sales and could afford his fees. There was just enough time for him and Katherine to find a new home at 8254 Fountain Avenue.

Publicists Maggie Ettinger and Helen Ferguson continued to work with him. In December, *Movie Mirror* devoted an article to him, "The Camera Does Lie"; the author, Marquis Busby, called him "Hollywood's youthful wizard." Not that he was without competition. George Hoyningen-Huene and Cecil Beaton were frequent visitors to Hollywood, photographing stars for *Vanity Fair* and *Vogue*. Hurrell photographed them both and studied their work.

Beaton had done a noteworthy portrait of Shearer four years earlier (plate 137), using spotlights and cellophane. Hurrell took note and then took aim, first at Jean Harlow, then at Paulette Goddard, Ethel Merman, and Mary Pickford. When asked about the cellophane years later, he laughed, "We had a run on it." It was typical of him to transform a familiar design element into a signature effect.

Hurrell's fourth period of work was distinguished by the effortless look of his images. Gone were the urgency and experimentation of his Verito days. Each sitting now followed a graceful arc. Each was tailored to the subject, but each had a consistent polish. His boisterous self-confidence was mellowing into an unspoken self-assurance. Having his own studio enabled him to continue his artistic development without interruption or interference.

His trademark effects now included elongated eyelash shadows (see plate 140); placement of the boomlight so that it shone down on the cheekbones (plate 141) or down the part in the subject's hair (plate 142); a spotlight shining up from the floor (plates 138, 144); lead retouching to lighten the iris of the eye (plates 141, 142); a tiny dot of retouching "opaque" to enlarge the highlight in each eye (plates 138, 141); and an occasional "Dutch tilt" to throw vertical lines zanily out of plumb (plate 145).

Except for manufacturing film, Hurrell controlled every aspect of his work. He was well known, for example, for his attention to the subject's wardrobe. Every sitting was preceded by a consultation in which he recommended specific clothing. "Personally I like blue and white, or a black and white contrast in gowns. It's interesting. Printed materials usually detract from the person." Once the correct garment was chosen, he carefully arranged the folds in its fabric (plate 147) and the fingers on each hand (plates 146, 149, 150). Inside 8706 Sunset, every client had to surrender to Hurrell's taste and abide by his judgment.

Of course, the clients had to get there first. "M-G-M has been trying to get Wallace Beery to come to my studio for two months, and he isn't here yet," Hurrell told *Movie Mirror*. "He'd rather go to the dentist." When Beery finally showed up, he'd come directly from the dusty sets of *Viva Villa!* He was still in costume and, as always, anxious to leave. Hurrell recalled, "I put him up against the wall and shot seventy-two poses in forty-five minutes!" Many of these poses were out of focus, but M-G-M used them anyway, for poster art. Just as many, though, were excellent (plate 143). Hurrell liked that sprayed stucco wall so well (plate 147) that his next apartment, 1332¼ North Miller Drive (plate 148) had the same look.

In 1934, the Depression lightened, and patrons returned to the theatres—an average of ten million more a week. The majors released 361 movies and Hurrell doubled his fee, from $250 to $500 a sitting. Howard Strickling gulped, but continued to send stars to 8706 Sunset. "One day that year I made fifteen hundred dollars!" Hurrell recalled. More often than not, he earned his money by finding the right look for a new M-G-M contractee. Rosalind Russell (plate 147) was one of these, and Jeanette MacDonald (plate 150) was another. They weren't camera-proof; they had a "something" that promised stardom, but needed a spark to ignite it. "You could feel an atmosphere to it," George later said. "You felt inspired when someone like Dietrich or Crawford or Mae West walked into the room."

It was a momentous occasion when Marlene Dietrich walked into Hurrell Photography for the first time. Even *International Photographer* called it a "big assignment." But Hurrell sensed trouble when Dietrich asked for a full-length mirror. "In the beginning, I just refused to have it there," he recalled. "I

136. *8254 Fountain Avenue, West Hollywood*
(author's photo).

insisted that she could be freer, more spontaneous but [she] didn't want to be in doubt about what she was doing. We used to argue and fight, but she always won."

Hurrell's freewheeling style was suddenly constrained. "The mirror had to be as close to the lens as possible," he said, and that meant that the camera was now immobilized. "She would strike her own poses . . . and say 'Shoot, George. Shoot.' Well, if I didn't like it, I'd say, 'Well, I don't like that.' And we were off on a rough track." While she was changing outfits and sprinkling gold dust on her hair, Hurrell would quietly roll the mirror out of the gallery. As soon as she returned, she'd say, "Where's my mirror?," and the mirror had to be restored to its position.

"She always had to have that face right the way she wanted it. The light used to be over her head. She'd see it in the mirror. She'd watch it . . . this shadow and this look. If you didn't get it, then all hell broke out," he laughed.

He was paid $1000 for this trying assignment. A sitting scheduled for two hours stretched to six, and he was not master of the situation. "Those sultry, sexy poses were mostly her creations. I never knew anyone who was so hot for pictures of herself."*

Besides M-G-M and Paramount, the other major studio using Hurrell's services was Twentieth Century-Fox, whose hyphenated name was the result of a 1935 merger. Hurrell had been shooting for the two companies before the merger, when United Artists was releasing for Twentieth Century Pictures, but he now had new personalities to showcase. There was the temperamental Simone Simon, the precocious and cooperative Shirley Temple, the sunny Alice Faye, and the exotic Dolores Del Rio. Last but not least, there was Loretta Young.

"Loretta Young was one of the most inventive subjects that I ever shot," said Hurrell. "She had a

strong personality and a kind of vigorous . . . energetic quality, and she always had exciting ideas about the way she should be shot. She had radiance."

Young was equally complimentary about Hurrell: "What I liked was the way he made you look so glamorous. And your skin looked so shiny. I know the secret with him. . . . He was the first man who said that he didn't want any makeup. You used to put a little oil on your face and that was all. You could wear eye makeup if you wanted to, but no greasepaint. [Your skin] looked like you could touch it. It looked like skin. It didn't look like chalk."

Less than three years after opening his own studio, Hurrell was the most sought-after photographer in Hollywood. In 1934 alone, he racked up more than forty sittings. But if his energy was inexhaustible, his patience was not. The old restlessness was back. "Familiarity breeds contempt" was admittedly one of his pet theories. He had to calm himself, though, because this was one job he couldn't quit. It helped if he got out of town, and he took Katherine to New York for a short vacation. The cream of Gotham society demanded portraits, so he rented a studio on the mezzanine of the Sherry-Netherlands Hotel. He also

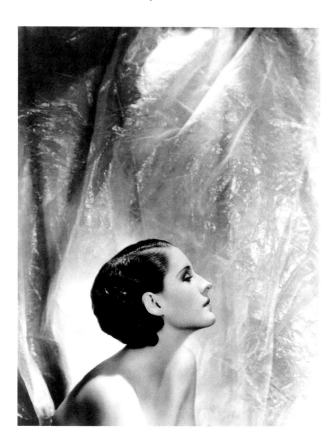

137. *A Cecil Beaton portrait of Norma Shearer made for the September 1930 issue of* Vanity Fair. *Beaton used cellophane as a visual analogue for Shearer's icy beauty. (Photo courtesy* Vanity Fair. *Copyright © 1930 [renewed 1958] by Condé Nast Publications, Inc.)*

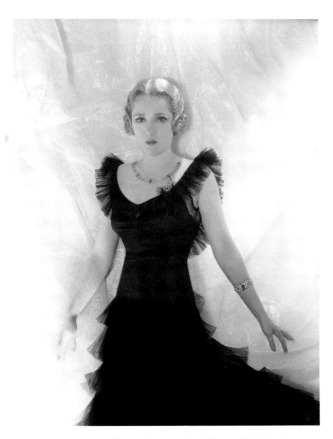

138. *A 1935 Hurrell portrait of Mary Pickford.*

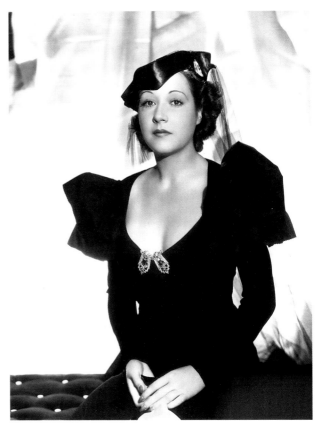

139. *A 1934 portrait of Ethel Merman; "I used to subscribe to* Vogue *so I could see what Steichen and Beaton and those guys were doing. I'm sure I was influenced to some extent."*

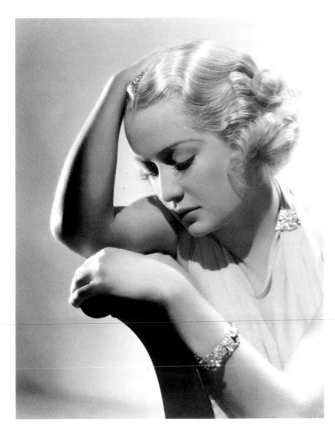

140. *In October 1935, Samuel Goldwyn commissioned Hurrell to photograph the stars of William Wyler's* These Three, *the first version of Lillian Hellman's* The Children's Hour; *Miriam Hopkins.*

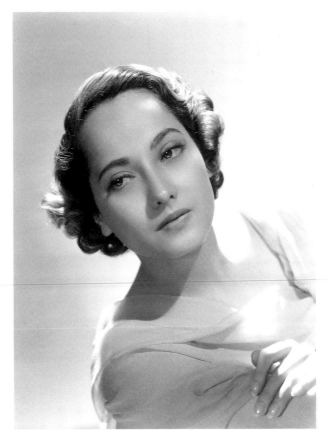

141. *Merle Oberon by Hurrell, 1935.*

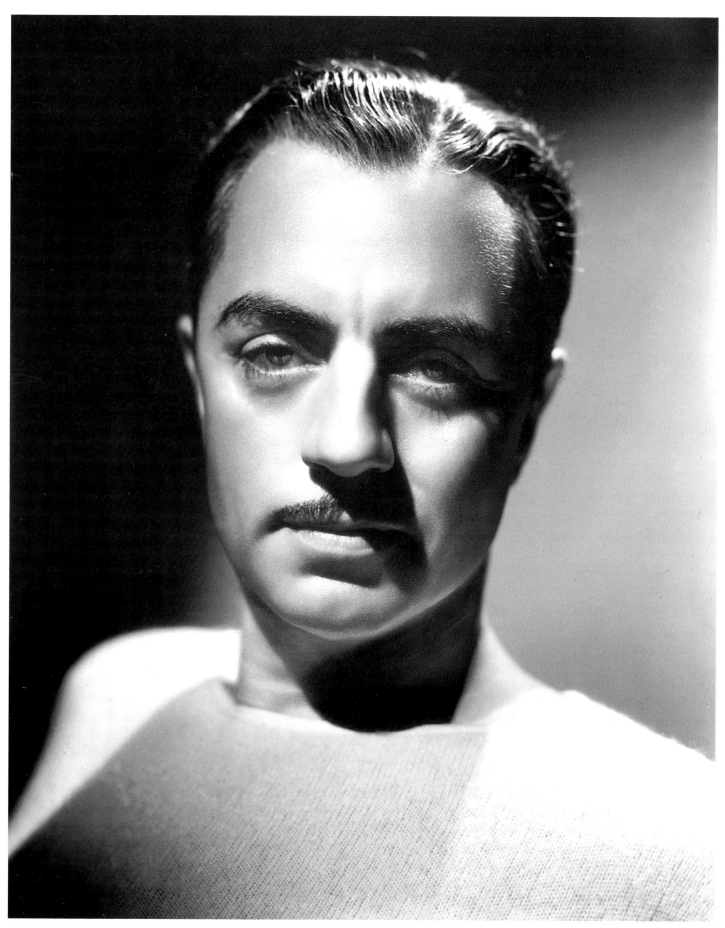

142. A 1935 portrait of William Powell, whom Hurrell described as "the most impeccably groomed man I ever met."

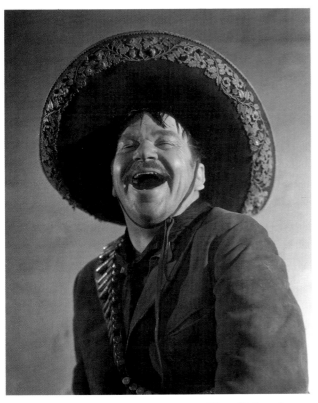

143. One of the seventy-two poses Hurrell shot of
Wallace Beery in the 45-minute session for Jack Conway's
Viva Villa!, January 1934.

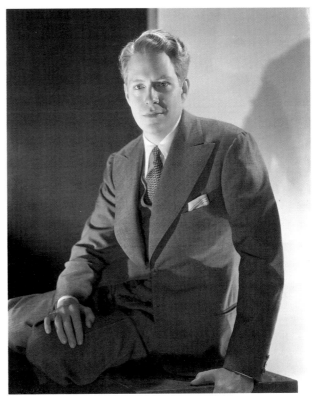

144. Hurrell photographed Nelson Eddy after
W. S. Van Dyke's Naughty Marietta made him a star.

145. Hurrell photographed Broadway star
Clifton Webb in May 1935 when Webb signed an eighteen-
month, $3000-a-week contract with M-G-M. He was to
co-star with Joan Crawford in Elegance, but the project
was dropped when dance rehearsals revealed that he was a
much better dancer than she.

146. This June 1935 Hurrell portrait of Johnny
Weissmuller was made for The Capture of Tarzan. Like
most Tarzan movies, it took forever to film and when it
was finally released in 1936, it was called Tarzan
Escapes. Hurrell and Weissmuller enjoyed weekend trips
to Mexico with Weissmuller's wife, Lupe Velez.

147. Hurrell shot Rosalind Russell against his sprayed stucco wall in March 1936 for J. Walter Ruben's Trouble for Two.

shot fashion for Bergdorf-Goodman and advertising for Elizabeth Arden. The vacation lasted two months, and Howard Strickling started interviewing photographers. According to then stills man Ted Allan, "He looked at one fellow's portfolio. His name was Stephen McNulty. They didn't know when—or if—Hurrell was coming back. So they hired this McNulty. Come to find out he was a male model and this portfolio was something he'd got together from all his pals' portfolios. . . . He gave himself away by putting oil in a lens to make it 'shoot faster.' "

Hurrell, meanwhile, was in Ensenada, shooting in tandem with *Los Angeles Examiner* columnist Ted Cook. Hurrell had gone there to recover from New York. Then he'd met Cook, stopped painting, and started shooting. When M-G-M fired McNulty and Joan Crawford started clamoring for Hurrell, the vacation ended.

Another hiatus was spent at the home of a new friend, the photographer Edward Weston. "I admired his work," said Hurrell, "and I still do think that he's the only great artist in the history of photography. He was a purist. He was a technician. You name it and he was it."

Hurrell's 1936 escape was to New York, where he agreed to supply *Esquire* with one Hollywood glamour portrait per month. Back in Los Angeles, he spent many weekends shooting with Ted Cook. The subject matter was usually abstract. This work was shown in April 1937 at the Chouinard Galleries. On the day after the opening, the two artists headed for Ixcatepec to shoot more abstracts.

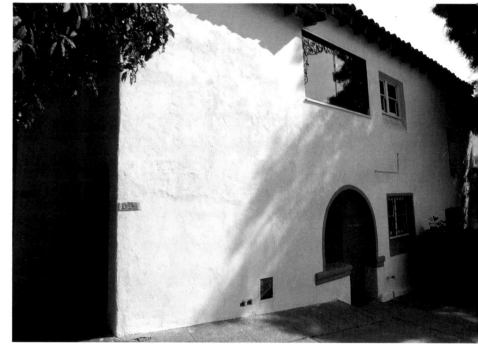

148. 1332¼ North Miller Drive (author's photo).

When Hurrell couldn't escape the pressure of Hollywood with travel, painting, or fine-art photography, he partied. "All you had to do was go to some friend's house, and boom, there was . . . a big gathering. But I didn't like standing around. I preferred, if I had to get drunk, to sit down with a friend or two and get drunk. I'd just play at it and keep chattering away, being *non compos mentis* about things you didn't even want to talk about."

Having let off steam, he would go back to his work and bring to it the same intoxicated charm. Once in a great while, the line between play and work would blur, as in the case of Jean Harlow's *Dinner at Eight* sitting.

149. Newly divorced Mary Pickford had Hurrell fashion a new image for her in 1935.

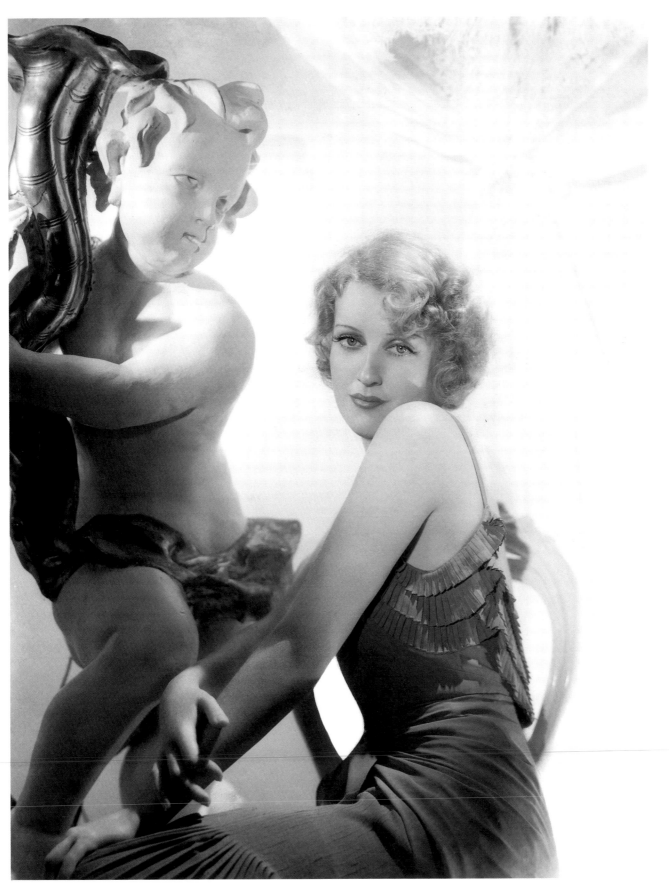

150. Hurrell glamorized Jeanette MacDonald in June 1935,
so that her fans could see what she looked like without the powdered wigs of Naughty Marietta.

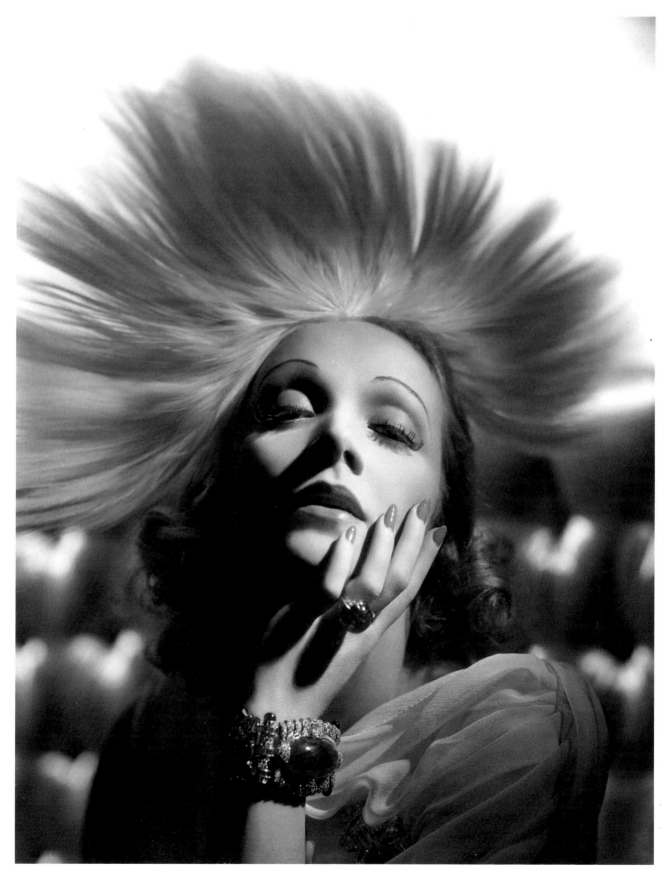

ABOVE: *151. Marlene Dietrich posed for Hurrell in the spring of 1937, after completing Ernst Lubitsch's* Angel.

OPPOSITE PAGE: *152. Dietrich used a full-length mirror to perfect her poses.*

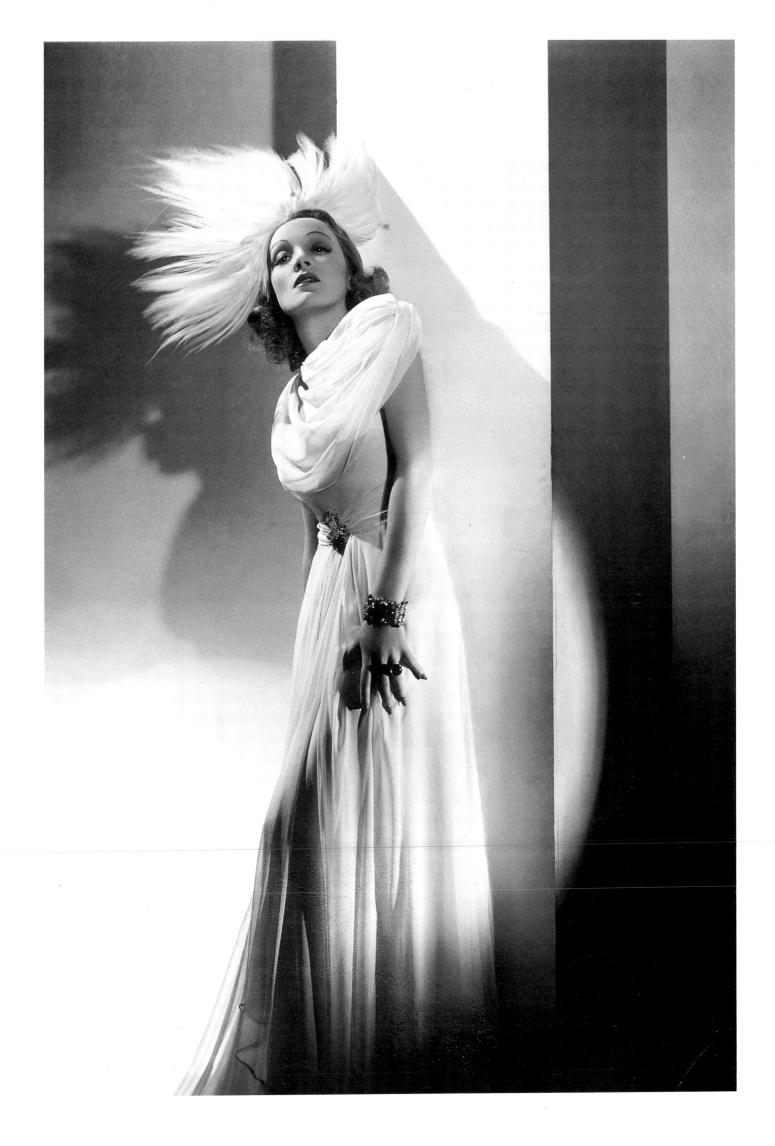

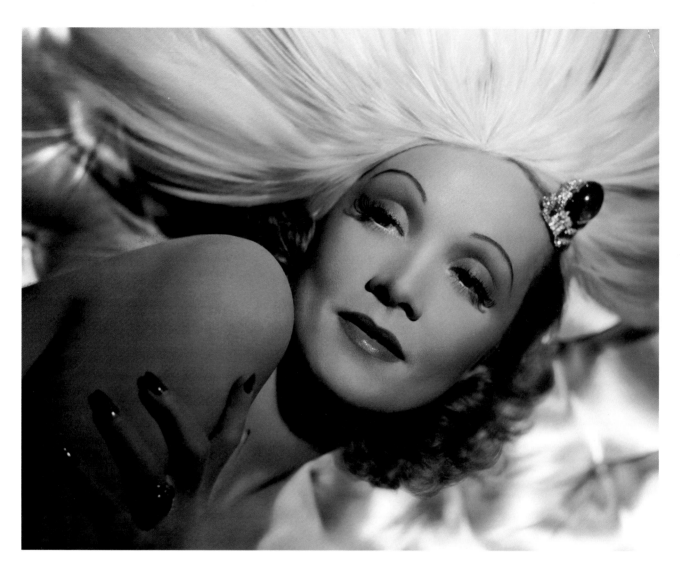

ABOVE: *153. When Hurrell was later asked for his opinion of Dietrich, he exclaimed, "Dietrich! Now there's a dame! Wow!"*

RIGHT: *154. Hurrell's portrait of Anna May Wong for Robert Florey's* Dangerous to Know, *a 1938 Paramount release.*

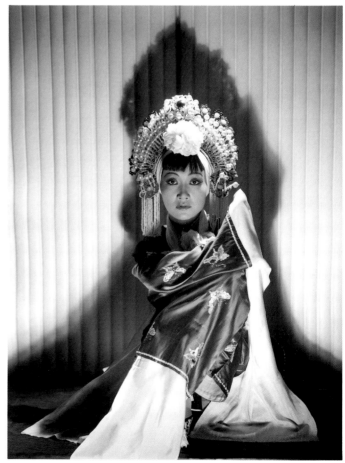

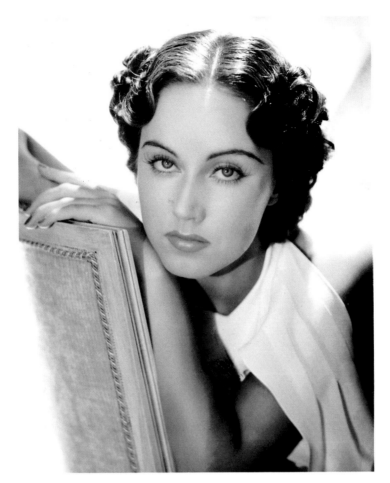

155. A 1935 Hurrell portrait of Fay Wray.

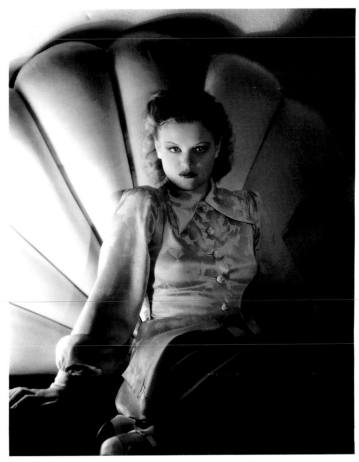

156. A 1936 portrait of Simone Simon.

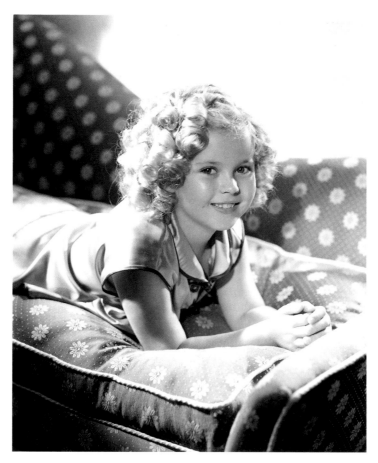

157. A 1937 portrait of Shirley Temple.

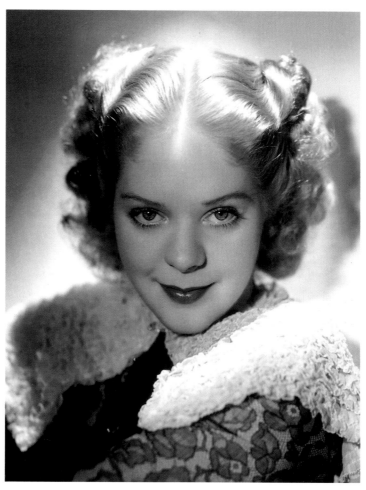

158. A 1937 portrait of Alice Faye.

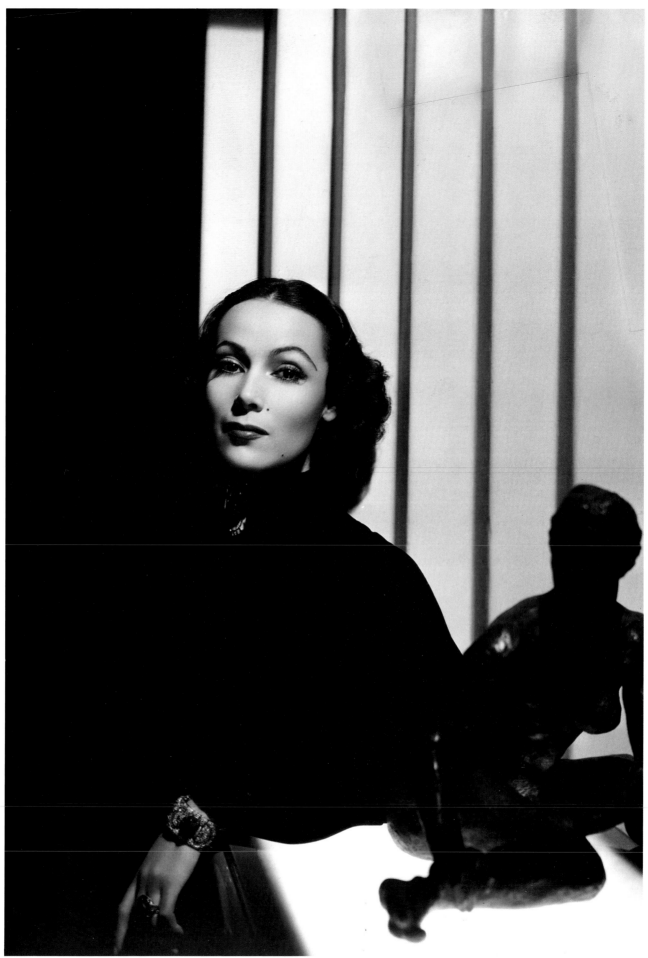

159. A 1937 portrait of Dolores Del Rio, taken in the home she shared with her husband,
M-G-M art director Cedric Gibbons.

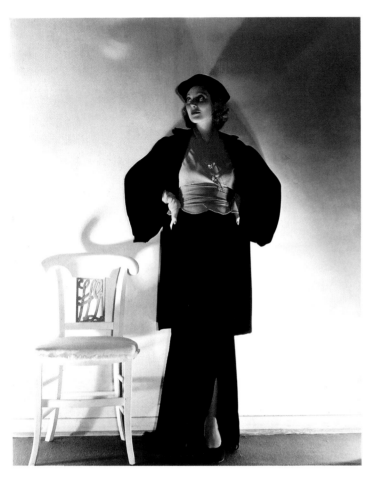

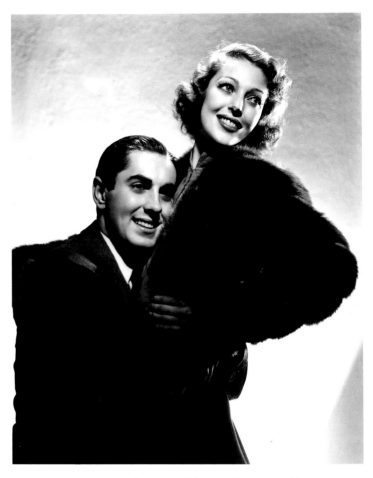

160. *This 1934 portrait of Loretta Young was made in the salon of couturier Howard Greer, which was designed by Harold Grieve. The dress was called "Firebird."*

161. *Tyrone Power and Loretta Young posed in Hurrell's studio to publicize Tay Garnett's* Love Is News.

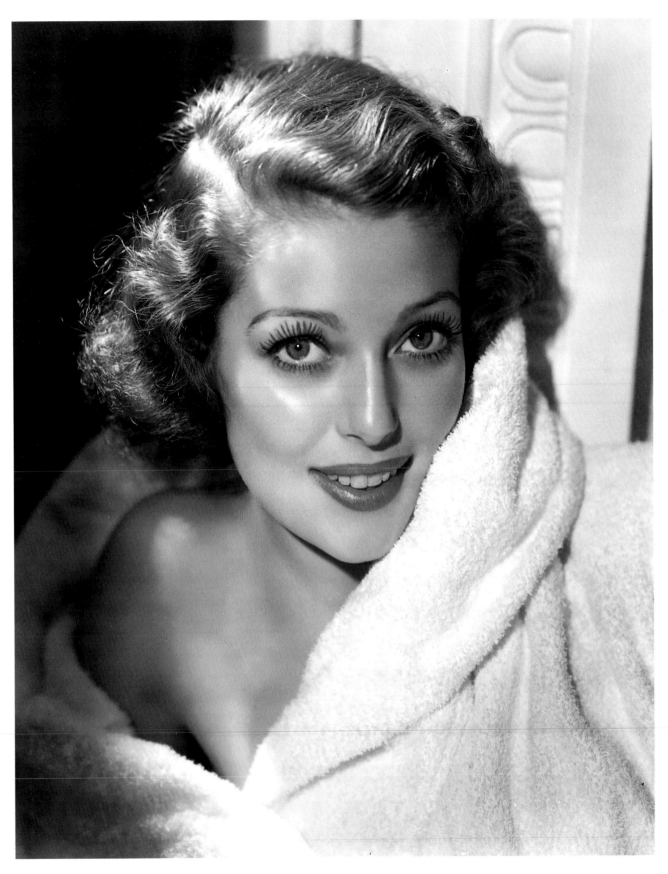

162. *A 1936 portrait of Loretta Young for Twentieth Century-Fox's* Love Is News.

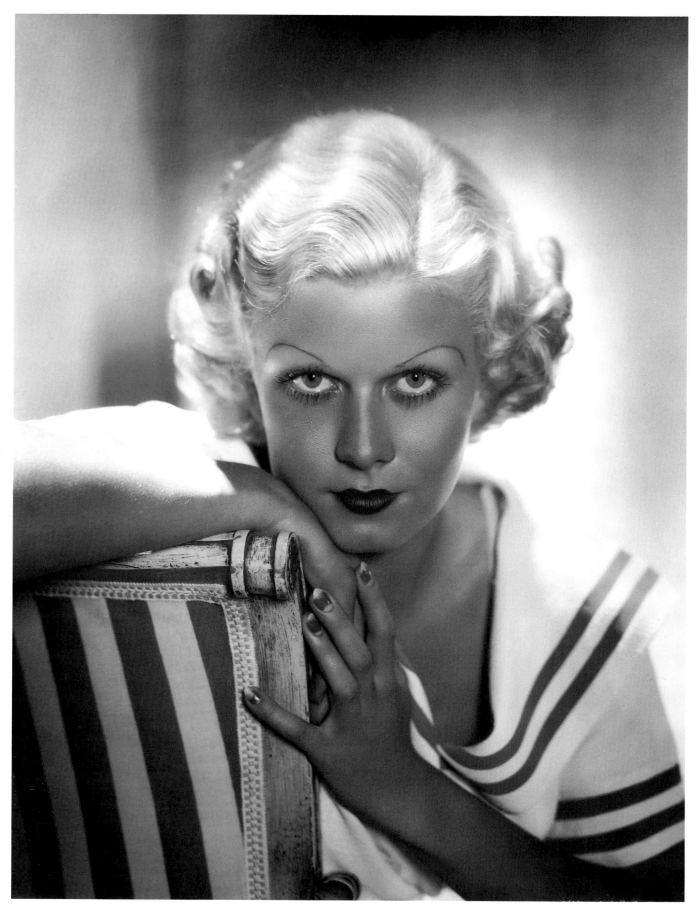

163. In June 1933, Jean Harlow was tanned, rested, and ready.
And so was George Hurrell.

WHITE-HOT HARLOW

At twenty-two, Jean Harlow was a veteran of twelve features, one divorce, and one husband's suicide. To Hurrell, she was "just a big, healthy, happy girl." Behind this care-free facade was an exploited child-woman whose only defense against her manipulative mother was furtive drinking.

"Mama Jean" tried to stop her, but Harlow was resourceful: "I'm not going to drink around her, but I *am* going to drink." One place where she could drink was at Hurrell's portrait sittings. Knowing that he did not countenance interference, she contrived to go to the *Dinner at Eight* sitting alone. Hurrell was well-acquainted with Harlow's mother. "She had *will*. She had will power, and the Baby didn't." The tanned tow-head who carried her navy blouse and white satin to the set that afternoon was not the porcelain siren she'd portrayed there three months earlier. "When you got her alone, she became sweet and shy. It was like she didn't have to be 'Jean Harlow' anymore," said Hurrell. ("Jean Harlow" was actually her mother's name, a replacement for her own, Harlean Carpenter.)

The sitting commenced with the navy blouse (see plate 163). It continued with gin, which Hurrell shared. Inspired by the Muse and fueled by the gin, he shot the most erotic sitting of his career. He accomplished it with a line of talk that would have scandalized the most seasoned trouper. There was no M-G-M stenographer there to transcribe it, but secondhand reports say that he painted word-pictures of her sexual fantasies.

The resulting photographs undoubtedly contributed to *Dinner at Eight*'s $998,000 profit. But a cloud of censorship was gathering over Hollywood, and Hurrell had only one more chance to pull out the stops with the Blonde Bombshell. In the spring of 1934, she was filming *Born to Be Kissed*. Hurrell was engaged to shoot poster art. This time, he convinced her to go as far as partial nudity (see plate 166). "She would just drop her dress and be nude underneath! Not in a seductive way; she just had no shame or inhibition about her body." Of course, those photos were never released. By the time of the film's release, the Production Code was in force, and neither suggestive titles nor ads were permitted. The film was now called *The Girl from Missouri*.

In keeping with Hollywood's newfound propriety, M-G-M decided to modify Harlow's image. Clarence Bull had already been shooting more sedate poses of her (see plate 168), but by September, it became obvious to Publicity that the image should be nearer to the real-life Harlow. Her M-G-M colleague Jeanette MacDonald later said, "She always played such sluts on the screen, and at heart she was a young, naive, nice girl who just wanted to be somebody's wife."

Hurrell had done a more dignified sitting with Harlow in July, but the scoop-necked white dress was still too revealing. A series of sittings was scheduled for late September and early October. The first to photograph her, on September 24, was the rather bloodless Russell Ball, a society photographer who occasionally did Hollywood portraits. His home layout was intended to publicize Mama Jean's latest decorating spree. In control again, Mama Jean managed three more home sittings. The next was by a woman named Gene Hanner, who shot Christmas art on the morning of October 18. In the afternoon, Hurrell showed up to shoot Harlow with the same hairdo but different gowns.

There was a reason for this piggyback shoot. Strickling had finally managed to get a full page for Harlow in *Vanity Fair* (see plate 171). After this superb photograph was published, everyone wanted a portrait with a polar-bear rug. Hurrell had to buy one. "I actually began to hate the popularity of that rug. I thought it was artificial." Still, he was proud of having his work appear in *Vanity Fair,* and pleased with the image of Jean it presented. "My inspiration for the lighting of that shot came when I posed her in front of the fireplace."

Yet more photos were needed. Hurrell returned to 214 South Beverly Glen Boulevard a few days later, for Jean's fourth shoot in less than a month. No one complained, then or later. "It was always a joy to have a sitting with her because you never stopped laughing. I didn't have to fall on my face for her."

The concept of this shoot was to make her look almost spiritual, so three classic-looking gowns were chosen. The first was of white ribbed crepe. Hurrell set up portable flats in the kitchen, and then pulled a hassock from the living room and put one of Mama Jean's lime-green sofa cushions on it. Then he posed Harlow in a series of contemplative attitudes. "Harlow was not frightened of the camera; she reacted to it, and in some strange way, I was the third party—they were the conspirators."

Harlow next donned a velour gown of forest green, and Hurrell began to shoot more moody images. He swung his boomlight over her head, creating precise shadows. She changed to black velvet and the images became more abstract. "She was very sensitive to suggestions. When I posed her in a certain attitude that did not look quite right in my camera, I would say, for instance, 'Change the position of your left hand,' and she would deftly move her palm or fingers

a fraction of an inch without altering the whole effect."

When Hurrell worked with her in May 1935, it was the last time he shot her as the Platinum Blonde. M-G-M was about to soften her look still further. Hurrell shot her at his studio in a wig from *Reckless* and a gown from *China Seas* (see plate 181), and then as he preferred her—supine (plate 182). A month later, M-G-M bowed to the Legion of Decency, which objected to brassy hair and braless dresses. A new Jean Harlow was created. When Hurrell next photographed her, she was wearing a lackluster brown wig. The Blonde Bombshell had been defused.

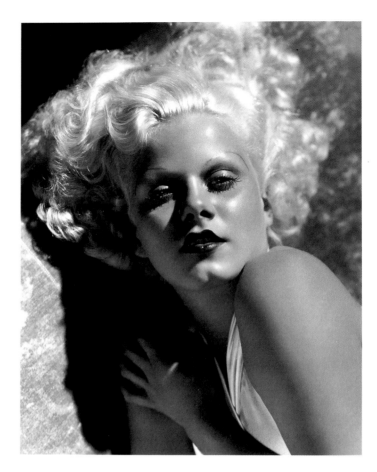

RIGHT: *164. A Hurrell portrait of Jean Harlow for* Dinner at Eight.

BELOW: *165. Hurrell's word-pictures made for exciting poses.*

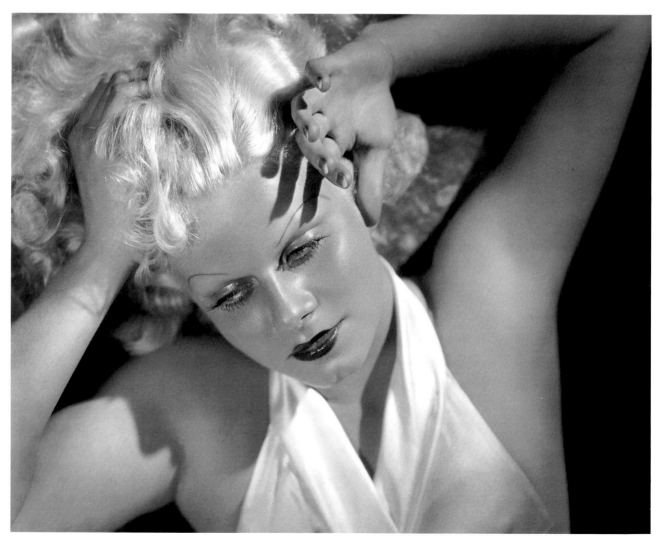

122

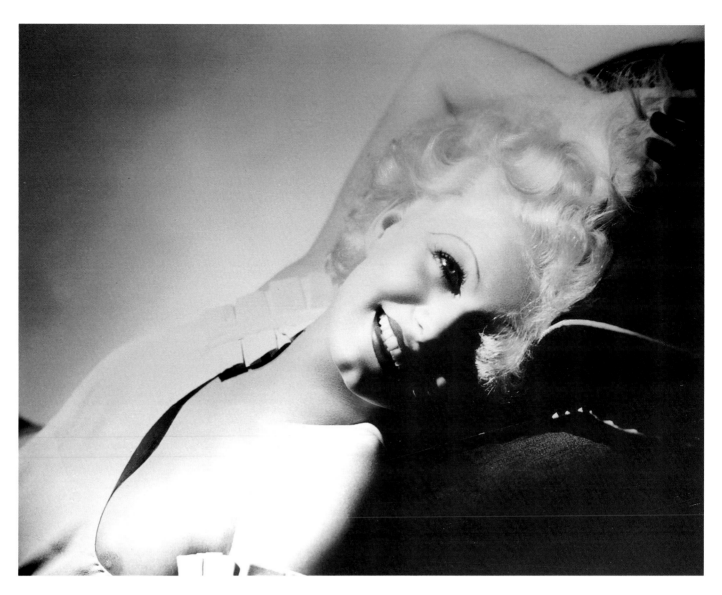

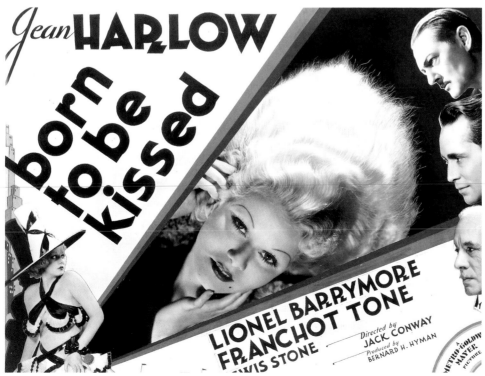

ABOVE: *166. A Hurrell photo with some of the retouching removed (by archivist John Kobal). It was shot to publicize Jack Conway's* Born to Be Kissed, *but could never have been released like this.*

LEFT: *167. This poster art was discarded when the title was changed—first to* 100% Pure, *then to* The Girl from Missouri.

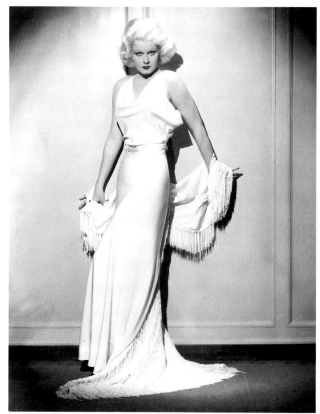

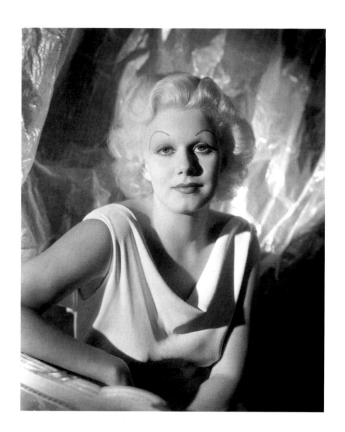

ABOVE: *168. A Clarence Bull portrait of Harlow taken February 17, 1934, and often misattributed to Hurrell.*

LEFT: *169. Harlow by Hurrell, summer 1934.*

BELOW: *170. An uncredited candid, possibly taken at the end of the same day as plate 169.*

OPPOSITE PAGE: *171. Jean Harlow at home, October 18, 1934. (Photo used with permission of Allan Rich, Creative Arts Images. © 1979 CAI, All rights reserved)*

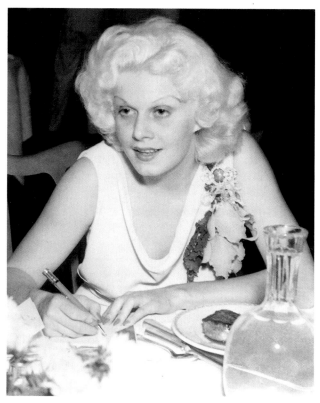

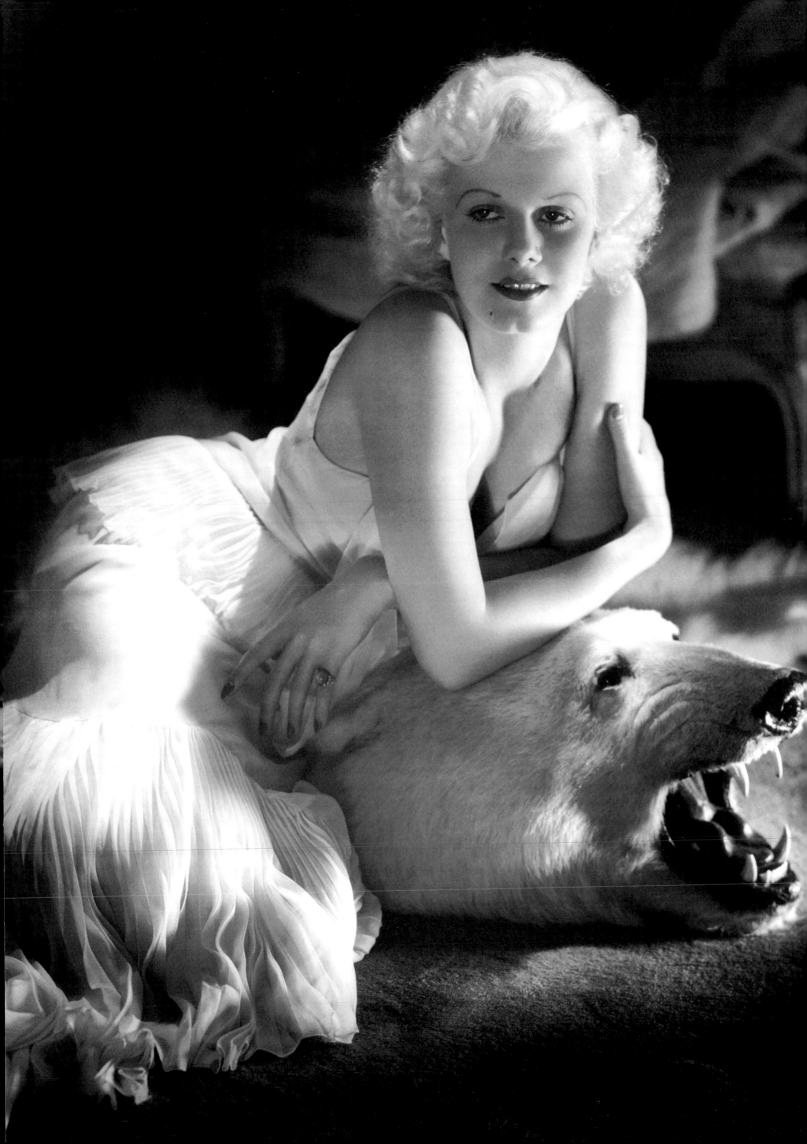

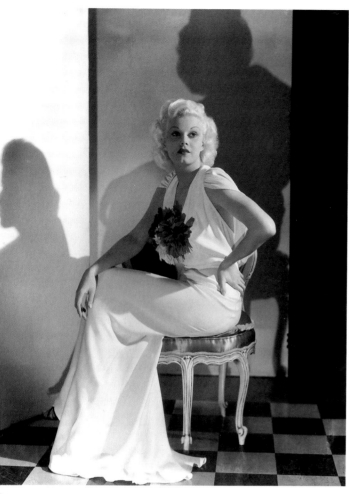

172. Hurrell set up portable flats
in Harlow's kitchen, and she still managed
to be glamorous.

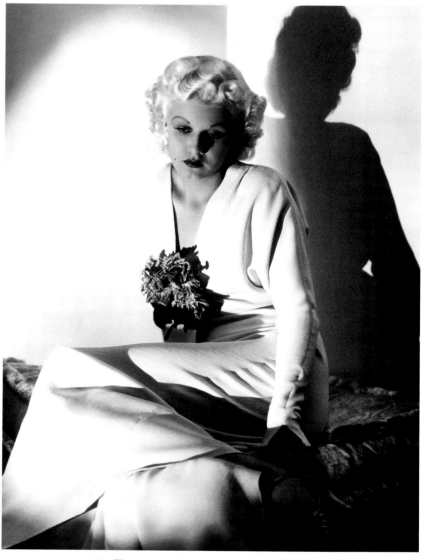

173. This portrait became a poster for Reckless.

126

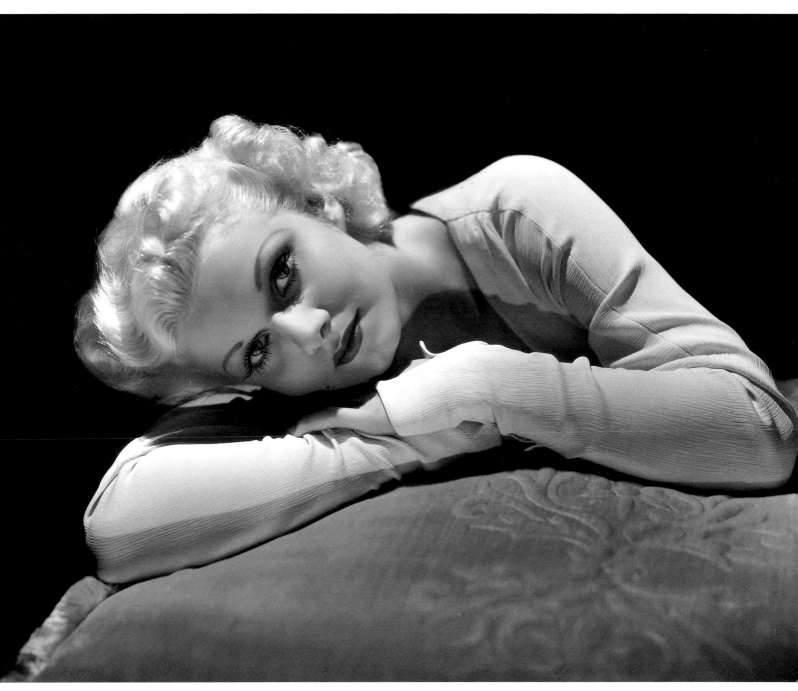

174. *Harlow sat on the kitchen floor for Hurrell.*

OVERLEAF: *175. Jean Harlow by George Hurrell;*
when asked what her favorite movie scene was, she replied
that it was the final closeup of Greta Garbo in
Queen Christina.

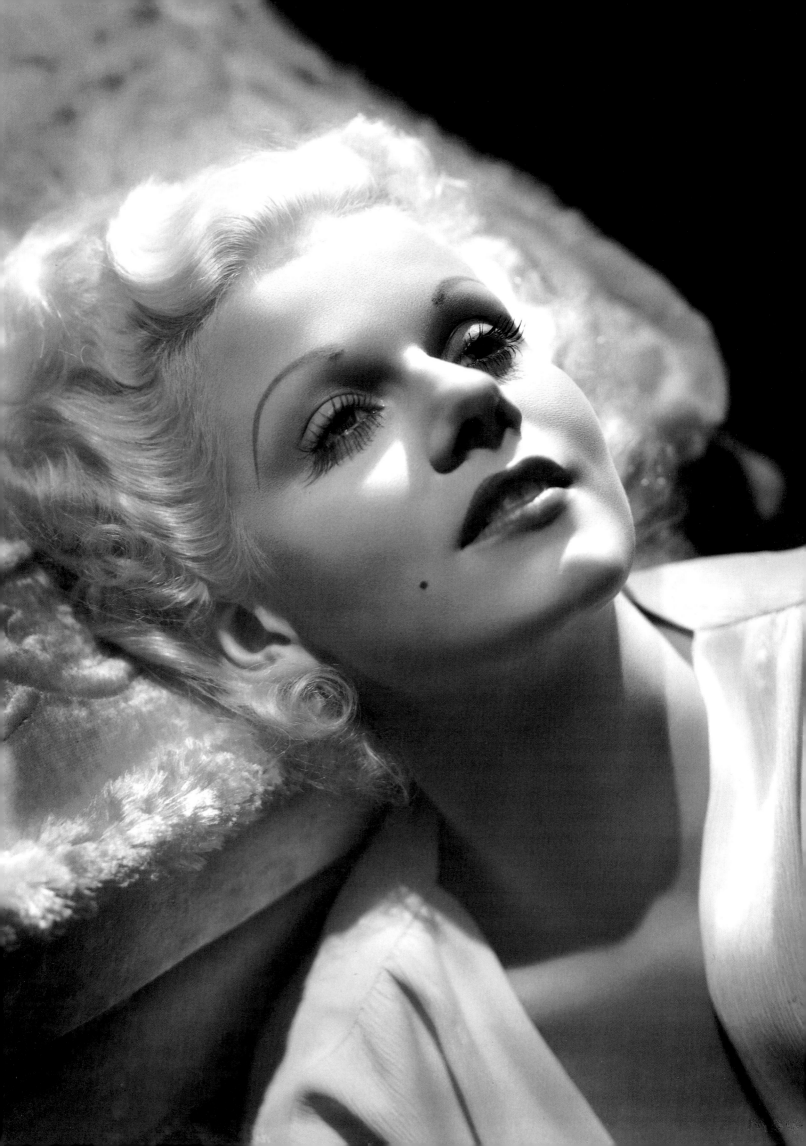

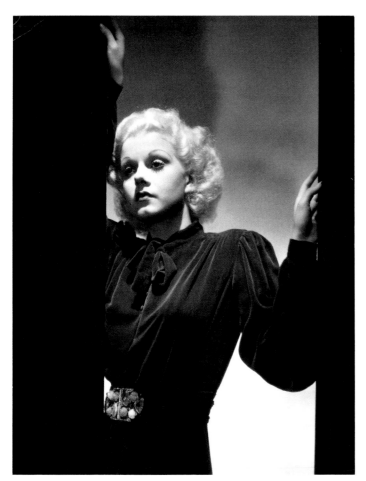
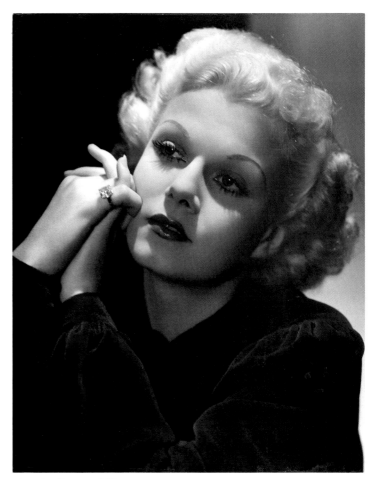

176, 177. Harlow in velour was bereft of her worldliness.

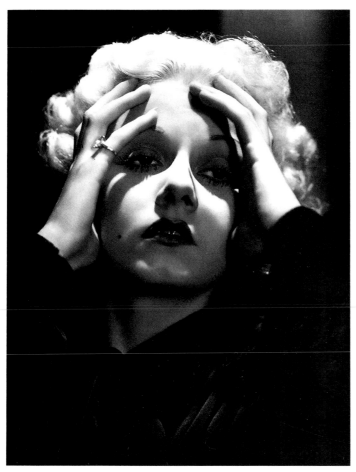
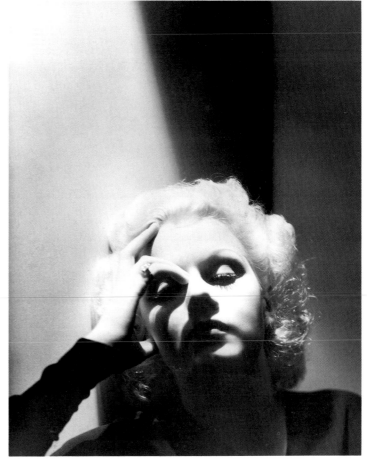

178, 179. Harlow in velvet was transcendent.

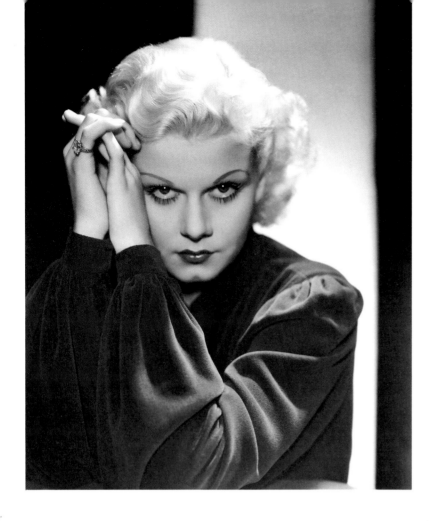

LEFT: *180. But when Hurrell was shooting, sensuality was never totally dispelled.*

BELOW: *181. Hurrell used his boomlight to throw geometric shadows from Harlow's platinum curls.*

OPPOSITE PAGE: *182. In this same spring 1935 session, Hurrell composed a picture of Jean Harlow that can be looked at from any angle, a tribute to his compositional skills. However, Hurrell marked the negative to indicate that the photograph should be oriented as shown here.*

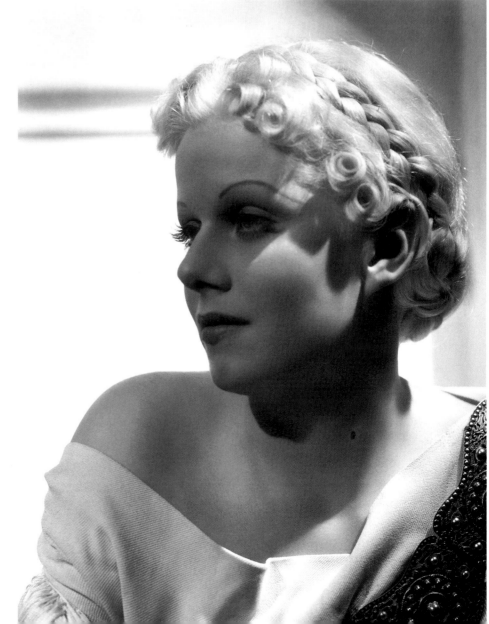

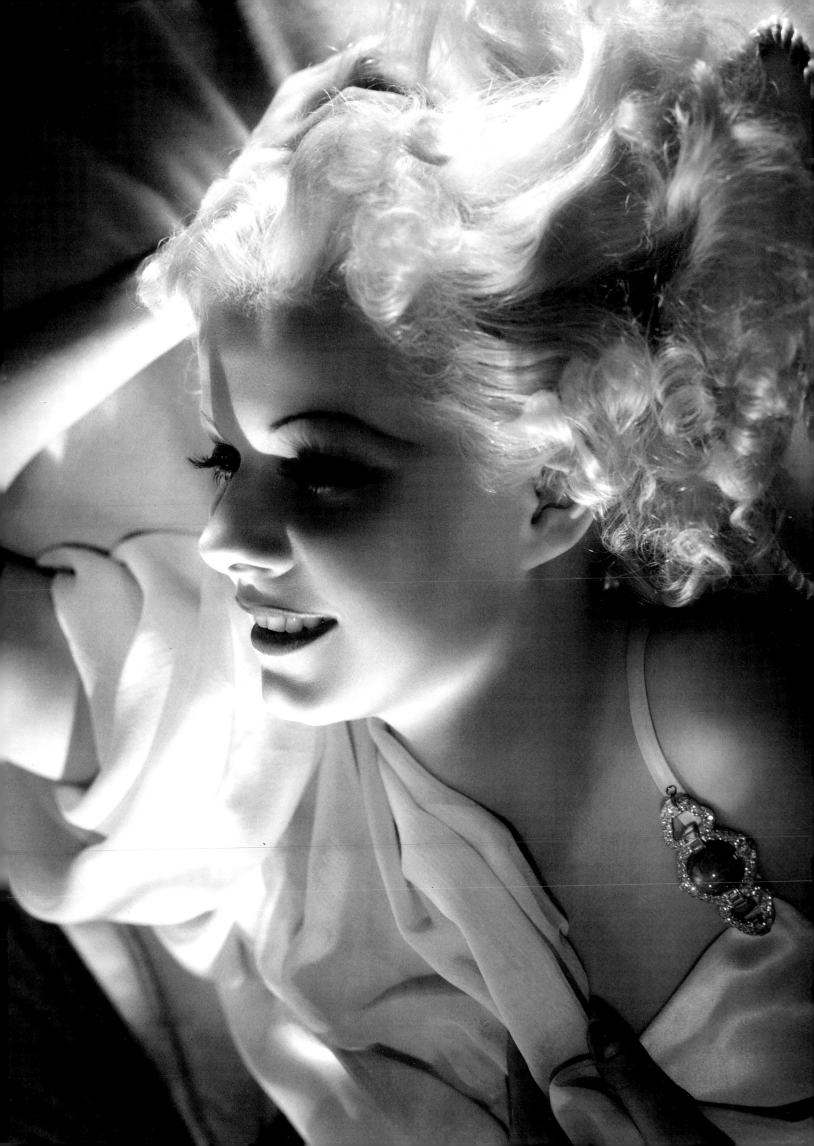

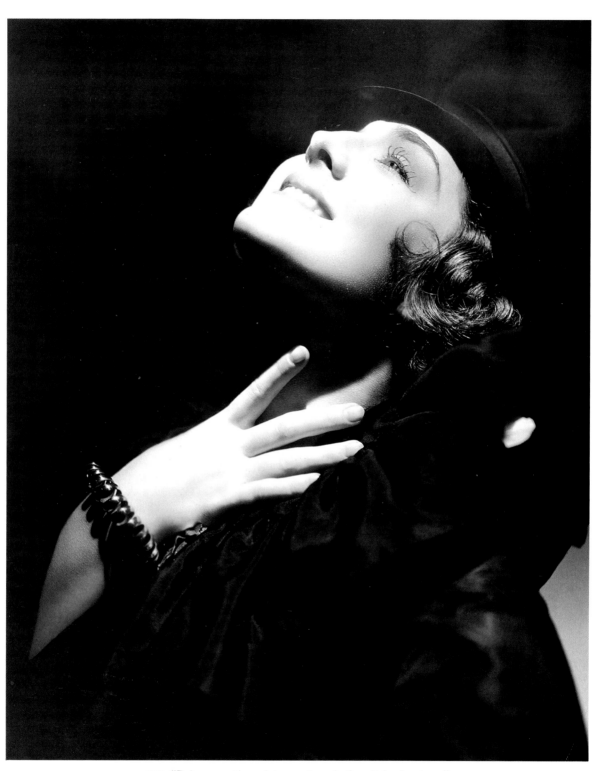

183. *"Being a motion picture actress is the pitch of ecstasy."*

THE FIRST LADY OF M-G-M

In 1934, George Hurrell's most momentous subject was Norma Shearer. In the relaxed moral atmosphere of pre-Code Hollywood, she brought her patrician beauty to a series of slightly scandalous and highly profitable films. "Shearer was something new," says the film critic Mick LaSalle, "a nice young woman who wants sex as much as a man does, and goes after it." To historian Lewis Jacobs, she was a prototype, "the ultra-civilized, sleek and slender, knowing and disillusioned, restless, oversexed and neurotic woman who leads her own life." To co-workers and fans, she was "The First Lady of M-G-M."

When Shearer's movies began to earn more than Garbo's, she became a prestige artist, required to make only one a year. What did she do the rest of the time? She couldn't let her fans forget her, so she commissioned portraits by Hurrell. Of their sixteen sittings together between 1929 and 1936, only half were done in connection with a specific film. The other half gave her an opportunity to present fresh images. Shearer routinely auditioned photographers and cinematographers, grading them on their ability to flatter her. In the portrait gallery, she preferred Hurrell, because she knew what he could accomplish. Because of him, she was considered one of the great beauties of the 1930s.

He told *Movie Mirror* that he never lit her from below, even though generally this was an effect he liked. "Strangely enough, it will appear that Norma's chin is too full, and that her cheeks are chubby, of all things." For years, her biggest problem was a well-kept secret: she had a weakness in the muscles of her left eye. Constant exercise kept the eye from wandering inward. Hurrell recalled, "She knew how to focus just beyond what she was looking at. She looked *through* the lens—to something right past it." The result was a knowing, seductive stare, as much a

Shearer trademark as her sculpted profile.

With the enforcement of the Production Code, Shearer's vehicles assumed a more conservative tone, but her portraits continued to personify the modern woman—intelligent, sexually aware, and in control. The control extended to Hurrell. He had to accede to her use of a whiter-than-white makeup known as Silver Stone Number One. He also had to allow the use of a full-length mirror in the gallery, as well as the questions it occasioned. He didn't like having to justify lighting and angles to Shearer, but she was, after all, his patron. She had taken him from a side-street salon to the loftiest photo job in Hollywood, and when he had impulsively chucked it, she had single-handedly kept him from being blackballed. She could be imperious, but she could also be funny. If the mood in the gallery grew tense, she would break into a rendition of "When My Baby Smiles at Me." Hurrell remembered, "She ribbed me for years about it."

Nonetheless, Shearer was demanding, both of herself and others. "She had this driving force inside her all the time." Like Crawford, she constantly strove to remake her image. Each sitting was produced with a new theme in mind. "Each time, she seemed a different personality or presented me with a different side of her personality," said Hurrell.

Shearer said, "I can't do the Garbo or Dietrich thing," but her 1934 work with Hurrell was increasingly iconic. She chose hairstyles and wardrobe that would give her a classic, timeless look, favoring velour or black velvet to set off her bone-white face.

Hurrell responded to these challenges with a series of images that were unprecedented in their boldness and sophistication. Indeed, they approached abstraction and transcended the purpose for which they were created. Intended to prepare Shearer fans for a new film, they assumed their own importance. Each image was a film in itself, telling its own story. In these transporting photographs, Hurrell created a firmament for the star pictured there. No wonder Shearer would later write, "Being a motion picture actress is the pitch of ecstasy."

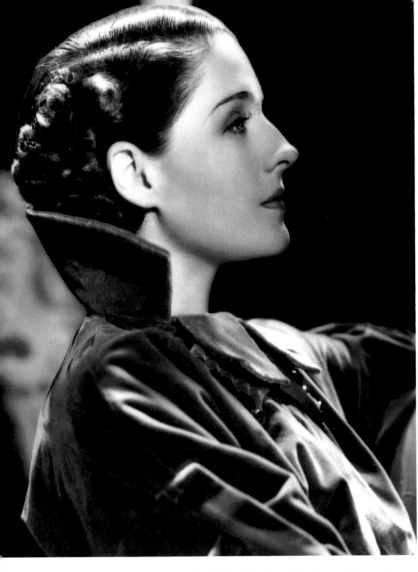

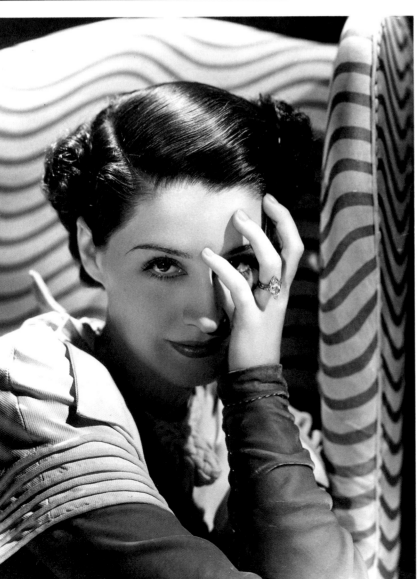

ABOVE: *184.*
Norma Shearer's profile was
her most famous
feature; a February 1934
portrait for Edmund
Goulding's Riptide.

BELOW: *185.*
Another famous feature
was the marquise-cut
engagement ring
Irving Thalberg had
given her.

OPPOSITE PAGE: *186.*
In 1994, author
James Card described
Norma Shearer
as "an international symbol
of particularly American chic,
youthful zest, urbane
polish, intelligent good taste
and, above all, a sense of
steadfast inner worthiness."
This portrait was made
for Riptide.

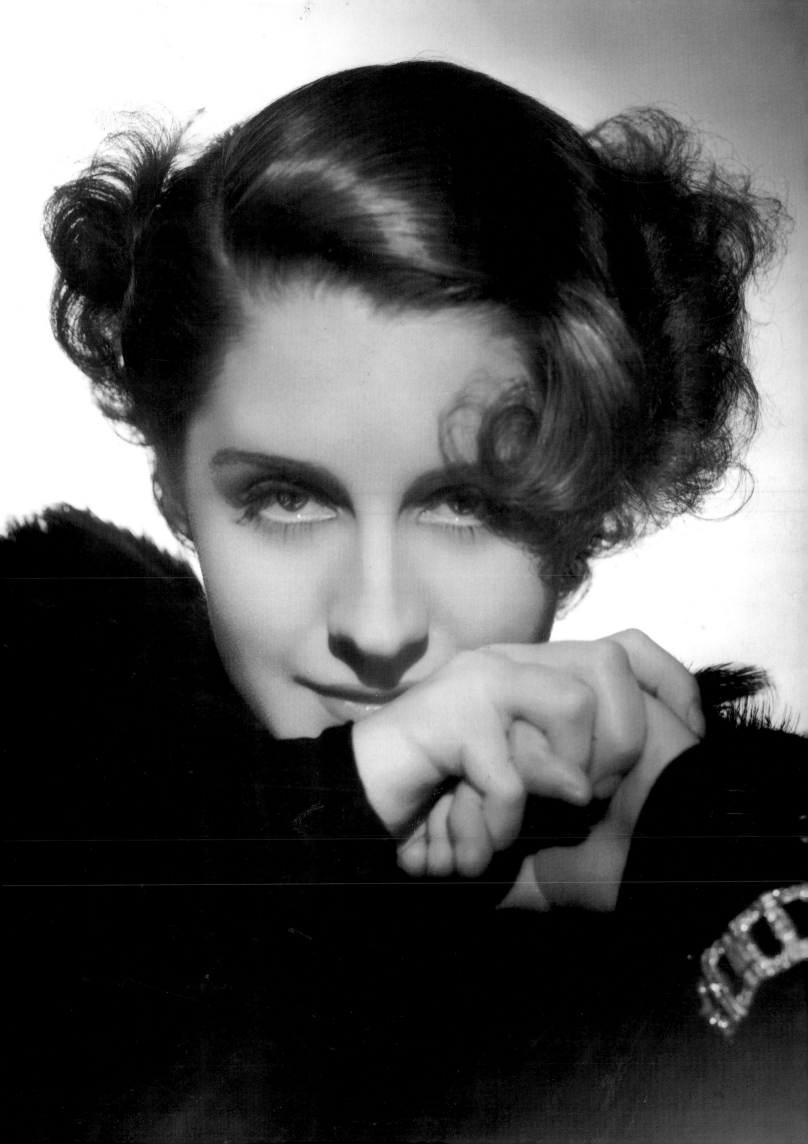

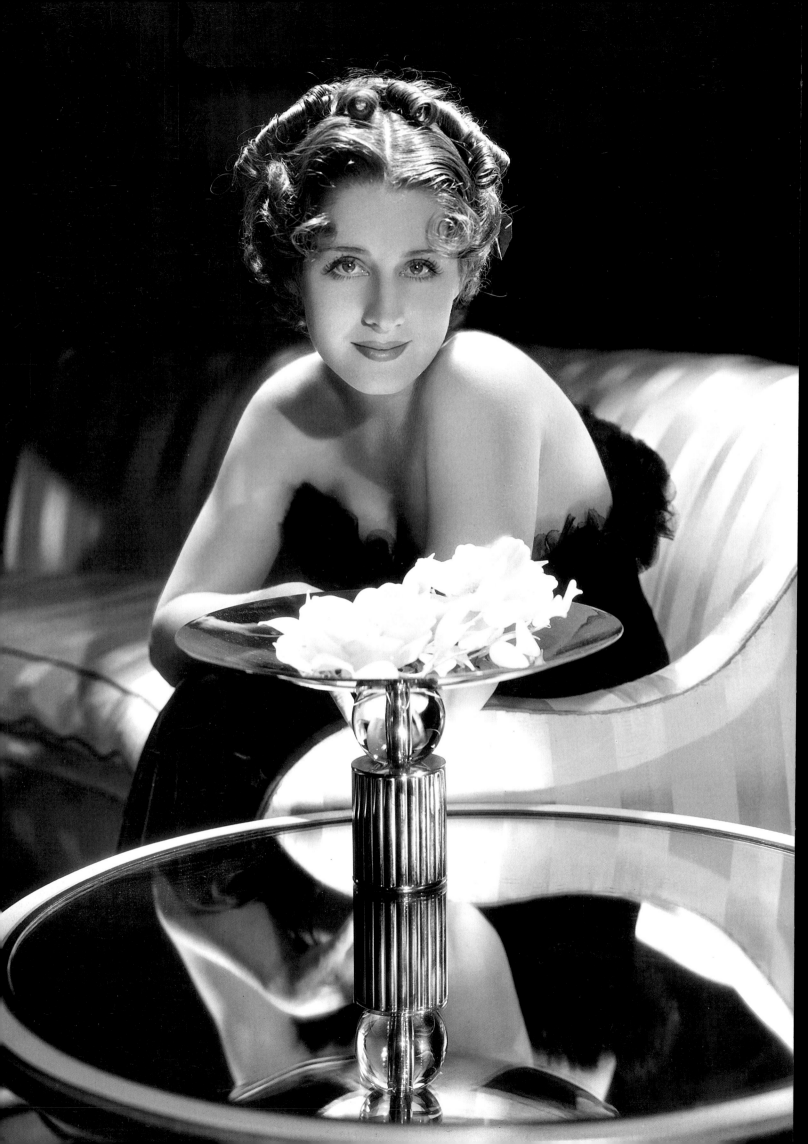

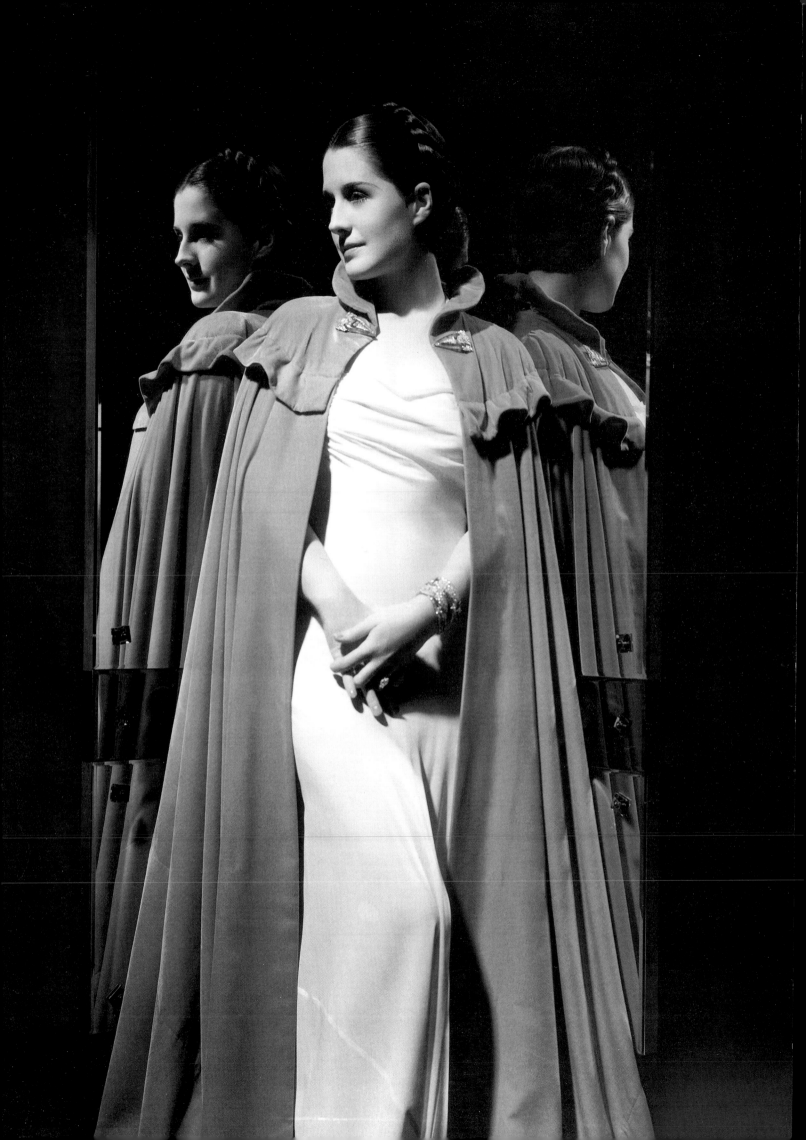

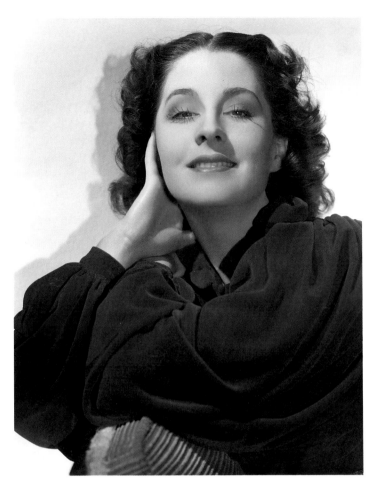

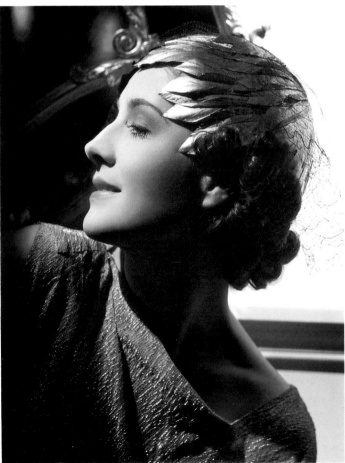

PAGE 136: *187. In September 1934, Norma Shearer commissioned Hurrell to photograph her in an ensemble designed by Irene. The resulting images were the most rarefied ever made of her.*

PAGE 137: *188. These portraits were not made in connection with any film, but rather to keep the fan magazines supplied with the latest permutation of Shearer's glamour.*

ABOVE: *189. In October 1935, Shearer was preparing for* Romeo and Juliet, *so she, Adrian, and Hurrell collaborated on an all-day session.*

BELOW: *190. Hurrell used both incidental light and reflected light to sculpt his subjects.*

OPPOSITE PAGE: *191. Shearer liked form-fitting dresses, but her work with Hurrell seldom approached the sexiness of their first session; this 1935 pose comes close, though.*

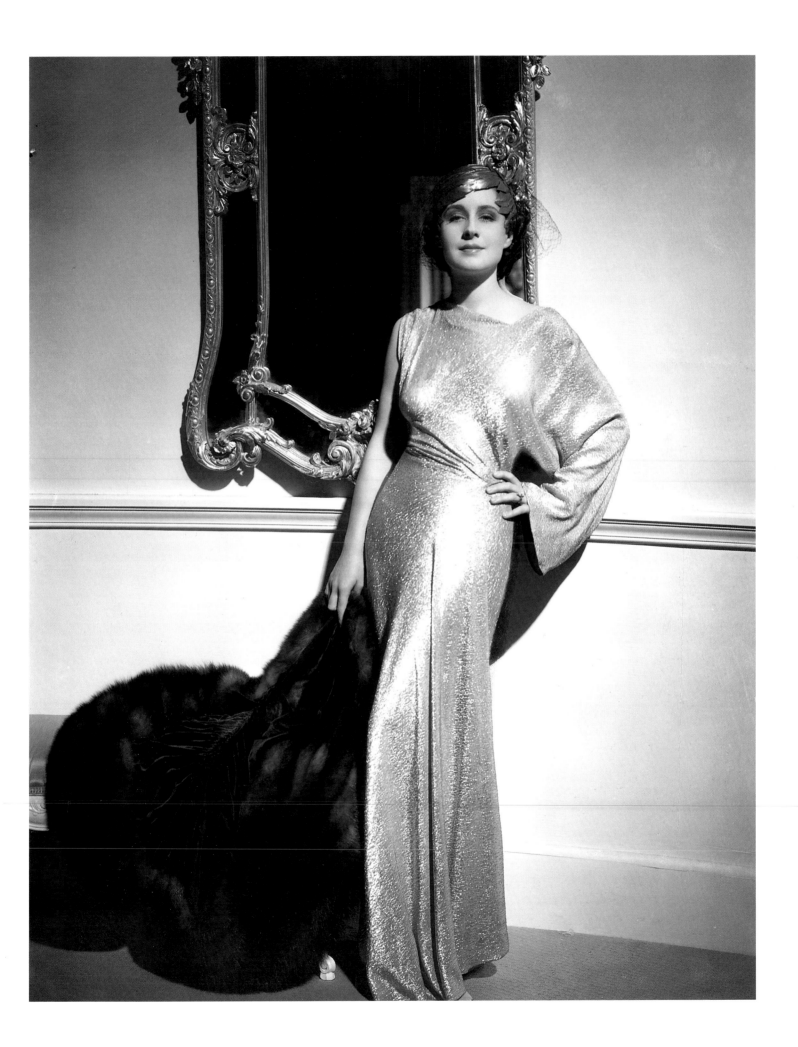

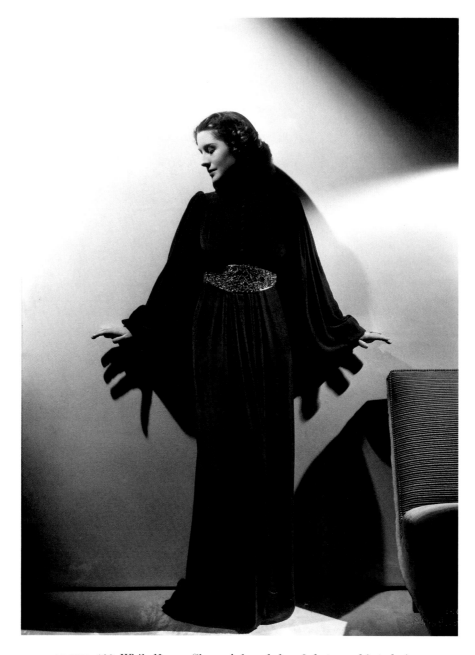

ABOVE: *192. While Norma Shearer's knowledge of photographic technique
made her ever-critical of posing, lighting, and retouching, she never interfered
with Hurrell's bursts of abstraction.*

OPPOSITE PAGE: *193. The apotheosis of Norma Shearer.*

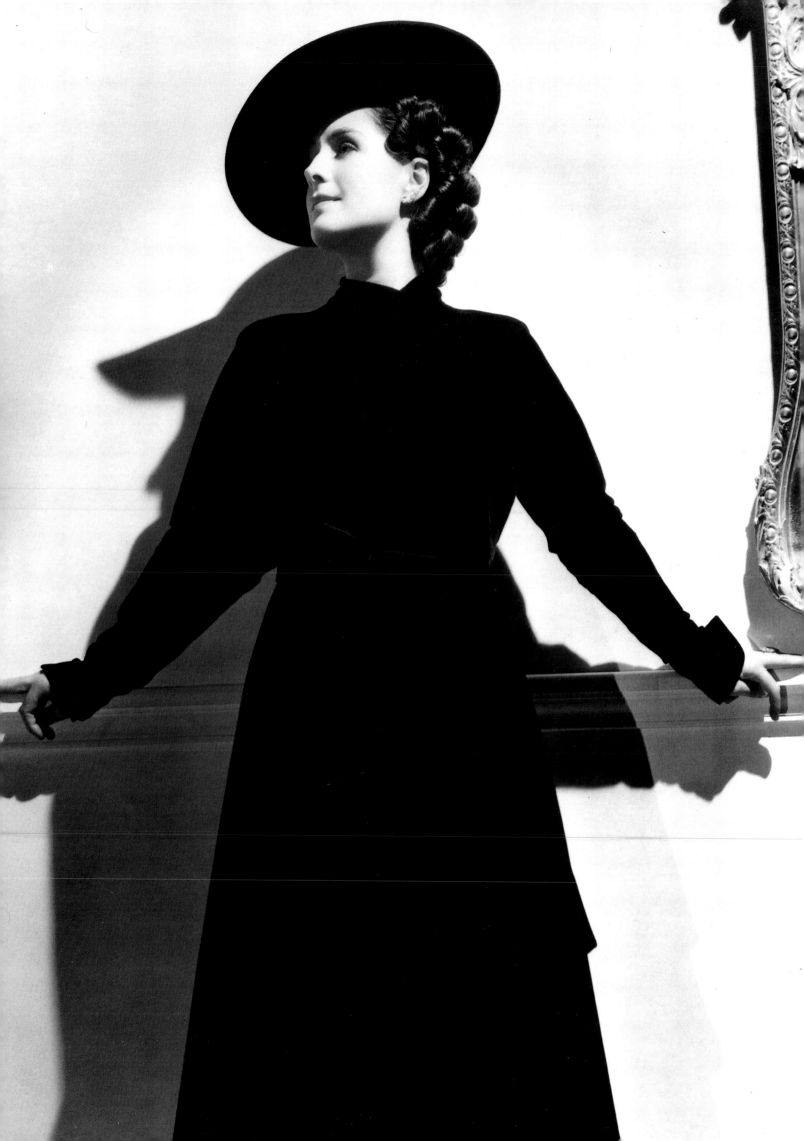

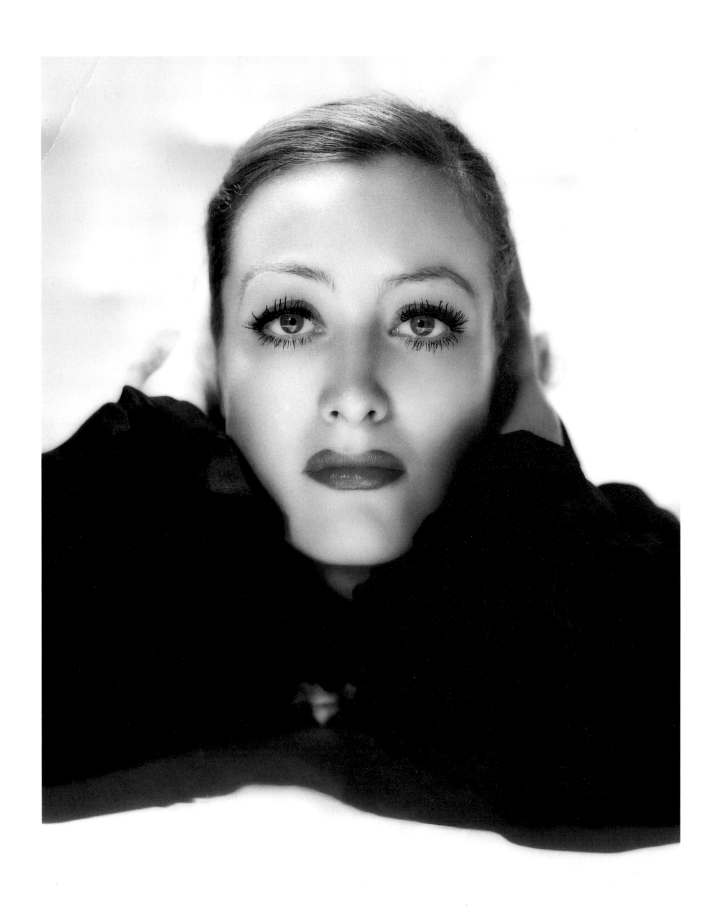

194. *George Hurrell photographed Joan Crawford in September 1933 for Robert Z. Leonard's*
Dancing Lady, *an apt summation of Crawford's rise to stardom.*

His Favorite Face

In 1933, Joan Crawford lost her marriage and nearly lost her career. Paternal L. B. Mayer teamed her with Clark Gable in *Dancing Lady* and supplied "all the talent, acumen, and resources that made working at M-G-M so exhilarating," wrote Crawford. "*Dancing Lady* was one of the happy experiences he made possible for all of us."

George Hurrell shot four sittings for this blockbuster (see plates 194, 195), the midpoint of his most prolific collaboration. He shot a total of thirty-three sittings with Crawford, most of which were in connection with a specific film, although there were exceptions. Photo archivist Joan Rose explains:

Sometimes Crawford would show up at the M-G-M gallery at the end of the day, after George had finished shooting somebody who didn't like having his picture taken and was always out of there by three or four. And she would know that George had a couple of hours left.

Lo and behold, there she was, waiting to have her picture taken. "Don't you like this dress?" Or "Isn't this the most adorable hat?" (She'd been down in wardrobe, carrying on.)

And she came to him because she had this instinct that these photographs were important to her career.

Dancing Lady made a profit of $744,000 and put her career back on track. It also cemented a relationship with co-star Franchot Tone. Hurrell was called to Crawford's house, ostensibly to shoot a home layout for *Dancing Lady*. What he got was a romantic scene between Crawford and her husband-to-be (plate 196). Crawford spent the next four years working with Tone and Gable—and being iconized by Hurrell. "He worked to catch you off guard," she said. "He'd talk to you constantly and he'd get pictures while I was talking, asking for a cup of coffee, whatever." But no one asked for a cup of coffee the way Joan Crawford did. Every pose was a strategic statement.

Hurrell later said: "Crawford was a natural at posing. She had an instinctive sense of design and of herself. I photographed her literally thousands of times, and each sitting was a new experience for both of us . . . she constantly altered her appearance, the color of her hair, eye makeup, eyebrows, mouth. Yet with all the changes there was a classic beauty, a weird kind of spirituality."

If her face was Hurrell's favorite, it was because it photographed the same from every angle. It was camera-proof. Its only problem angles involved her right rear jaw, which was a little heavier, and the bridge of her nose, which was so slender that it could make her nostrils look too large.

After 1933, Crawford never came to Hurrell's studio. She preferred the individuality of posing on sets or at home. He agreed with her, and made use of the increased visual opportunities. "Whenever we went to her house, I brought a truckful of canvas and covered her white rugs so we couldn't dirty them. I always started at nine or ten in the morning. She'd spend the whole day changing outfits and moods. She'd spend maybe an hour between changes, just getting herself ready. And I would have some different kind of approach before she arrived."

"Hurrell would follow me," Crawford said. "His camera was on wheels and he'd follow me around. How he used to move that camera, shoot the picture, and move the key light with it, I'll never know! He looked like an octopus! But it all got there!"

Hurrell was assisted in these feats by Al St. Hilaire and by Eastman Kodak's new Super Sensitive Pan film, which let him shoot at exposures as fast as a tenth of a second. Even with these aids and his boundless energy, the work was grueling. Hurrell recalled: "Joan was the most serious. She relished a full day's shooting." She'd put Bing Crosby records on and "go from one pose to another. Practically everything she did was a picture. She loved to be photographed. I think she'd rather do that than work in movies! . . . Sometimes I shot 100 to 150 negatives in one day, *and* different poses—and 100 more the next. I would work the whole day, until five or six. Sometimes by four o'clock I'd be tired and suggest that we finish up, but she never wanted to stop. She loved being looked at. 'Let's get one more, just for luck.'"

On one occasion, Hurrell and Crawford got so carried away that they exposed five hundred sheets of film. St. Hilaire collapsed from exhaustion. Hurrell gave him the next three days off. Hurrell spent the weekend in Carmel, painting landscapes.

A seven-year survey of his work with Joan Crawford shows a gallery of faces and moods (plates 205–212). Because of Hurrell's next career move and some political changes at M-G-M, he would not work with Crawford again until 1941. In an *International Photographer* interview, he disclosed: "Joan Crawford has always been the most decorative subject I have ever photographed. There is a strength and vitality about her that prevails even in the finished print. If I were a sculptor, I would be satisfied with just doing Joan Crawford all the time."

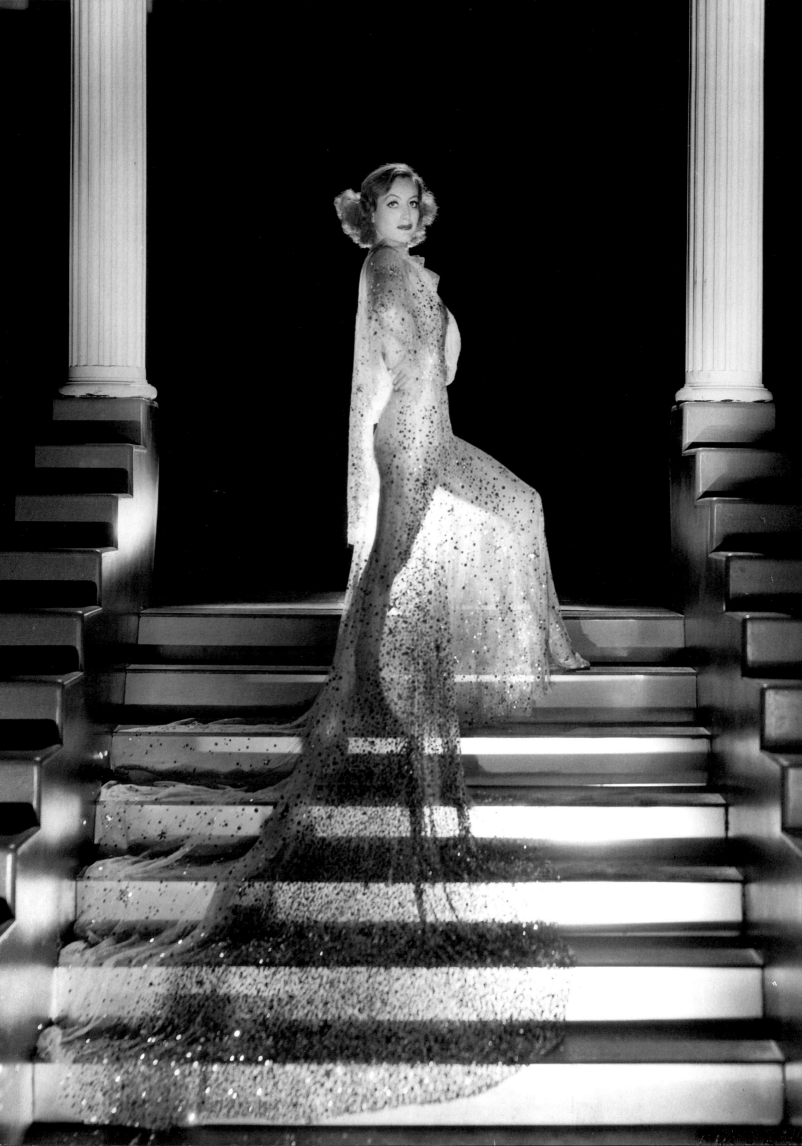

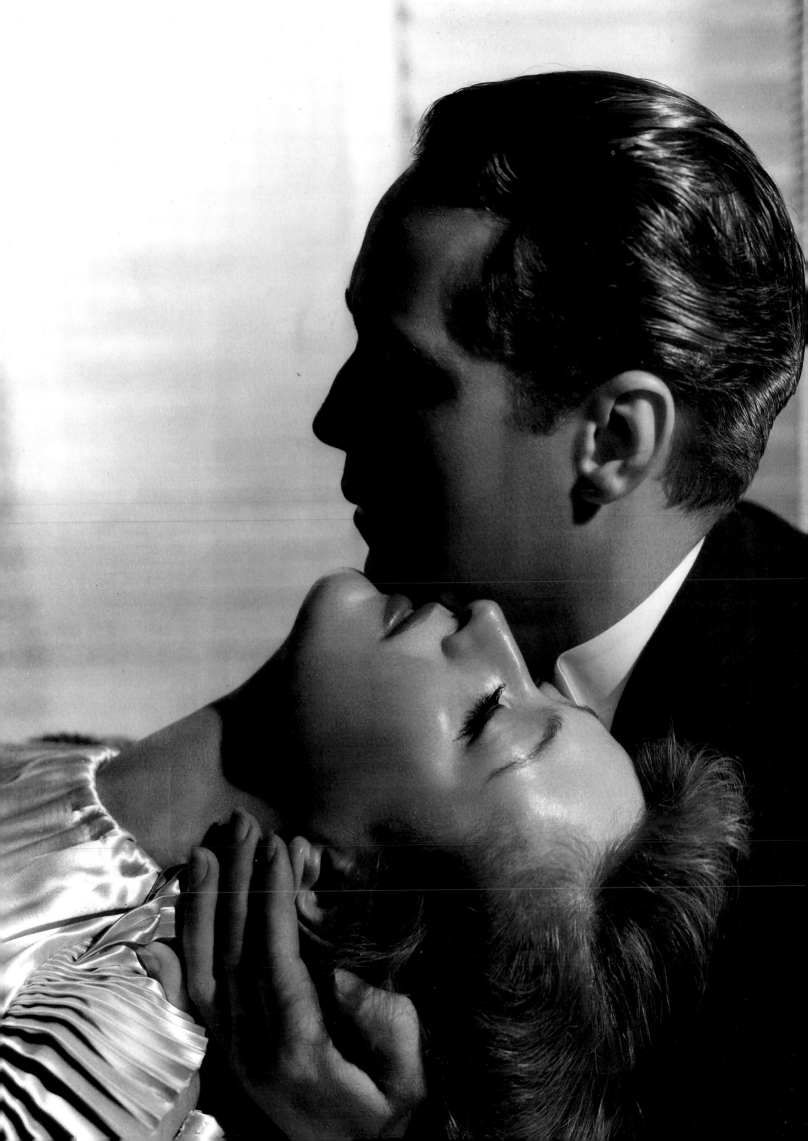

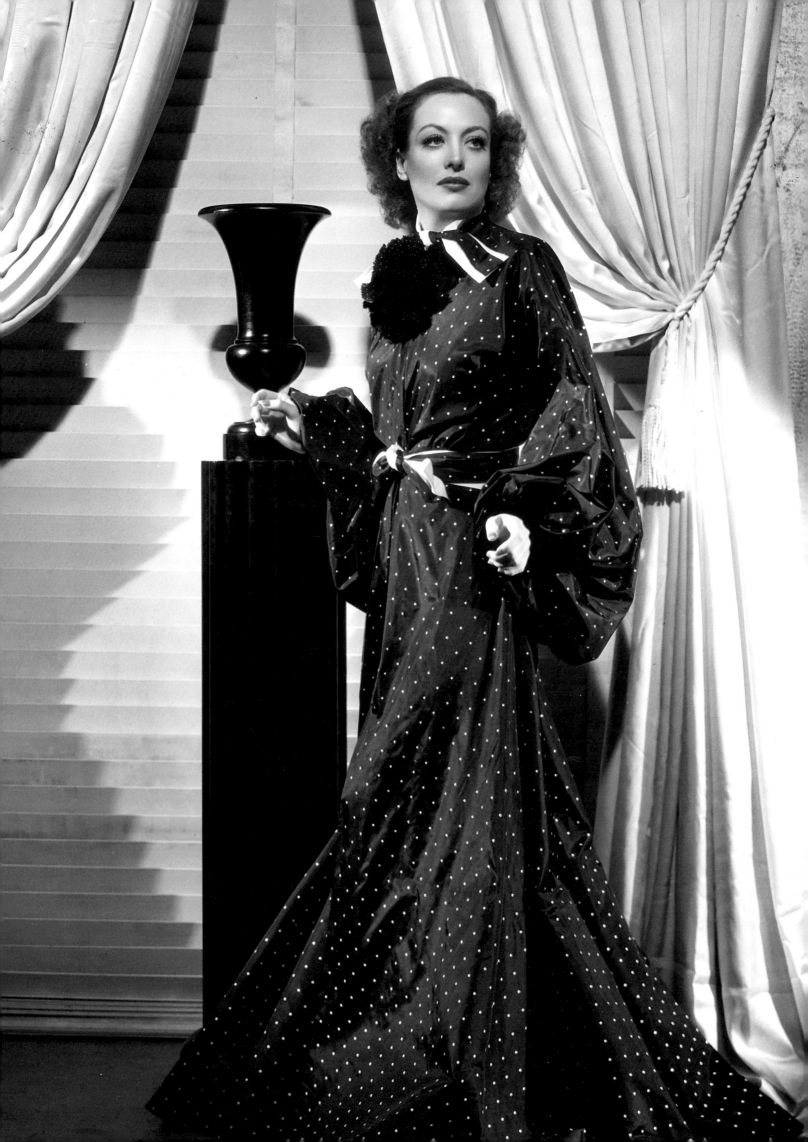

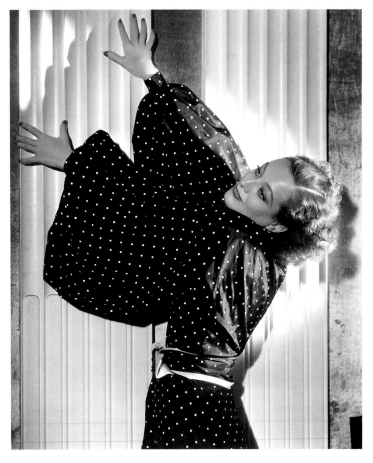

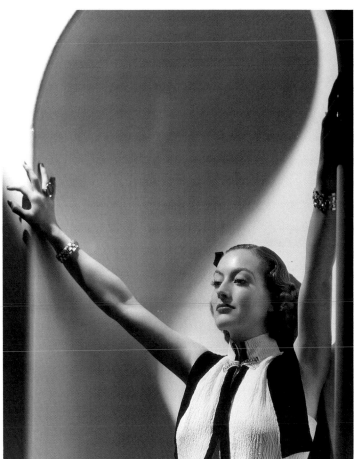

PAGE 144: *195. "She was radioactive with belief in herself!" declared author Quentin Crisp in a 1979 lecture.*

PAGE 145: *196. Hurrell posed Joan Crawford and Franchot Tone on a couch in her living room, then used only one light to illuminate them.*

OPPOSITE PAGE: *197. Adrian's gowns lent themselves to dramatic poses. This one is from Clarence Brown's* Chained, *July 1934.*

ABOVE: *198. Crawford moved from pose to pose so quickly that Hurrell almost couldn't keep up with her.*

BELOW: *199. Crawford's arms and shoulders were often elements of design in Hurrell portraits, as were the standing sets of M-G-M films; W. S. Van Dyke's* Forsaking All Others, *1934.*

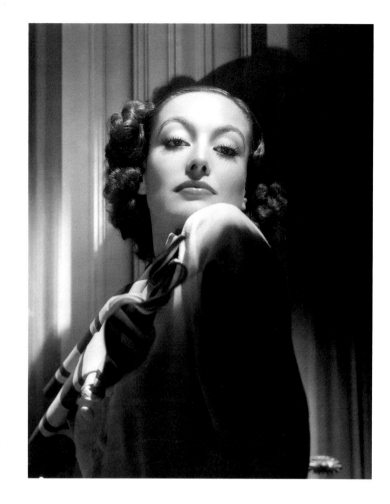

200. New York Times *critic Andre Sennwald wrote of* Forsaking All Others, *"Although in real life [the characters] would be pushed off the first convenient precipice by their outraged contemporaries, it is obvious that they regard themselves as the final quintessence of gay disillusion."*

201. *An April 1934 portrait for Clarence Brown's* Sadie McKee; *note how a soft light shining from below changes Crawford's face from the toplit mask of plate 200.*

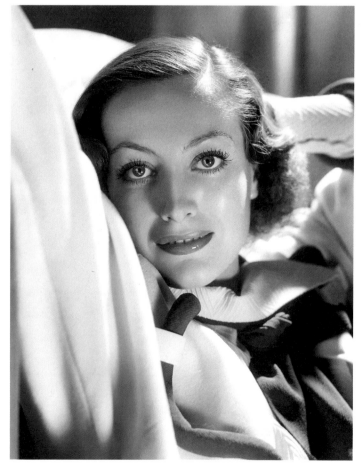

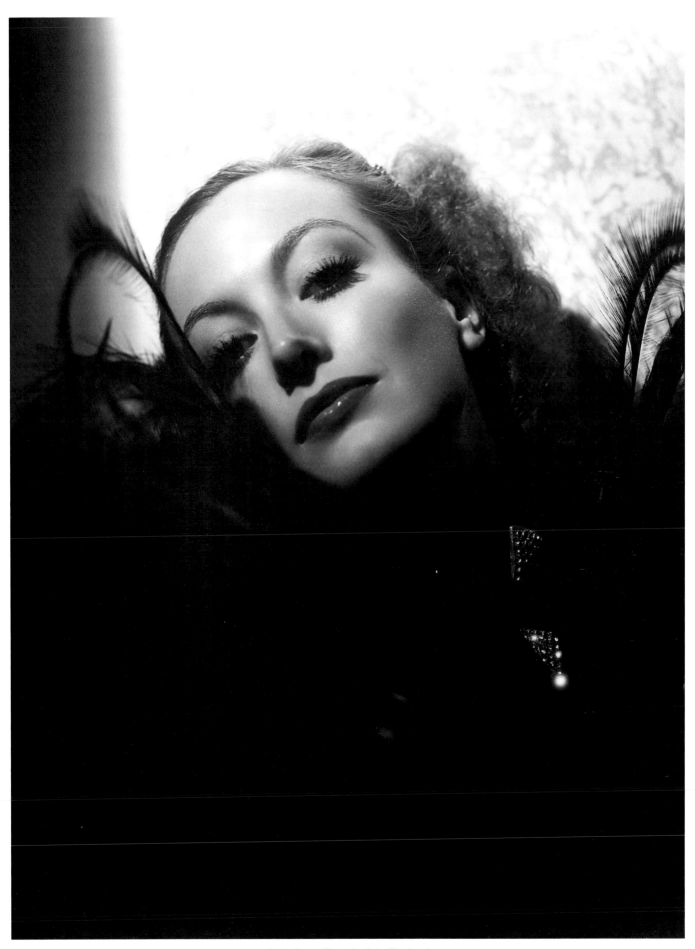

202. *Joan Crawford in* Chained.

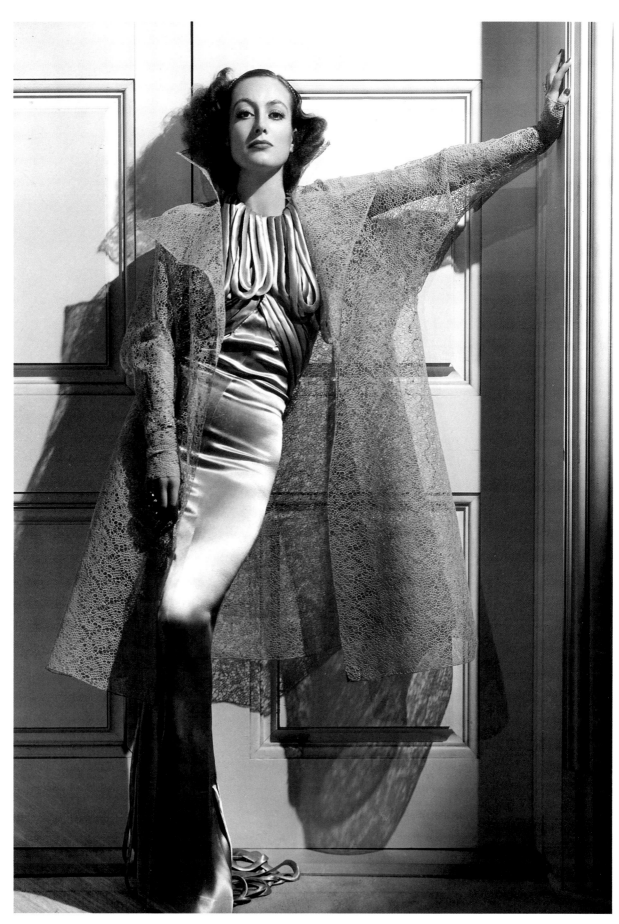

203. Joan Crawford in Forsaking All Others.

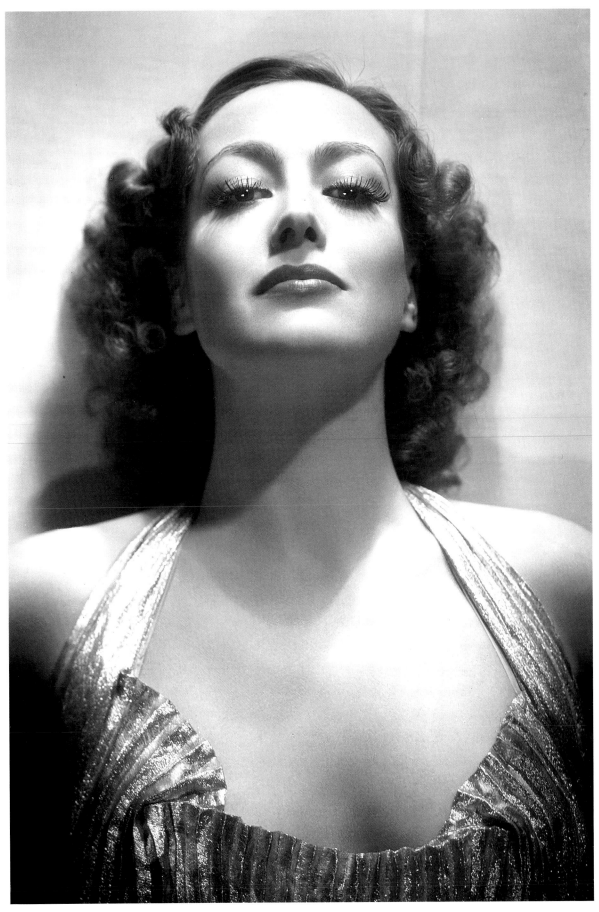

204. Joan Crawford in E. H. Griffith's No More Ladies, *April 1935; the odd tonality of this portrait is due to Hurrell's light source—an overhead floodlight containing four lamps.*

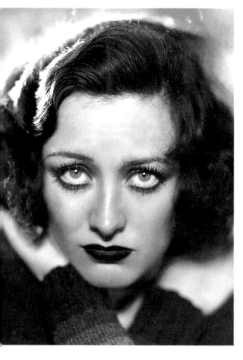

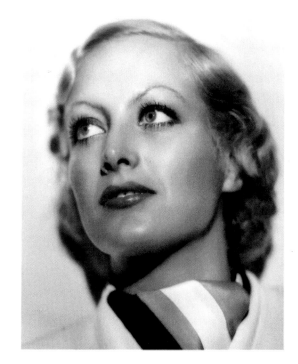

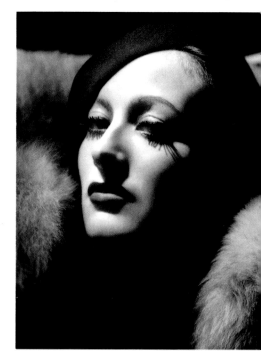

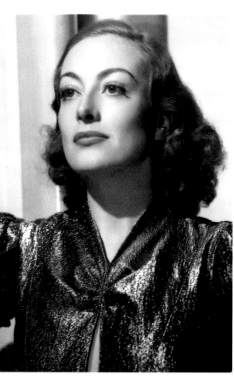

*Every year that
Hurrell shot Crawford, she
had a different face.
Here they are, beginning
with 1930.*
CLOCKWISE, FROM TOP LEFT:
*205. 1930
206. 1931
207. 1932
208. 1933
209. 1934
210. 1935
211. 1936
212. 1937*

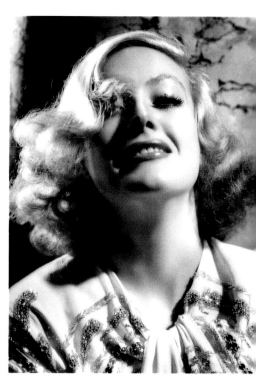

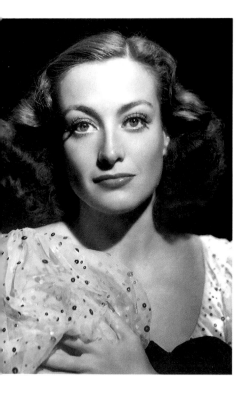

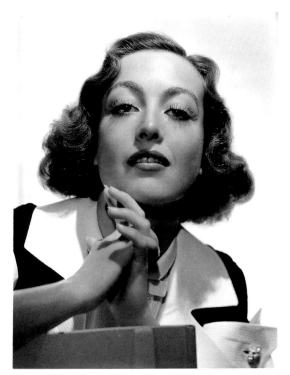

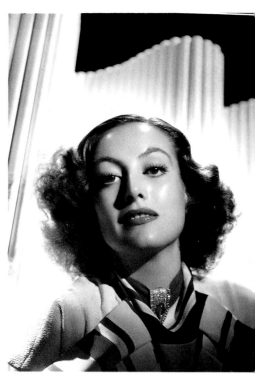

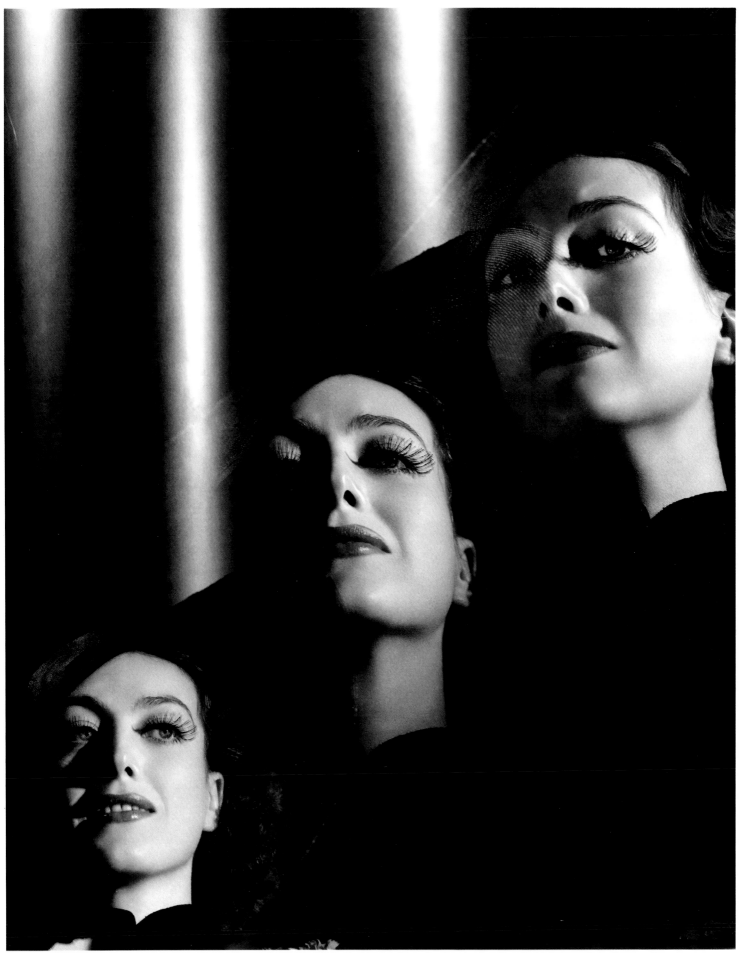

213. *"It has been said that on screen I personified the American woman,"* wrote Joan Crawford. *If she didn't, she certainly personified the American movie star, as in this triple exposure from* No More Ladies.

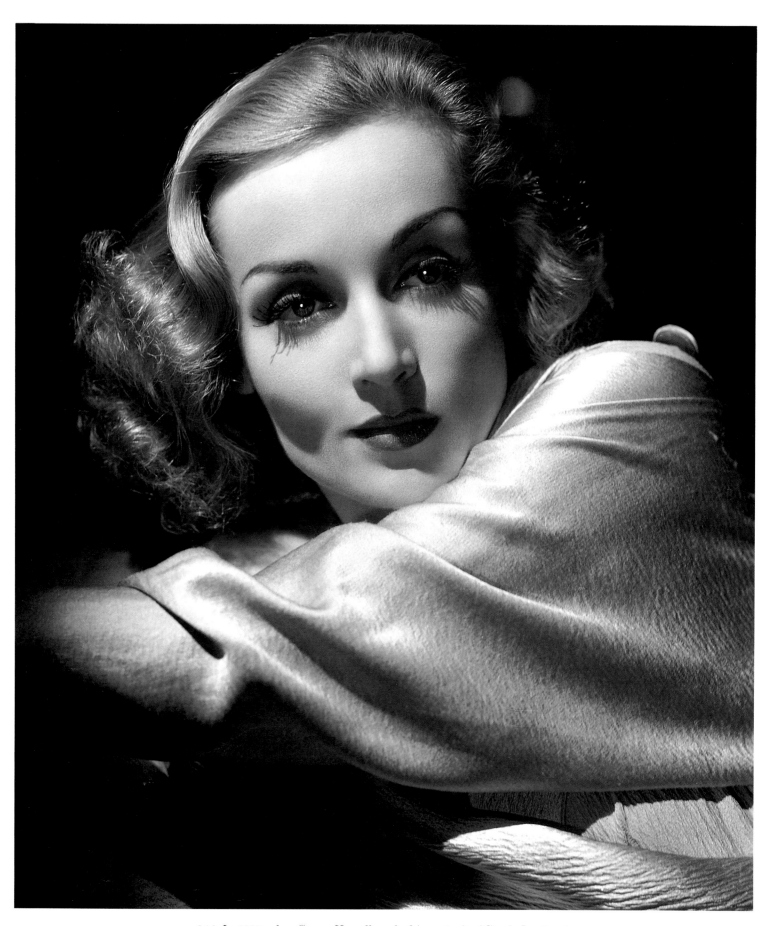

214. *In 1937, when George Hurrell made this portrait of Carole Lombard,*
she was hugely popular, well compensated, and was dating Clark Gable.

COMETS AT TWILIGHT

Until 1936, George Hurrell's Hollywood was a happy, productive place populated by beautiful, healthy people. The studios were enjoying renewed prosperity, and this time it looked as if it would last. "Those days were like a storybook," Hurrell said. "There was drama and romance every day. The stars had faces, electric personalities. They were truly glamorous people and that was the image that I wanted to portray."

Few stars were more glamorous than Carole Lombard. Along with Shearer, she was one of Hurrell's first color subjects for *Photoplay,* and, like Dietrich, she had a thorough understanding of lighting technique. She was in charge of her own career, but as Hurrell recalled, "She never gave me any trouble. She was a real professional. Whatever you asked her to do, it was always fine with her."

She had one quirk. "She could swear so fast a truck driver couldn't keep up with her. She did it to get attention. When Clark Gable was around, he was so embarrassed . . . he would turn red in the face. The more he tried to get her to quit, the more she would swear, just to aggravate him. She had him wrapped around her little finger." It was all in fun, though, and never interfered with the progress of the sitting.

In 1938, Hurrell gave his opinion of America's highest-paid star: "Carole Lombard has a knack for striking poses that are stately and graceful without being artificial. Ordinarily I don't like the poses of actresses, but I like Carole's. The modeling of her face is excellent, but I have to use a top light with her, because a flat light would emphasize her jaw and that's one thing she is particular about. She's a lot of fun to work with."

Sad to say, Hurrell would not work with this uniquely talented woman again. She died in 1942, one of the first American civilians to be lost in World War II.

In September 1936, no one in Hollywood believed in death. "We were talented. We were working. We were making money and assumed it would always be so. We didn't fret and worry about it," recalled Hurrell. "We were too busy being alive. We were the children of the gods." Among these children were Irving Thalberg and Jean Harlow, both prodigies and both friends of Hurrell's.

Hurrell, along with Clarence Bull and Ted Allan, worked to make a success of Thalberg's heartfelt but ill-advised project *Romeo and Juliet.* Hurrell spent a day in January shooting Shearer in Oliver Messel costumes on Cedric Gibbons's opulent sets and produced images of a delicate loveliness. It was his last sitting with Shearer. The film premiered on September 3. On September 14, Irving Thalberg died of pneumonia. He was thirty-seven years old. His widow later said, "He looked more like a starving violinist than a producer. Hollywood still mourns his loss . . . the original Boy Wonder." Greta Garbo said, "I liked him. But he died much too early. The best die young."

In March 1937, Jean Harlow turned twenty-six. To the world, her life looked blithe and privileged, but it was laced with frustration and resentment. One evening Rosalind Russell began to admire Harlow's famous polar bear rug, then noticed that "half the bear's fangs were missing, and the ones he had left were sticking straight down toward his throat. 'What happened to his teeth?' I said. 'I kicked 'em in,' said Jean."

Harlow came to Hurrell's studio for a sitting that would combine wardrobe from the already completed *Personal Property* with wardrobe from the upcoming *Saratoga.* As soon as Hurrell saw her, he knew something was wrong. "I could tell she wasn't well," he recalled. "She looked heavier, and she faded fast."

The added weight was a kind of bloating. Hurrell dealt with it by shining a bright light on the background behind her waist, then opaquing the negative to approximate her former slimness (plate 219). But he couldn't disguise her wan, defeated mood. Less than three months later, Harlow died of degenerative kidney disease. Hurrell later said, "This girl was driven like you'd drive a team of horses. They just worked her to death."

In July 1937, M-G-M hired a well-known European portrait photographer named Laszlo Willinger, and this time there was an ironclad contract; it even included television rights.* Consequently, Hurrell was informed that M-G-M could no longer afford to send contractees to his studio. In the aftermath of Thalberg's death, Shearer had taken a leave of absence. Hurrell's patron was not able to speak in his behalf, nor was Joan Crawford, whose popularity had taken a sudden dip. L. B. Mayer had waited five years, but he was finally able to fire Hurrell.

At the time, Hurrell was shooting for every major studio but Warner Brothers, and he didn't really care. In fact, he was getting fed up with having to deal directly with movie stars. "I got tired of being a businessman, having to greet people, and sit and discuss with them whether they liked the picture or not. [Before that] I just took the picture and ran."

But he couldn't run from his own reception area when a star didn't like his retouching. He later quoted an anonymous star:

"That's not my mouth, George."

155

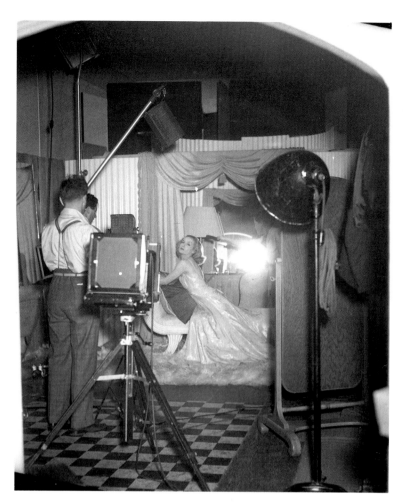

"Well, if it isn't your mouth, whose is it?" he retorted unsympathetically.

"I don't know, but it's not mine. Fix it," said the unnamed star, whose studio was paying $1000 for photos of her and her mouth. Hurrell had no choice but to unretouch the negative and then reretouch it. He didn't like it one bit, and quoted James McNeill Whistler: "A portrait is a picture with something wrong with the mouth."

"I'm not a good straw boss," said Hurrell later. "I had to be everything—businessman, retoucher, salesman, collector, and sometimes comforter for people who didn't photograph as well as they expected."

By the summer of 1938, Hurrell had been at 8706 Sunset for nearly six years. This was an awfully long time for him, and he was bored silly. "Just about the time I was threatening to drink my hypo [i.e., sulfuric-acid fixing bath] to ensure a forced vacation, Warners sounded me out on a job."

ABOVE: *215. This portrait session was done to publicize Wesley Ruggles's* True Confession. *This uncredited behind-the-scenes shot shows Hurrell (partially hidden) posing Carole Lombard.*

BELOW: *216. Here is the finished portrait of Lombard.*

OPPOSITE PAGE: *217. Another portrait made with the same setup, but with a mink coat and a different backdrop.*

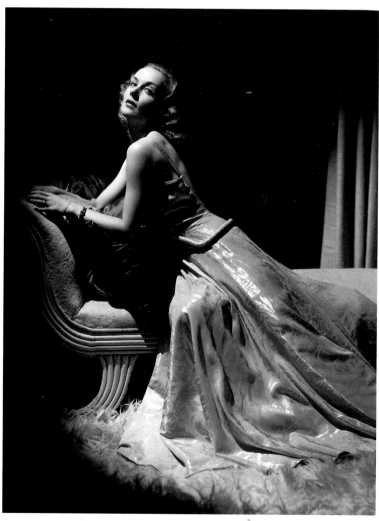

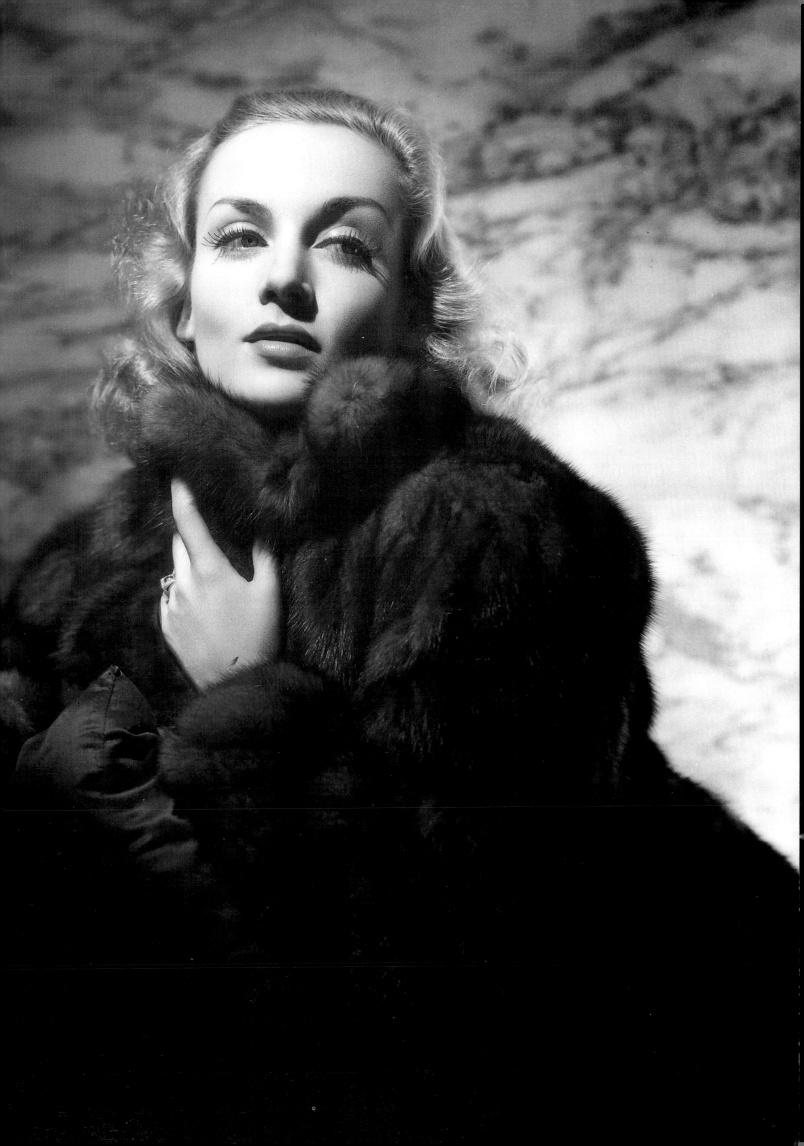

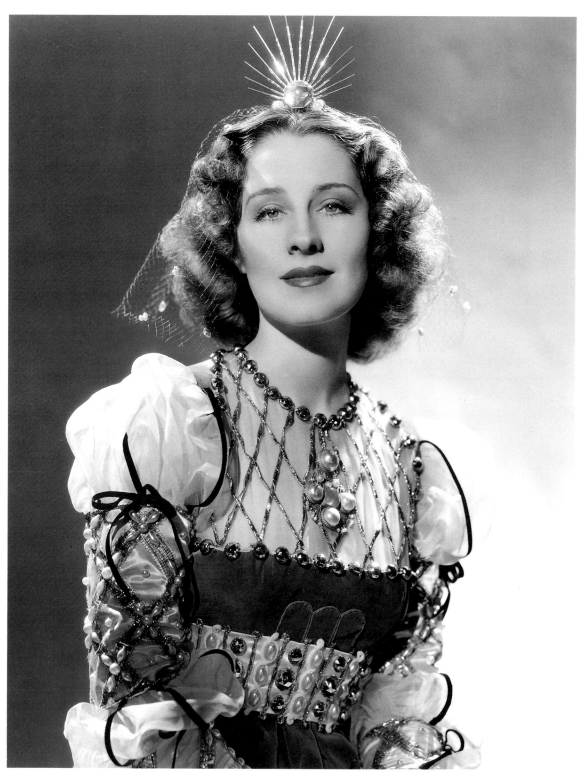

218. *Hurrell's last session with his patron Norma Shearer took place in January 1936, on the set of* Romeo and Juliet.

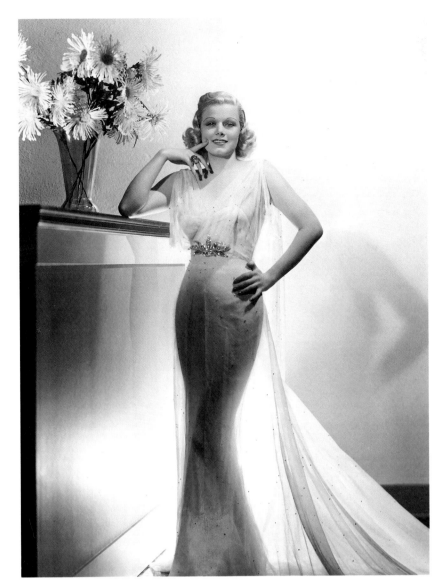

219. *Hurrell's last sitting with Jean Harlow took place in April 1937, when he photographed her in costumes from* Personal Property *and* Saratoga.

220. *Hurrell's longest tenure at any studio was at his own: six years at Hurrell Photography, 8706 Sunset. This 1937 photo was made by Dick Whittington.*

BURBANK AND BEVERLY HILLS 1938–43

"God, if you wish for our love,
Fling us a handful of stars!"

—*Louis Untermeyer,* Caliban in the Coal Mines

THE WARNERS LOOK

I n the summer of 1938, George Hurrell was approached by the Warner Brothers–First National Studios. Robert Taplinger, publicity chief, knew that Hurrell was ripe for a change and offered him a contract as head portrait photographer for two years at $350 a week. On July 11, Hurrell wrote to Taplinger, asking for $400 a week during the second year of the contract. He signed the letter "Georgie." His request was refused. On July 20, Hurrell signed the contract.* On August 1, he wrote his last check to Montgomery Properties, for $75, and closed down his operation at 8706 Sunset.

Hurrell's last period of artistic evolution was marked, as usual, by a change of geography. When he went to Burbank on September 1, he took over the most sophisticated portrait gallery in Hollywood. It was spacious, well appointed, and well staffed. One of three galleries situated in the center of the Warners lot, it even had a storage loft and doors tall enough to admit upright scenery. Working in the other two

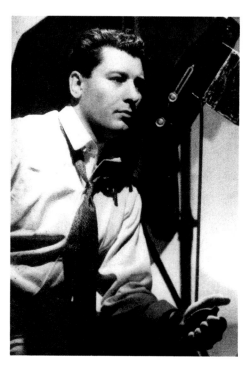

221. George Hurrell's self-portrait was made for a 1938 Warner Brothers publicity push.

galleries were Elmer Fryer, a Warners veteran who shot portraits, and Scotty Welbourne, a newcomer who shot fashion. The studio also employed a full-time film processor, six retouchers, ten printers, and five print finishers. This efficient team turned out 100,000 prints a year.

The productivity of the entire studio was due to the tight-fisted management of the brothers Warner. Harry Warner said, "Listen, a picture, all it is is an expensive dream. Well, it's just as easy to dream for $700,000 as for $1,500,000." Albert Warner called his assembly-line studio "The Ford of the Movies."

Jack L. Warner routinely recycled scenarios; and he patrolled soundstages, turning off lights left burning by errant employees. The typical Warners film was topical, hard-hitting, and slick. This fare appealed to a proletarian audience, but it still had to compete with the M-G-M gloss and the Paramount glow. George Hurrell could give Warners an edge, and so his contract excluded any outside work. He had been shooting movie stars for Lux Soap, and even appeared on the Lux Radio Hour, where Cecil B. DeMille introduced him, saying that "Hurrell is to a portrait camera what Rembrandt was to paint and canvas." He gave up Lux, but kept *Esquire,* with the provision that he shoot only Warners

starlets for the publication.

The first star Hurrell had to publicize at Warners was himself. Taplinger declared him a celebrity, had him shoot a self-portrait, and began placing stories about him. They ranged from items such as "He's [a] Landmark in Hollywood" to "Studio Photographer Confesses." Within a year, he was the subject of eight features. A colorful interview subject, he began to receive his own fan mail. He and Katherine were now living in a large apartment at 1360 North Crescent Heights Boulevard. Although he could no longer walk to work, the twenty-minute drive through the Cahuenga Pass was a pleasant one, especially when he'd be welcomed as warmly as any of the stars he was shooting.

The look of Hurrell's fifth period of work was in keeping with his employers' product, acquiring a hard, lacquered reflectivity. There were technical reasons for this. First, he changed film stocks. For six years he'd been using Super Sensitive Pan, even after Eastman changed its base from the unstable, inflammable nitrate to the easily storable diacetate. But the new "Safety Film" was no faster than nitrate; it was the equivalent of today's ISO 125. In the late 1930s, Eastman introduced a number of "fast" (i.e., light-sensitive) new films: Super XX, rated at 200; Panchro Press, rated at 250; Super Panchro Press, rated at 400; and the ever-popular Tri-X, rated at 500. Hurrell chose Panchro Press because of its dramatic contrast. It even made contact prints sparkle and allowed him to shoot at an amazing 1/50 of a second—with his new 10-inch Goerz Celor lens stopped down to F/16. At this f-stop, his prints had an almost scientific clarity.

Next, Hurrell changed lights. His new workplace was equipped with not one but two boomlights. He had neglected to patent his invention, so it was being manufactured by many companies. Warners used the "Boom Lite" sold by Beattie's Hollywood Hi-Lite Company for the nominal fee of $68.* This lightweight adaptation had superior maneuverability, enabling Hurrell

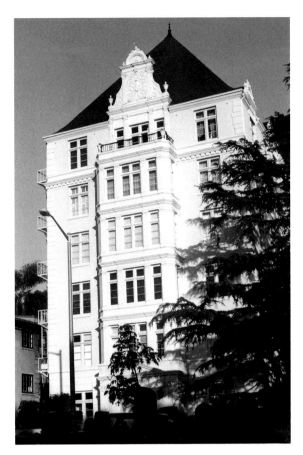

222. 1360 North Crescent Heights Boulevard (author's photo).

to light his subject from angles that would be inconceivable with lightstands. Using two boomlights at once made his work soar to new heights, both literally and figuratively. Further aided by the "boom" of the boogie-woogie music from a cabinet phonograph, he went to work.

This was where Hurrell went into high gear, leaving competitors and imitators behind, drawing from his own life to create tangible expressions of intangible fantasies. It began in 1933, when he had Madge Evans or Conchita Montenegro lie across a black satin pillow, hair cascading toward the camera. He discovered that shooting down toward a supine woman whose head was pointed toward the camera gave a look of unmistakable eroticism. As Josef von Sternberg said, "The power of glamor in a photograph . . . consists of the evocation of sexual surrender." Hurrell experimented with this effect over and over in his *Esquire* series, finally perfecting it at Warners with Ann Sheridan.

In 1938, the columnist Walter Winchell described Warners player Ann Sheridan as "umphy." Robert Taplinger seized on this item, changed the spelling to "oomph," and it took off. Sheridan said, "They got George Hurrell to take sexy-looking photos of me—he didn't know what 'oomph' was either—and it snowballed on them." The word and the photos created a sensation, and Sheridan suddenly had some much-needed bargaining power. "All that silly fuss gave me a chance to fight for better parts. Of course, at Warners everybody seemed to have to fight. . . . You didn't always win, but it let them know you were alive."

Once again, a series of Hurrell photos had been used to change the course of a career. He didn't care about the studio's long-range schemes. The most important thing to him was the next nubile subject. "They are all sexy," he said in 1940. "Every one of them. They are the wickedest-looking women in the world. And my job . . . is to make them look even more wicked." He did it with his patented gallery manner, but turned on full force (see plates 236–242).

Every once in a while, I'd get carried away and say "Lie down."

"What do you mean 'Lie down'?" I'd get a reaction like that. And when I had them on the floor, I'd shoot down and automatically it changed the whole business of what they were going to do. . . . You know, glamour to me was nothing more than just an excuse for saying sexy pictures.

One writer heard Hurrell say as he aimed the camera: "Oh, you're so good to me!" Another heard him say, "One more—for a hot cup of coffee!" A third heard, "Give!" In the studio, Hurrell was a law unto himself; at least he wanted to give that impression. A born showman, he knew that hyperbole garnered newsprint. Reporters knew that there was never any question of familiarity between artist and model. Sessions were conducted only during work hours and in the presence of two assistants, a makeup artist, wardrobe person, and a publicity representative. Hurrell enjoyed these silly, sexy performances, and the press did, too. In October 1939, he told *Coast* magazine that his rule was "Shoot for the sex angle first; you should try something else only if that fails."

How seriously he took these sensational exercises was revealed in *Esquire:* "There are friends who testify that after he had spent a day photographing the oomph girl in all her glory he spent nine hours painting the gnarled trunk of a pine tree."

His next assignment was only slightly less grand. He was called upon to glamorize Hollywood's newest Queen.

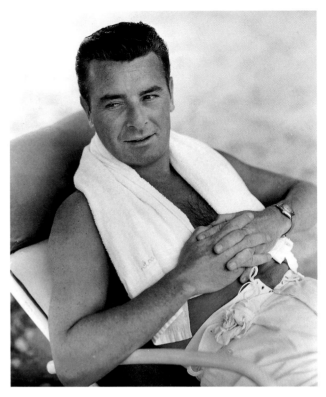

223. *George Brent was working in Edmund Goulding's* The Old Maid *when Hurrell made this 1939 portrait.*

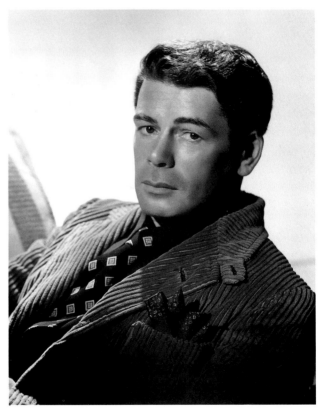

224. *Paul Muni had just finished* Juarez *when he posed for this January 1939 portrait. Working without any makeup made him uncomfortable; in William Dieterle's film, he had been rendered almost unrecognizable. A studio employee bumped into him and exclaimed, "Jesus Christ!" Muni responded, "No—Benito Juarez."*

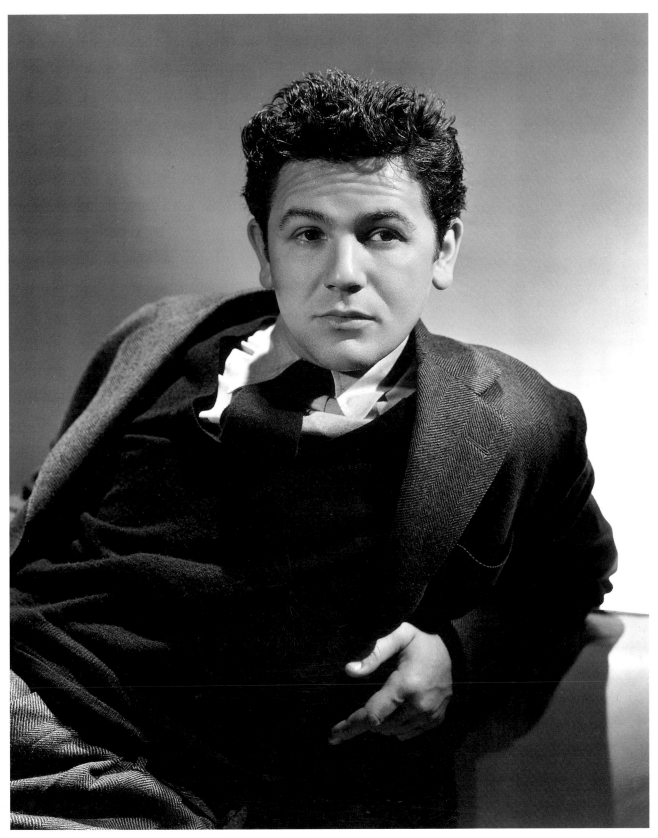

225. A 1938 Hurrell portrait of John Garfield.

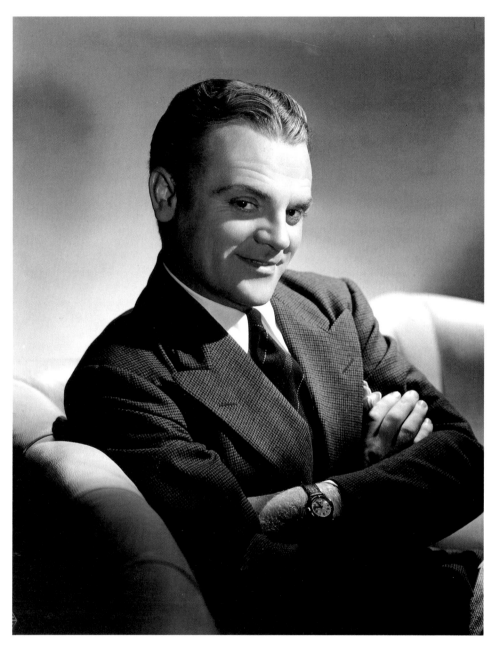

226. A 1939 portrait of James Cagney.

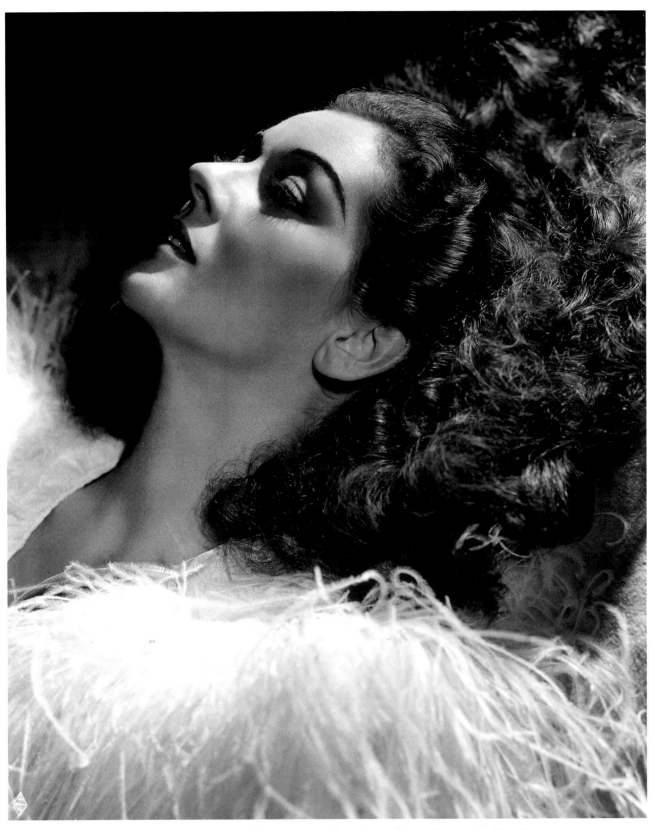

227. Rosalind Russell didn't mind Hurrell's antics, as long as he retouched her face
to an alabaster smoothness. This portrait was made in 1940 for William Keighley's No Time for Comedy.

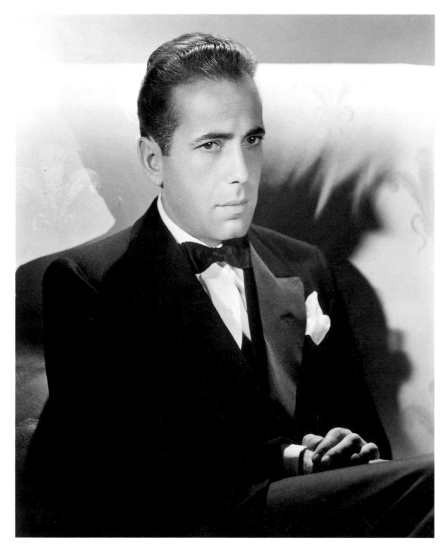

LEFT: *228. A portrait of Humphrey Bogart for Michael Curtiz's 1938* Angels with Dirty Faces.

BELOW: *229. A 1939 portrait of Olivia DeHavilland for Michael Curtiz's* Dodge City; *the intelligent, sensitive actress found Hurrell's wordplay offensive—and told him so. His portraits of her were among his few failures. She never looked comfortable.*

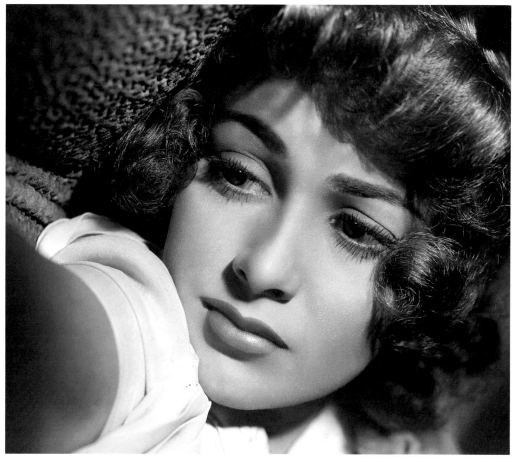

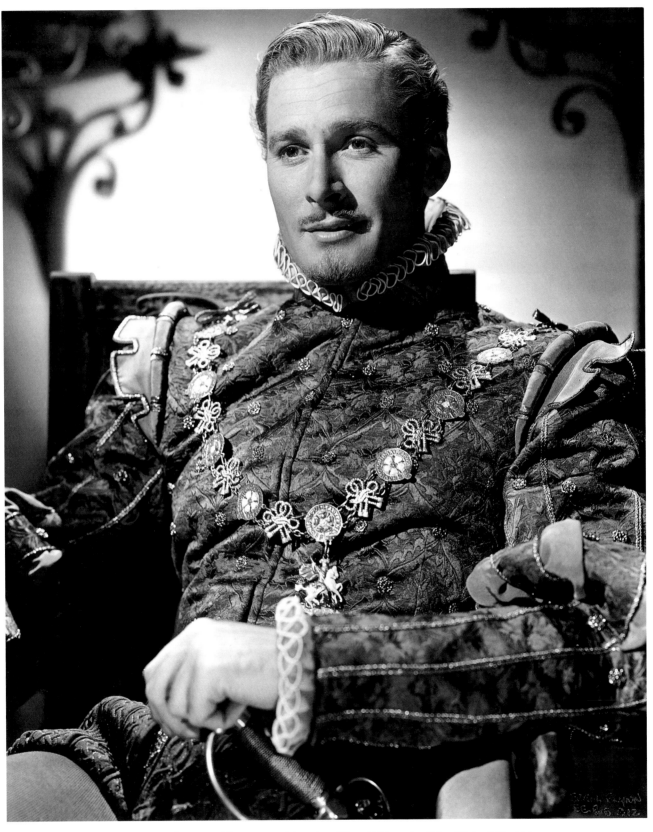

230. Errol Flynn, without retouching, in a May 1939 portrait for Michael Curtiz's
The Private Lives of Elizabeth and Essex.

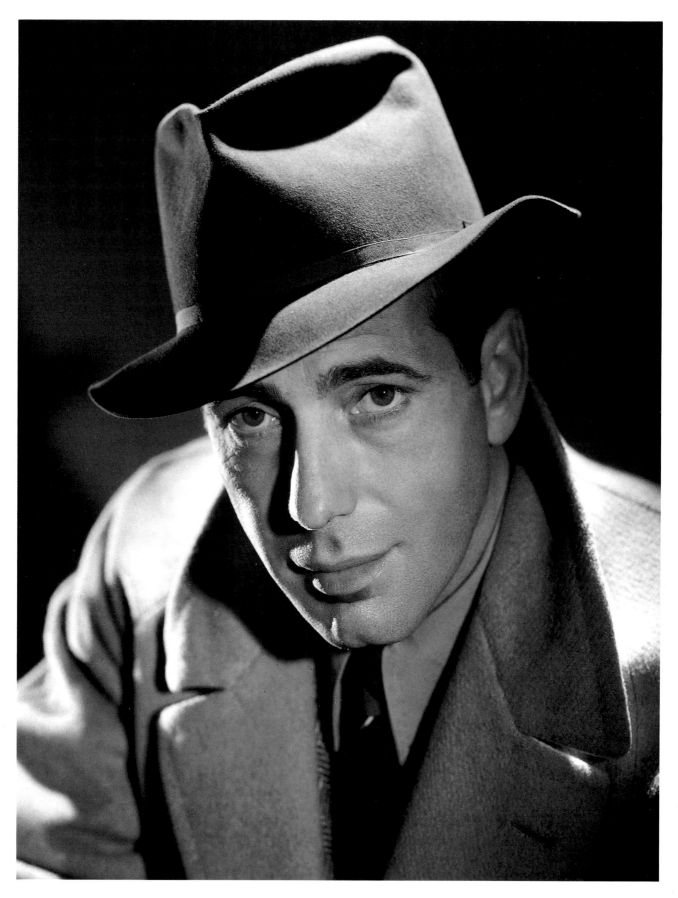

231. *Hurrell photographed Bogart time and again during his two years at Warners, but only after Hurrell left did Bogart become a star.*

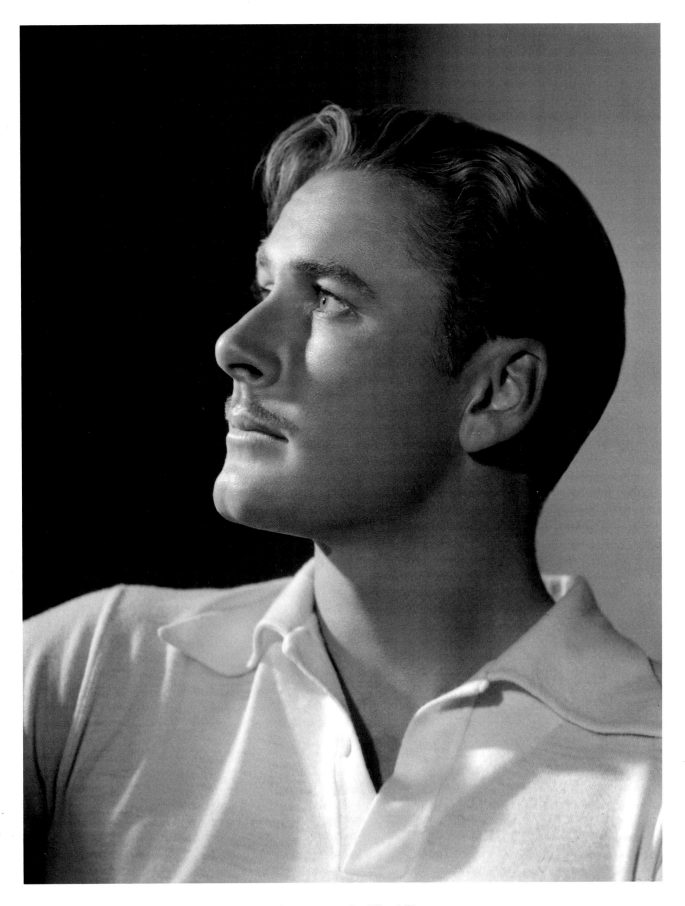

232. *A 1938 portrait of Errol Flynn.*

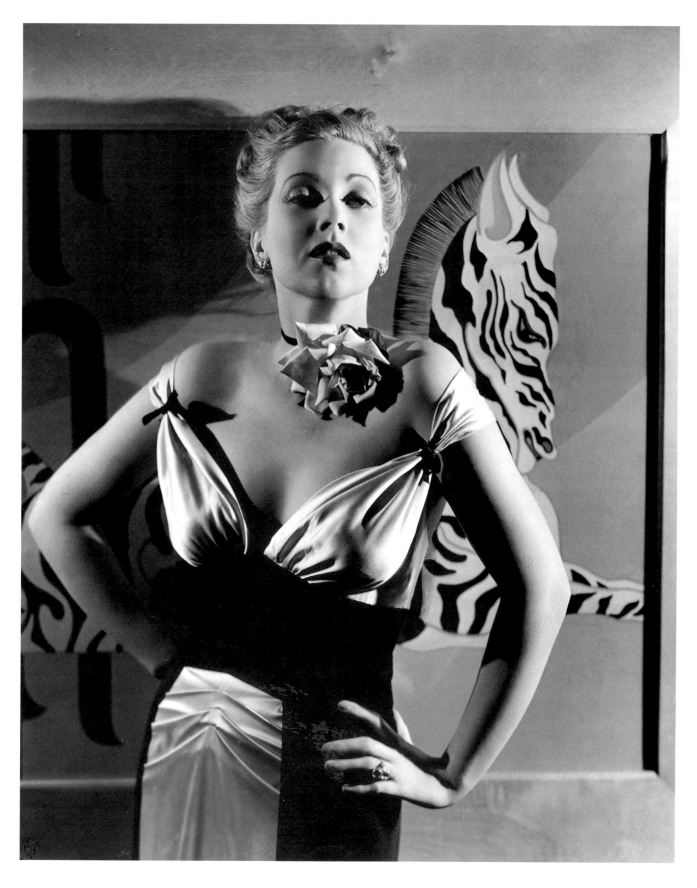

233. *Hurrell balanced zebra stripes and satin striations in this 1940 portrait of Ann Sothern for Lloyd Bacon's* Brother Orchid.

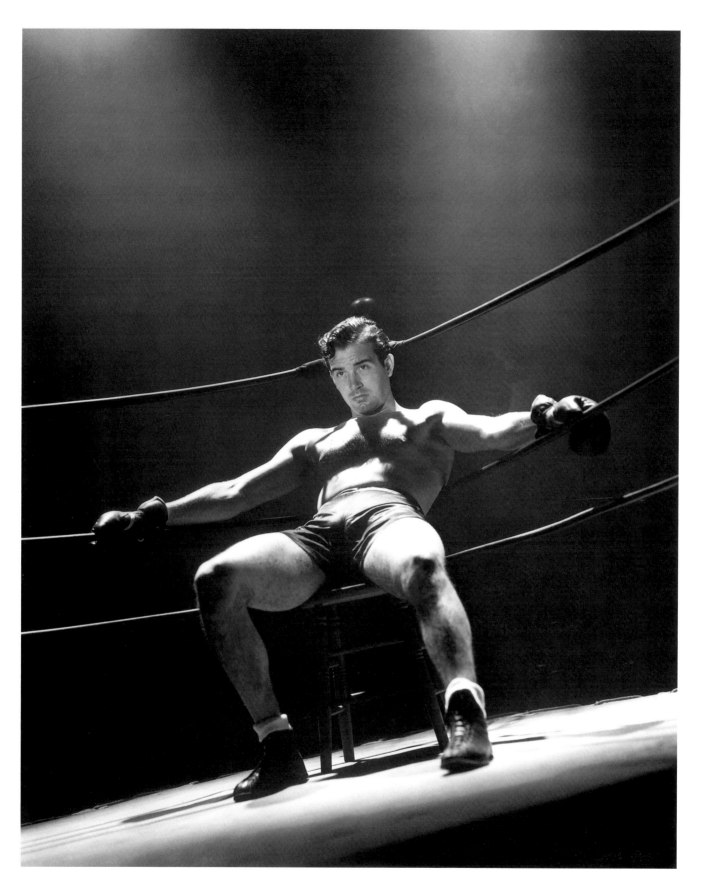

234. A 1939 portrait of John Payne for George Amy's Kid Nightingale.

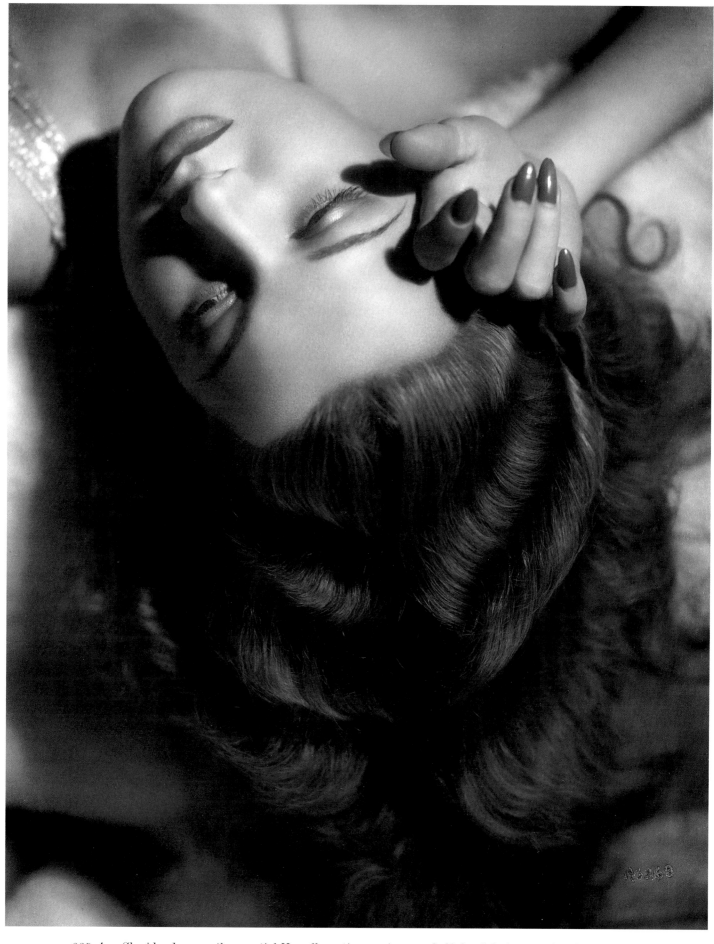

235. *Ann Sheridan becomes the essential Hurrell creation: supine, eyes half-closed, hair streaming downward as a warm spotlight plays on flesh and fingernails.*

236. *An overhead view of the Warner Brothers portrait gallery reveals Hurrell at his camera and, under the boomlight, Ann Sheridan. On the dark chaise (upper left) are a makeup artist and Sheridan's ciré satin jacket.*

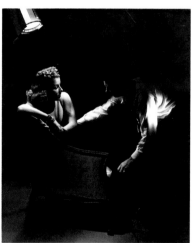

237. *Hurrell moves in front of the fill light to precisely position Sheridan's foot.*

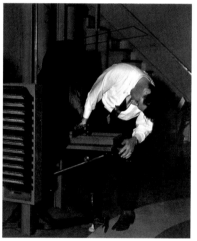

238. *The ground glass of a view camera only shows the subject upside down; hence, Hurrell's hinged neck.*

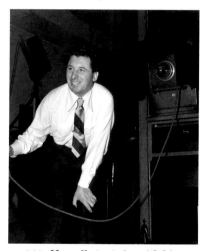

239. *Hurrell starts in with his mumbo jumbo.*

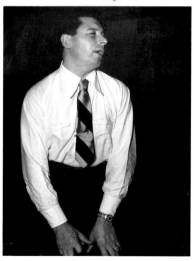

240. *"Why are you so good to me?" he asks.*

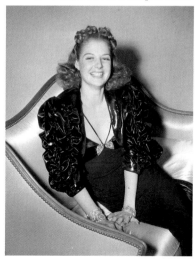

241. *Ann Sheridan breaks up.*

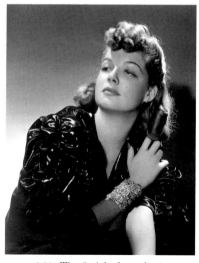

242. *The finished product, a seductively glamorous "Oomph Girl."*

173

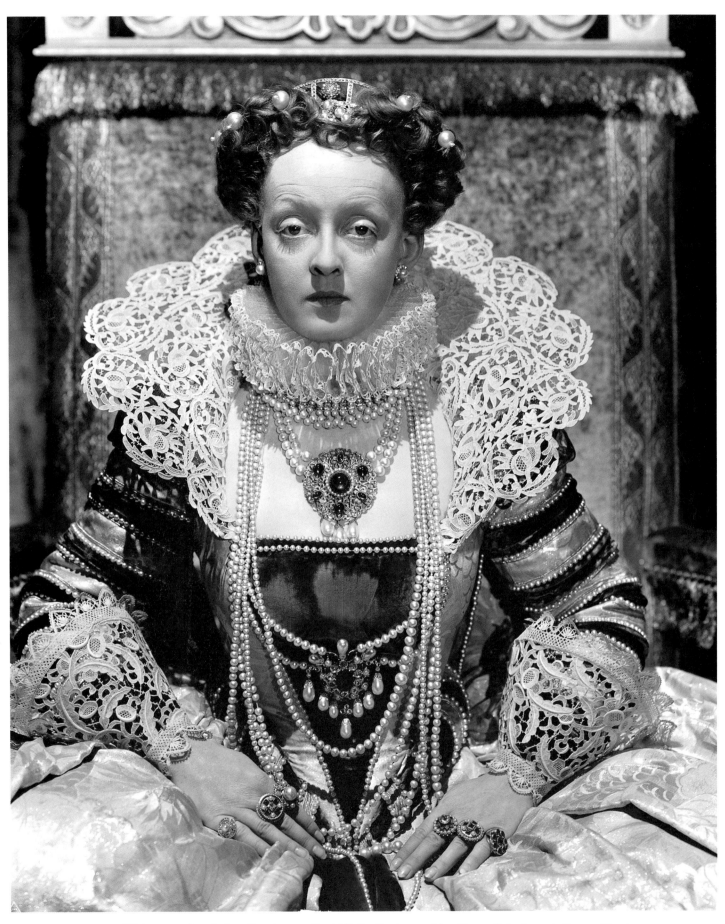

243. *"To be queen is to be less than human," said Bette Davis, speaking Maxwell Anderson's famous line in Michael Curtiz's* The Private Lives of Elizabeth and Essex.

GLAMORIZING "THE ACTRESS"

I n 1939, Bette Davis was the biggest moneymaker at Warner Brothers, completing five films in twelve months, and contributing heavily to a $2,000,000 profit. An exhibitors poll declared her America's most popular star. The fan magazines were laden with portraits of her by Elmer Fryer and Bert Longworth, but the portraits were mostly in character. After all, she was a unique Hollywood commodity, "The Actress," more concerned with the honesty of her performance than with her appearance. There were no full-length mirrors for her, and some of her characterizations were downright scary (plate 243).

George Hurrell, meanwhile, was prettifying the rest of the Warners roster and moving Katherine and himself into a new house. This rental was above Sunset, at 1348 North Miller Drive. When Hurrell shot Davis in character for *Juarez*, there was no fuss, just seventy-two plates in seventy-eight minutes.* Then Taplinger decided that Davis, too, must be glamorized.

"I don't want some glamour girl stuff," Davis said. "I want to be known as a serious actress, nothing else."

Hurrell suspected why: "Every now and then we run across some new actress who approaches my studio with genuine fear. She has heard that I am a man who takes sexy pictures. She doesn't know what will happen to her once she gets into my studio. Will I order her to take off all her clothes right then and there? She suspects as much."

Whatever Bette Davis suspected, posing for portraits was in her much-contested contract, and she had no choice but to show up. Hurrell greeted her effusively: "You're the most glamorous gal in pictures and I'm going to prove it!"

"Go easy on the glamour, George," she warned. "I'm not the type."

Hurrell turned on the phonograph, loud. When asked why he played it for his subjects, he answered,

244. 1348 North Miller Drive (author's photo).

"I don't play the music for them. I play it for myself. I've got to keep myself pepped up."

Davis was used to being the performer, but here Hurrell was the madcap, running to and fro, singing with Cab Calloway, pushing a light, tripping over a thirty-foot hose. He later explained: "All I had was a bulb in my hand. [The] shutter would open and close based on the air pressure in that bulb. . . . The subject wouldn't know when the actual photograph was being taken because I would make much more noise pushing the air out of that bulb than the shutter would make releasing. This would defeat their interest in holding a pose."

Davis loosened up and Hurrell cut loose. "I don't remember what I said to her, but it broke her up so much tears would run down her face. That caused makeup problems, but her smiles were real, not forced."

When Davis saw the proofs, she exclaimed, "Hell, these are fine!" After this general-purpose glamour sitting, Taplinger commissioned a series of sessions to comprise a new ad campaign. "Study This Face" (plate 247) challenged Hurrell to create many faces for the most recognizable star at Warners. The campaign was devised to promote Davis's new film, *Dark Victory*. In it, she played a headstrong society woman who discovers that she has terminal cancer and then musters the courage to put her life in order. One of Hurrell's sittings recorded not only Davis's sensitive portrayal, but also some unnamed torment: "There was something in her face that I'd not seen before . . . a special kind of beauty. I played classical music, which I didn't often do for her, because we both liked upbeat tunes. When I looked through the lens, there was a compelling force about her, a kind of inner anguish" (see plates 248, 249).

He never learned the reason for this sadness, but felt that it added to the resonance of the portraits. By the time of their next session, Davis's usual cheer had returned, but she could still impart whatever mood Hurrell required. "She had the ability to switch from a gay, laughing pose to a completely dramatic attitude in a matter of seconds," he recalled.

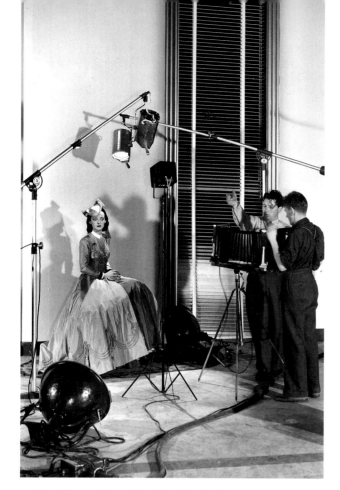

245. *George Hurrell, assisted by Al Harvey, shot Bette Davis's in-character portraits for William Dieterle's* Juarez *on a vacant modern-day set. Note that Hurrell was now using two boomlights, as well as a small spotlight, and a floodlight on the floor. (Photo by Schuyler Crail.)*

Robert Taplinger needed something unusual for the centerpiece of the "Study This Face" layout. Could Hurrell make Davis look transfigured, spiritual? What was needed was the apotheosis of Bette Davis. To accomplish this goal, Hurrell implemented new techniques.

When shooting the average portrait, he used 500-watt lights. "If you can keep the light low-key," said Hurrell, "that's to your advantage. People aren't too conscious of the lighting—or blinking." He found that 500- or even 200-watt lights were better than 1000-watt lights. Lower wattages were less hot and they allowed for more bounce light—excellent for "skin texture and portrait work. When the light is too hot, you lose highlights."

For plate 252, Hurrell deliberately broke this rule. He put a 1000-watt spotlight two feet away from Davis's face and purposely overexposed the film, shooting various angles. Then he underdeveloped the film, thereby retaining the highlight detail that would ordinarily have been lost. His next step was to retouch the negatives as usual. He then projected two of these negatives onto one sheet of direct positive film, creating a double exposure in the darkroom. The result was an image combining technical wizardry and dreamy beauty.

One of Hurrell's last assignments with Davis was in the summer of 1940, for *The Letter.* She was at the peak of her fame, but Hurrell was slowing down. Working feverishly in the same room since 1938 was having the usual effect. "You think about shooting people day in and day out for two years at a stretch, especially when they are the same kind of people—to keep getting variety is maddening." One way to get variety was to shoot on standing sets, but it was expensive. "I liked the sets because you always had new things to work with, [but] you had to have a prop man, an electrician, and a grip . . . and that advanced the cost," Hurrell recalled.

He made arrangements with a reluctant Taplinger to shoot Errol Flynn and Bette Davis on the set of *The Knight and the Lady,* later released as *The Private Lives of Elizabeth and Essex.* While waiting for his stars to arrive, he chatted with the electrician. Hurrell heard a peremptory question from somewhere behind him.

"Well, what are *you* doing?" asked Jack Warner, obviously in the process of checking up on dawdling employees.

"Waiting to take some shots, Mr. Warner."

"Well, I'm not paying you to stand around talking," said Warner, who then walked away before Hurrell could collect himself. The humiliation of this pointless incident stayed with him. In July 1940, he

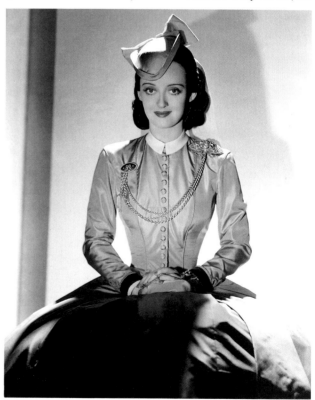

246. *Bette Davis was pleased with the results, but would not submit to the full glamorization process. "I will not be turned into a piece of shiny wax fruit!"*

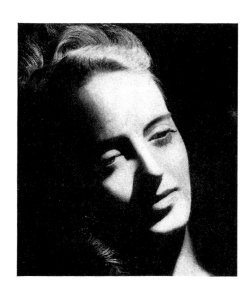

STUDY THIS FACE!

You'll never forget it. For here are forever written the ecstasy and pain of woman loved and loving. Here is the face of Bette Davis in her supreme dramatic triumph, "Dark Victory." Here is the screen's most gifted actress in a role which is destined to win for her another Academy Award. Watch for "Dark Victory"—a Warner Bros. presentation—in America's leading theatres soon.

247. The ad campaign for Edmund Goulding's Dark Victory.

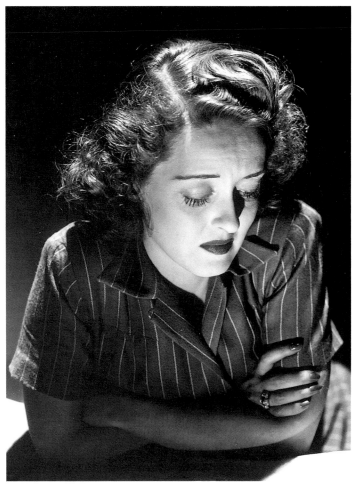

248. In 1972, Bette Davis said, "Hurrell was able to make you re-live the part from the film you had just finished."

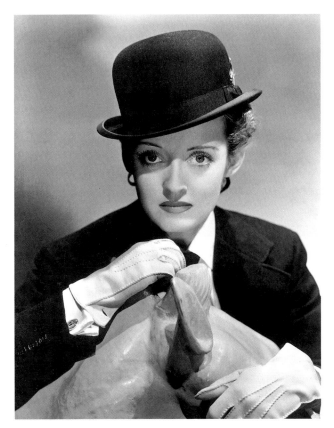

249. A 1939 Hurrell portrait of Bette Davis for Dark Victory.

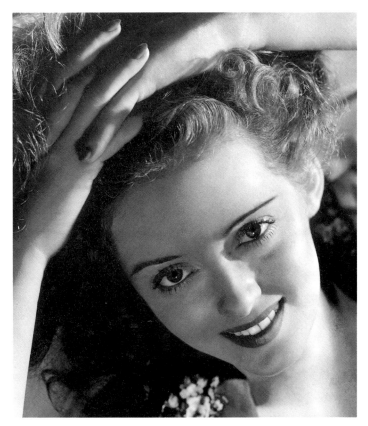

250. Davis gets the glamour treatment.

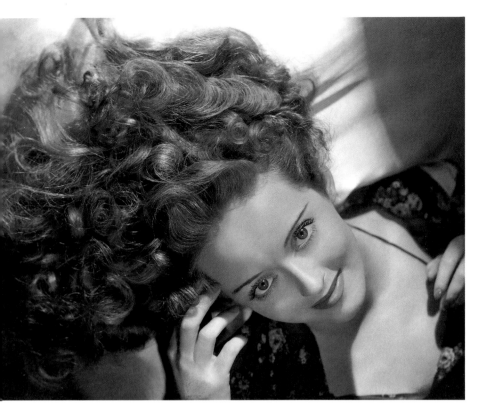

left for a three-week unpaid vacation. He went to New York, worked for some ad agencies, and his absence stretched to six weeks. Warner put him on suspension. He didn't care. In September, when his contract was up, he declined to renegotiate it. He worked off the six weeks of his suspension, and then, on October 15, he gave Jack Warner a farewell speech that should have been filmed.*

But this time he wasn't jumping without a parachute. He had eyes for Rodeo Drive.

251. In 1942, Hurrell said, "Bette Davis is Hollywood's most self-conscious portrait subject. She doesn't think of herself as photographically pretty. She's the most self-critical girl in Hollywood. Which is probably the reason why she's the greatest actress."

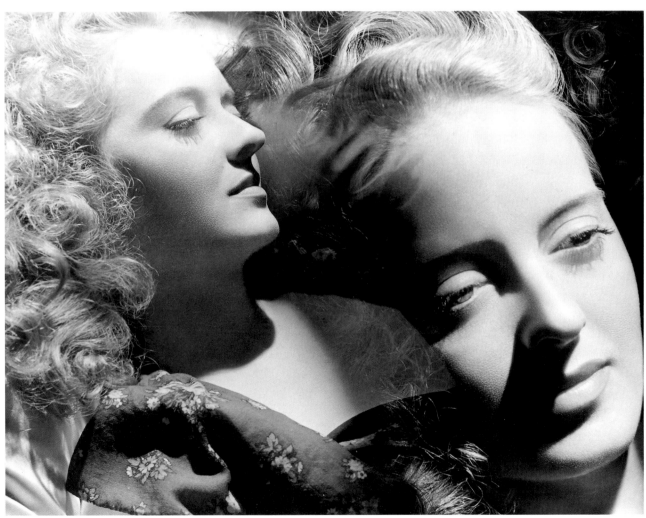

252. Bette Davis said, "George Hurrell was the greatest. He took fantastic portraits of me . . . he was brilliant."

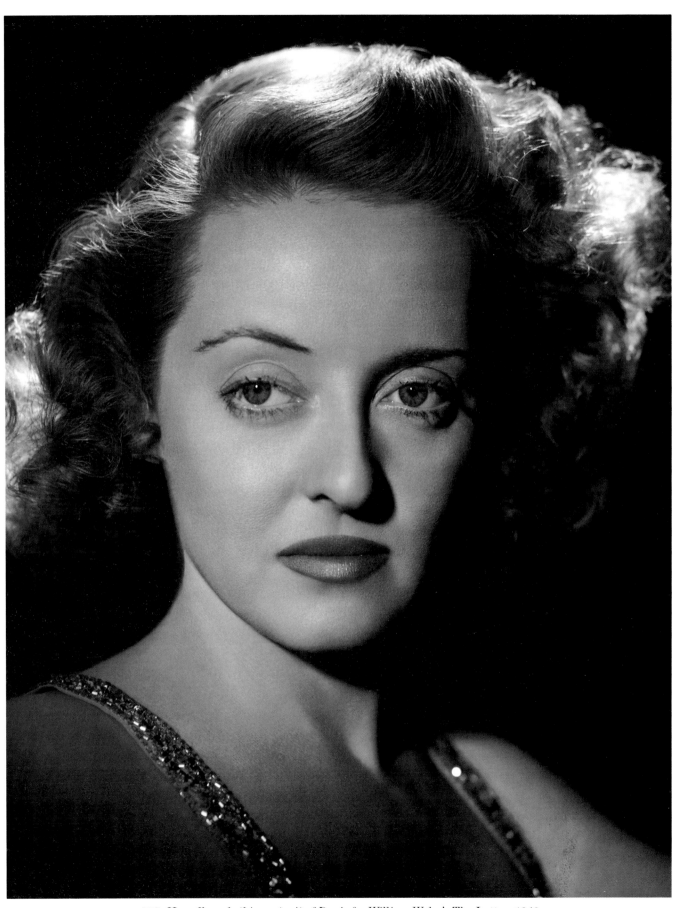

253. Hurrell made this portrait of Davis for William Wyler's The Letter, *1940.*

254. This was the exterior of George Hurrell's Beverly Hills studio.
It featured a hand-carved wooden picture frame, displaying a 40 × 50 print of Hurrell's latest masterpiece,
in this case a 1941 portrait of Joan Crawford.

Hurrell's next move was to fashionable Beverly Hills. He and Katherine had saved most of his Warners earnings, and they now splurged on a commercial space at 333 North Rodeo Drive. Collaborating with architect Douglas Honnold, Hurrell designed a studio where he could shoot both portrait and commercial work. Like 8706 Sunset, the space was a narrow storefront set in a commercial property. Unlike it, this space extended behind neighboring shops, giving the gallery a width of forty feet. The gallery, reception area, and offices had airy twenty-foot ceilings. This height was broken by a catwalk and second-floor darkrooms. On the first floor there were also a women's dressing room, a men's dressing room, and a storage room.

Interior decoration was by Joseph Copp, Jr., and reflected Hurrell's wry theatricality. The brick-and-plaster walls were painted pink so they would photograph properly, and because Katherine forbade pink at home. The focusing cloth on Hurrell's new Korona view camera was dyed the same shade of red as the roses on the wallpaper in the women's dressing room. The reception desk was the sawed-off base of a huge gold column. *U.S. Camera* called the studio "a triumph of modern design."

While the studio neared completion, Hurrell loaded his Buick station wagon with camera gear and took off for New York with his former Warners assistant, Al Harvey. He then leased a space in the Waldorf Astoria Hotel and spent the next few months shooting socialites such as Doris Duke and Helena Rubinstein. When he returned to California in January 1941, the studio still wasn't ready, so he rented a small space at 8404 Sunset Boulevard, where he shot his monthly *Esquire* work.

In the fall of 1941, he finally opened his smart new studio. One day, he was surprised to find Greta Garbo in his reception area. "Alloo, Mister 'Urell. Thought I would come by and see how my new tenant is doing."

"*You're* my landlady?"

"Yes," she said. "It pleases me very much to have you on my property. Show me around, please."

Hurrell gave her the grand tour, and when she commented on the lightweight new Korona camera, he saw that here was another movie star who was "very astute and completely knowledgeable."

"Before she left, I popped the question, 'How about some shots?'

"'Oh, no, no, Mister 'Urell. I am not photographed any more.' She waved and was gone." Hurrell didn't know that on October 3, she'd had her last session with Clarence Bull. Her next film, *Two-Faced Woman,* was a terrible flop, and though she signed to do another film, her career was over. Within a year, many of her contemporaries would also leave Metro: Myrna Loy, Jeanette MacDonald, Joan Crawford, and Norma Shearer. The stars whom Hurrell had spent a decade polishing were one by one burning out, and with them, an era.

Ann Sheridan later said, "There was a certain kind of fantasy, a certain imagination that is not accepted now. The world is too small. Those were glamorous days." Norma Shearer later wrote: "We have no new Garbos or Dietrichs or Crawfords. . . . After these extraordinary, gifted ladies, they simply broke the mold. They came out of an era when sophistication was the keynote. They were young when they gained their fame, but they gave the impression that they had lived and loved . . . and so they were glamorous. They weren't afraid to be women."

Hurrell's next assignment showed just how fast the world was changing. He was paid the astounding sum of $4000 to glamorize an unknown high-school girl. The check was signed by Howard Hughes. The subject was Jane Russell. Hurrell must have sensed history in the making, because he invited G. T. Allen of *U.S. Camera* to witness the first of several sessions with Russell. The result was a word-for-word transcription of a George Hurrell portrait session (plates 255–258):

As appointment time nears, Hurrell and his assistant pull out the lights—a power line and six lamps. The assistant pulls the green curtains half closed over the north windows, George throws some chintz cushions from the sofa onto the model stand, covers them with a bearskin rug. That's the extent of his preparation. . . .

The model arrives—Jane Russell. George has never shot her before. He studies her a moment, says to her publicity man [Russell Birdwell], "She's a good-looking girl."

Jane: "I feel like a guinea pig."

Geo: "You won't when we've finished with you."

Jane goes into the dressing room, puts on a creation of satin and lace. . . .

Geo: "Kind of housewifey, don't you think? Try the other one. It might be better, simpler. All this dizzy design up here might not be so good."

Jane changes and comes out.

Jane: "Did you say the other one was fussy?"

George groans: "The first one was best."

Jane changes back.

Geo: "Ah, yes. This will have the boudoir flavor, which we want."

George puts Jane on the bearskin, tries different

poses, all recumbent, pulls at her dress, walks off and starts the phonograph, pulls the green curtains completely shut, snaps on the lights, squints through the camera, slides up to the model stand. "Can't you lose this leg?"

Jane obeys. George fusses some more with the folds of her satin skirt. Jane pulls a comb through her hair, tucks comb and mirror out of sight. Music, hot and boogie-woogie, floods the studio, low in volume, but insistent. With the music, George's timing changes from that of a shuffling, thinking, puttering man . . . to a dancer come to life.

From this point, the shooting of Jane is a process that defies explanation, a process lightning fast, sensitive, unified, as George fox-trots his camera tripod over the cement floor, seeks the right camera angle, shifts a light before the assistant can reach it, changes an angle of Jane's arm and wrist.

The big studio falls out of the picture. There is nothing except the magic circle of light, the camera, George, and the model, nothing except the music which is around them, part of George, the powerful determinant of his tempo and rhythm. . . . It is the music, both the tonic and George's other self, to whom he talks, mumbles, and shouts. . . .

He bends, twists, trots, dances his tripod to the position he wants, crooning, "Now, let's see," whispers to Jane, "Look," points, presses the bulb.

George's "Shooting Blues" song . . . strings out to half-hour length. Sung to any music:

> *Now let's see*
> *Where was we*
> *Now we're getting places and doing things.*
> *That's it. That's what the doctor ordered.*
> *Now we're getting places and doing things.*
> *Now let's see where was we.*
> *It's funny stuff, this bizness.*
> *Now let's see the best picture of the year.*
> *That's it.*
> *Oh, Little Joe*
> *From Chicago*
> *Where was we.*
> *That's it.*
> *It's good.*
> *Too good.*

> *Much too good for them.*
> *It's the picture of the age.*
> *That's good, just the way it is.*
> *It's the picture of the age.*
> *But good.*
> *Ah, the frightful significance of it all! . . .*

Rhythmically flashing through the sitting, George's actions form a repeat pattern, a work pattern, repeated as often as the bulb is pressed. At each exposure, George is at lens position, checking the direction of Jane's eyes . . . if it isn't what he wants, he shoots again. If it's right, he glides into the next.

It's a symphony, and you don't interrupt to ask the whys and hows of shading. Yes, there are lights, six to begin and one to finish. Changes flow from one arrangement to the next too fast to be checked or diagrammed. Hurrell's right when he says, "A man's a goat to try to explain how he shoots."

The concept of Hurrell's next session with Jane Russell came from the film she was completing for Howard Hughes, *The Outlaw*. "A haystack!" he shouted at Russell Birdwell, Hughes's publicist. "I'll shoot Jane Russell in a haystack!" In short order, a truck from a Santa Monica feed-and-seed store backed into the studio through the twenty-foot-high doors, unloaded a half ton of hay, and drove off. Related Hurrell: "We just had a haystack there. But one funny thing about it is that I realized, 'She can't get up on the hay. She's going to keep falling off.' So I had to put steps under the hay just to get her up there. . . . She was a great gal."

The public thought so, too. Howard Hughes made vigorous use of Hurrell's pictures to promote *The Outlaw*, and everyone wanted to see it. Unfortunately, the film had serious censorship problems and was quickly withdrawn from circulation. Hurrell's pictures took over. *The Outlaw* was outlawed, but everyone knew who Jane Russell was. In 1980, Hurrell stated, "You don't make a star on the strength of a photograph." Perhaps not, but you do make a celebrity. It may have been to Russell's advantage that the film was unseen, and that she didn't do another for five years. In the meantime, she had Hurrell's images of her, and she was a household word.

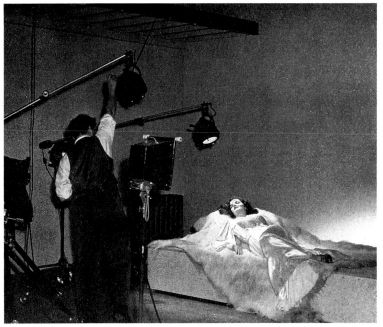

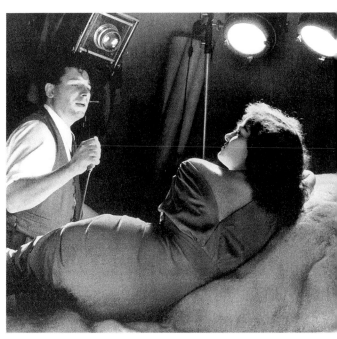

255. The "magic circle of light" as Hurrell glamorizes a high-school girl named Jane Russell and creates a star. The shy but cooperative girl passed through Hurrell's lens to become a wartime pinup.

256. Hurrell photographing Jane Russell.

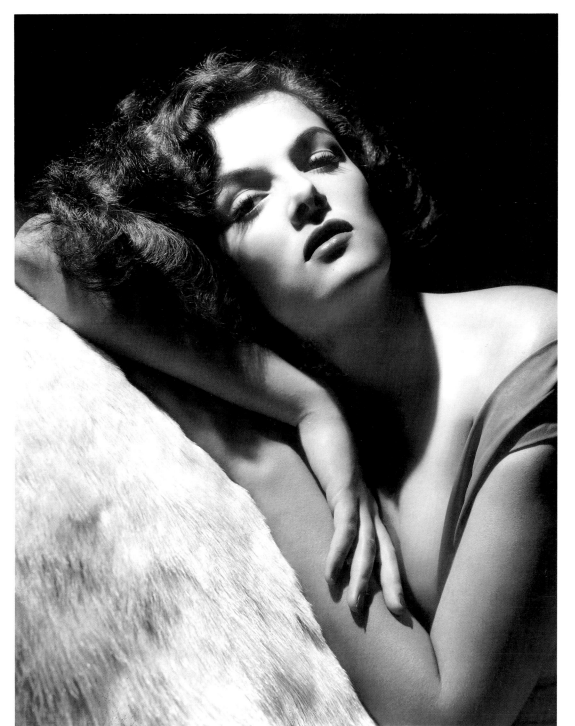

LEFT: 257. The resulting portrait.

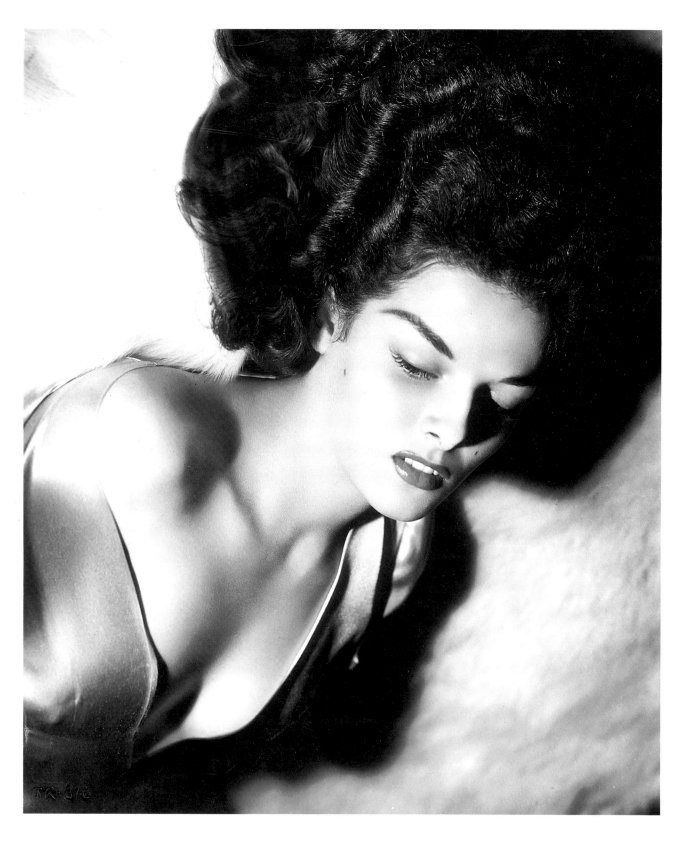

ABOVE: *258. George Hurrell's idea of flesh and fantasy,*
accomplished with one silky softlight and a polar bear rug.

OPPOSITE PAGE: *259. The happy meeting of artist and model;*
this was the best-known image from the sitting Hurrell made for The Outlaw.

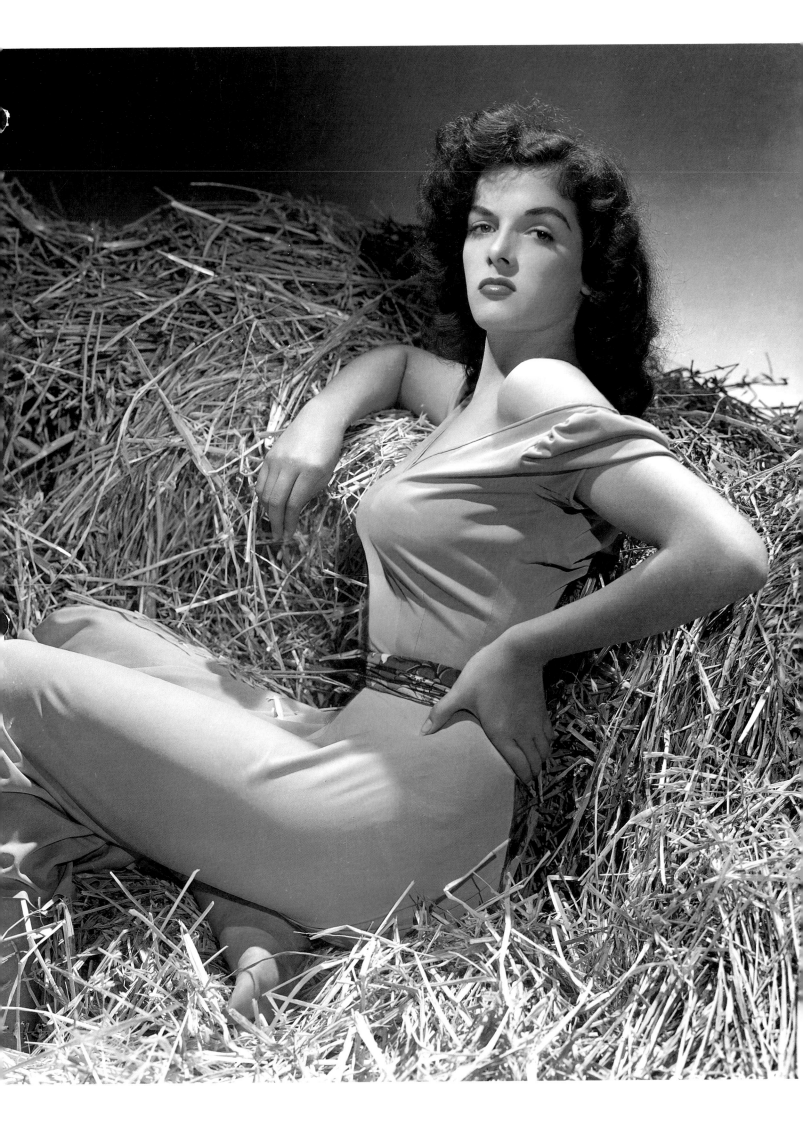

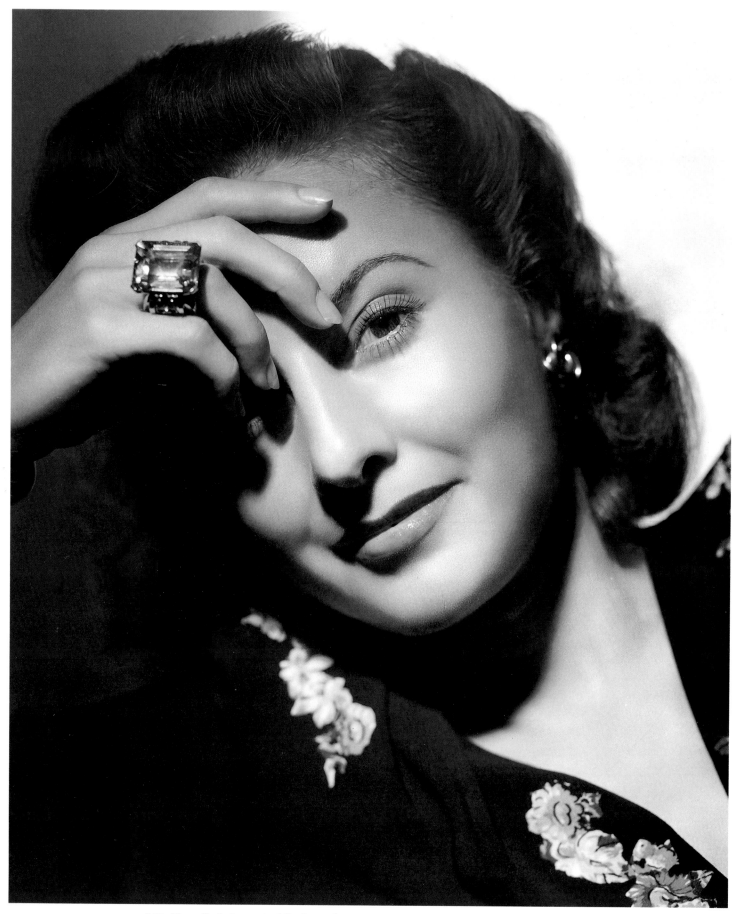

260. *Hurrell photographed Barbara Stanwyck for Frank Capra's* Meet John Doe *in 1941.*

THE COLUMBIA STINT

As 1941 drew to a close and the film industry counted a revenue of $800,000,000, Japan bombed Pearl Harbor. Everyone took a nervous breath and kept working. George Hurrell was no exception. His first few months in Beverly Hills had been outstanding, and he had just bought a house at 3309 Tareco Drive, overlooking the Cahuenga Pass. He was loath to have his work interrupted when every major studio was sending stars to him. Barbara Stanwyck, for example, was first sent by Warners and then by Goldwyn. She had joined the increasing number of freelance stars.

Another repeat client was Bette Davis. Goldwyn publicists had the task of selling her to the public in an unsympathetic, heavily madeup period role, in *The Little Foxes,* so they hired five noted photographers to interpret her Regina Giddens: Ned Scott, Charles Kerbe, Paul Hesse, James Doolittle, and George Hurrell. Hurrell's portraits were by far the most flattering, with spectacular lighting effects facilitated by the new Super XX film.

261. The Hurrell home at 3309 Tareco Drive (author's photo).

Even M-G-M called Hurrell in 1941, albeit at the behest of an old friend. Joan Crawford requested that he shoot a fashion layout in her home, and they worked together for the first time in four years. His studies of her revealed a new poise, as well as the same timeless beauty. In the March 1942 *Motion Picture* magazine, Hurrell said, "She has the clearest conception of what it takes to make a picture interesting. She knows what to do and when to do it. She keeps a photographer hopping, trying to keep up with her." Whenever he was asked for a favorite image, he would present something from this elegant sitting. He would admit that Crawford was his favorite subject, but he resisted the term *glamour photo* as a literal description of work with her or anyone else: "All of us glamorize everything, including the documentaries who glamorize filth and squalor. Even Weston does it, taking a picture of a gnarled tree trunk. It's a question of emphasizing . . . the dirt or the beauty."

When pressed for a formula, he would grudgingly say, "Bring out the best, conceal the worst, and leave something to the imagination."

By mid-1942, 333 North Rodeo Drive was so busy that Hurrell had to hire other photographers to cover parties and nightclubs. Even without his daily presence, the studio was supporting itself, and the "Hurrell" stamp was now appearing on the backs of many different types of photos: portraits, products, and events.

Robert Taplinger had moved from Warners to Columbia, and invited Hurrell to work as head portrait photographer for the smallest of the major studios. Columbia was upgrading its product, and Taplinger knew Hurrell could bring distinction to its publicity, if Rodeo Drive could do without him for a year. In July 1942, Hurrell went to work for Columbia Pictures. He was working on Sunset Boulevard again, but this was a far cry from the Sunset Strip.

The studio at Sunset and Gower was run by the redoubtable Harry Cohn, and it was run cheaply. Hurrell recalled, "The still gallery was located below street level, beneath hairdressing and makeup. The place was barely adequate— a cubicle compared to the galleries at Fox and Warners." He adjusted to it, but occasionally went shooting on sets or even on the roof. Still, he found the cheapness of the studio oppressive. Cohn called him on the carpet for spending $30 to rent a negligee from Western Costume. Waving his riding crop, Cohn shouted at him, "If I were you, I'd use our own wardrobe! Savvy?"

Despite these limitations, Hurrell made quality images of Columbia stars. Like him, many of them were just passing through. Rosalind Russell earned the honor of being his most-retouched subject; she habitually returned prints for more retouching. Hurrell related, "You'd retouch until you couldn't put any more lead on the emulsion, because that mucilage retouching fluid can only hold so much and then it got too slippery. So you'd have to work on the base side of the neg. My God, she wanted her face ironed out!" Hurrell explained that she didn't want the contours changed; she wanted the same smoothness she'd had at M-G-M nine years earlier.

Hurrell's most important subject at Columbia didn't care how her pictures looked. Rita Hayworth was Columbia's answer to everyone else at every other studio. She was a dancer, a singer, a glamour girl, and even an actress. Hurrell was expected to register all these aspects, and he usually did (plate 271). He later said, "She had a nice personality, but could

be rather subdued. But if she was experiencing a case of the blahs, all I had to do was place a tango, samba, or rumba record on the phonograph, and her spirits would perk up."

Toward the end of 1942, Hurrell found himself distracted by personal problems and unengaged by his work. It was bad enough to toe the line for an autocratic pennypincher, but worse to do it in the service of uninspiring material. He was approaching forty, but he had to expend the same energy in order to jump from one banal subject to another, while hamstrung by cheap settings and talentless "talent." Even though he was losing steam, he never compromised his work. Even in cut-rate circumstances, he never cut corners.

Most of his subjects were bland, unexciting starlets. The portraits he made of them were pleasing, but lifeless. He later said: "You can't work with a person and be exactly cold-blooded, because there's got to be a rapport, there's got to be that quality, that *something* that rings between the two of you. If it doesn't, you might as well quit and go home."

When he went home one day in late October, he opened his mail and got a big surprise. "I discovered that I had been drafted into the First Motion Picture Unit of the United States Army Air Force."

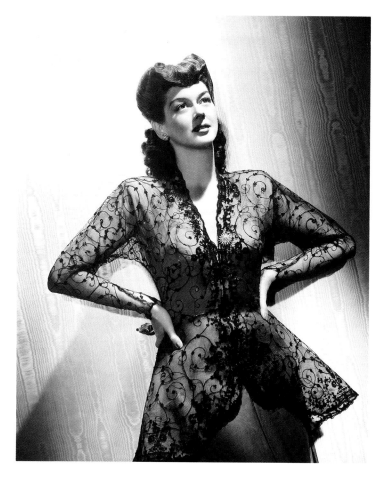

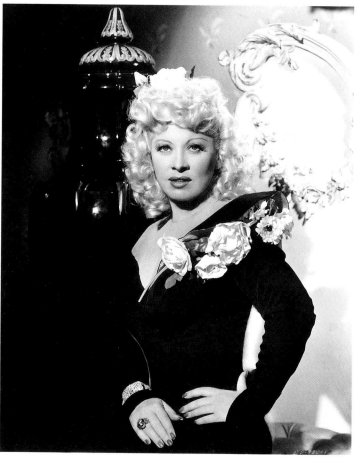

ABOVE: 262. *A 1942 portrait of Rosalind Russell.*

BELOW: 263. *Hurrell remembered using a portable 4 × 5 view camera to shoot this portrait of Mae West for Gregory Ratoff's* The Heat's On.

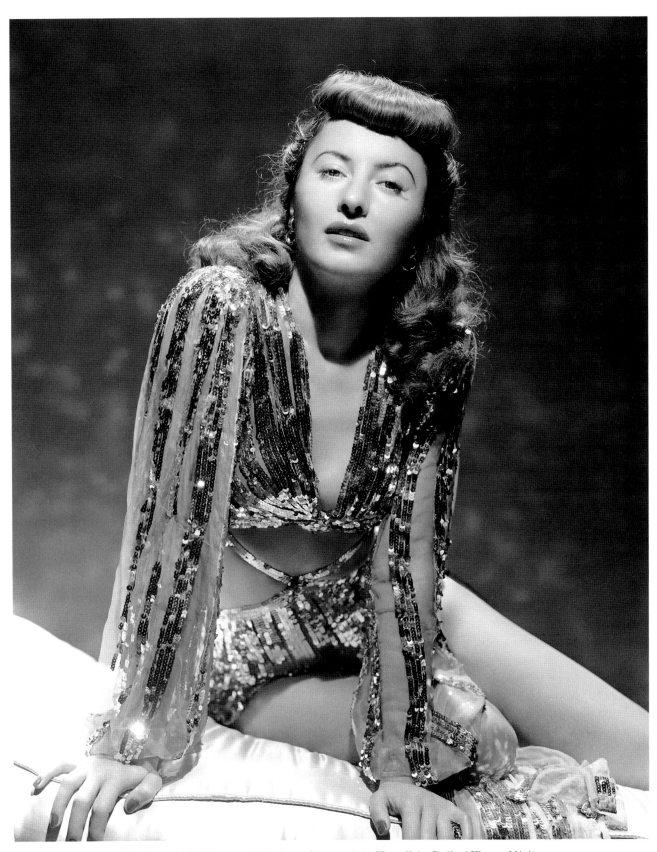

264. *Samuel Goldwyn sent Barbara Stanwyck to Hurrell for* Ball of Fire *publicity.*

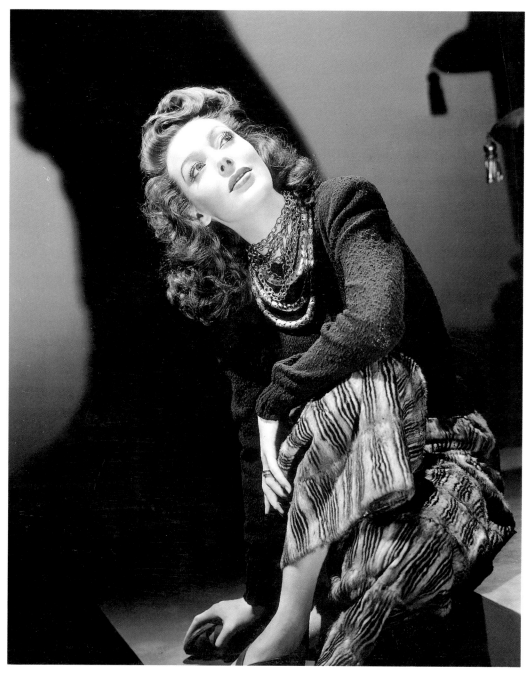

265. *A 1942 portrait of Loretta Young for Richard Wallace's* A Night to Remember.

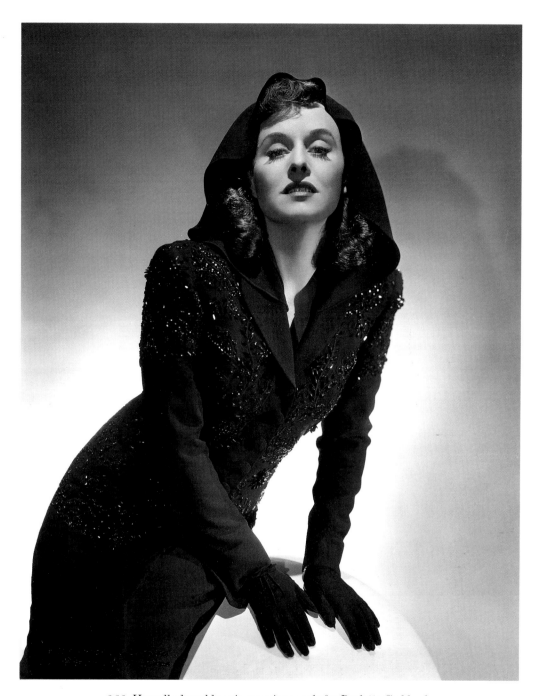

266. *Hurrell played boogie-woogie records for Paulette Goddard.*

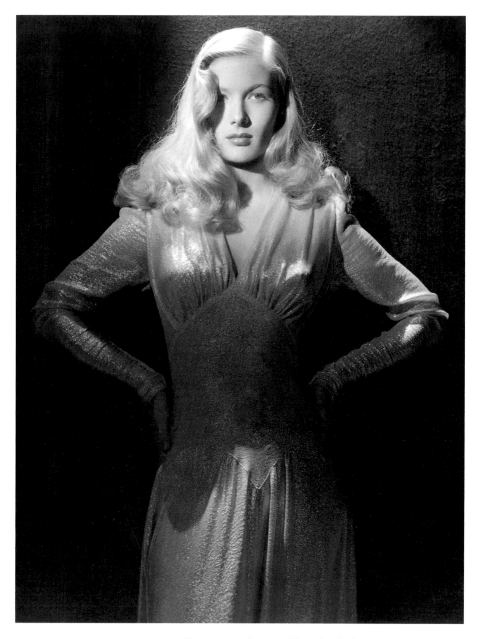

ABOVE: *267. Paramount also sent Veronica Lake
to Hurrell's studio; she was so overworked she could
hardly stay awake.*

OPPOSITE PAGE: *268. Hurrell went to Goldwyn Studios
to photograph Bette Davis on the set of William Wyler's*
The Little Foxes *in 1941.*

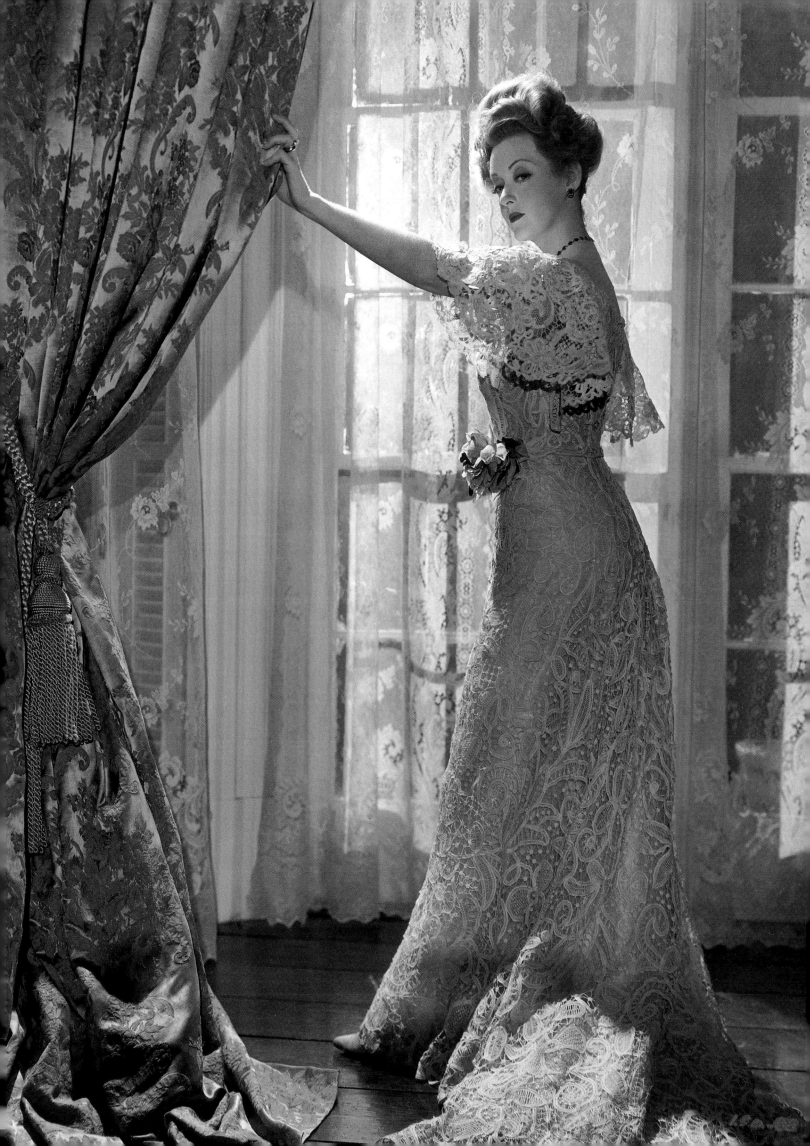

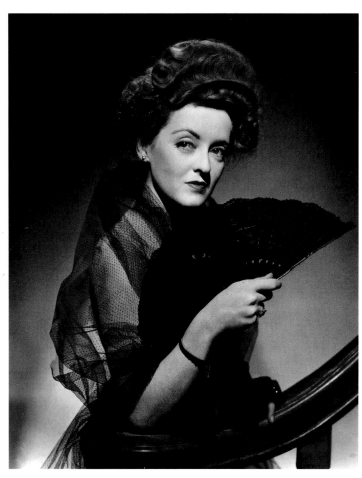

269. *Bette Davis as the wicked Regina Giddens.*
Sam Goldwyn was still enthusiastic about Hurrell's work,
but kept calling the film "The Three Little Foxes."

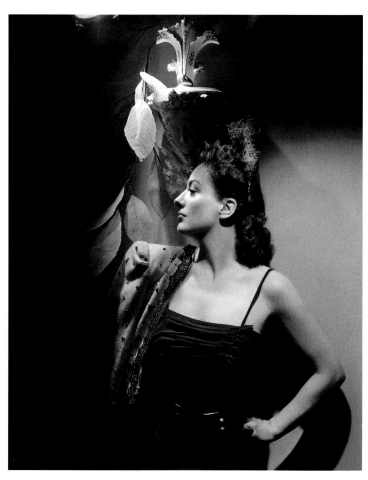

270. *In early 1941, George Hurrell was reunited*
with his favorite subject, Joan Crawford. This portrait
was made in her home.

OPPOSITE PAGE: 271. *Rita Hayworth modeled her own*
wardrobe for this 1942 Hurrell session.

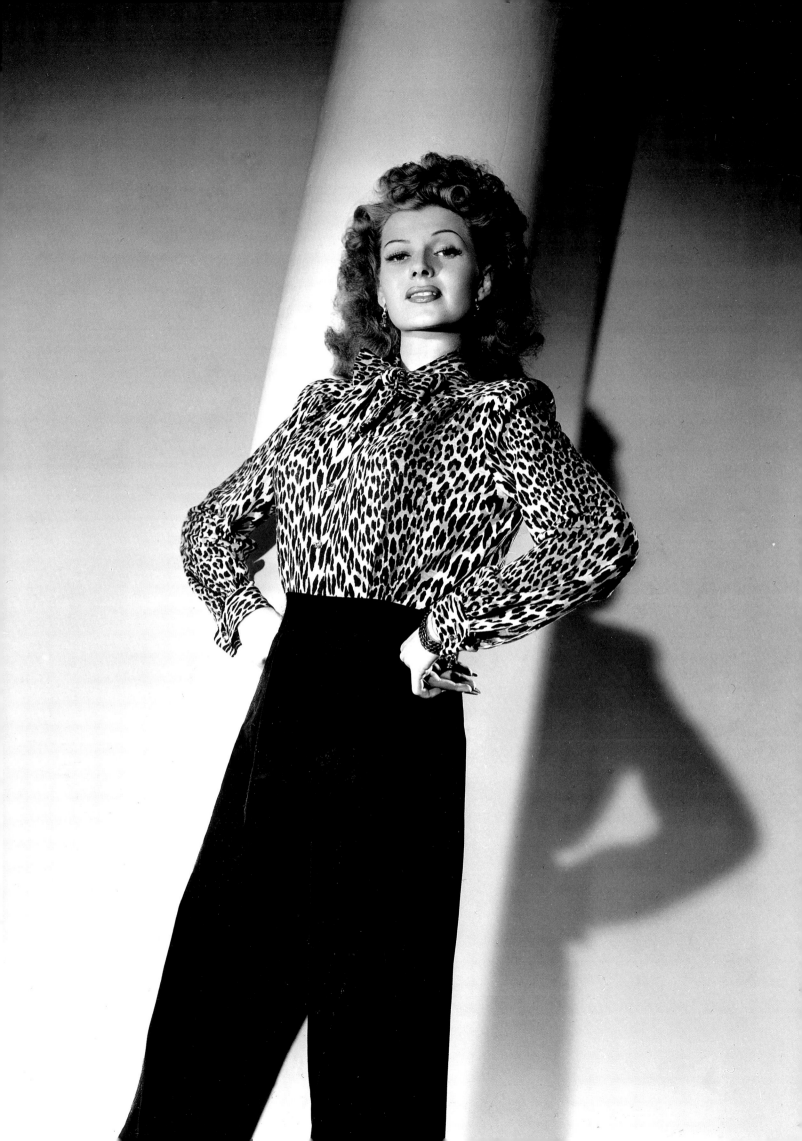

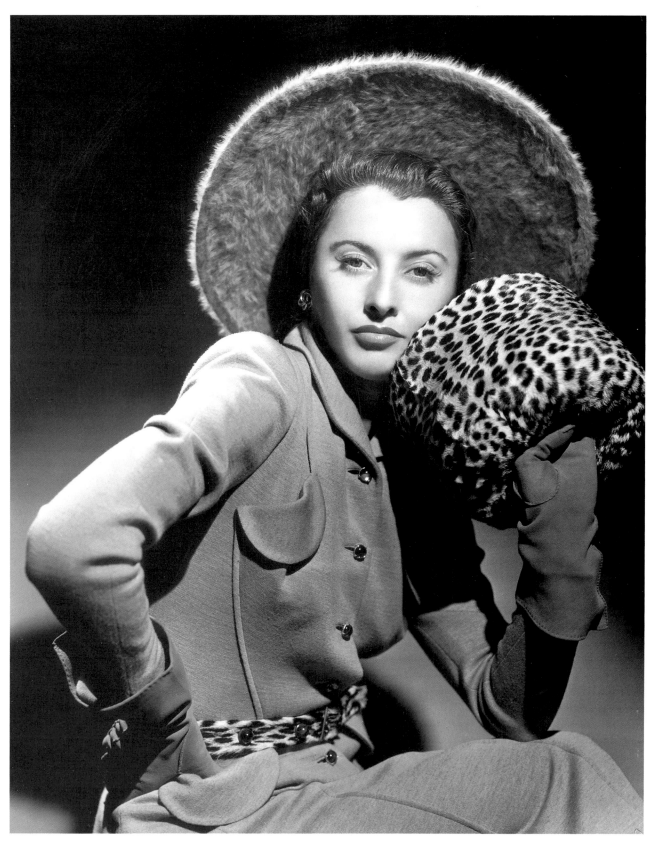

ABOVE: 272. *Barbara Stanwyck became a Hurrell favorite*
once she overcame her fear of being glamorized.

OPPOSITE PAGE: 273. *This is the actress to whom George Hurrell referred*
in later years as "the dear girl." Joan Crawford is shown here in a 1941 portrait.
She and Hurrell collaborated on thirty-three sessions
and left a dazzling photographic legacy.

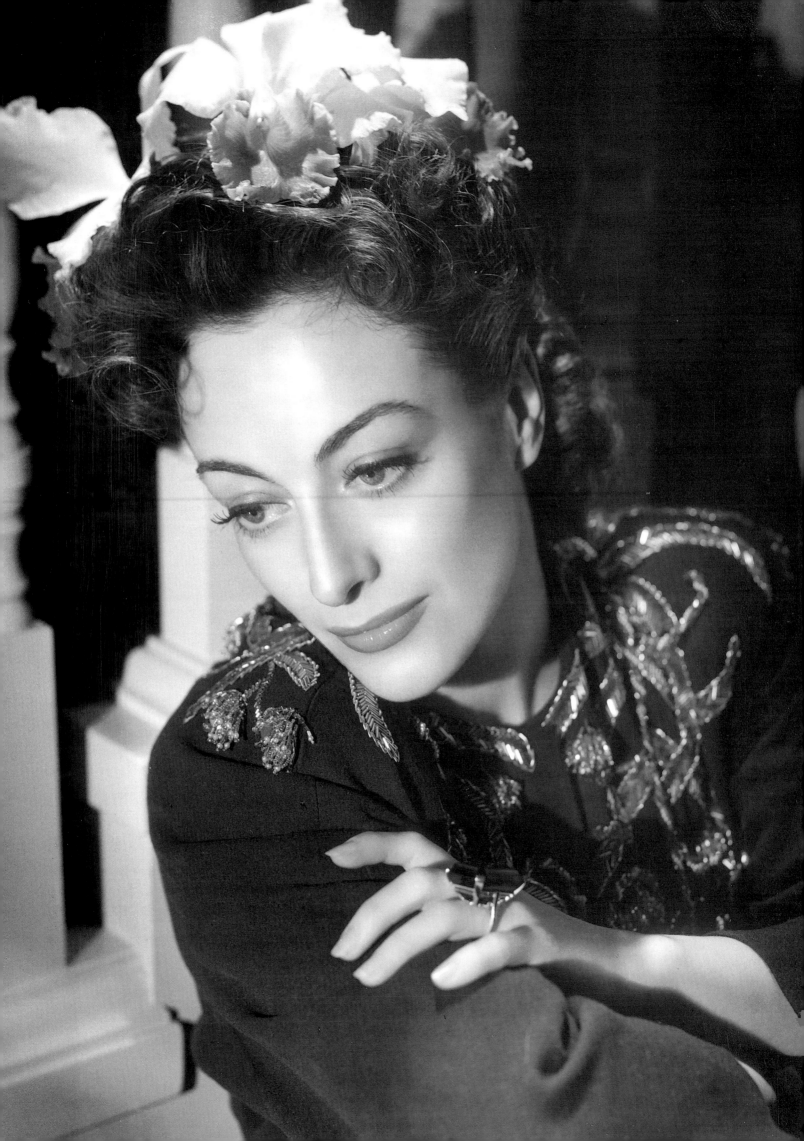

AN ERA ENDS

On November 2, 1942, George Hurrell left Los Angeles, bound for Monterey, California, where he would become a private in the Army Air Force.* Several days later, he found himself "peeling potatoes with composer David Rose. We looked ruefully at each other, and then burst out laughing."

His tour of duty was neither exotic nor dangerous. He began it in Culver City, where Hal Roach Studios had been converted to a production unit for military films. He found himself behind a camera, not a gun. "I shot stills of personnel involved in training films produced by the unit," he said. "I was at the Pentagon after that . . . shooting mostly portraits of generals." Hurrell also recalled, "When I was in the Army, those photographs of Jane Russell haunted me everywhere I went: every boat, every locker room, every latrine." He was not only promoting Howard Hughes's protégée, but also boosting morale.

"In April of 1943, having reached the age where the Army no longer wanted me, I was quietly mustered out and just as quietly resumed my contract at Columbia." In the next six months, Hurrell shot poster art, fashion, and starlets—the type of work he liked least. He even shot publicity photos of stars contributing to the war effort. But he mostly waited for his contract to run out. Before it did, he made sure that his old assistant, Al St. Hilaire, was put on salary as a photographer. Then, in October 1943, he left the Columbia Pictures portrait gallery and returned to 333 North Rodeo Drive.

M-G-M had recently released the musical comedy *DuBarry Was a Lady*. It featured the song "I Love an *Esquire* Girl," with lyrics praising "those lovely pictures by Hurrell." This sort of acclaim was of small comfort to him in a period of awkward, unpleasant transitions. Within a year, he divorced Katherine, married a model named Phyllis Bounds, and declared bankruptcy. The stress and expense of these events put him back where he was in 1927. But he wasn't a young man now, and the jaunty grace of the Jazz Age was gone. The world had changed, and photography with it.

Magazine editors now shunned large-format, posed pictures. "Life in the raw is seldom mild," said

Life magazine, and candid pictures proved it. Candids were taken with medium- or small-format cameras, and they were never retouched. It was almost impossible to retouch the little 2¼ × 2¼ or 35 mm negatives. Hurrell later said, "When we stopped using those 8 × 10 cameras, the glamour was gone."

Lighting techniques were in a state of flux, too. Even conservative Clarence Bull was experimenting, along with the scientist Harold M. Egerton, in the use of stroboscopic flash. Movie-star portraits became bright, sharp, and artless. Bull later denounced flash, saying, "Those speedlights are the worst thing that ever happened to portrait photography." Hurrell was certainly able to adapt to new technology, but in the politically charged climate of Hollywood? Philistine publicists now wanted him to "demystify" the stars, and the stars wouldn't cooperate. He later admitted, "I'd get bored with movie stars. They're all a pain in the ass. So I'd go to New York." He didn't actually move to New York until 1946, but when he left Columbia in 1943, his fifth period of artistic development was over. Hurrell's Hollywood portraits had come to an end.

I n the fourteen years since his first Hollywood portrait, Hurrell had created, perfected, and popularized a photographic idiom. That this idiom blossomed at the same time as talking pictures was no coincidence. It was needed. The dreamlike world of silent pictures had created a star system based on personalities who were bigger than life. The naturalism of talking pictures diminished them. If the star system

*274. A 1938 self-portrait
by George Hurrell.*

was to survive, the studios would have to magnify them again. Along came Hurrell, who saw photography, and stars, in a unique way. He endowed them with glamour and invested them with greatness.

Hurrell's portrait style was widely imitated. The look of Hollywood publicity changed dramatically. One of the few photographers who didn't copy him was Paramount director Josef von Sternberg, who used smoke, spotlights, and cloth diffusion filters to create Marlene Dietrich. But Hurrell and Sternberg were both working toward the same goal: the creation of icons. By the time they finished, Hollywood stars were no longer mere mortals. They were gods and goddesses.

Sternberg was able to use both motion pictures and still photography to accomplish this. Hurrell used only still photography. His specific innovations and contributions are worth reviewing here: He freely adapted photographer's tools that were previously limited in their stylistic application (arc lights, Verito lens, ortho film). He invented a liberating new tool, the boomlight. He modified the protocol of the portrait gallery in order to make artistic use of his own personality. As his career evolved, he made each change of studio an impetus to advance his visual style. And finally, he used a popular art form to create a vision of humankind that was at once sensual and spiritual. He accomplished all these things in a brief fourteen years, in the five periods of work described by the five chapters of this book. The result was a new style of photography, the Hollywood glamour portrait. This style expressed both Hurrell's personality and the ideals of a culture—a worthy aspiration for any artist.

NOTES TO THE TEXT

The notes are keyed to page numbers. Sources of the quotations in the text and captions are given here in abbreviated form, with books and signed articles cited by author and title, and unsigned articles by title alone. Full publication data can be found in the Bibliography. Notes marked by an asterisk give further information supplemental to the text or provide technical explanations. Notes are to the essay text unless designated *caption*.

Page

7 (caption) *If I have a special talent . . .* "Hurrell," p. 172.

10 *All information on cameras and film stocks was supplied by George Eastman House, Rochester, New York. Price quotes are from *Studio Light*, October 1930.

10 *Soft focus could also be achieved with "diffusion disks," optical glass filters with concentric circles pressed into them, or with "marquisette" cloth filters. In this way, sharp commercial lenses could be instantly converted to portrait lenses.

10 *Edgar Alwyn Payne later founded the Laguna Beach Museum of Art.

11 *That slow pace . . .* Hayes, "George Hurrell," p. 32.

11 *astounded when the great Steichen . . .* Carle, "Backward Look at Glamor," p. 9.

11 *Never let your subject . . .* Ibid.

11 *She was from the Lowe family . . .* Kapitanoff, "Sixty-three Years of Shooting the Legends."

11 *hysterical crowd from Laguna . . .* Carroll, "George Hurrell," p. 111.

12 *destroys the artistic quality . . .* Fiedler, *Portrait Photography*, p. 20.

12 *this hearty young man . . .* *Legends in Light* (film).

12 *Everyone takes me for a Spaniard . . .* Stine, *The Hurrell Style,* p. 5.

12 *Pete had photographically perfect features . . .* Ibid.

12 *I'm old-fashioned . . .* Quirk, "Fulfillment of a Wink," p. 88.

12 *I was really inspired . . .* Carle, "Backward Look at Glamor," p. 9.

14 *You have caught my moods . . .* Stine, *The Hurrell Style,* p. 6.

14 *chose about five . . .* Deutelbaum, *"Image" on the Art and Evolution of Film,* p. 192.

18 *gracious Norma Shearer . . .* Conrad Nagel, spoken prologue of the M-G-M film *The Hollywood Revue of 1929.*

18 *Why, Ramon! . . .* Stine, *The Hurrell Style,* p. 7.

18 *I always chose sophisticated parts . . .* Norma Shearer, unpublished interview, 1958; author's collection.

18 *I knew that M-G-M . . .* Parsons, "Norma Talks About Joan!," p. 13.

18 *Oh, Miss Shearer . . .* "Norma Shearer," p. 71.

18 *But I was determined . . .* Parsons, "Norma Talks About Joan!," p. 13.

19 *a tough little gal . . .* Kapitanoff, "Sixty-three Years of Shooting the Legends."

19 *The idea was . . .* Kobal, *People Will Talk,* p. 257.

19 *a great deal depended on . . .* Busby, "The Camera Does Lie," p. 74.

19 *I'm afraid my legs . . .* Stine, *The Hurrell Style,* p. 8.

19 *And when my baby smiles . . .* "When My Baby Smiles at Me," words by Andrew B. Sterling and Ted Lewis, music by Bill Monroe; published by Harry von Tilzer, 1920. The recording played by Hurrell that day was most likely Columbia 922D, recorded in Chicago on November 22, 1926, by Ted Lewis and his band.

19 *She didn't like it . . .* Lambert, *Norma Shearer,* p. 130.

19 *the height of lavishness . . .* Busby, "The Camera Does Lie," p. 74.

19 *I didn't feel so good . . .* George Hurrell to the author, December 1, 1975.

20 *like an excited child . . .* "Norma Shearer," p. 71.

21	*Why, I believe you can play that role . . .*	Parsons, "Norma Talks About Joan!," p. 13.
21	*It was a tremendous gamble . . .*	Ibid.
21	*I played hard to get . . .*	Kapitanoff, "Sixty-three Years of Shooting the Legends."
21	*I said, "Well . . .*	Fahey, "Interview with George Hurrell," p. 4.
21 (caption)	*wicked and siren-like . . .*	Kobal, *People Will Talk*, p. 257.
26	*If only those who . . .*	Broman, *Conversations with Greta Garbo*, p. 119.
27	*Apollos and Venuses . . .*	Beaton, *The Wandering Years*, p. 189.
27	*I didn't care about . . .*	Fahey, "Interview with George Hurrell," p. 5.
27	*I didn't care whether . . .*	Hayes, "George Hurrell," p. 31.
27	*I went in there . . .*	Fahey, "Interview with George Hurrell," p. 5.
27	*We used to shoot . . .*	Kobal, *People Will Talk*, p. 263.
27	*With George, it was always . . .*	Anita Page to the author, February 24, 1996.
28 (caption)	*I invited him there . . .*	Anita Page to the author, February 24, 1996.
28	*I was always fighting . . .*	Kobal, *Art of the Great Hollywood Portrait Photographers*, p. 211.
28	*He thought that . . .*	Fahey, "Interview with George Hurrell," p. 5.
28	*I found that . . .*	Carle, "Backward Look at Glamor," p. 10.
28	*Clarence Bull was . . .*	Trent, *The Image Makers*, p. 54.
30	*I kept telling her . . .*	Fahey, "Interview with George Hurrell," p. 5.
30	*I was the "posy" type . . .*	Trent, *The Image Makers*, p. 54.
30	*Please forgive me . . .*	George Hurrell to the author, November 1, 1975.
32 (caption)	*Are you starting . . .*	Anita Page to the author, February 24, 1996.
36 (caption)	*When I signed with M-G-M . . .*	Kern, "A Friendly, Personable Young Man," p. 128.
41	*Don't worry . . .*	Stine, *The Hurrell Style*, p. 14.

41 *Not today ...* Ibid., p. 15.

41 *Good morning ...* Jordan, "Photographing Garbo," p. 100.

41 *Do I make you feel nervous ...* Ibid., p. 101.

41 *Oh, oh ...* Ibid.

41 *Well, that's that ...* Ibid.

41 *I'll try to do better ...* Pepper, *The Man Who Shot Garbo*, p. 21.

41 *I took a look ...* George Hurrell to the author, December 1, 1975.

41 *She could "feel" light ...* C. S. Bull to the author, December 2, 1975.

41 *There wasn't any problem ...* Kobal, *People Will Talk*, p. 265.

44 *stone statue ...* Kapitanoff, "Sixty-three Years of Shooting the Legends."

44 *stiffness ...* Kobal, *People Will Talk*, p. 265.

44 *I hummed and jumped ...* Stine, *The Hurrell Style*, p. 20.

44 *I had to work ...* Ibid.

44 *She was going to do ...* Kobal, *People Will Talk*, p. 265.

44 *On each sitting ...* Hayes, "George Hurrell," p. 32.

44 *You didn't just tell ...* Fahey, "Interview with George Hurrell," p. 3.

44 *She didn't respond ...* Kobal, *People Will Talk*, p. 265.

45 *Finally, I almost fell ...* Stine, *The Hurrell Style*, p. 20.

45 *Once I found out ...* Fahey, "Interview with George Hurrell," p. 3.

45 *There's a crazy man ...* Pepper, *The Man Who Shot Garbo*, p. 23.

45 *I at last got through ...* Vickers, *Loving Garbo*, p. 41.

45 *The afternoon ...* Pepper, *The Man Who Shot Garbo*, p. 21.

45 *Garbo was probably ...* Kobal, *People Will Talk*, p. 266.

45 (caption) *She just sat ...* Kapitanoff, "Sixty-three Years of Shooting the Legends."

47 (caption) *You couldn't get ...* Ibid.

47 (caption)	*It didn't help . . .*	Kobal, *People Will Talk*, p. 265.
47 (caption)	*Actually, in person . . .*	Kapitanoff, "Sixty-three Years of Shooting the Legends."
47 (caption)	*That grim personality thing . . .*	Ibid.
48 (caption)	*I was trying . . .*	Kobal, *Art of the Great Hollywood Portrait Photographers,* p. 112.
48 (caption)	*They didn't turn out . . .*	Ibid.
50	*Hollywood is like life . . .*	Crawford and Ardmore, *A Portrait of Joan,* p. 54.
50	*I want a small light . . .*	Stine, *The Hurrell Style*, p. 21.
50	*When I'm trying . . .*	Ibid.
51	*I always tried . . .*	Kobal, *People Will Talk*, p. 266.
51	*skin has a sheen . . .*	Hayes, "George Hurrell," p. 34.
51	*George Hurrell used to . . .*	Trent, *The Image Makers*, p. 54.
51	*I was trying . . .*	Kobal, *People Will Talk*, p. 262.
53	*I'd scrub my skin . . .*	Crawford and Ardmore, *A Portrait of Joan,* p. 96.
53	**blending stump . . .*	George Hurrell to the author, December 1, 1975; terminology clarified by David Chierichetti, December 3, 1995.
53	*I tried to create . . .*	Kapitanoff, "Sixty-three Years of Shooting the Legends."
53	*That was just the rule . . .*	Kobal, *People Will Talk*, p. 264.
56	*The starlets knew . . .*	Ibid., p. 263.
56	*I used to hate . . .*	George Hurrell to the author, December 1, 1975.
58 (caption)	*We always used to try . . .*	Kobal, *People Will Talk*, p. 270.
61	*It was hopelessly . . .*	Crawford and Ardmore, *A Portrait of Joan,* p. 89.
61	*Best photos . . .*	Stine, *The Hurrell Style*, p. 38.
61	*He was almost shy . . .*	Ibid., p. 79.
61	*If you can put it there . . .*	Norma Shearer, unpublished interview, 1958; author's collection.

61 *His "presence" . . .* Stine, *The Hurrell Style,* p. 53.

68 *If I couldn't work alone . . .* Fahey, "Interview with George Hurrell," p. 5.

68 *To hell with . . .* Ibid.

68 *Black backgrounds . . .* Ibid.

68 *Photo archivist Joan Rose heard this from George Hurrell in 1991 (Joan Rose to the author, November 1, 1995).

68 *I told him . . .* George Hurrell to the author, December 1, 1975.

73 (caption) *She was extremely photogenic . . .* Stine, *The Hurrell Style,* p. 41.

75 (caption) *could be an artistic . . .* Norma Shearer, unpublished interview, 1958; author's collection.

75 (caption) *Aren't you going to use . . .* George Hurrell to the author, December 1, 1975.

77 (caption) *When still photographer . . .* Crawford and Ardmore, *A Portrait of Joan,* p. 91.

80 *on a weekend . . .* Fahey, "Interview with George Hurrell," p. 4.

80 *And while I had no contract . . .* Kobal, *People Will Talk,* p. 264.

80 *I saw no reason . . .* Ibid.

80 *My God . . .* Fahey, "Interview with George Hurrell," p. 4.

80 *The artist's accounts of this episode named either Tashman or Bennett. Photographic evidence shows that he shot them both.

80 *George has quit . . .* George Hurrell to the author, November 1, 1975.

84 *Mayer did, in fact, blackball Harvey White, Stephen McNulty, and Ted Allan (Ted Allan to the author, March 2, 1986).

84 *That's highway robbery . . .* Stine, *The Hurrell Style,* p. 78.

84 *The sitting took place on March 19, 1932. Beaton had Weissmuller pose like Jean Harlow.

84 *I'm not much of a technician . . .* C. S. Bull to the author, November 2, 1975.

85 *tried to talk her out of it . . .* Kapitanoff, "Sixty-three Years of Shooting the Legends."

85 *Oh, don't do that* . . . Busby, "The Camera Does Lie," p. 74.

85 *the Queen* . . . Stine, *The Hurrell Style*, p. 25.

85 *The present landowner, Francis J. Montgomery, writes: "About 1892, Victor and Nellie Ponet bought approximately 280 acres, extending from Santa Monica Boulevard to the top of the mountain. Victor Ponet died in 1914 and control of his business passed to his son-in-law Francis S. Montgomery, who in 1924 built four store buildings . . . along the south side of the two-lane paved road that was Sunset Boulevard.

"About 1931, my father and my mother (Gertrude Ponet Montgomery) formed a corporation, Montgomery Properties, Limited, which was eventually George Hurrell's landlord. In 1951, it became the Montgomery Management. I'm sorry to have no personal recollection of Hurrell; I was in college at the time. I do remember that the entire building burned down twenty-five years later.

"About four years ago, two-thirds of the building was rebuilt for Armani Exchange. The rest of the building is now being rebuilt for Wathne, an outdoor clothing company from Iceland, presently operating in New York City" (letter to the author, February 26, 1996).

86 (caption) *a navy blue woolen ensemble* . . . Lane, "Norma Shearer's New Wardrobe," p. 40.

87 *I admire and like Joan* . . . Parsons, "Norma Talks About Joan!," p. 12.

87 *Erudite, urbane* . . . Stine, *The Hurrell Style*, p. 68.

87 *I wish I looked like that* . . . Busby, "The Camera Does Lie," p. 74.

87 *Harvey came to M-G-M* . . . David Stenn to the author, December 2, 1995.

98 (caption) *Most of them* . . . George Hurrell to the author, July 17, 1976.

98 *When I looked* . . . Stine, *The Hurrell Style*, p. 116.

98 *I took hundreds of exposures* . . . Ibid., p. 117.

99 (caption) *He was a real great artist* . . . Kobal, *People Will Talk*, p. 271.

103 *We had a run* . . . George Hurrell to the author, December 1, 1975.

103 *Personally I like blue and white* . . . Busby, "The Camera Does Lie," p. 74.

103 *M-G-M has been trying* . . . Ibid., p. 47.

103 *I put him* . . . George Hurrell to the author, December 1, 1975.

103 *One day that year* . . . Ibid.

103 *You could feel . . .* Borger, "George Hurrell's Hollywood Glamour," p. 74.

103 *big assignment . . .* "All in a Day," p. 1.

103 *In the beginning . . .* Kobal, *People Will Talk*, p. 267. At the time of his first interviews with George Hurrell, Kobal had just written books on Garbo and Dietrich and questioned Hurrell thoroughly about his famous (although limited) work with these two women.

104 *Hurrell photographed Dietrich once in 1937, once in 1938, and then once in 1952, at which time Dietrich looked at the proofs and said, "George, you don't photograph as well as you used to." Hurrell replied, "Marlene, I'm fifteen years older" (George Hurrell to the author).

104 *Loretta Young was . . .* Stine, *The Hurrell Style*, p. 134.

104 *What I liked . . .* Kobal, *People Will Talk*, p. 385.

104 *Familiarity breeds contempt . . .* Fahey, "Interview with George Hurrell," p. 6.

105 (caption) *I used to subscribe . . .* George Hurrell to the author, October 20, 1978.

106 (caption) *the most impeccably groomed man . . .* Stenn, *Bombshell*, p. 176.

109 *He looked at . . .* Ted Allan to the author, March 2, 1986.

109 *I admired his work . . .* Fahey, "Interview with George Hurrell," p. 4.

109 *All you had to do . . .* Hayes, "George Hurrell," p. 34.

114 (caption) *Dietrich! Now there's a dame . . .* "He Distracts the Hollywood Stars."

121 *just a big, healthy, happy girl . . .* Borger, "George Hurrell's Hollywood Glamour," p. 77.

121 *I'm not going to drink . . .* Stenn, *Bombshell*, p. 168.

121 *She had* will . . . Ibid., p. 169.

121 *When you got her alone . . .* Ibid., p. 171.

121 *She would just drop . . .* Ibid., p. 170.

121 *She always played . . .* Ibid., p. 196.

121 *I actually began to hate . . .* Borger, "George Hurrell's Hollywood Glamour," p. 74.

121 *My inspiration . . .* Ibid.

121 *It was always a joy . . .* Kapitanoff, "Sixty-three Years of Shooting the Legends."

121 *Harlow was not frightened . . .* Stine, *The Hurrell Style,* p. 41.

121 *She was very sensitive . . .* Ibid.

132 (caption) *Being a motion picture actress . . .* Norma Shearer, unpublished interview, 1958; author's collection.

133 *Shearer was something new . . .* Mick LaSalle to the author, March 9, 1996.

133 *the ultra-civilized, sleek and slender . . .* Kobal and Durgnat, *Garbo,* p. 47.

133 *Strangely enough . . .* Busby, "The Camera Does Lie," p. 74.

133 *She knew how to focus . . .* Lambert, *Norma Shearer,* p. 132.

133 *She ribbed me . . .* Kobal, *People Will Talk,* p. 257.

133 *She had this driving force . . .* Lambert, *Norma Shearer,* p. 109.

133 *Each time . . .* Fahey, "Interview with George Hurrell," p. 3.

133 *I can't . . .* Quirk, *Norma,* p. 148.

133 *Being a motion picture actress . . .* Norma Shearer, unpublished interview, 1958; author's collection.

134 (caption) *an international symbol . . .* Card, *Seductive Cinema,* p. 174.

143 *all the talent . . .* Crawford and Ardmore, *A Portrait of Joan,* p. 96.

143 *Sometimes Crawford . . .* Joan Rose to the author, November 1, 1995.

143 *He worked to catch . . .* Trent, *The Image Makers,* p. 54.

143 *Crawford was a natural . . .* Stine, *The Hurrell Style,* p. 62.

143 *Whenever we went . . .* George Hurrell to the author, July 17, 1976.

143 *Hurrell would follow me . . .* Trent, *The Image Makers,* p. 54.

143 *Joan was the most serious . . .* Christy, in *The Hollywood Reporter.*

143 *go from one pose . . .* Hayes, "George Hurrell," p. 34.

143 *Joan Crawford has always been . . .* Hurrell, "Interview," p. 3.

147 (caption)	*She was radioactive . . .* recording).	An Evening with Quentin Crisp (audio
148 (caption)	*Although in real life . . .*	Sennwald, "Forsaking All Others."
153 (caption)	*It has been said . . .* p. 156.	Crawford and Ardmore, *A Portrait of Joan,*
155	*Those days were . . .* p. 63.	Long, "The Man Who Made the Stars Shine,"
155	*She never gave me . . .* Queens."	Taylor, "Still Photographer's View of Film
155	*She could swear . . .*	Ibid.
155	*Carole Lombard has a knack . . .* Confesses," p. 53.	Surmelian, "Studio Photographer
155	*We were talented . . .*	Kobal, *Hollywood Glamor Portraits,* p. x.
155	*He looked more like . . .* author's collection.	Norma Shearer, unpublished interview, 1958;
155	*I liked him . . .*	Broman, *Conversation with Greta Garbo,* p. 65.
155	*half the bear's fangs . . .*	Russell, *Life Is a Banquet,* p. 66.
155	*I could tell . . .*	Stenn, *Bombshell,* p. 210.
155	*This girl was driven . . .*	Joan Rose to the author, November 1, 1995.
155	*Laszlo Willinger to the author, January 21, 1985.	
155	*I got tired . . .* Long, "The Man Who Made the Stars Shine," p. 63.	
155	*That's not my mouth . . .* George Hurrell to the author, April 1, 1976.	
156	*I'm not a good straw boss . . .* Fragmentary clipping from the *Oakland Post-Enquirer,* October 20, 1939.	
156	*Just about the time . . .*	Ibid.
160	*From Warner Brothers documents in the Warner Brothers Collection at the University of Southern California, Los Angeles.	
160	*Hurrell is to a portrait . . .* *Lux Radio Theatre* aircheck, January 3, 1938.	
161	*Product information: "Tradewinds," p. 6.	
161	*The power of glamor . . .*	Baxter, *Sternberg,* p. 53.

161 *They got George . . .* Kobal, *People Will Talk,* p. 421.

161 *They are all sexy . . .* "George Hurrell Leaves to Join Army Air Force."

162 *Every once in a while . . .* John Kobal, *People Will Talk,* p. 262.

162 *Oh, you're so good . . .* "He Knows All the Angles."

162 *One more . . .* Carroll, "George Hurrell, Glamour Monger," p. 89.

162 *Give . . .* "Movie Glamor to Order," p. 18.

162 *Shoot for the sex angle . . .* "Hurrell's Magic," p. 18.

162 *There are friends . . .* Carroll, "George Hurrell, Glamour Monger," p. 112.

173 (caption) *Why are you so good . . .* "Movie Glamour to Order," p. 18.

175 *Technical data: Warners press release on reverse of stills.

175 *I don't want some glamour girl stuff . . .* Taylor, "Still Photographer's View of Film Queens."

175 *Every now and then . . .* "He Distracts the Hollywood Stars."

175 *You're the most glamorous . . .* "Movie Glamor to Order," p. 18.

175 *Go easy . . .* Ibid.

175 *I don't play the music . . .* "He Knows All the Angles."

175 *All I had . . .* Hayes, "George Hurrell," p. 31.

175 *I don't remember . . .* Taylor, "Still Photographer's View of Film Queens."

175 *Hell, these are fine . . .* Ibid.

175 *There was something . . .* Stine, *The Hurrell Style,* p. 144.

175 *She had the ability . . .* Ibid.

176 *If you can keep . . .* Kobal, *People Will Talk,* p. 261; also, George Hurrell to the author, July 17, 1976.

176 *You think about shooting . . .* Hayes, "George Hurrell," p. 32.

176 *I liked the sets . . .* Kobal, *People Will Talk,* p. 261.

176 *Well, what are you doing . . .* Stine, *The Hurrell Style,* p. 150.

176 (caption) *I will not . . .* George Hurrell to the author, June 27, 1988.

177 (caption) *Hurrell was able . . .* Trent, *The Image Makers*, p. 56.

178 *Account of Hurrell's departure from Warners: John Kobal to the author, February 14, 1986.

178 (caption) *Bette Davis is Hollywood's . . .* Carroll, "He Glamorizes Glamour," p. 64.

178 (caption) *George Hurrell was the greatest . . .* Trent, *The Image Makers*, p. 56.

181 *a triumph . . .* Allen, "Glamour Workshop," p. 76.

181 *Alloo, Mister 'Urell . . .* Stine, *The Hurrell Style*, p. 164.

181 *Before she left . . .* Ibid.

181 *There was a certain kind of fantasy . . .* Kobal, *People Will Talk*, p. 420.

181 *We have no new Garbos . . .* Norma Shearer, unpublished interview, 1958; author's collection.

181 *As appointment time nears . . .* Allen, "Hurrell Exposes Glamour," pp. 26–27.

182 *A haystack . . .* Stine, *The Hurrell Style*, p. 165.

182 *We just had a haystack there . . .* Fahey, "Interview with George Hurrell," p. 6.

182 *You don't make a star . . .* Ibid.

187 *She has the clearest conception . . .* Carroll, "He Glamorizes Glamour," p. 64.

187 *All of us glamorize . . .* Allen, "Hurrell Exposes Glamour," p. 25.

187 *Bring out the best . . .* Ibid.

187 *The still gallery was located . . .* Stine, *The Hurrell Style*, p. 175.

187 *If I were you . . .* Ibid., p. 178.

187 *You'd retouch until . . .* George Hurrell to the author, December 1, 1975.

187 *She had a nice personality . . .* Stine, *The Hurrell Style*, p. 177.

188 *You can't work with a person . . .* Fahey, "Interview with George Hurrell," p. 6.

188 *I discovered that I had been drafted . . .* Stine, *The Hurrell Style,* p. 179.

188 (caption) *Hurrell remembered . . .* George Hurrell to the author, November 1, 1975.

196 (caption) *the dear girl . . .* Unpublished letter, George Hurrell to John Kobal, May 20, 1977; from the Kobal Foundation, courtesy of Simon Crocker.

198 *Departure date, destination: "George Hurrell Leaves to Join Army Air Force."

198 *peeling potatoes . . .* Stine, *The Hurrell Style,* p. 179.

198 *I shot stills . . .* Ibid.

198 *When I was in the Army . . .* Hayes, "George Hurrell," p. 33.

198 *In April of 1943 . . .* Stine, *The Hurrell Style,* p. 179.

198 *those lovely pictures . . .* The song "I Love an *Esquire* Girl" was written specifically for the film by Lew Brown, Ralph Freed, and Roger Edens.

199 *When we stopped using those 8 × 10 cameras . . .* George Hurrell to the author, January 22, 1980.

199 *Those speedlights . . .* C. S. Bull to the author, August 12, 1978.

199 *I'd get bored with movie stars . . .* "Hurrell," p. 234.

BIBLIOGRAPHY

BOOKS

Baxter, Peter. *Sternberg*. London: BFI Publishing, 1980.

Beaton, Cecil. *The Wandering Years*. Boston: Little, Brown, & Company, 1960.

Broman, Sven. *Conversations with Greta Garbo*. New York: Viking, Penguin, 1992.

Bull, Clarence Sinclair, and Raymond Lee. *Faces of Hollywood*. Cranbury, N.J.: A. S. Barnes, 1968.

Card, James. *Seductive Cinema*. New York: Alfred A. Knopf, 1994.

Crawford, Joan, and Jane Kesner Ardmore. *A Portrait of Joan*. Garden City, N.Y.: Doubleday, 1962.

Crowther, Bosley. *The Lion's Share*. New York: E. P. Dutton, 1957.

Deutelbaum, Marshall, ed. *"Image" on the Art and Evolution of Film*. New York: Dover, 1979.

Fiedler, Franz. *Portrait Photography*. Boston: American Photographic Publishing, 1936.

George Hurrell: Hollywood Glamour Portraits. With an interview with George Hurrell by John Kobal. London: Schirmer Art Books, 1993.

Guiles, Fred Lawrence. *Joan Crawford: The Last Word*. New York: Birch Lane Press, 1995.

Hurrell, George. *The Book of Stars*. London: Schirmer Art Books, 1991.

Kobal, John. *People Will Talk*. New York: Alfred A. Knopf, 1985.

———. *The Art of the Great Hollywood Portrait Photographers*. New York: Alfred A. Knopf, 1980.

———. *Hollywood Glamor Portraits*. New York: Dover, 1976.

Kobal, John, and Raymond Durgnat. *Greta Garbo*. New York: Dutton, Vista, 1965.

Lambert, Gavin. *Norma Shearer*. New York: Alfred A. Knopf, 1990.

Pepper, Terence, and John Kobal. *The Man Who Shot Garbo*. New York: Simon & Schuster, 1989.

Quirk, Lawrence J. *Norma*. New York: St. Martin's Press, 1988.

Russell, Rosalind, and Chris Chase. *Life Is a Banquet*. New York: Ace Books, 1979.

Shipman, David. *The Great Movie Stars: The Golden Years*. New York: Crown, 1970.

Stenn, David. *Bombshell: The Life and Death of Jean Harlow*. New York: Doubleday, 1993.

Stine, Whitney. *The Hurrell Style*. New York: John Day, 1976.

Trent, Paul. *The Image Makers*. New York: McGraw-Hill, 1972.

Vickers, Hugo. *Loving Garbo*. New York: Random House, 1994.

SIGNED ARTICLES

Albright, Thomas. "The Art of Capturing Stars." *San Francisco Chronicle,* June 27, 1980.

Allen, G. T. "Hurrell Exposes Glamour." *U.S. Camera* 5, no. 1 (January 1942), pp. 23–27.

———. "Glamour Workshop." *U.S. Camera* 5, no. 1 (January 1942), pp. 74–76.

Barrett, Sharon. "Shooting Stars." *Chicago Sun-Times,* May 18, 1980.

Borger, Irene. "George Hurrell's Hollywood Glamour." *Architectural Digest* 49, no. 4 (April 1992), pp. 66, 70, 74, 77.

Boz, Napoleon. "Shooting the Stars." *Hollywood Studio Magazine* 4, no. 5 (November 1969), pp. 4–5.

Busby, Marquis. "The Camera Does Lie." *Movie Mirror* 5, no. 1 (December 1933), pp. 46–48, 74.

Carle, Teet. "Backward Look at Glamor." *Hollywood Studio Magazine* 5, no. 9 (January 1971), pp. 8–10.

Carroll, Roger. "He Glamorizes Glamour." *Motion Picture* 63, no. 2 (March 1942), pp. 27–34, 62–64.

Carroll, Sidney. "George Hurrell: Glamour Monger." *Esquire* 13, no. 3 (March 1940), pp. 89, 111–12.

Champlin, Charles. "Tending His Pose Garden." *Los Angeles Times,* December 31, 1976.

Christy, George. Item in *The Hollywood Reporter,* July 27, 1979, p. 46.

Crane, Tricia. "Grand Master of Glamor." *Los Angeles Herald Examiner,* January 29, 1988.

Curtis, Alyce. "What Fate Did to Norma Shearer!" *Screenplay* 13, no. 91 (October 1932), pp. 27, 58–59.

Denhoff, Alice. "An Appreciation of Hal Phyfe." *Studio Light* 22, no. 8 (October 1930), pp. 14–18.

Fahey, David. "Interview with George Hurrell." *G. Ray Hawkins Gallery Photo Bulletin* 3, no. 3 (June 1980), pp. 1–6.

Hall, Gladys. "Discoveries About Myself (Norma Shearer)." *Motion Picture* 39, no. 3 (April 1930), pp. 58–59, 100.

Hayes, Robert. "George Hurrell." *Interview* 11, no. 3 (March 1981), pp. 31–34.

Hurrell, George. "Glamour Portraits with Any Camera." *PIC,* April 30, 1940, pp. 12–13.

———. "Interview." *International Photographer,* September 1941, p. 3.

Jensen, George. "Movie Mag Pictures." *Rocky Mountain News,* December 1, 1974, p. 25.

Jones, Carlisle. "Studio Portraits." *International Photographer,* March 1941, pp. 13–15.

Jordan, Allan. "Photographing Garbo." *Movie Mirror* 2, no. 3 (July 1932), pp. 46, 100–101.

Kapitanoff, Nancy. "Sixty-three Years of Shooting the Legends." *Los Angeles Times Calendar,* December 15, 1991.

Kern, John. "A Friendly, Personable Young Man (Robert Montgomery)." *Yankee Magazine,* October 1979, pp. 126–31, 174.

Knight, Christopher. "The Legends Created by Photographer George Hurrell." *Los Angeles Herald Examiner,* August 25, 1982.

Lacy, Madison. "An Interview with George Hurrell." *International Photographer,* January 1977.

LaSalle, Mick. "Lights Up on Hollywood's Hurrell," *San Francisco Chronicle,* January 16, 1995.

Lane, Virginia T. "Norma Shearer's New Wardrobe." *Modern Screen* 5, no. 4 (March 1933), pp. 40–42, 96–98.

Lee, Sonia. "Norma Fights Back!" *Hollywood* 22, no. 6 (June 1932), pp. 29, 63.

Leider, R. Allen. "George Hurrell." *Celebrity* 3, no. 4 (April 1977), pp. 32–35.

Long, Rod. "The Man Who Made the Stars Shine." *Petersen's Photo Graphic* 9, no. 12 (April 1981), pp. 63–64.

Loynd, Ray. "Glamour Gallery of Hollywood." *Los Angeles Herald Examiner,* January 4, 1977.

Massengill, Reed. "The Unsung Glamour of George Hurrell." *Flatiron News,* September 1995, p. 19.

Morrison, Mark. "The Old Master Today." *Los Angeles* 26, no. 1 (January 1981), pp. 139, 251.

Parsons, Harriet. "Norma Talks About Joan!" *Picturegoer* 2, no. 96 (March 25, 1933), pp. 12–13.

Quirk, May Allison. "Fulfillment of a Wink (Ramon Novarro)." *Photoplay* 43, no. 5 (April 1933), pp. 58, 87.

Sennwald, Andre. "Forsaking All Others." *New York Times,* December 26, 1934.

Sullivan, Meg. "Hurrell's Magic Camera." *Los Angeles Daily News,* September 18, 1992.

Surmelian, Leon. "Studio Photographer Confesses." *Motion Picture* 56, no. 6 (January 1939), pp. 38–39, 53.

Tallmer, Jerry. "Rembrandt to the Stars." *New York Post,* March 13, 1985.

Taylor, Frank. "Still Photographer's View of Film Queens." *Los Angeles Times,* June 1, 1969.

Thirer, Irene. "Hurrell Waxes on Famed Lens Subjects." *New York Post,* November 13, 1940.

Wayne, Hollis. "Hollywood Hot Shots." *Playboy* 38, no. 12 (December 1991), pp. 118–23.

ANONYMOUS ARTICLES

"All in a Day." *International Photographer* 9, no. 3 (April 1937), p. 1.

"Auction Notes." *The ARTnewsletter,* June 9, 1981, p. 8.

"Camera." *International Photographer* 9, no. 3 (October 1937), p. 9.

"The Camera Speaks." *Photoplay* 52, no. 8 (August 1938), pp. 26–27.

"5 by Hurrell." *PM,* March 8, 1942, pp. 16–17.

"George Hurrell Leaves to Join Army Air Force." *Hollywood Citizen,* November 2, 1942.

"He Distracts the Hollywood Stars." *Oakland Tribune,* December 3, 1940.

"He Knows All the Angles." *Charlotte News,* July 26, 1941.

"How Hurrell Shoots." *Motion Picture,* November 1940, pp. 48–49.

"Hurrell." *Playboy* 30, no. 1 (January 1983), pp. 161, 172, 234.

"Hurrell's Magic." *The Coast,* October 1939, pp. 18, 48.

"Movie Glamour to Order." *Look* 4, no. 18 (August 27, 1940), pp. 18–21.

"Norma Shearer." *New Movie* 9, no. 5 (May 1934), pp. 32–33, 70–71.

"Novarro with Impressions." *Los Angeles Sunday Times,* October 20, 1929.

"Portrait Studies." *International Photographer* 12, no. 10 (November 1940), pp. 6–8.

"Shooting Stars." *People and Places,* February 1941.

"Short Takes: Hammered Out." *American Photographer* 7, no. 2 (August 1981).

"Tradewinds: News of New Products." *International Photographer* 9, no. 11 (December 1937), p. 6.

AUDIO RECORDING

An Evening with Quentin Crisp. DRG Records, 1979.

DOCUMENTARY FILM

Legends in Light. Produced and directed by J. Grier Clarke, 1995.

INDEX